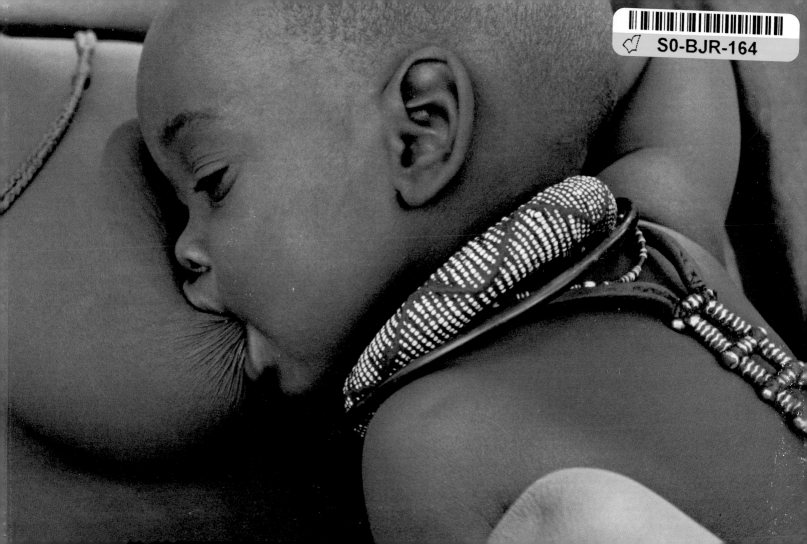

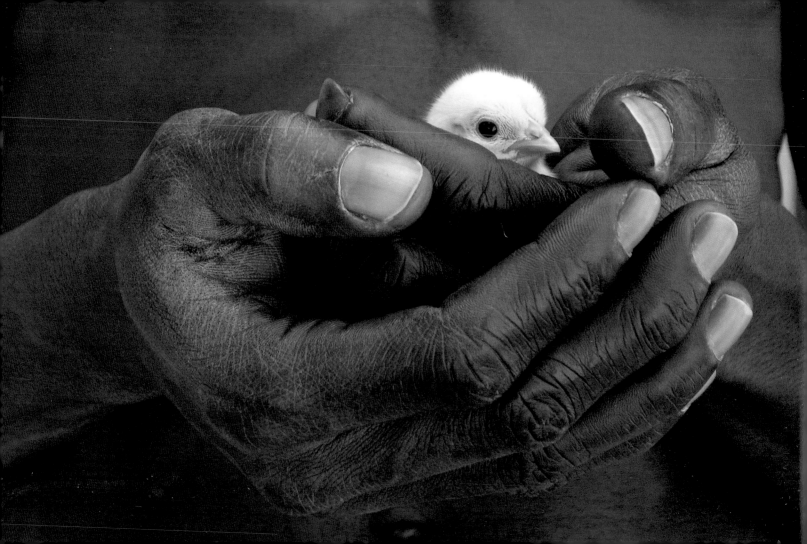

Origins
AFRICAN WISDOM FOR EVERY DAY

Danielle & Olivier Föllmi

With the collaboration of the Institut Fondamental d'Afrique Noire (IFAN), Dakar;
Youssou Mbargane Guissé, Ali Guindo, and Mame-Kouna Tondut-Sène.

Preface by Doudou Diène

Text drawn from the oral tradition of great initiates belonging to the Bambara, Bantu, Baoule, Bariba, Bassar, Bushman, Dagara, Dogon, Ewe, Kikuyu, Malinke, Mande, Mandingo, Masai, Massongo, Mossi, Peul, Serere, Swahili, Tukulor, Warega, Wolof, and Xam peoples.

Text also from Chinua Achebe, Louis Armstrong, Amadou Hampâté Bâ, Mariama Bâ, Cheikh Oumar Bâ, Seydou Badian, Ken Bugul, Aimé Césaire, Bernard Dadié, Manthia Diawara, Manu Dibango, Irénée Guilane Dioh, Birago Diop, Bouna Boukary Diouara, Jean-Marc Éla, Ali Guindo, Dr. Raymond Johnson, Cheikh Hamidou Kane, Jomo Kenyatta, Dr. Martin Luther King Jr., Joseph Ki-Zerbo, Ahmadou Kourouma, Barnabé Laye, Nelson Mandela, Thurgood Marshall, Nsame Mbongo, Father Engelbert Mweng, Jacques Nanéma, Diatta Nazaire, Alassane Ndaw, Ebénézer Njoh-Mouelle, Titinga Frédéric Pacere, Léopold Sédar Senghor, Ousmane Socé, Sobonfu Somé, Efua Theodora Sutherland, Djibril Tamsir Niane, Aminata Traoré, Albertine Tshibilondi Ngoyi, Kwasi Wiredu, and Abner Xoagub.

Translated from the French by Graham Edwards

Harry N. Abrams, Inc., Publishers

Taking Control of the Heart
July 2 to September 2

Song of the Spirit

Passions and Emotions

The Marriage of Two Souls

Becoming Parents

Living Together

Gratitude

Living in Peace

A Community for Self-Expression

Taking Control in Relating
September 3 to November 5

Social Life, a Cosmic Mission

Sickness and Healing

Becoming Aware

Dialogue and Freedom

Culture and Development

Knowledge and Consciousness

Environment and Spirituality

Production and Consumption

The Civilized Man

Generosity

Vital Energy
November 6 to December 31

Distributing Power

Being and Inspiring

A Sage Never Dies

Valuing Being Born, Living, Dying

Taking Time to Live

Creative Energy

When Words Become Sacred

When Our Hearts Come Together

"In the forest, when the branches

This African proverb pleads for a return to the sources that feed, invigorate, unite, and give sense to the world's diversity.

The branches, which are obvious, visible, tangible, are the words of life; its "myriad flowers" are humankind, with its multitude of individuals, races, and groups, as well as nature with its multifaceted forms and colors. All of these are demonstrably alive, with singularities and contrasts within which they can become confined.

quarrel, the roots embrace."

The roots are the invisible, immaterial, indiscriminate, silent places that are the origin and destination of all things. The trunk, where cross-fertilization and meetings happen, is where the eyes and ears of Danielle and Olivier Föllmi have found their source.

The prevailing clamor would have us hear only the siren voices that speak the language of power, the end of history, materialism, and the struggle for domination. These are the criteria by which Africa tends to be viewed and described. But as Africa's venerable sages observed of the colonial visitor, "The white man (the European) sees only what he already knows." This book takes us back to the "roots that embrace," exposing us to what we do not already know, the murmuring of deep, hidden waters.

—Doudou Diène

Director of Intercultural Dialogue, UNESCO, and UN Special Rapporteur
of the Commission on Human Rights on contemporary forms of racism,
racial discrimination, xenophobia, and related intolerance.

Before the creation of the world, before all things began, there was nothing, save ONE BEING.

This being was a Void without name or limit;

yet it was a living Void: it harbored within it the potential sum of all possible existences.

Infinite, eternal Time was the dwellingplace of that ONE BEING.

—Mande cosmogony

Dusk, Namibia.

The ONE BEING *gave himself two eyes. He closed them, and there was night.*

He opened them, and day was born.

Night was embodied in the Moon. Day was embodied in the Sun.

The Sun wed the Moon. They begat divine temporal Time.

—*Mande cosmogony*

The watering hole in Okaukuejo, Namibia.

The Supreme Being accomplished his Great Work of Creation by multiplying his person,

yet thereby lost nothing. He quickened all things with energy.

—Bantu cosmogony

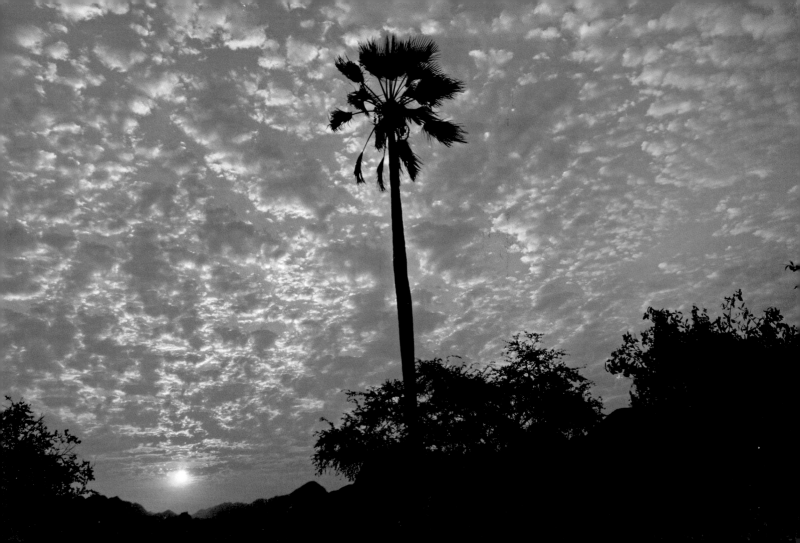

First were the demigods or genies. Then came the primordial, mythical ancestors, followed by ordinary ancestors.

Then living men, in order of their birth, and the animal, the vegetable, and the mineral.

—Alassane Ndaw

The watering hole in Choudop, Namibia.

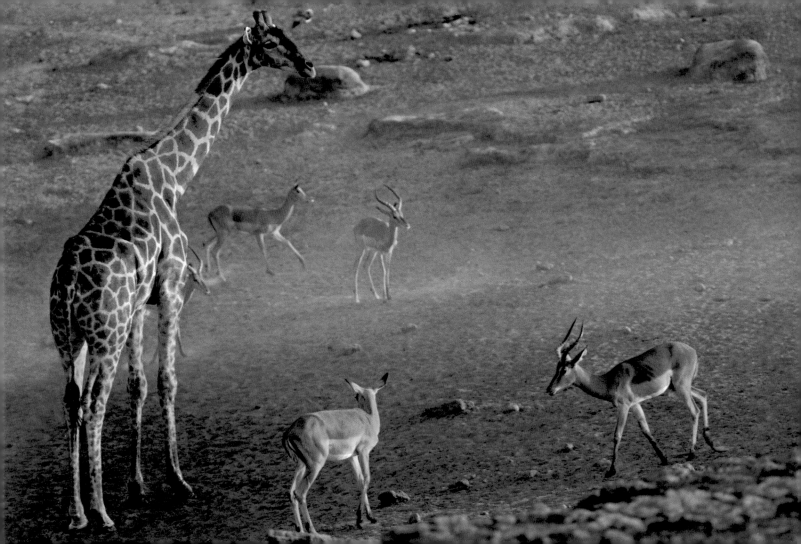

The more closely you approach God, the greater your vital force. Every being, even the humblest, even the seemingly most inanimate, has a soul, a force.

—Alassane Ndaw

Dan mask, Ivory Coast.

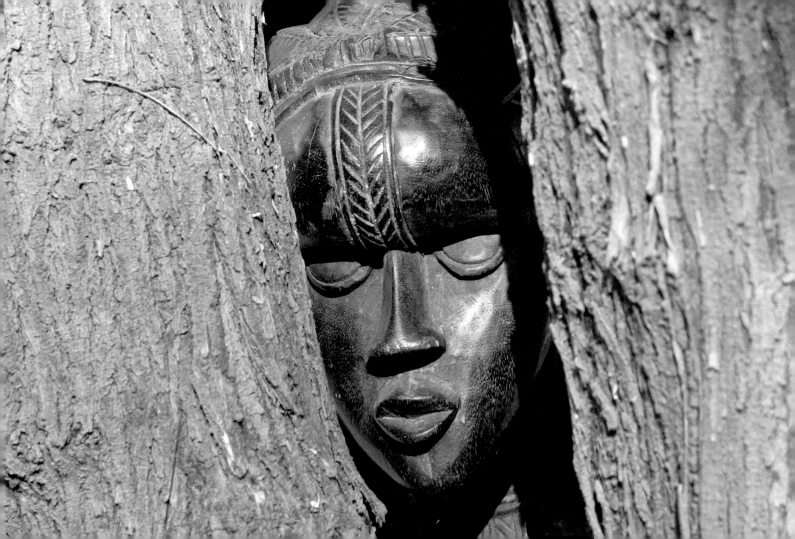

The Supreme Being blew the Spirit into Man with his breath.

—Bantu tradition

Oumar, in his house by the Niger River, Mali.

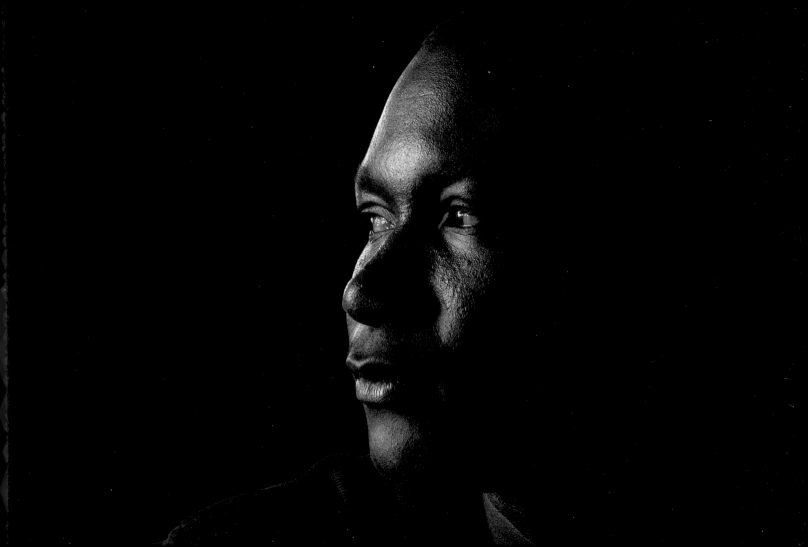

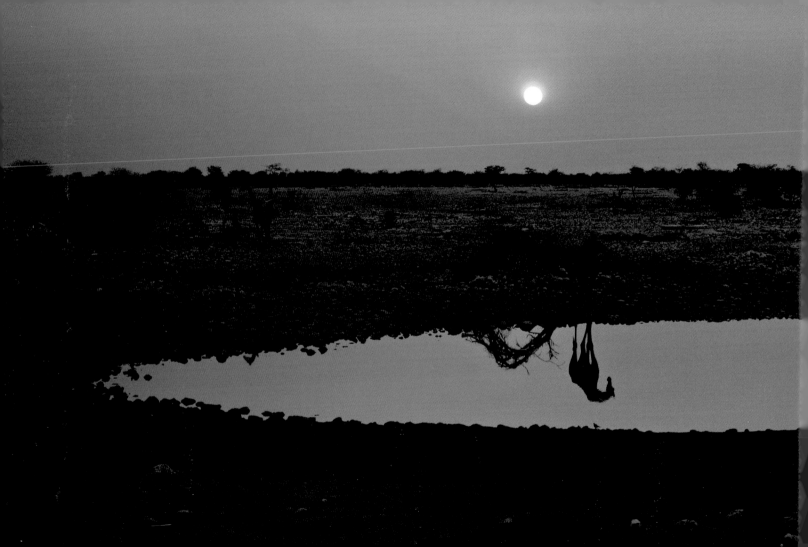

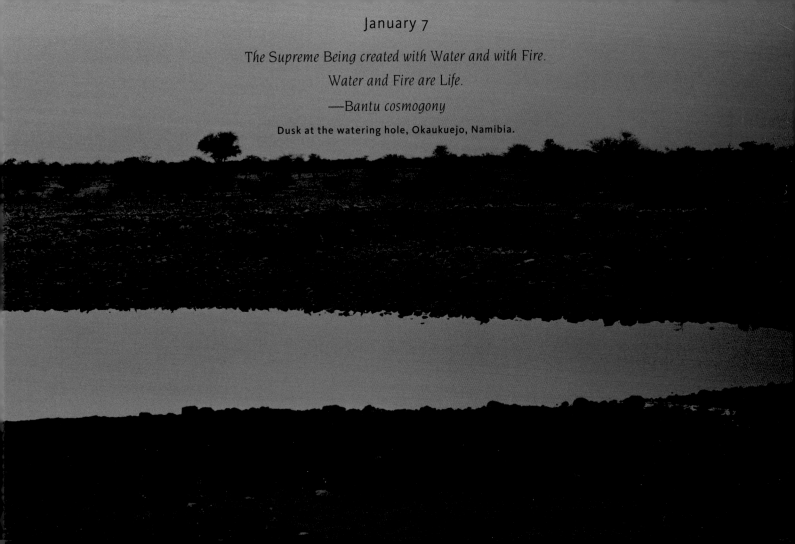

January 7

The Supreme Being created with Water and with Fire.

Water and Fire are Life.

—Bantu cosmogony

Dusk at the watering hole, Okaukuejo, Namibia.

Encompassed by a world of tangible, visible things—animals, plants, and stars—mankind has from time immemorial perceived that deep within these beings and things dwells something powerful, yet indescribable, that gives them life.

—Peul oral tradition

Alemayehu Belachew, in her earthen kitchen, Ethiopia.

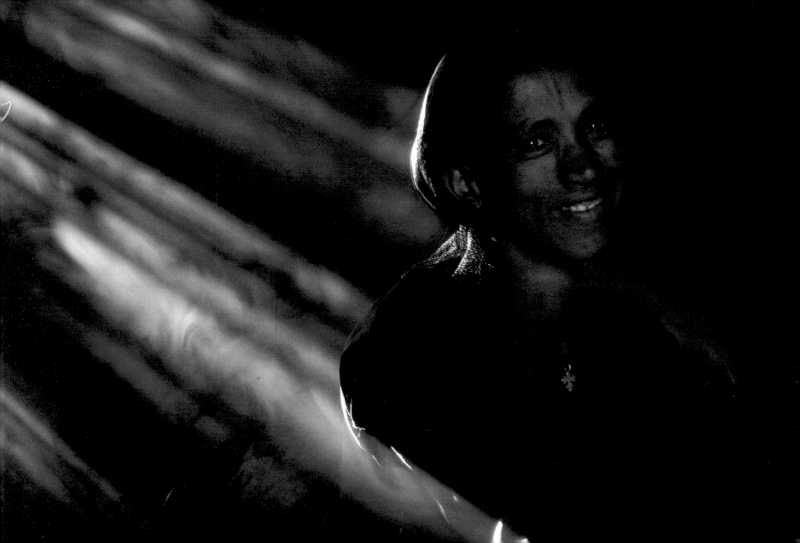

There is the spirit of nature, the spirit of the river, the spirit of the mountain.

There is the spirit of the animals, of the water, the spirit of the ancestors.

Spirit is everywhere.

—*African oral tradition*

The herds are smoke-treated against mosquitoes, Lake Chad, Chad.

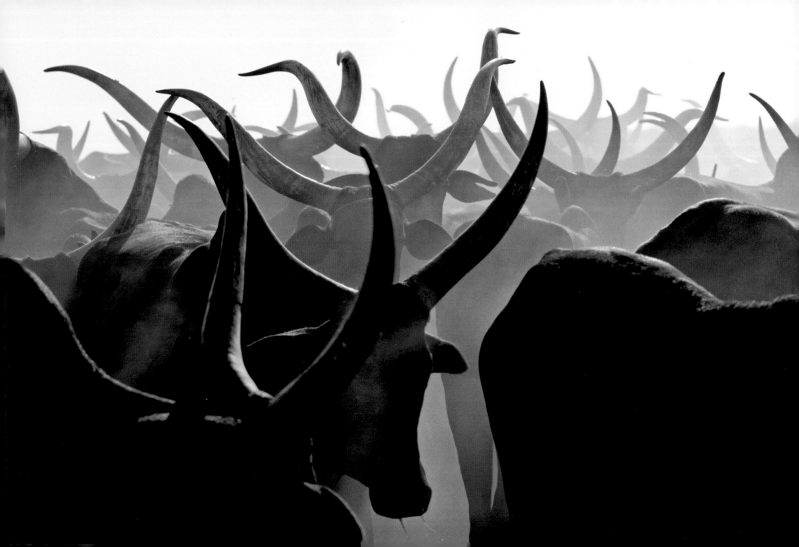

The spirit is power, the life that is in everything.

—African oral tradition

On the high plateaus of Ethiopia.

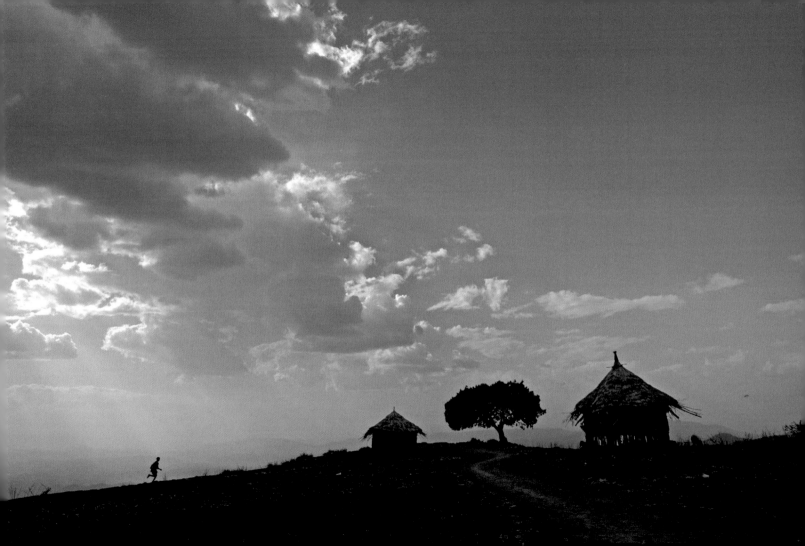

Listen more often

To things than to beings

The voice of the fire can be heard

Hear the voice of the water

Listen in the wind

To the sobbing bush.

It is the breath of the ancestors.

—Birago Diop

An Ethiopian shepherd watches over his sheep.

The black man is convinced of the existence of a Force, a Power, a Source of all Existence;

it is what drives beings' actions and movements. At the same time, he does not see this Force as outside

of creatures. It is in every being. It gives beings life and watches over their development.

—Alassane Ndaw

A typical western savanna landscape, Mali.

Every being, even a mere appearance, the smallest detectable sign, is endowed with singular force.

The truth is that man, especially living man,

is endowed with the privilege of possessing the most active and dynamic force of all.

—Alassane Ndaw

Ihahina N'diaye, a Senegalese dancer.

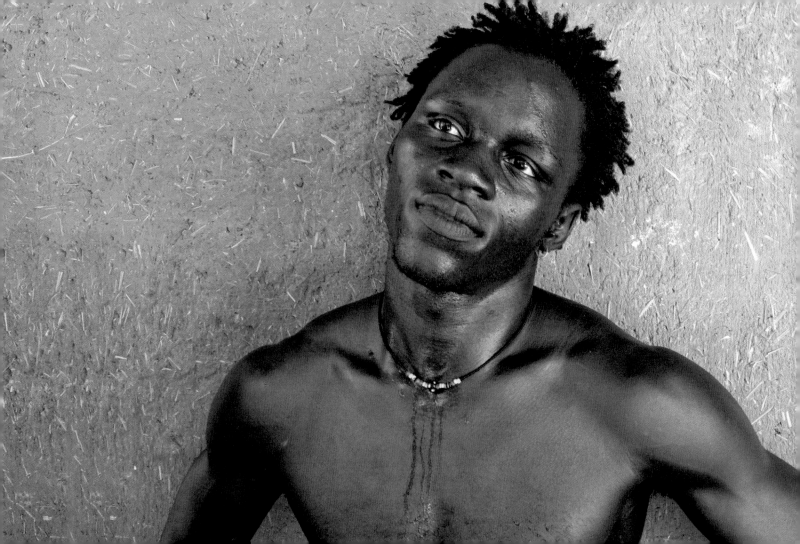

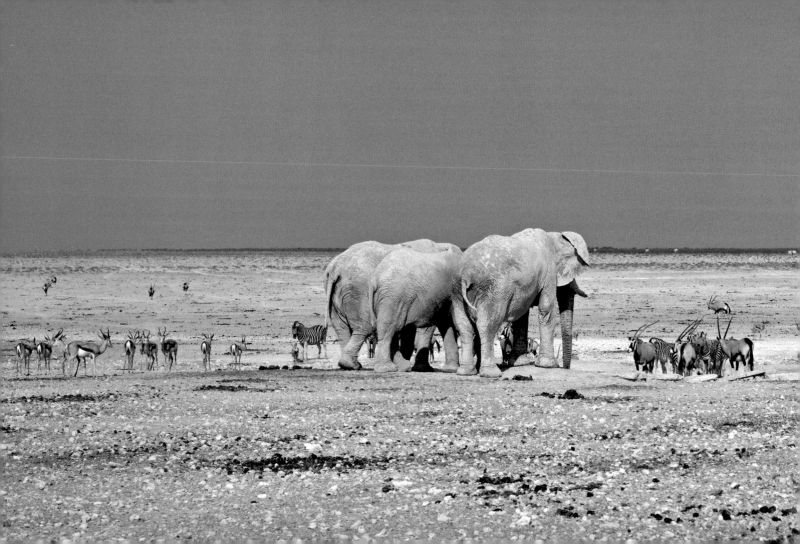

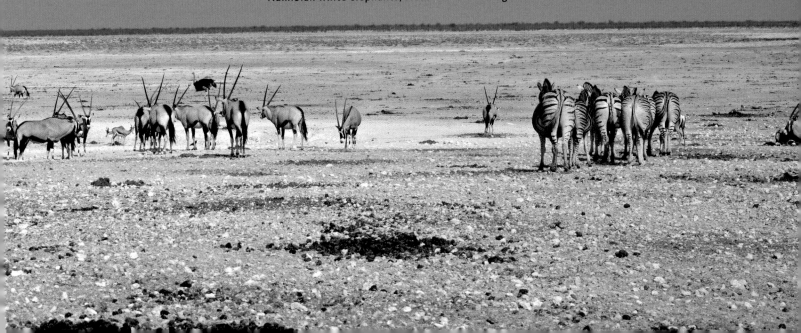

January 14

Everything living has a soul.

—African oral tradition

Namibian white elephants, Neubrowni watering hole.

We are about to go on a journey into an "underground" world,

the world of meanings hidden beneath the appearances of things,

the world of symbols where everything is significant,

where everything speaks to those who can hear.

—Peul oral tradition

Within the confines of the hilltop church of Asheten Maryam, Ethiopia.

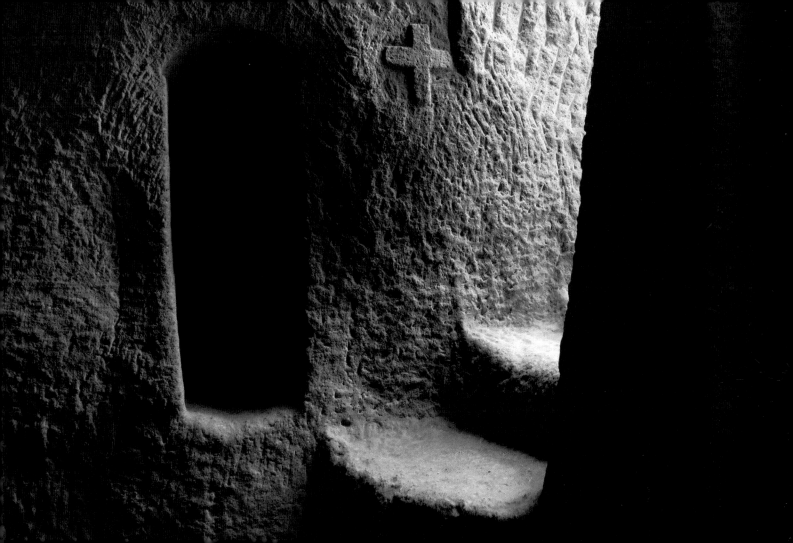

Awakened, nature pays homage to her master, the dispenser of brightness to mankind,

the radiant illuminator of all that is alive on Earth.

—Irénée Guilane Dioh

Returning fishermen, Niger River, Mali.

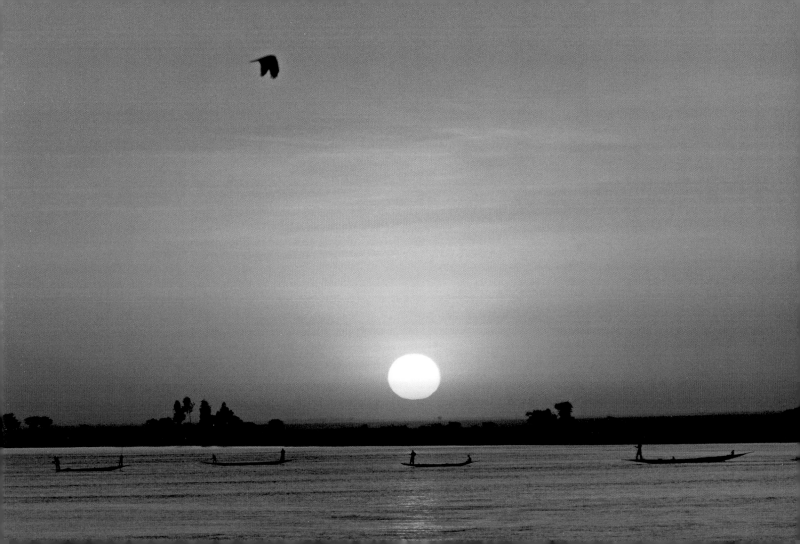

The earth is the mother of all that moves, and is the common bond between

the generations that have been, are, and are to come.

—Kikuyu oral tradition

Makarukasa, a young Himba mother, with her first child, Namibia.

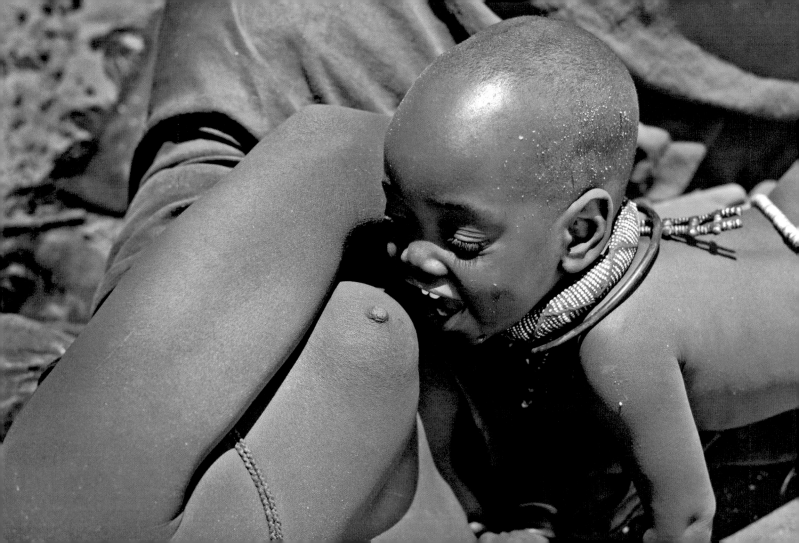

This you must remember: the fact that a thing cannot be seen, handled, or perceived

does not absolutely prove it does not exist.

—Amadou Hampâté Bâ

The shadow of a Bambara statue, Mali.

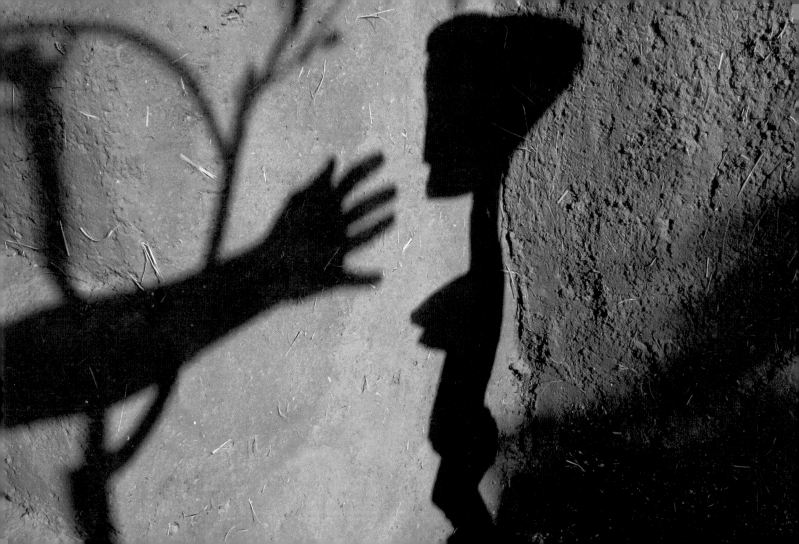

The first weaver, the spider.

The first builder, the ant.

The first craftsman, the smith.

—Bantu oral tradition

Termites are part of all African savannas.

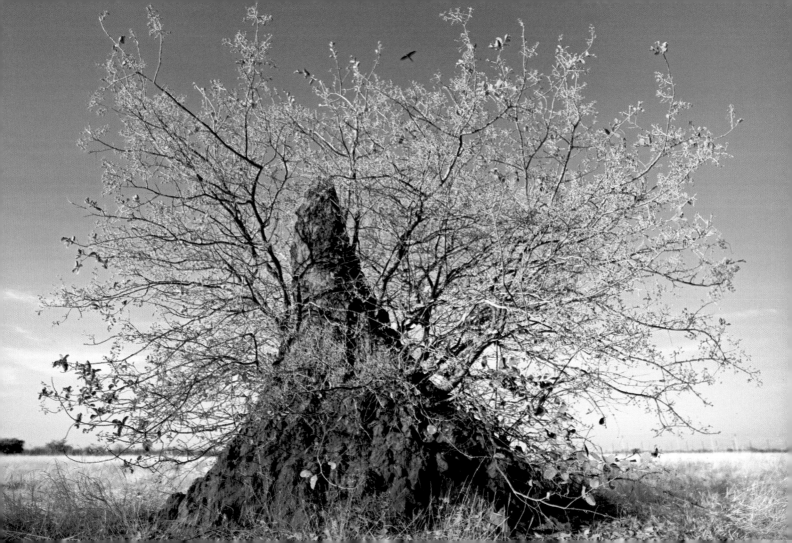

The First Son of the earth, the smith, transforms matter to create objects.

He therefore is the first one to mirror the original Creation.

His workshop is a reflection of the great cosmic forge.

All objects therein are symbolic, and every gesture he performs there is ritual.

—Peul oral tradition

Beings were first mineral, then vegetable,

and finally animal.

This hybrid being unifies the three kingdoms.

It is crowned by man.

He signifies unity.

—African oral tradition

An Ethiopian believer at prayer, Gondar, Ethiopia.

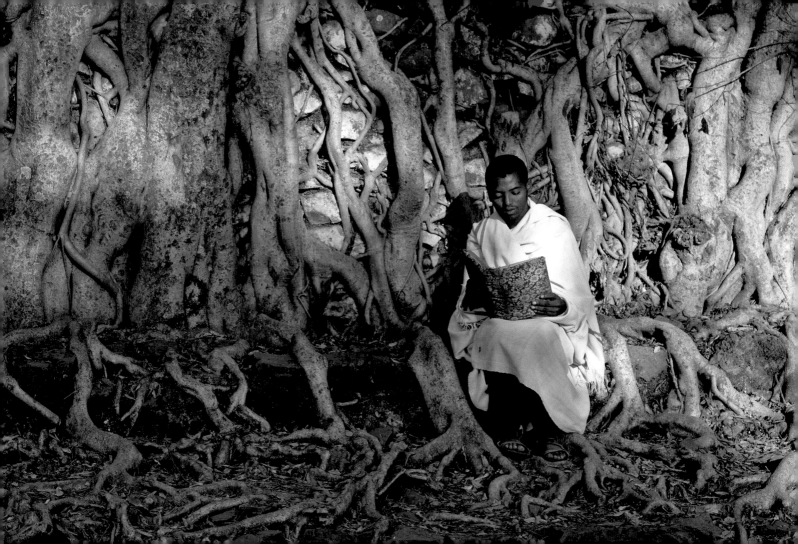

Everything visible has a connection to an invisible force, to which it is subject.

If a thing is to be used, this force must first be consulted.

—Amadou Hampâté Bâ

Dogon news-bearing mask, Mali.

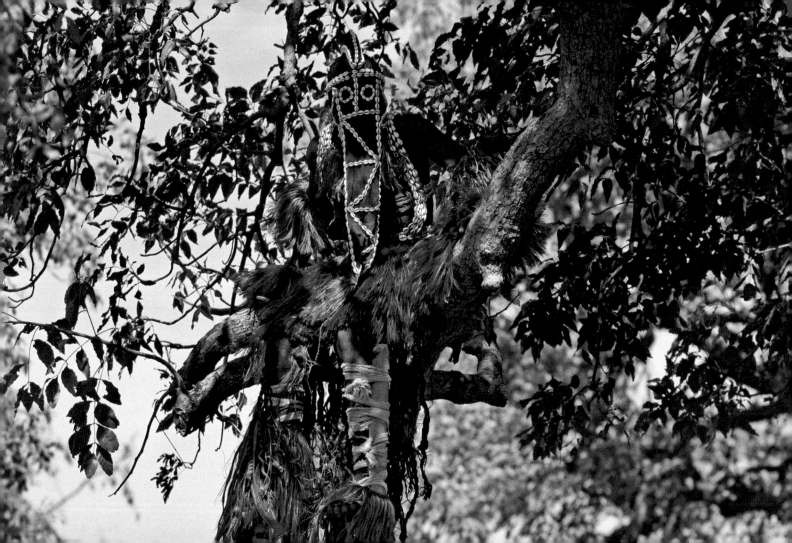

The divine Force, which inhabits every being, every thing, every place, may be intensely realized when man takes the trouble to invite it to reveal itself.

—Alassane Ndaw

Within the church of Beta Maryam, by Lake Tana, Ethiopia.

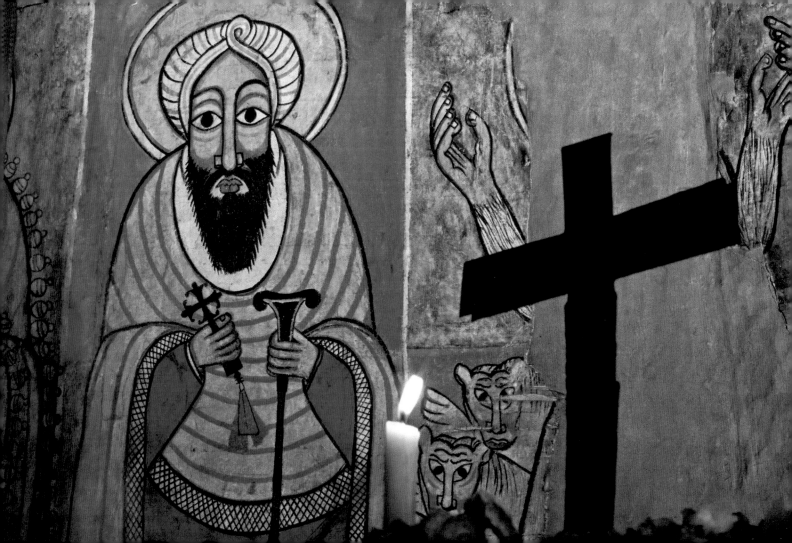

The body of a man is very small compared with the spirit that inhabits it.

—African oral tradition

Tracks linking villages on the Ethiopian high plateaus.

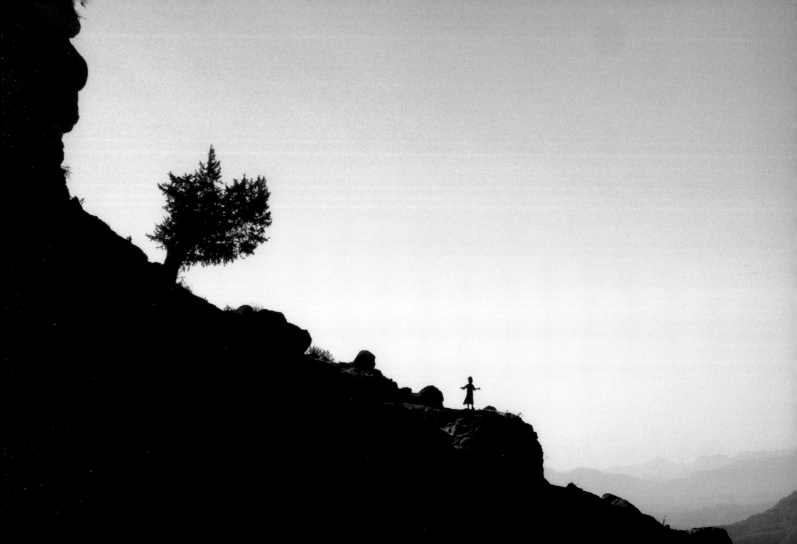

Within the universe, at every level, all things vibrate.

Only the differing frequencies of the vibrations prevent us from

perceiving the realities we call invisible.

—Amadou Hampâté Bâ

Dugout canoes are the links among the fishing villages along the Niger River, Mali.

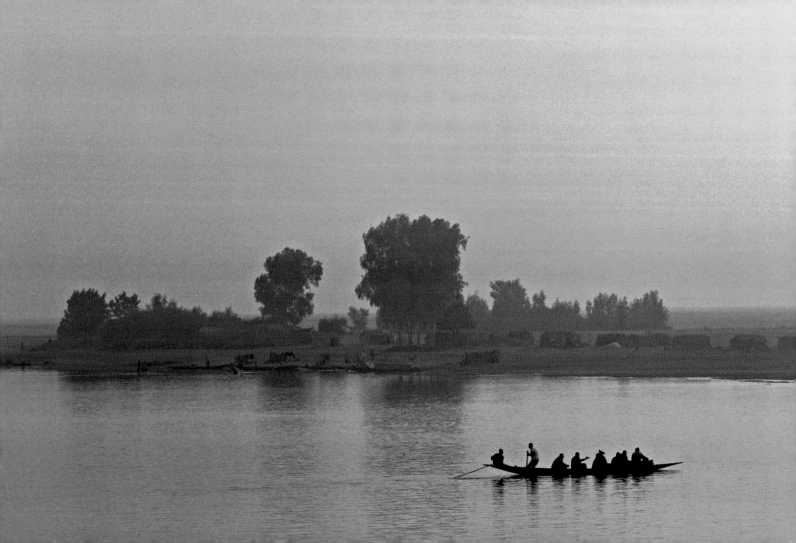

It is very easy for us to get lost in the mundane world and forget about our connection to spirit.

Yet without that connection we are basically the walking dead.

—Sobonfu Somé

Moussa N'diaye, a Senegalese dancer.

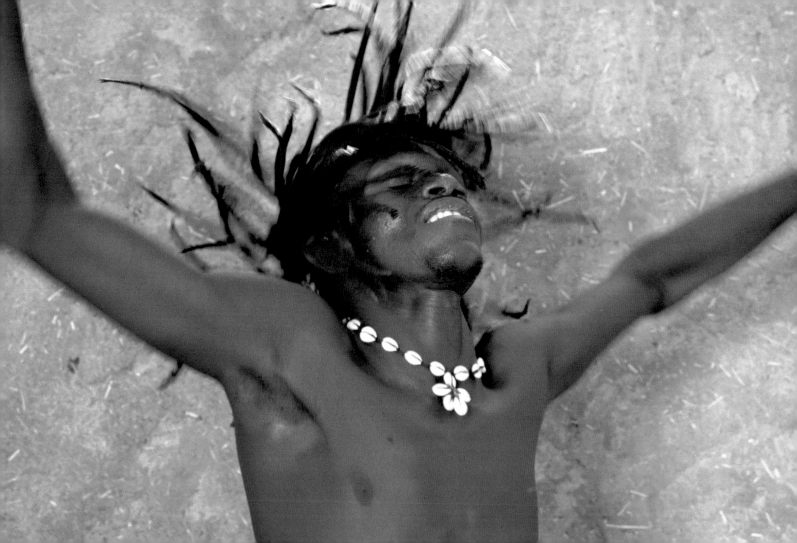

To harmoniously maintain all the vital forces and powers that fill the world,

man's task is to organize the world, to give a place to everything that exists.

—Alassane Ndaw

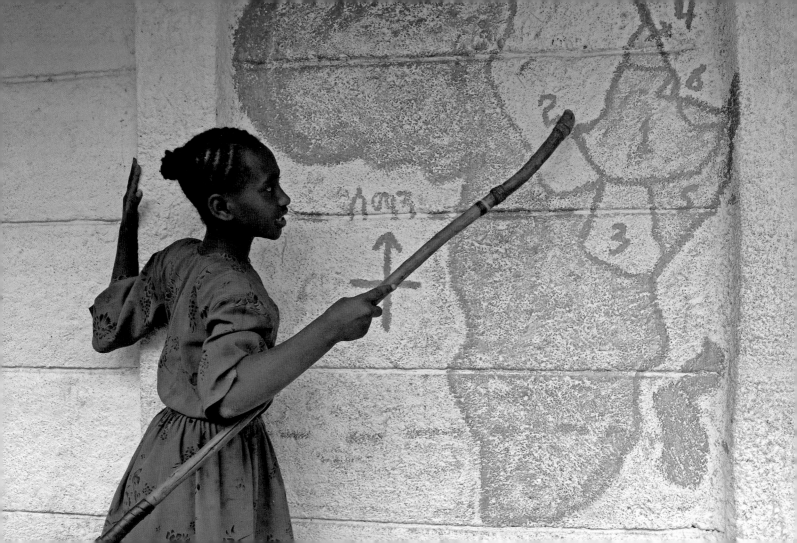

The infinity of deities and invisible spirits,

like molecules,

protects mankind in their villages,

thereby building peace and unity.

—Ali Guindo

Bambara statue, Mali.

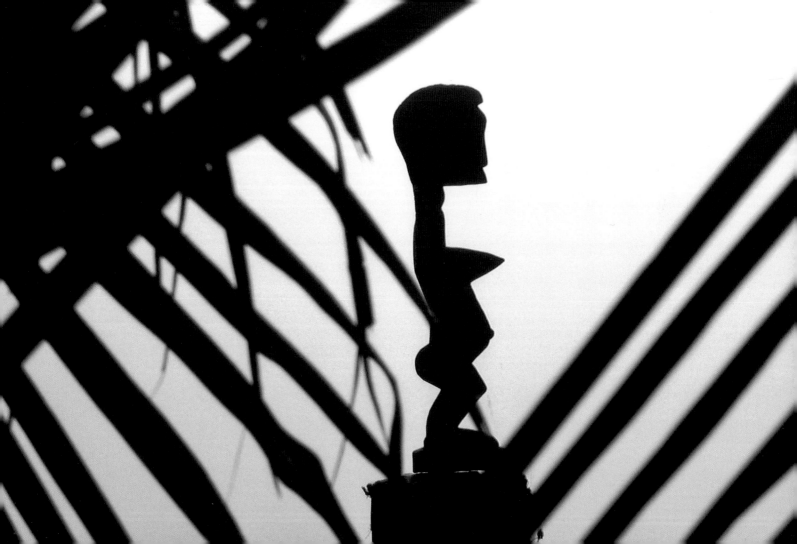

The nail supports the shoe, the shoe supports the horse,

the horse supports the man, and man supports the world.

—*Malinke oral tradition*

Aïssa, a young Malian.

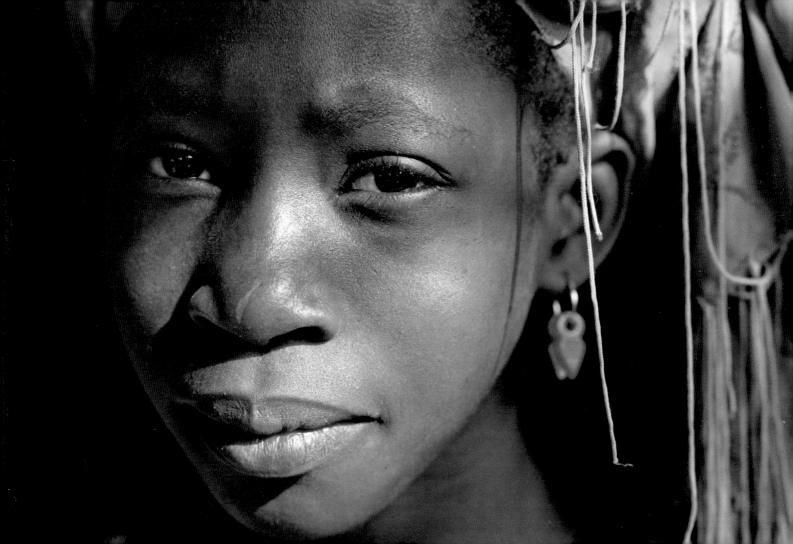

Sun, Moon, and Stars

Many stars are in heaven;

there are whole clans of people—

men, women, and children—

long since become stars.

—Xam oral tradition

Mosque frontispiece in a Chad village.

The world is unending, because those dear to us never definitively leave us.

And we do not like to disappoint them.

Is this simply a mental construction?

By no means!

It is a meaningful conception of the world and of the relationship of the living to the dead.

It is also an ethic.

—Aminata Traoré

A villager's ritual walk, Tama Lodge, Senegal.

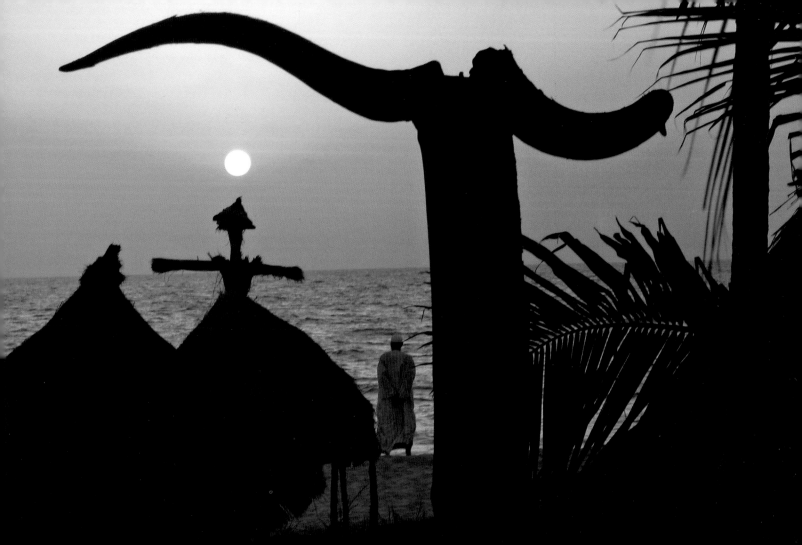

To know something is to be in union with it, to be within it, to approach it internally.

Remaining on the outside, you can never know something in its essence.

To know things, you have not to dissect them but rather to link them with something else.

—Alassane Ndaw

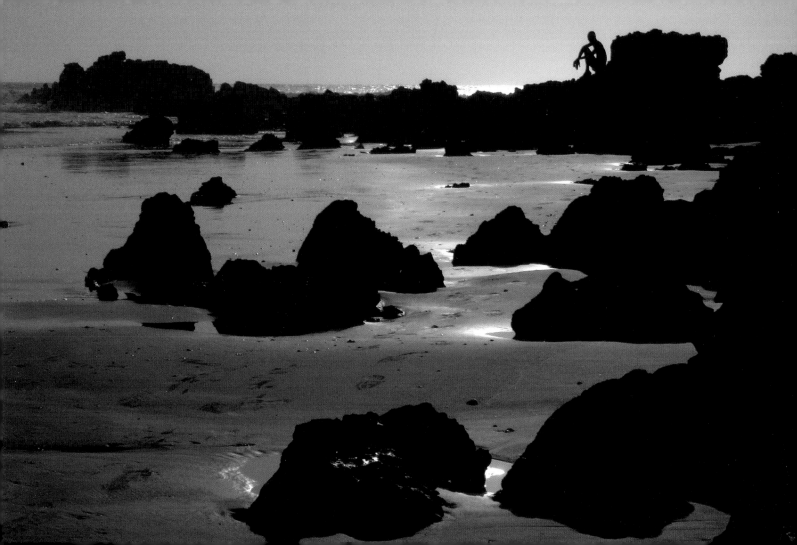

We all have something in common,

which is the craving for intimacy.

Intimacy is a sacred thing.

—*Sobonfu Somé*

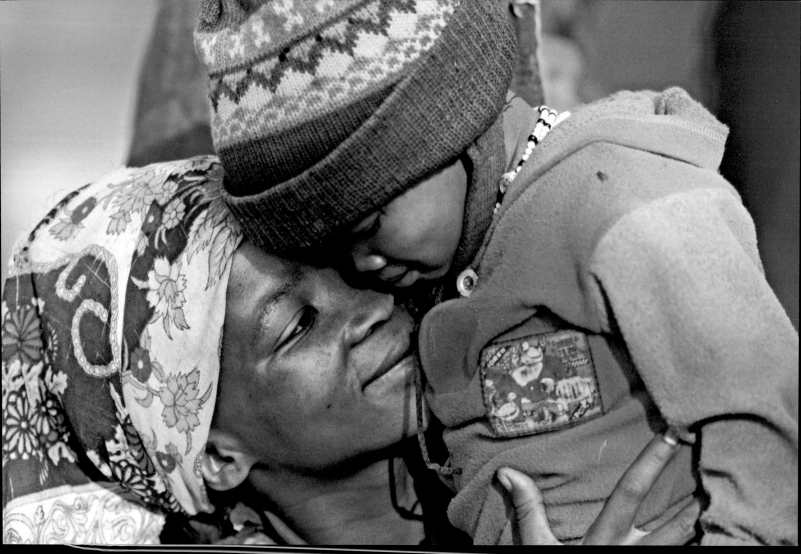

The whole concept of the intimate is primarily derived from ritual.

Outside of ritual, nothing can be truly intimate.

—Sobonfu Somé

Winnowing millet, the village of Songho, Mali.

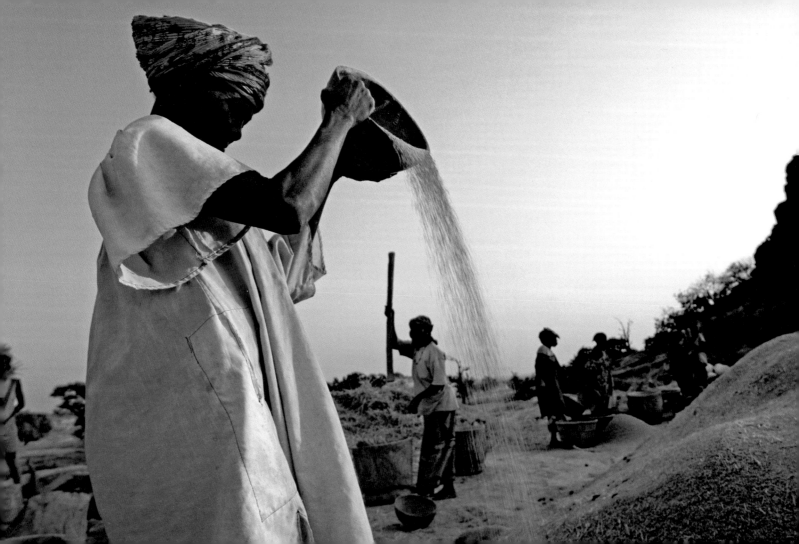

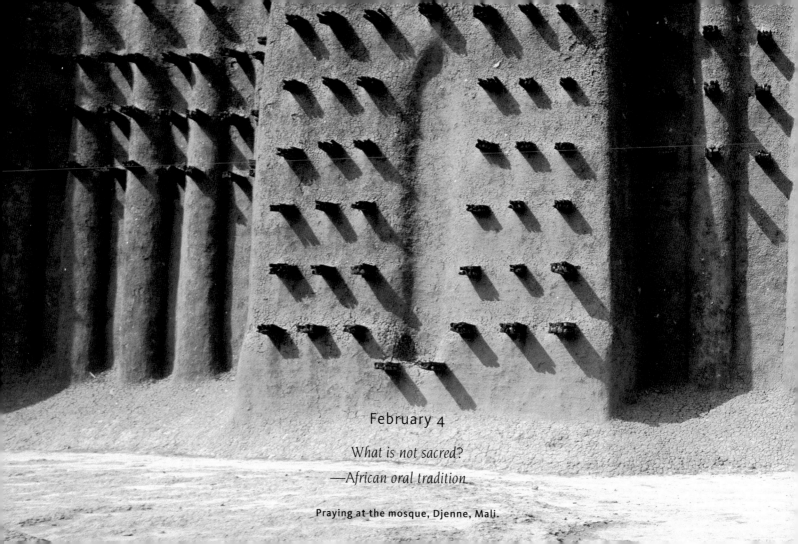

February 4

What is not sacred?

—*African oral tradition*

Praying at the mosque, Djenne, Mali.

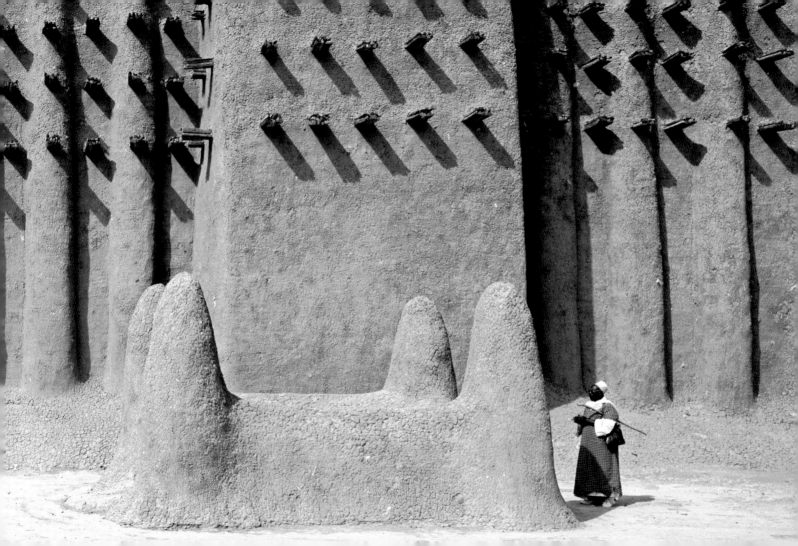

What is a ritual?

A ritual is a ceremony in which we call on spirit to come and be the driver,

the overseer of our activities.

—Sobonfu Somé

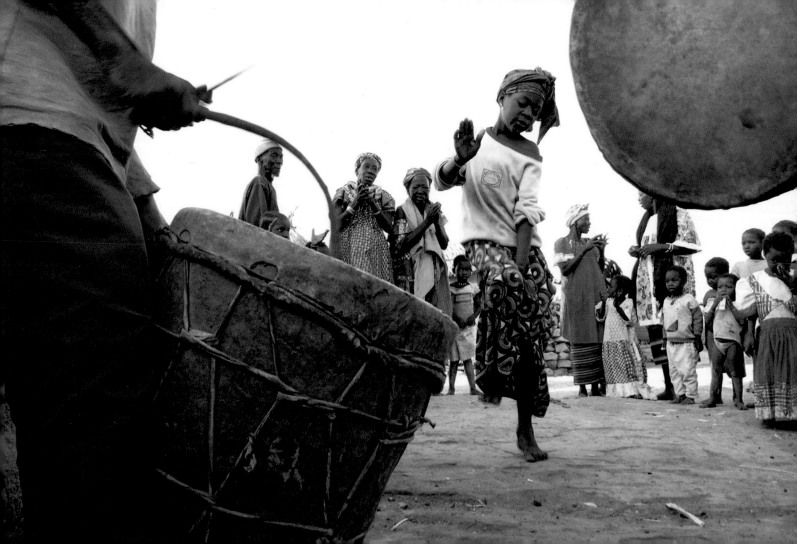

Every time you want to move into a ritual,

you need to recognize that there's a whole line of ancestors behind you,

there's a whole spirit world around you,

there is the animal world, the ground world, the trees, and so forth.

—Sobonfu Somé

The painted village of Tankassoko, Burkina Faso.

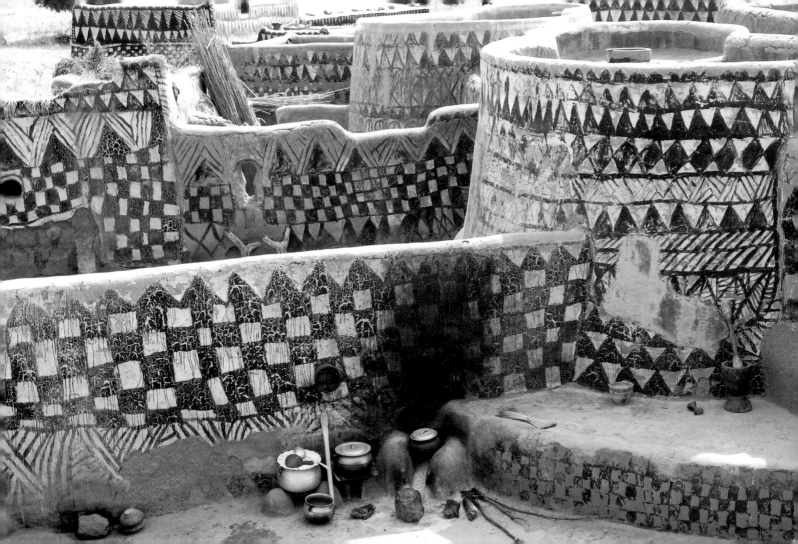

The spirit of an ancestor has the capacity to see not only into the invisible spirit world but also into this world, and it serves as our eyes on both sides.

—Sobonfu Somé

The Sossusvlei Dunes, Namibia.

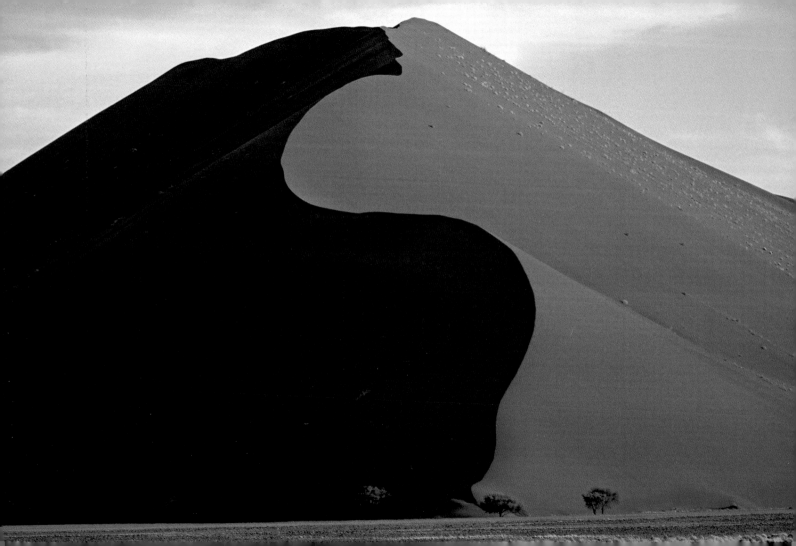

We have to learn to let go of our defenses and any need to control.

We have to trust spirit absolutely for guidance.

—Sobonfu Somé

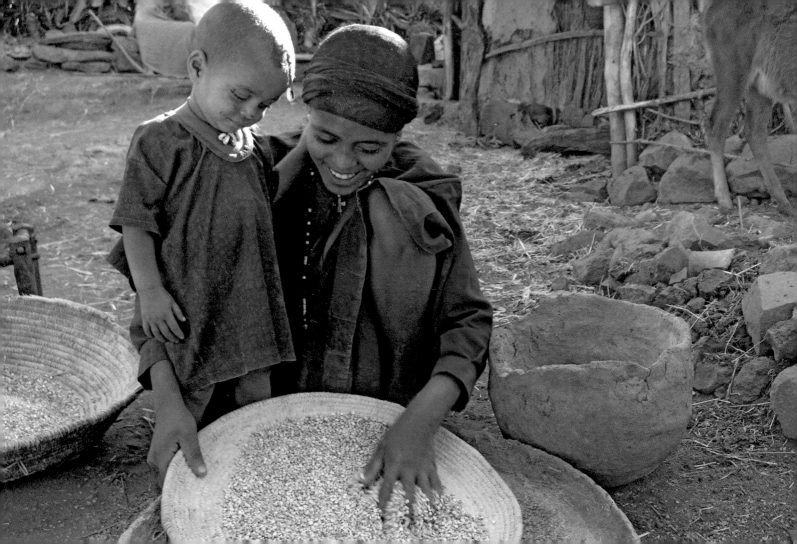

Every time you speak from the heart,

invoking or telling a being from the other world that something is going on in this world,

you are in ritual.

—*Sobonfu Somé*

Amesal, a young Ethiopian.

How does it get the substance that gives it life?

How does it become so vast compared to the tiny seed scarcely visible to the naked eye?

And then all the hardships!

Compared to man, it grows entirely upside down.

Its legs and feet are its foliage, its head the roots that plumb the depths and

do business with the soil in a deal that profits both.

The tree says, "You give me nourishing sap;"

the soil replies, "You give me humus and cohesion."

Such is the secret alchemy that operates between plant and earth.

—Irénée Guilane Dioh

Baobab tree, Namibia.

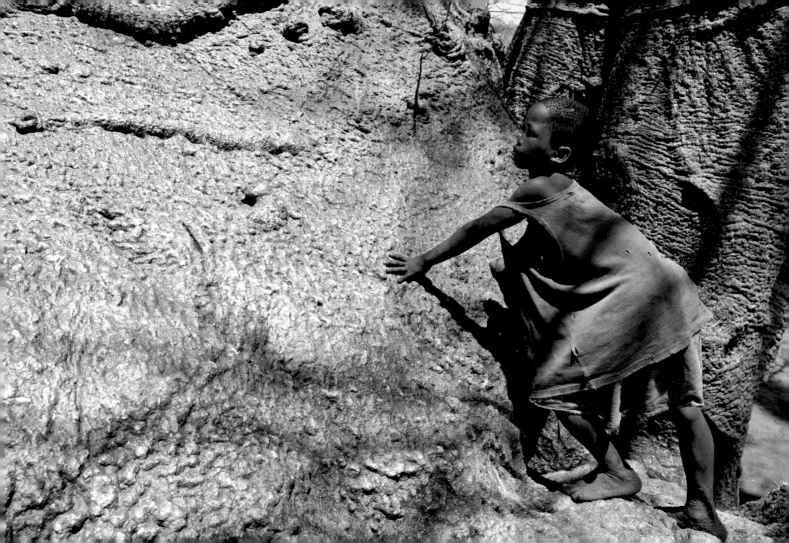

The ritual requires us to speak

through our heart; the logic of the mind

is an obstacle to its success.

—*Sobonfu Somé*

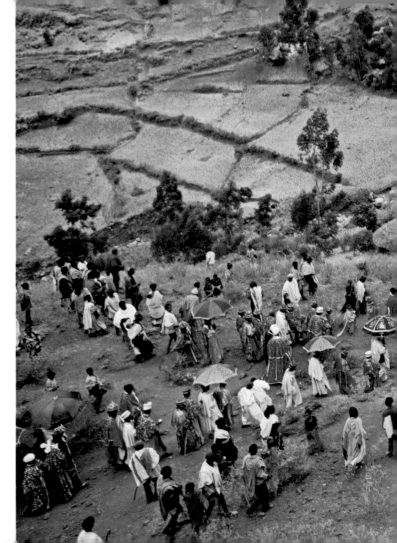

Timkat procession, the church of Yemrehanna Krestos, Ethiopia.

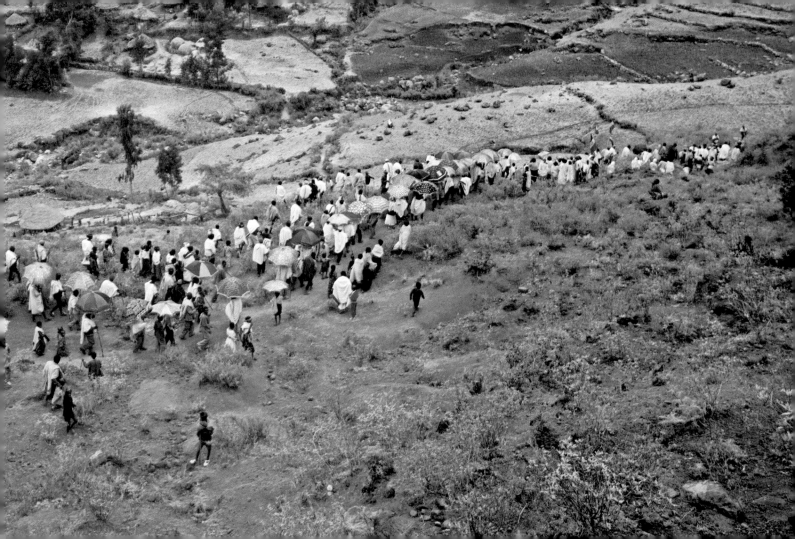

O my brother! Learn this, that every symbol has one, two, or several meanings.

These meanings are of the day and of the night.

Those of the day are favorable, and those of the night unfavorable.

—Amadou Hampâté Bâ

In an Ethiopian tavern.

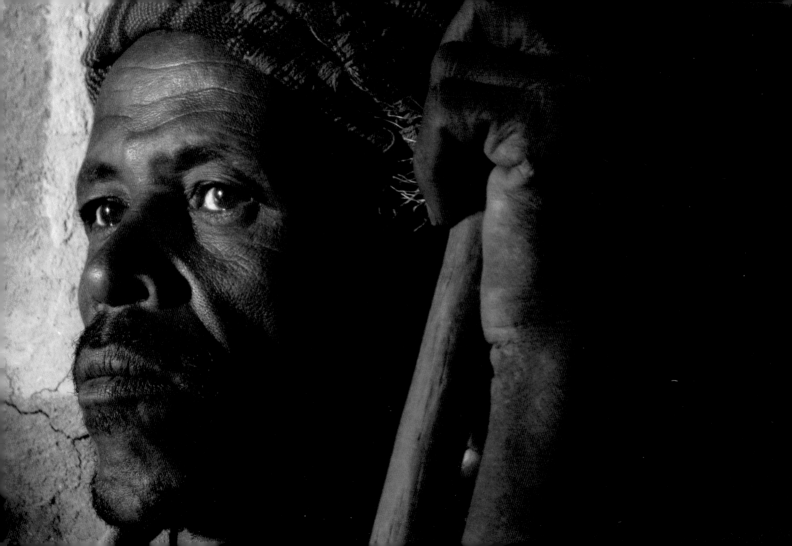

Man walks only by the "contradiction" of his feet, for all opposites are complementary.

Such is the great law of dualism.

—Peul oral tradition

Returning from a village on the Ethiopian high plateaus.

The Universe is neither passive nor static.

It is a dynamic whole whose balance is due to the opposition of contrary, twinned elements.

—African oral tradition

Two Peul villagers on their camels, Mali.

Since shadows walk and animals walk upon the walking earth, why should I not walk also?

—*Peul oral tradition*

Lete, a young Ethiopian.

Man is the synthesis of the universe, a crossroads of life forces,

the trysting-place of contradictory forces in perpetual motion.

Only through initiation can a life be ordered and well filled.

—Elder Bambara initiate

Koba Oma, a young Bushman girl in her baobab, Namibia.

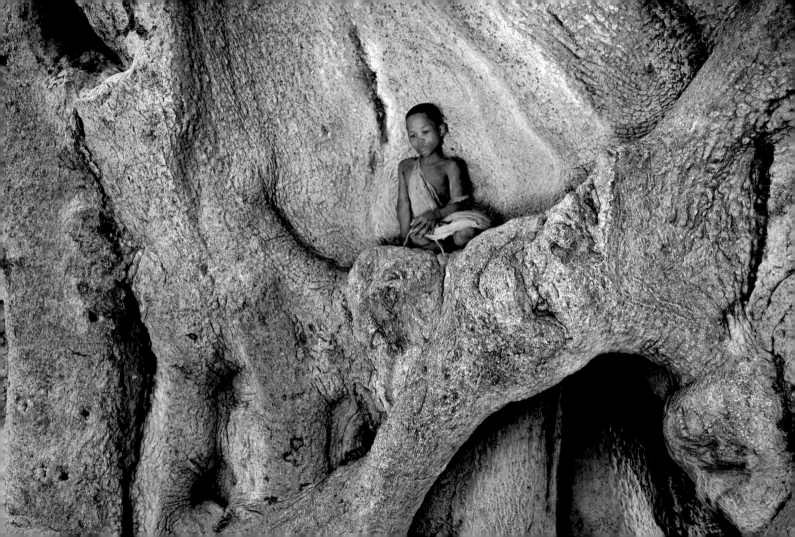

What then is truth?

It is the fragile balance that emerges from clashing antagonisms.

It is the white foam on the waves.

It is the savor that comes from the totality of ingredients brought together and simmering in the cooking pot.

Truth is not monolithic. It is enrichment that results from the mutual respect of opposites.

—Irénée Guilane Dioh

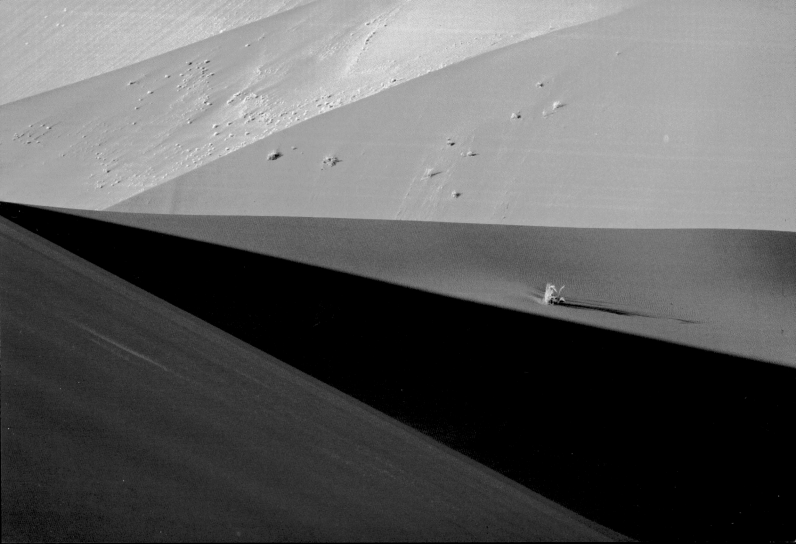

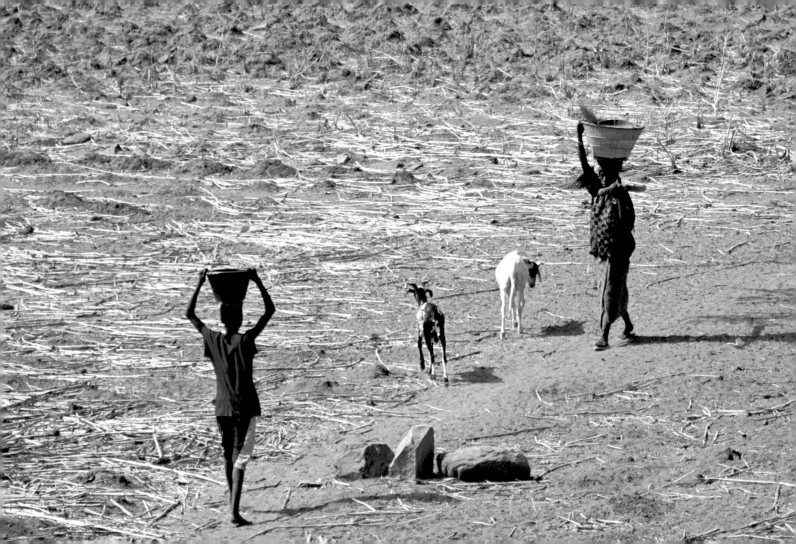

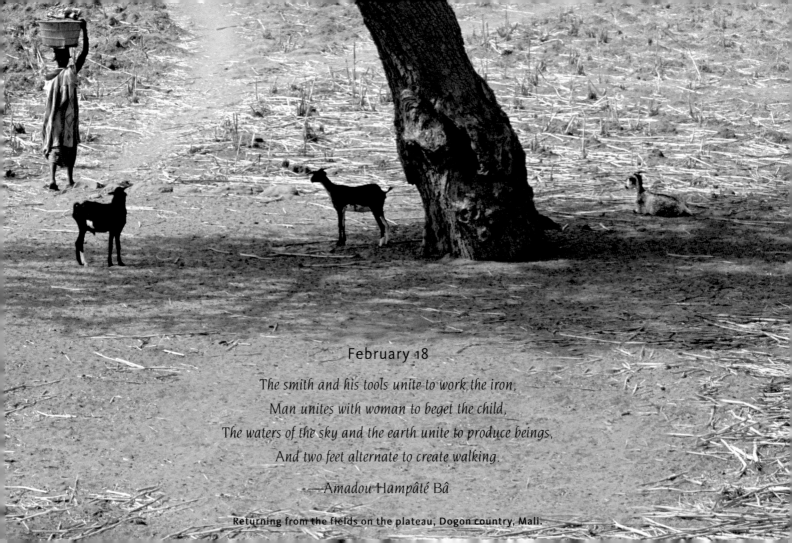

February 18

The smith and his tools unite to work the iron,
Man unites with woman to beget the child,
The waters of the sky and the earth unite to produce beings,
And two feet alternate to create walking.

—Amadou Hampâté Bâ

Returning from the fields on the plateau, Dogon country, Mali.

Good is everything that promotes and increases the life force: bad is everything that hampers and lessens it.

—African oral tradition

After a good catch on Lake Chad, Chad.

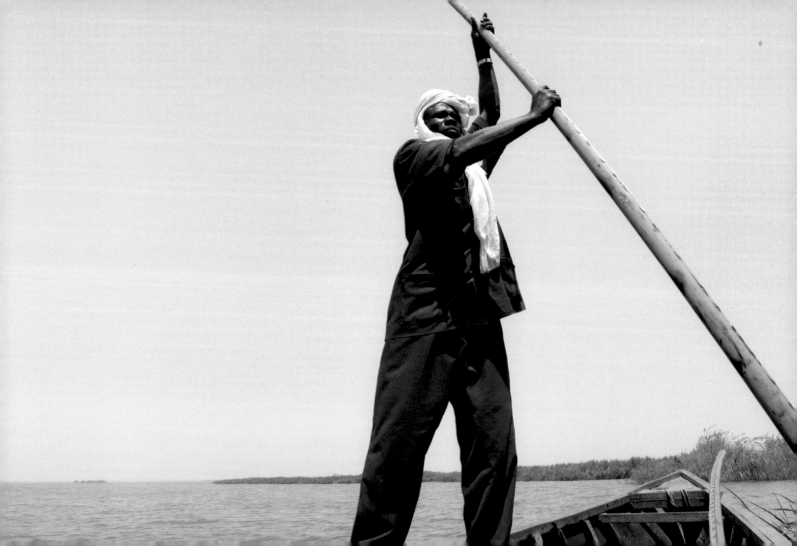

When deeply rooted, one is prepared for every opening;

or, as Aimé Césaire expresses it, "Porous to all the breathings of the world."

—Joseph Ki-Zerbo

A Bushman child, Namibia.

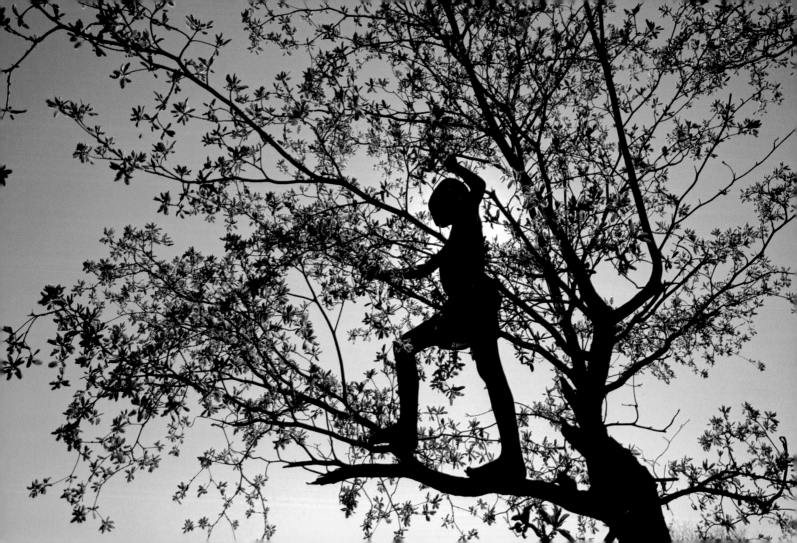

"Nothing" is really just a distraction. The profane does not exist.

Everything is religious; everything has an aim; everything has a motive.

Chance does not exist.

There are simply "laws of coincidence" whose workings we do not know,

a higher order that we do not understand.

—African oral tradition

Return of the herds, Mali.

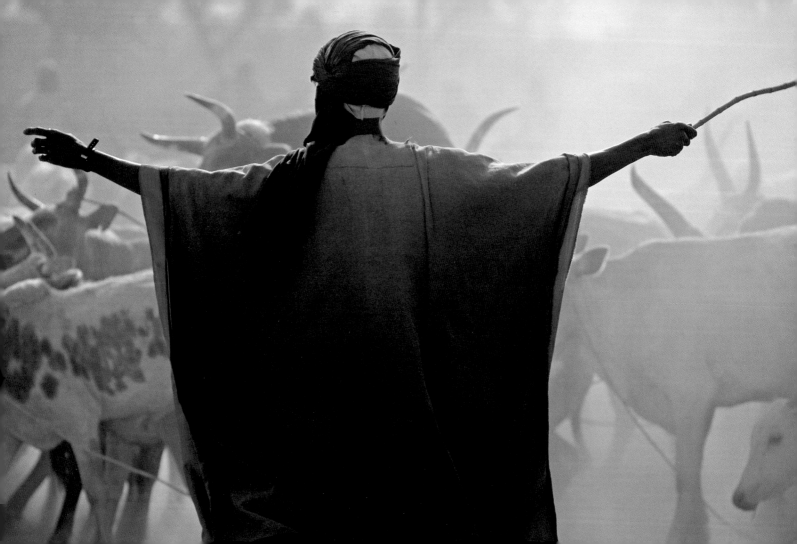

Listen to the ancestors, to spirit, to the trees, to the animals. Listen to all those forces that come and speak to us.

—Sobonfu Somé

Moussa, a young Peul shepherdess, Burkina Faso.

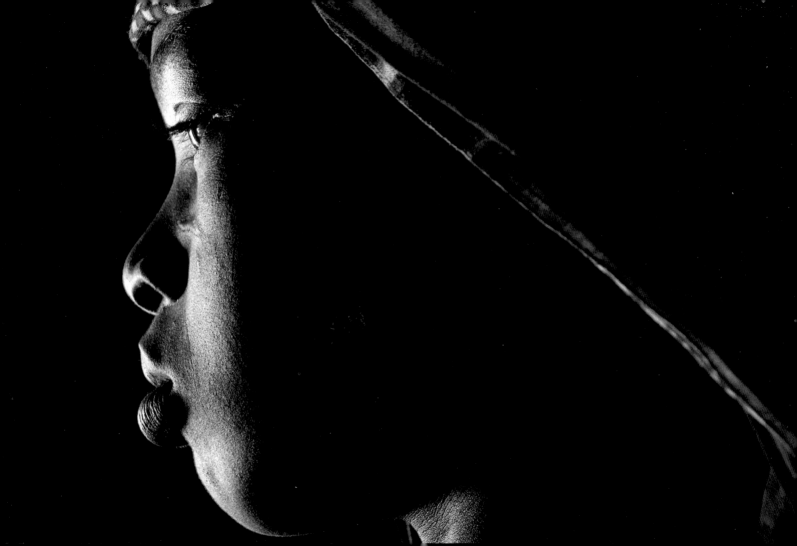

After the arrival of a child, or even before its birth, a ritual should be done involving spirit and the community,

welcoming the baby into the family, acknowledging the new spirit that has come,

and affirming the parents' commitment to the child and to each other.

—Sobonfu Somé

Dancing at a wedding in the Oulad Surour tribes, Chad.

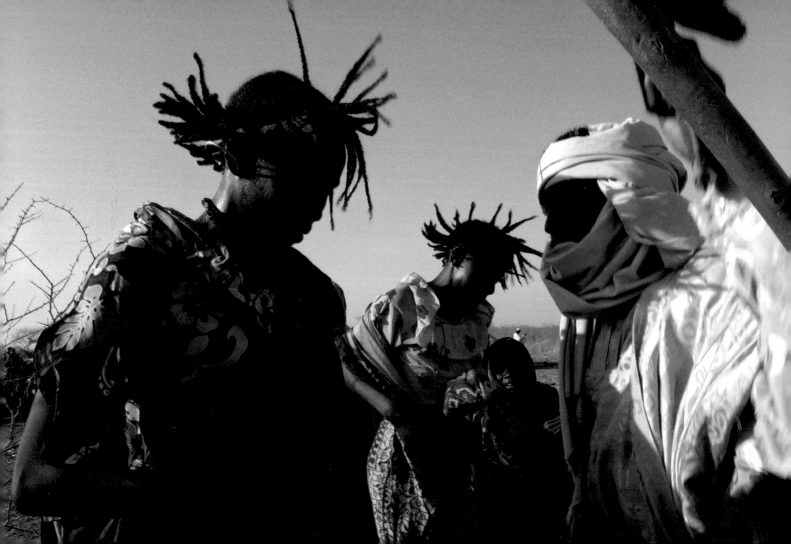

Long before birth, the child, as a "pre-existing soul," is watched over by a whole line of ancestors,

down to and including the placenta, the primordial Mother that began to fashion him.

—Alassane Ndaw

In the shade of a bamboo canopy, Burkina Faso.

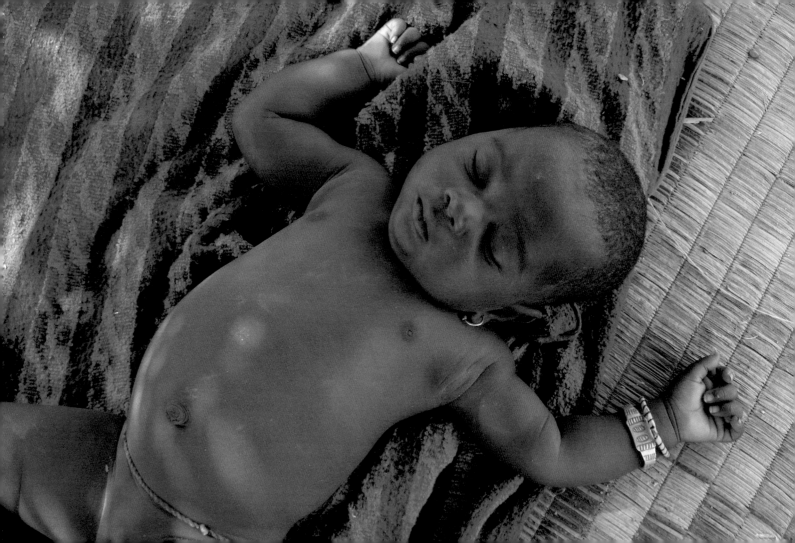

February 25

Though you know not whither you are bound, may you know whence you come.

—*Serere oral tradition*

Returning to the village, high plateaus of Ethiopia.

Spirits of good children lived in that tree waiting to be born.

On ordinary days, young women who desired children came to sit under its shade.

—Chinua Achebe

At the foot of the Sossusvlei Dunes, Namibia.

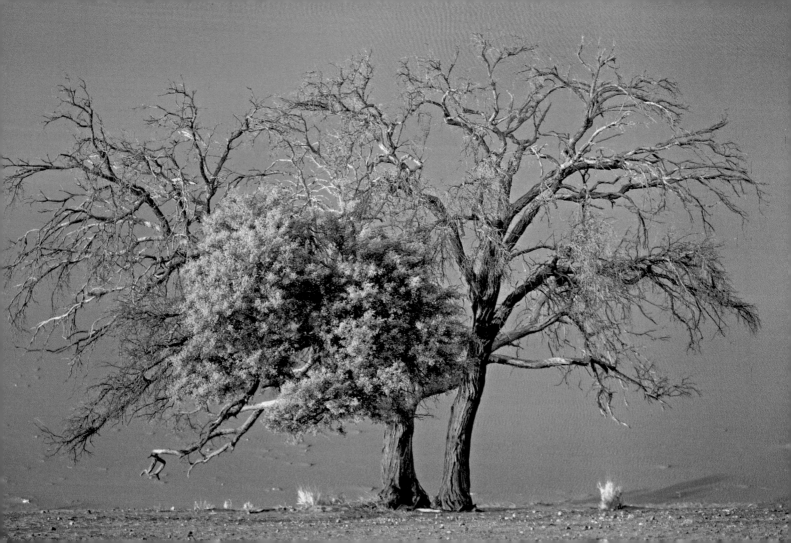

Every birth is the rebirth of an ancestor.

—*African oral tradition*

Siesta in the shade of an acacia, Himba country, Namibia.

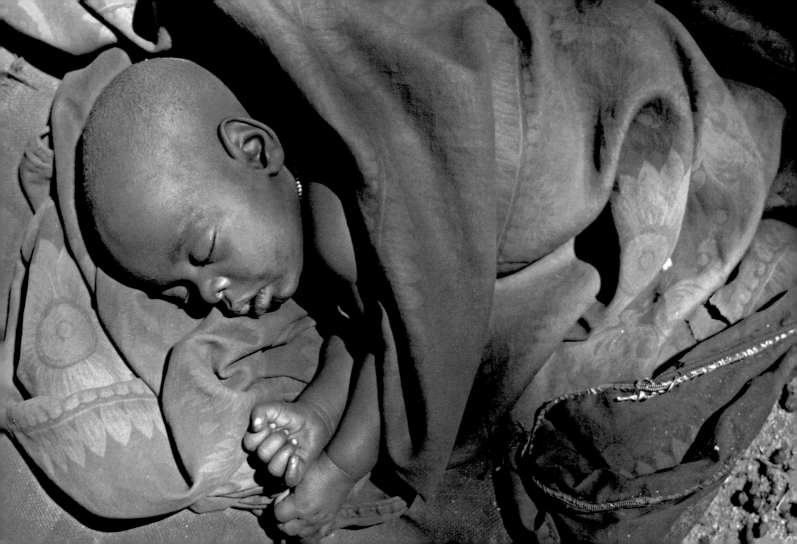

I am a link in the chain of men that will transmit to my descendants

the life I received from my parents and that I do not own.

—African oral tradition

School at the Mangetti Dunes, Namibia.

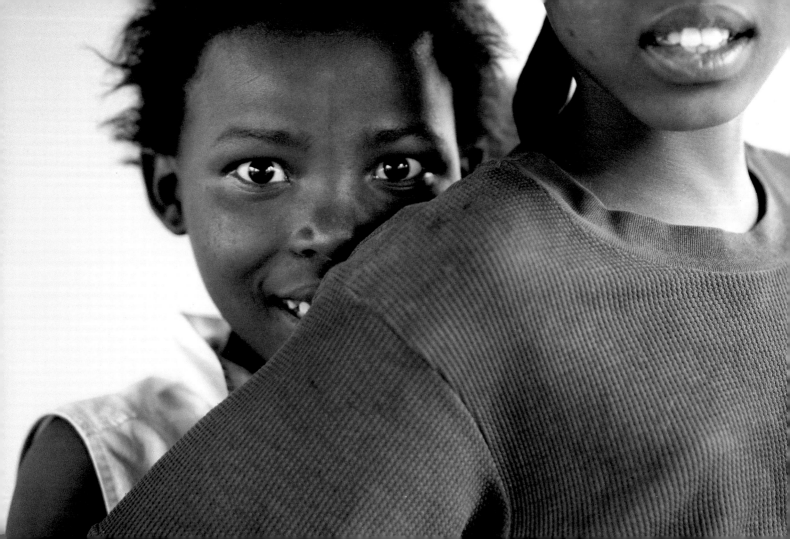

It is crucial to have a trusted circle of people who can give you that sense of belonging and of community.

—Sobonfu Somé

Himba children's games, putting them in direct contact with nature, Namibia.

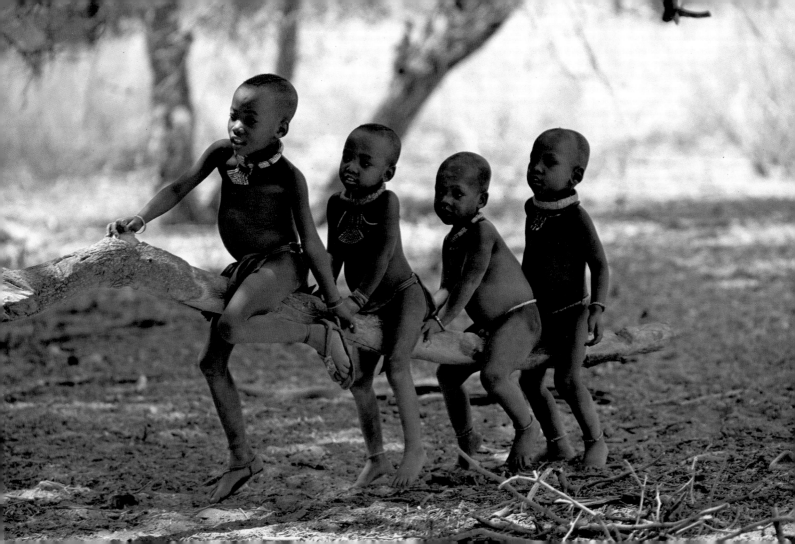

A *lone man is surrounded only by emptiness.*

—Efua Theodora Sutherland

Waiting for the fishermen to come back, Senegal.

Who are you, my brother?

What village do you come from?

To what tribe or community do you belong?

—African greeting

Kakitu, a young Himba, Namibia.

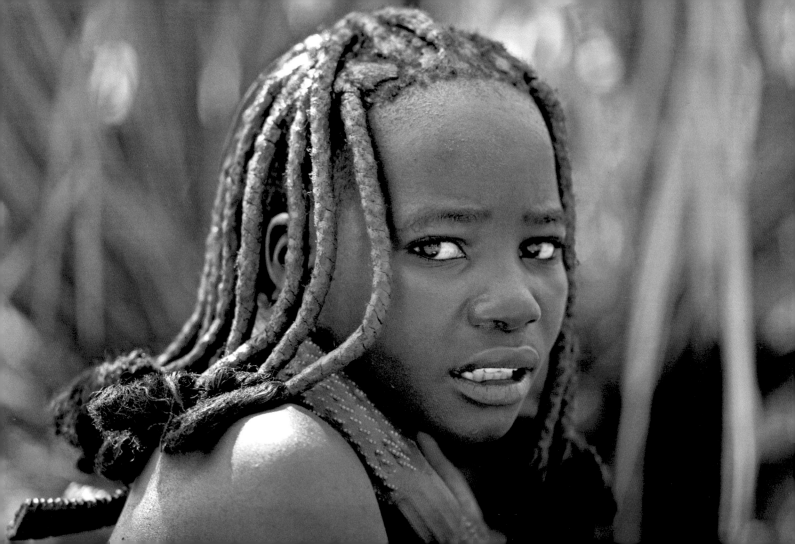

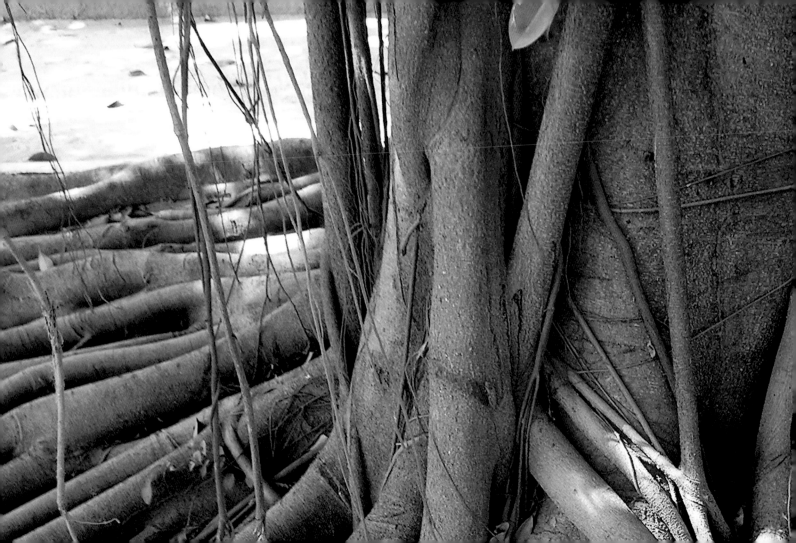

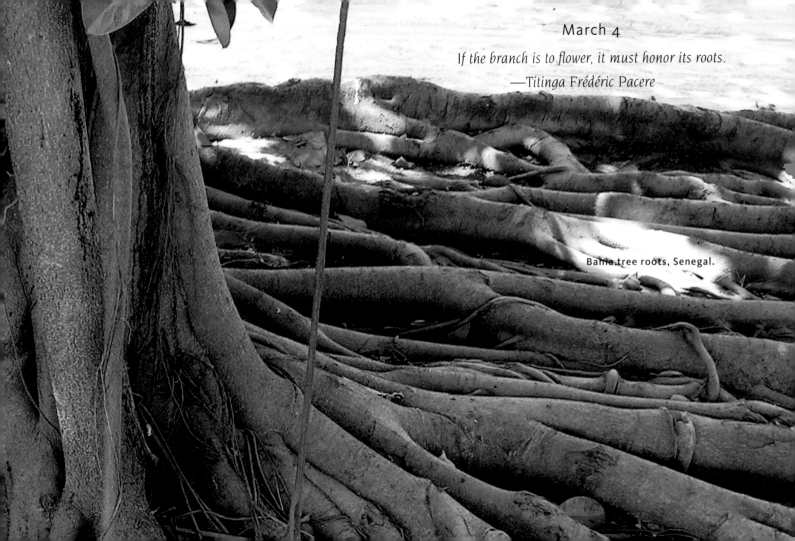

March 4

If the branch is to flower, it must honor its roots.

—Titinga Frédéric Pacere

Bahia tree roots, Senegal.

March 5

If you want to preserve knowledge and enable it to travel through time, entrust it to children.

—Elder Bambara initiate

School class, Dogon country, Mali.

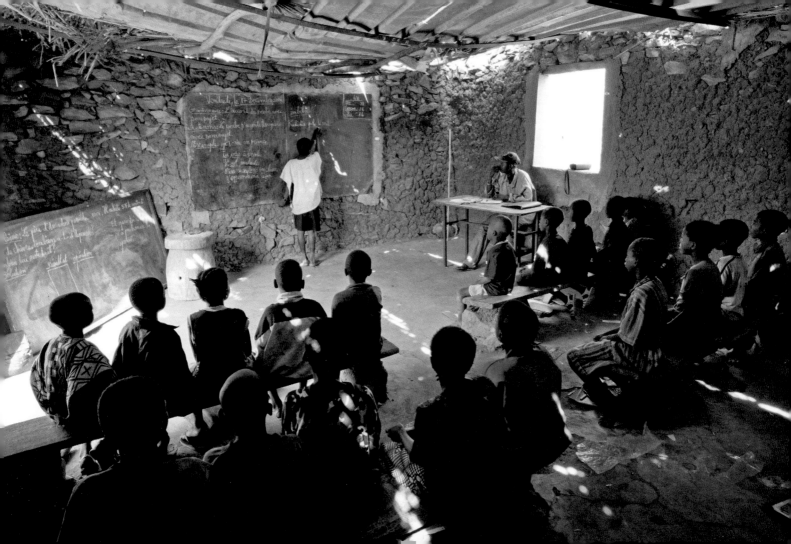

Each person chooses his or her life purpose before he or she is even born.

—Sobonfu Somé

Ndagou, a young Senegalese.

The life force, sacred, invisible, and powerful, contains the memory of the past and the vision of the future.

It enables creation to reveal itself in matter here and now.

—Marie-Noëlle Anderson

Three generations of Bushmen, Namibia.

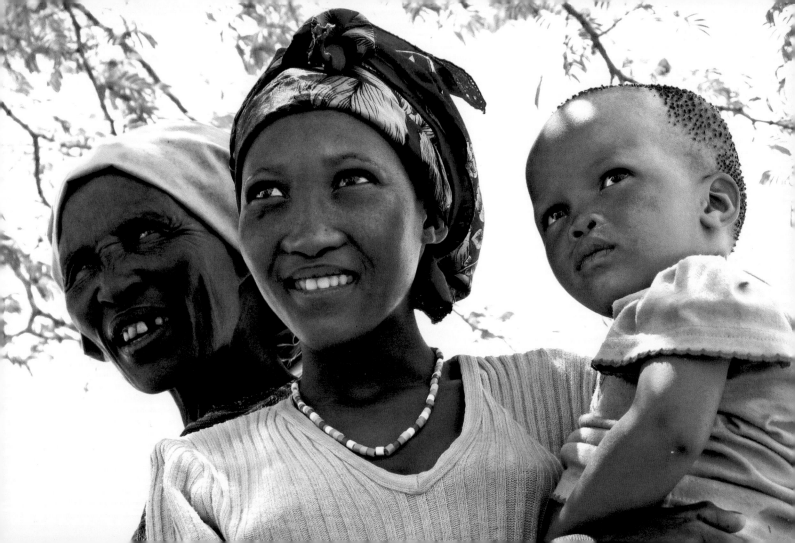

Thus is man born to a new life, which shall be his into old age.

And such is his vocation: to become the point of equilibrium,

where the various dimensions that he bears may join together through him.

Then shall he truly deserve the name of Man,

who speaks with the Everlasting and guarantees the balance of creation.

—Amadou Hampâté Bâ

An Ethiopian priest on a Sunday.

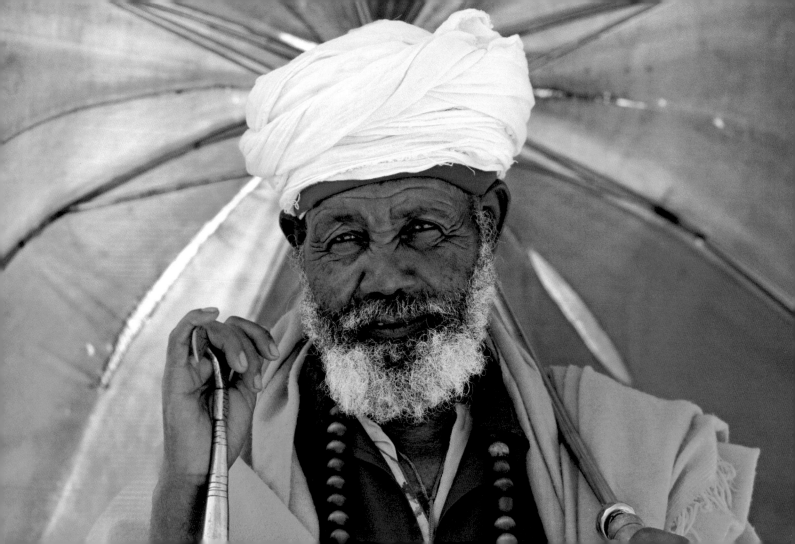

Birth is the arrival of somebody from another place;

the person who is arriving must be welcomed, must be made to feel that she has arrived

in a place where there are human beings who will receive her gifts.

—Sobonfu Somé

Easy living in Himba country, Namibia.

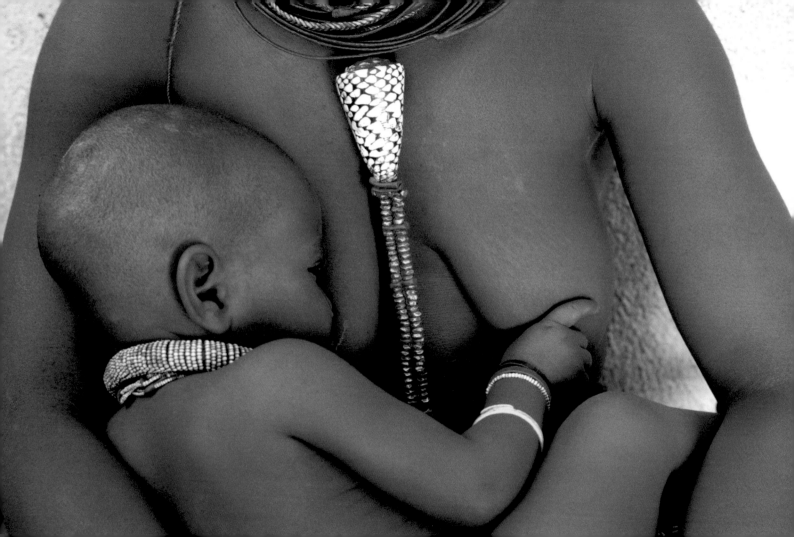

The absence of a welcoming village around a newborn may inadvertently erase something in the psyche;

later on in life, that loss will be felt like a huge gap.

—Sobonfu Somé

A chief's villa, Cameroon.

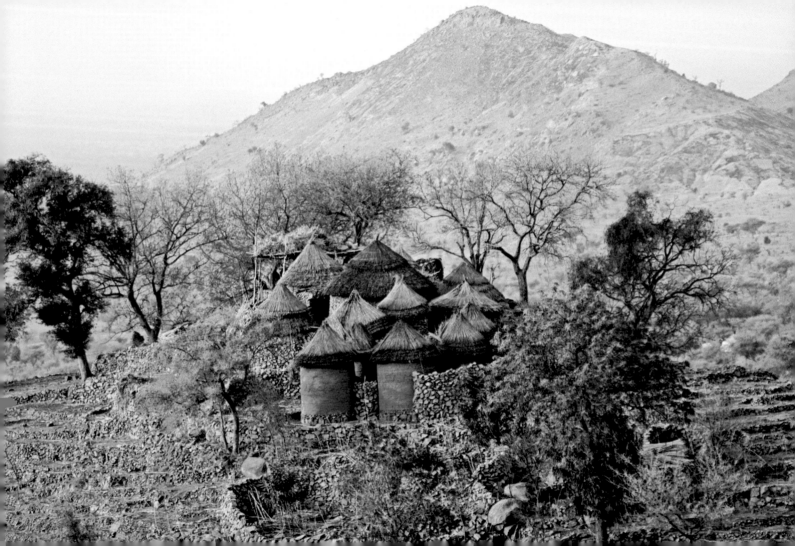

March 11

The respect given to others rebounds to the giver; to deny the sacred in the Other is to deny it in oneself.

—Dr. Raymond Johnson

Ousman, at prayer, in the Ennedi Desert, Chad.

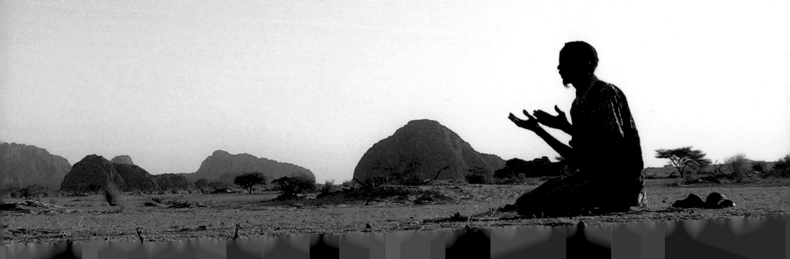

Go deep into your heart and listen to the rhythm of it.

There is a language spoken to you by the beings you have called into your circle.

The problem is, we usually don't listen enough, and therefore we don't hear it.

—Sobonfu Somé

An afternoon among the Dogon, Mali.

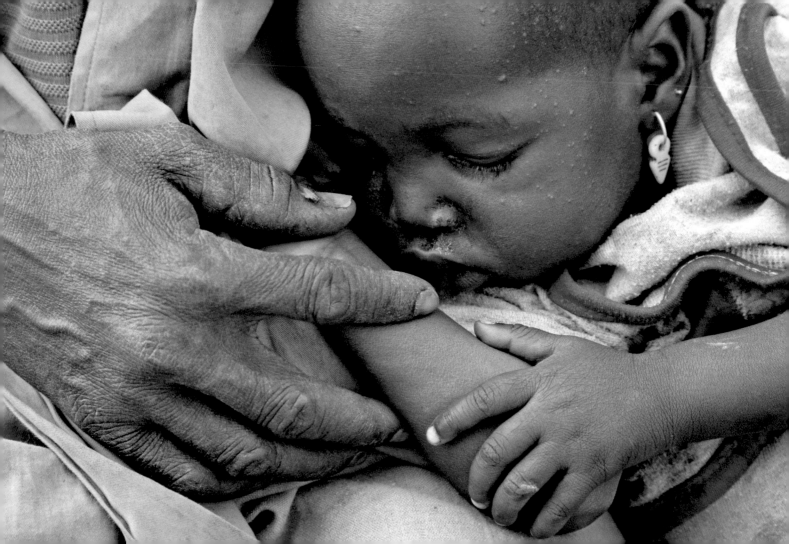

Question me not now.

Many are the mysteries of this world.

Everything you see before your eyes is a blessing.

—Efua Theodora Sutherland

Daouda, Dogon child, Mali.

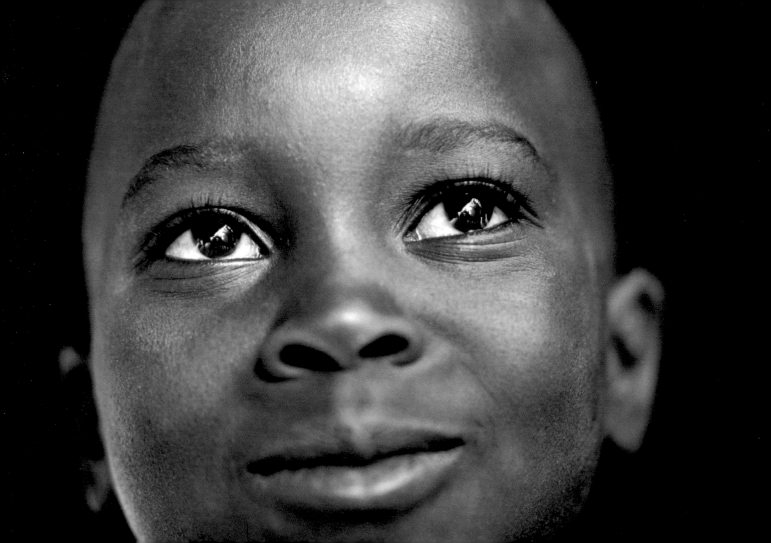

May I sleep in the peace

Of your breast smelling of cinnamon apples. We will drink the moon's milk streaming on the midnight sand.

—Léopold Sédar Senghor

Amid the Peul nomads of the Sahel, Burkina Faso.

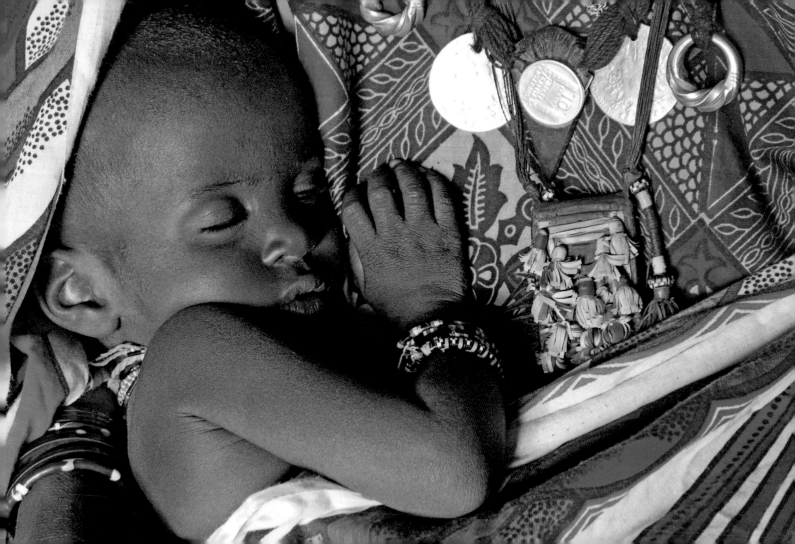

Oh, the enchantment when, waking from deep sleep, we open up the house to the sounds of the world!

How the morning air invigorates, caressing the senses and penetrating our whole being!

The tang of it, the welcome it draws from us—they take us by surprise.

What joy this breath that recreates and gives life!

Every breath is a new birth of mankind, begetting and begotten to infinity.

—Irénée Guilane Dioh

In a Malian market.

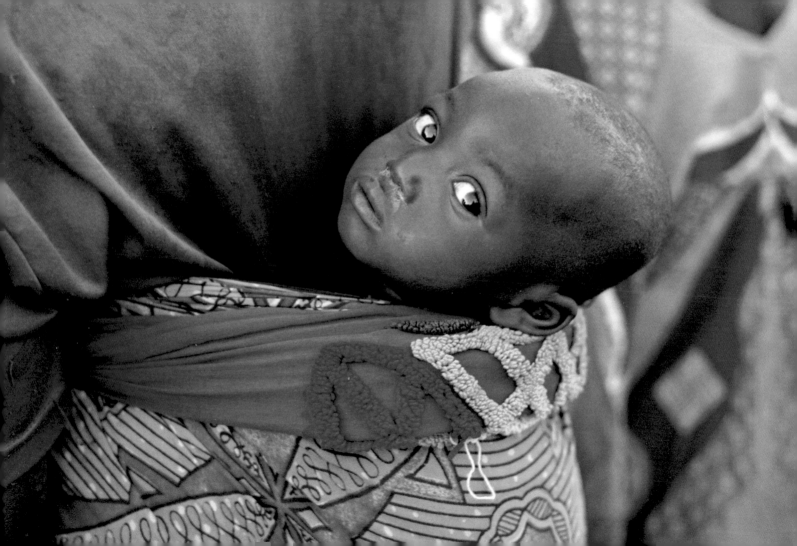

March 16

The child learns to dance when carried on his mother's back, before he begins to walk.

His contact with his surroundings, his mother, sisters, brothers, even his grandparents,

shows him very early how his body is an instrument of dialogue.

—Dr. Raymond Johnson

Makarukasa, a young Himba mother, Namibia.

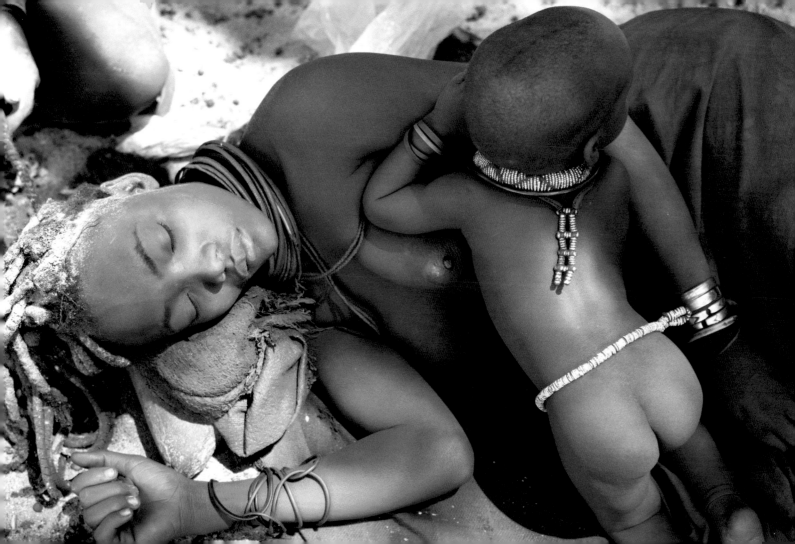

What can I do without other men, for when I arrived in this world I was in their hands,

and going hence shall I not be in their hands again?

—Malinke oral tradition

Two young Dogon friends, Mali.

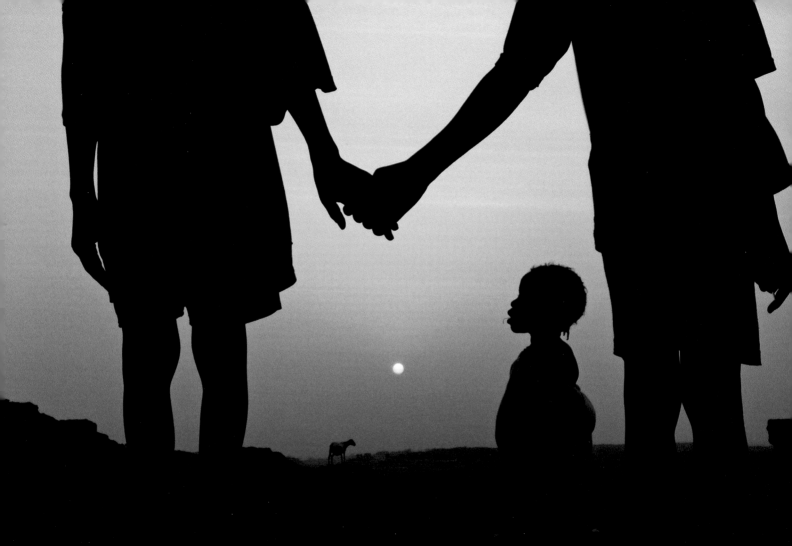

The nature and quality of our connection

to the world owe much to our perception

of ourselves.

—Aminata Traoré

Tea ritual in the Ennedi massif, Chad.

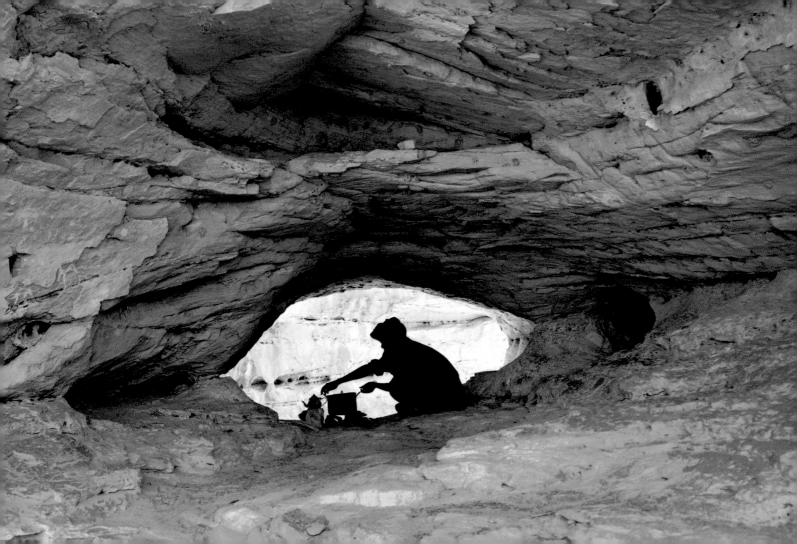

If you look at your child, you will see his questions before you hear them.

—*Serere oral tradition*

Amadou, 11 years old, Mali.

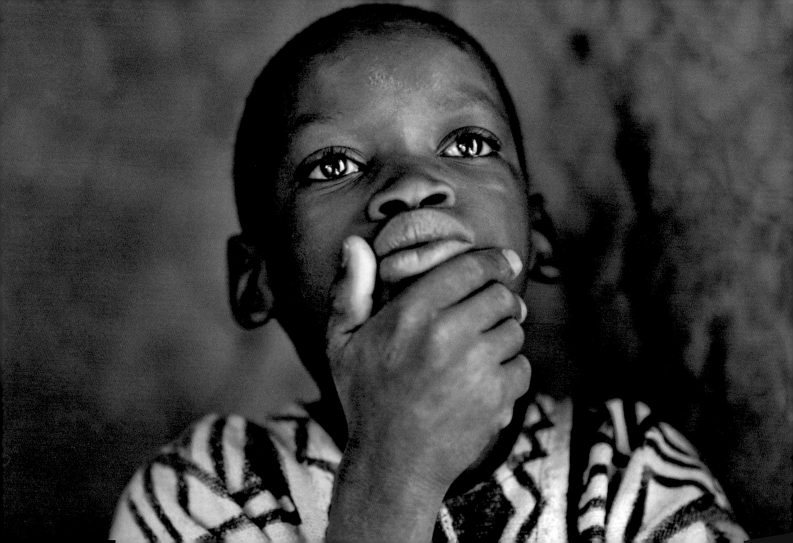

When you have a child, it's not just your child, it's the child of the community.

From birth onward, the mother is not the only one who is responsible for a child.

Anybody else can feed and nurture the child. If another woman has a baby, she can breast-feed any child.

—Sobonfu Somé

Dressed for a nomad tribal wedding, Chad.

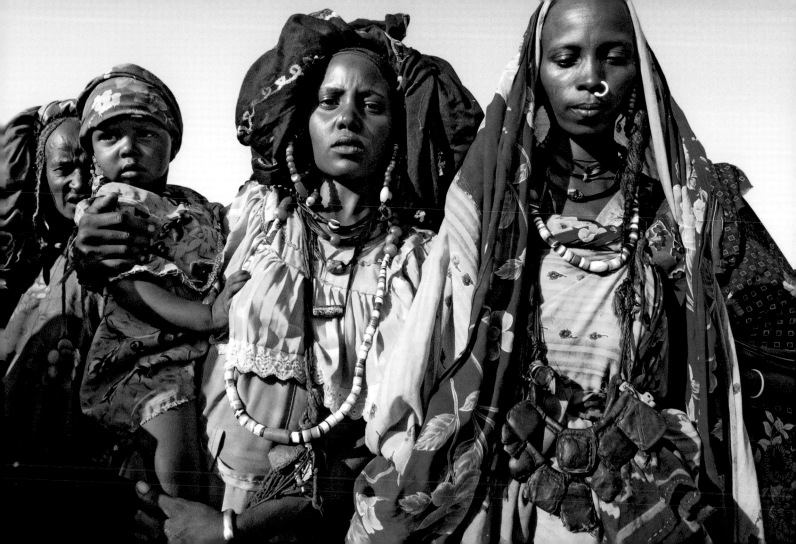

Our best seeds and our dearest fields—those are our children.

—Cheikh Hamidou Kane

Resting after work well done among the Himbas, Namibia.

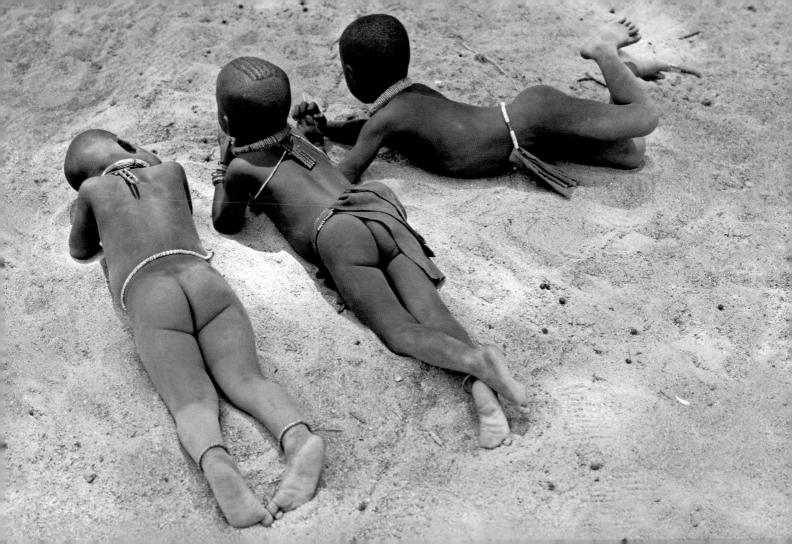

You will see in the temple of your heaven a face of light, your face, my brother, my sister,

shining amidst the dust of human stars.

You are a star. Do not forget it. Lift up your eyes!

—Irénée Guilane Dioh

Samba, 12 years old, Mali.

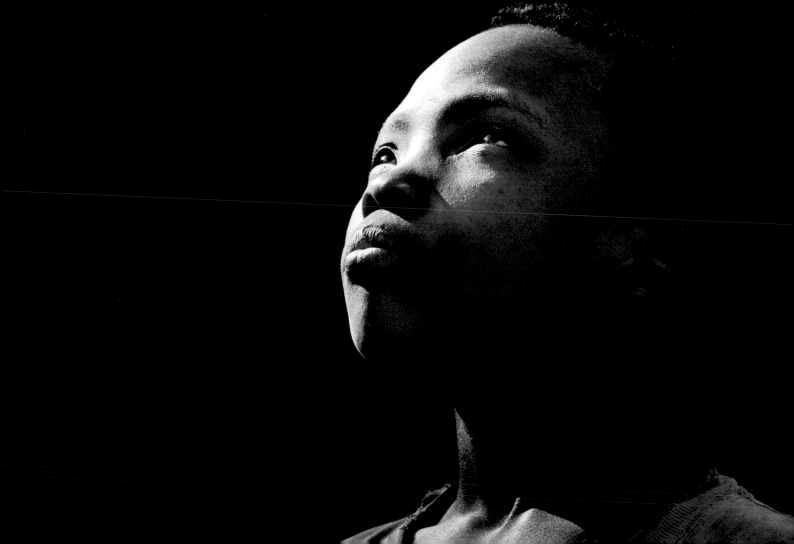

It is through the sacred feasts, celebrated and maintained day by day through rituals,

that we find our place in the circle of life,

and the bond between matter and spirit becomes a bearer of harmony and strength.

—Marie-Noëlle Anderson

Siesta in the shade of the acacias, Himba country, Namibia.

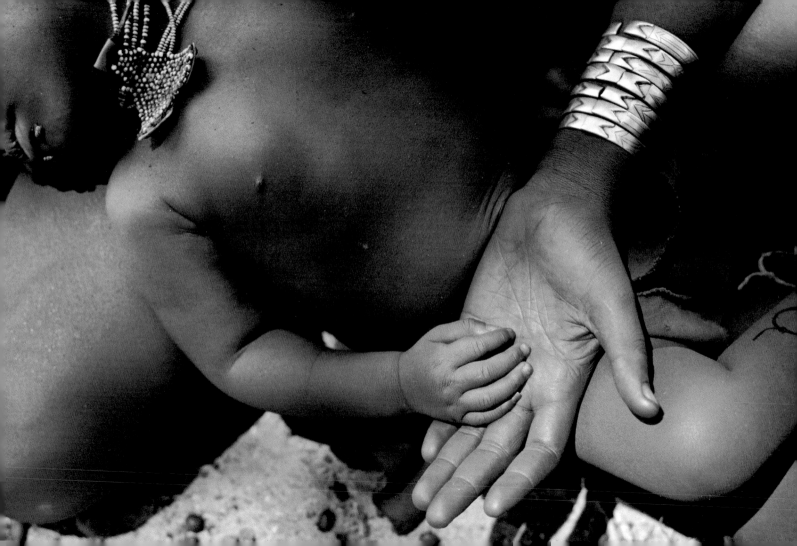

It's important in any relationship to do ritual—in order to keep peace,

to ground ourselves, and to create better communication.

—Sobonfu Somé

Dancing at a nomad tribal marriage, Chad.

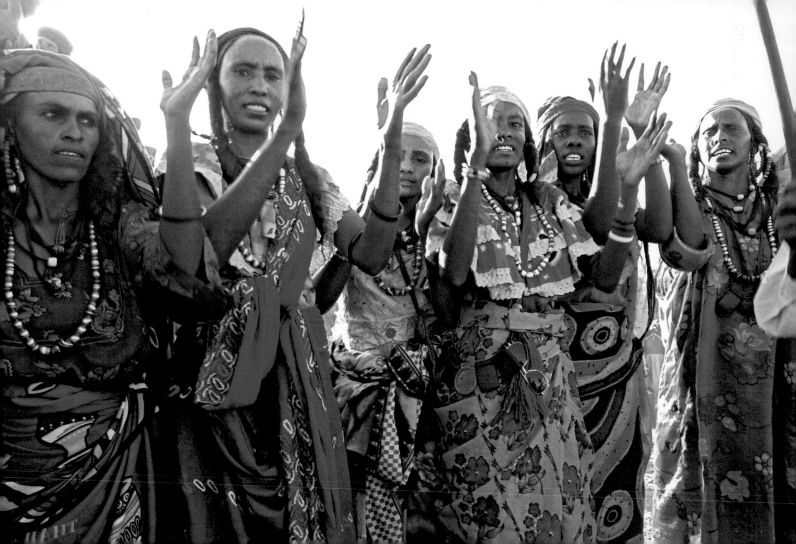

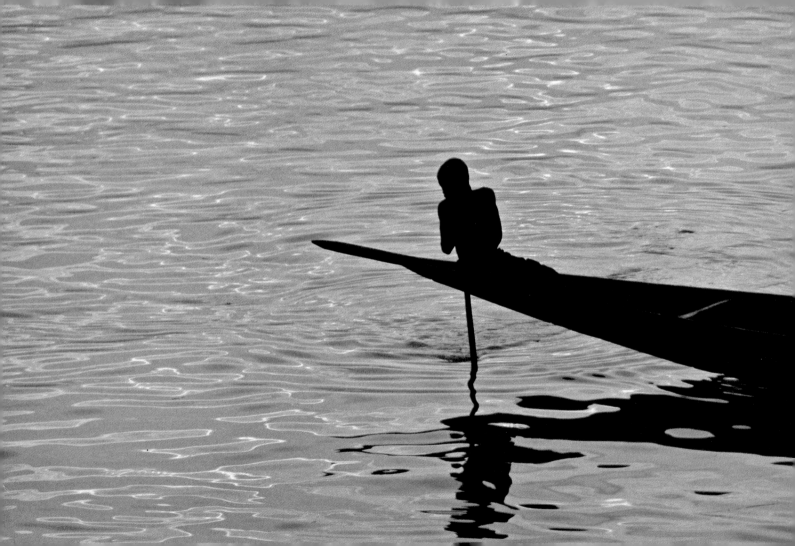

March 25

A child is like a dugout canoe. If you make one, it will one day get you across water.

—Warega oral tradition

On the Niger River, Mali.

The *purpose of intimacy is not our attainment of personal happiness.*

It is the fulfillment of our raison d'être, the enrichment of the village, spiritual expression.

It is a means of bestowing the gifts that we have received.

—Marie-Noëlle Anderson

Allou Katiga repainting her home, Burkina Faso.

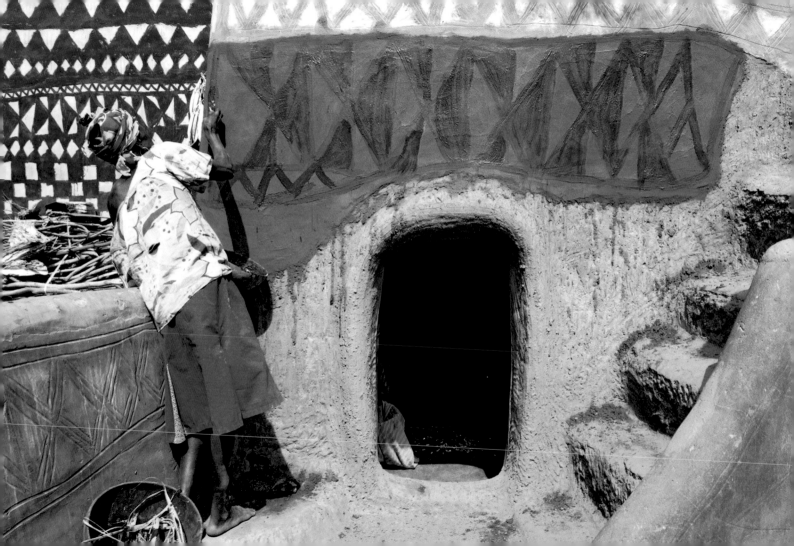

March 27

May your action have an effect like that of the seed of the baobab.

—Peul oral tradition

Wondiwo, a 10-year-old Himba, Namibia.

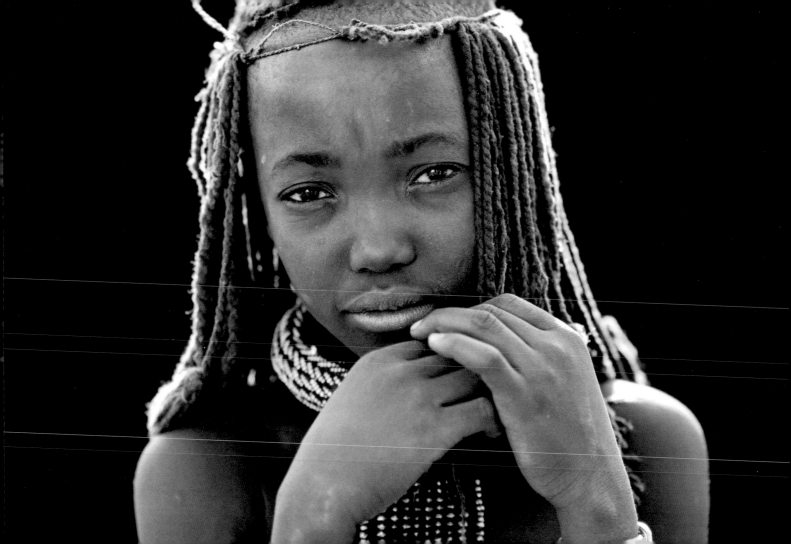

Evidence is a quality of the surface. Your science is the triumph of evidence, a proliferation of the surface.

It makes you master of the external, but at the same time it exiles you there, more and more.

—Cheikh Hamidou Kane

The village television, Mali.

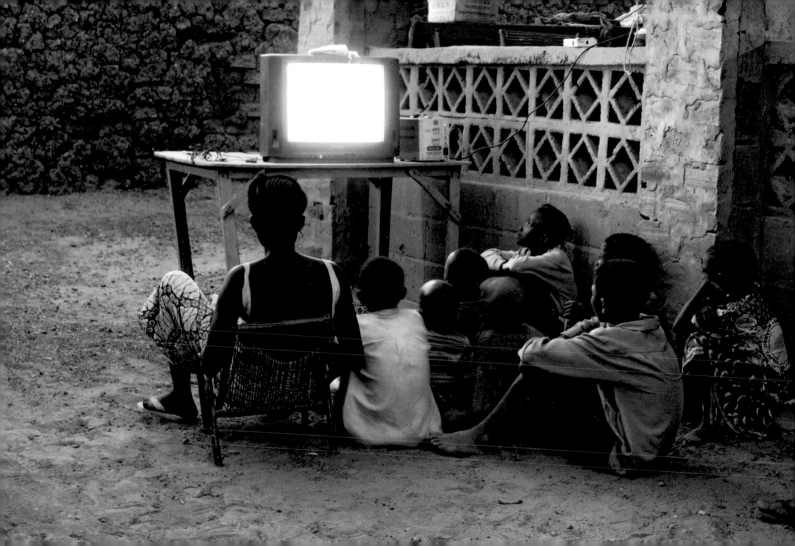

I wish for you to rediscover the feeling of anguish in the face of the dying sun.

I ardently wish that for the West.

When the sun dies, no scientific certainty should keep us from weeping for it,

no rational evidence should keep us from asking that it be reborn.

You are slowly dying under the weight of evidence.

I wish you that anguish—like a resurrection.

—Cheikh Hamidou Kane

Short rainy season, Namibia.

Learning, children would also forget. Would what they would learn be worth as much as what they would forget?

I should like to ask you: can one learn this without forgetting that, and is what one learns worth what one forgets?

—Cheikh Hamidou Kane

The privilege of being at school, Mali.

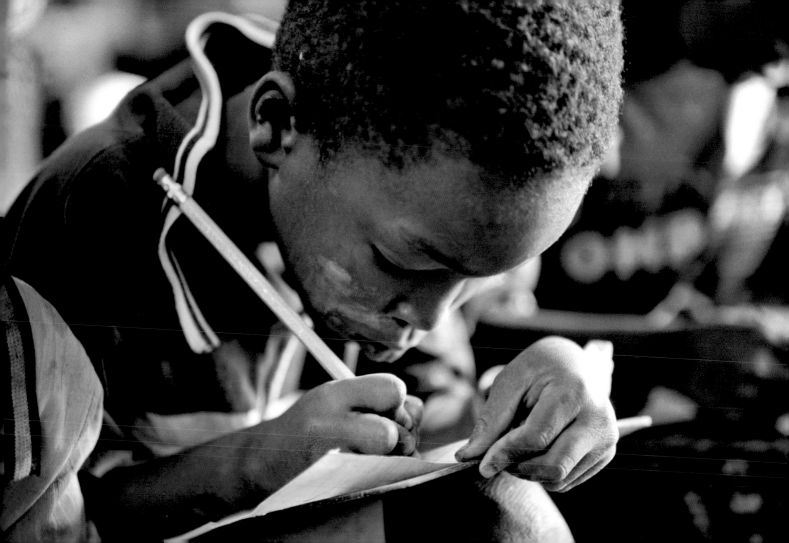

You need, if possible, to grasp the sense of what is related.

If that is not possible, listen attentively so as to distinguish the sound of what is related.

—Amadou Hampâté Bâ

Dikore, a 7-year-old Peul girl, Burkina Faso.

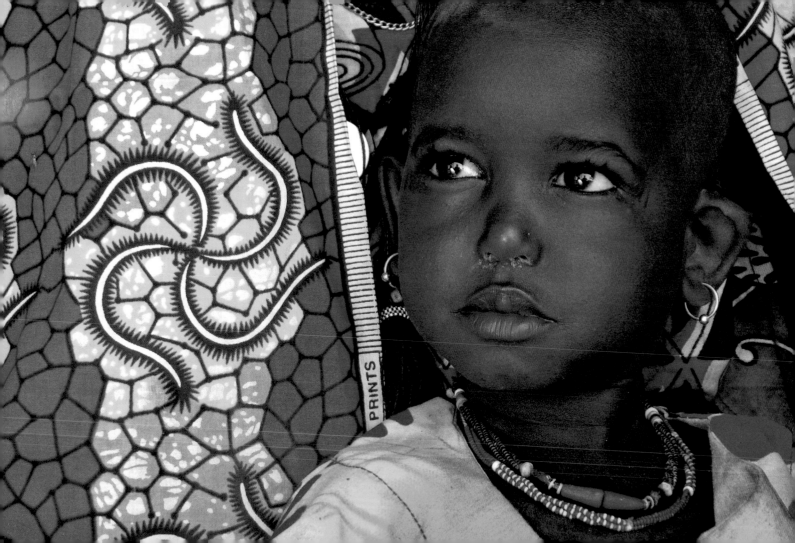

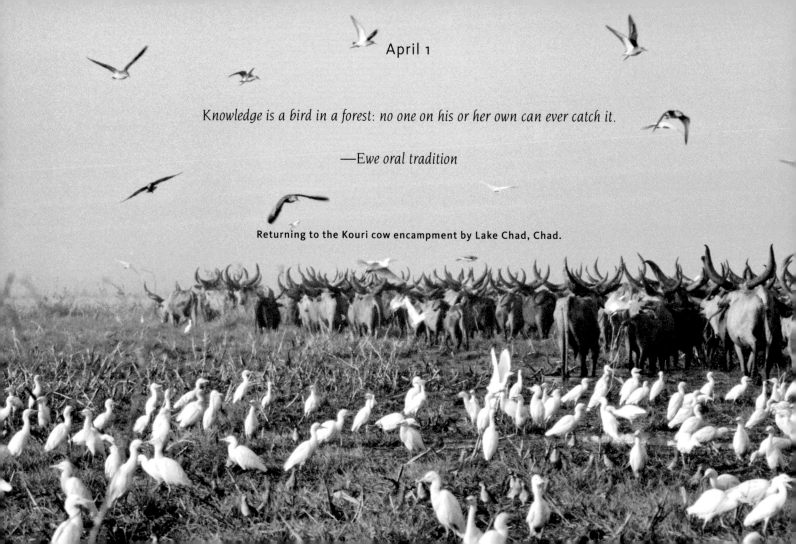

April 1

Knowledge is a bird in a forest: no one on his or her own can ever catch it.

—Ewe oral tradition

Returning to the Kouri cow encampment by Lake Chad, Chad.

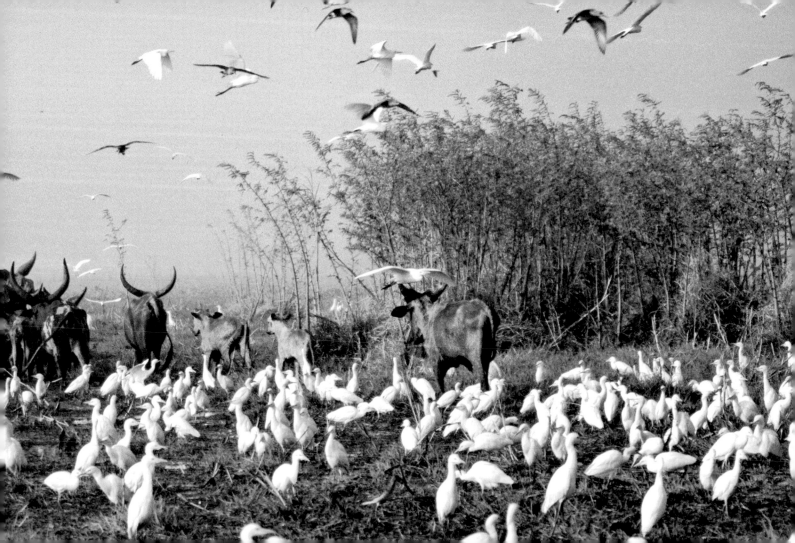

Nature helps us to be our true self, to go through major changes and life-threatening situations.

It brings magic and laughter.

—Sobonfu Somé

The watering hole, Choudop, Namibia.

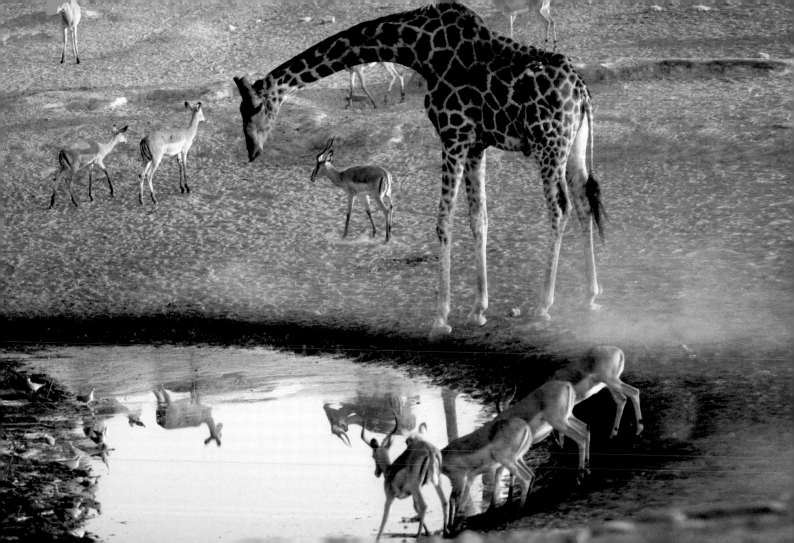

They dance as they walk, or they walk as they dance, to the sound of an inner melody,

for with their bodies they pass through the world around them in quest of a still-remembered harmony.

—Dr. Raymond Johnson

On the Atlantic beaches, Senegal.

If you are a good hunter, never stay at home. Get out,

find the tracks of animals, see where they were going, when they passed through, the wind direction,

where to move, where the grass is tall enough to hide. Then you will be a very good hunter.

Then you will marry well and make your family happy.

—Elder Bushman

Ngau, young Bushman hunter, Namibia.

No one would have her vision clouded by the smoke of kitchens.

She composed poems out loud, fitted words to the rhythm of the birds singing or the rain falling,

expressed the meaning of drumbeat music through dance,

discovered how to dress and behave to good effect—such arts as these were the sole lessons of her childhood.

—Ousmane Socé

Young shepherdess of the Fochda tribe, Al Ebel well, Chad.

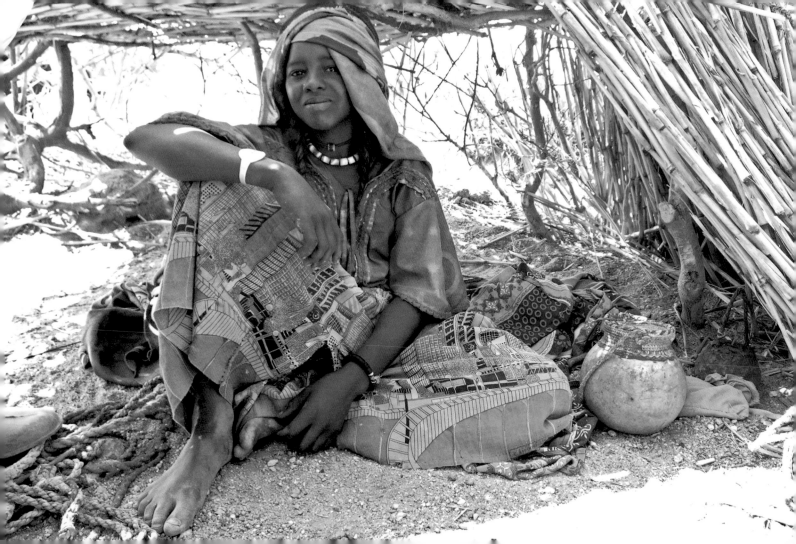

Hunters take no pride in killing: they have only praise and respect for the hunted.

The hunter and the hunted simply play out their roles in the drama of existence.

Nature is therefore not an enemy that has to be beaten.

—Alassane Ndaw

Springbok in Etosha National Park, Namibia.

[They] yield, captivated, to the essence of all things,

ignorant of surfaces but captivated by the motion of all things.

—Aimé Césaire

The beaches of Senegal's Little Coast.

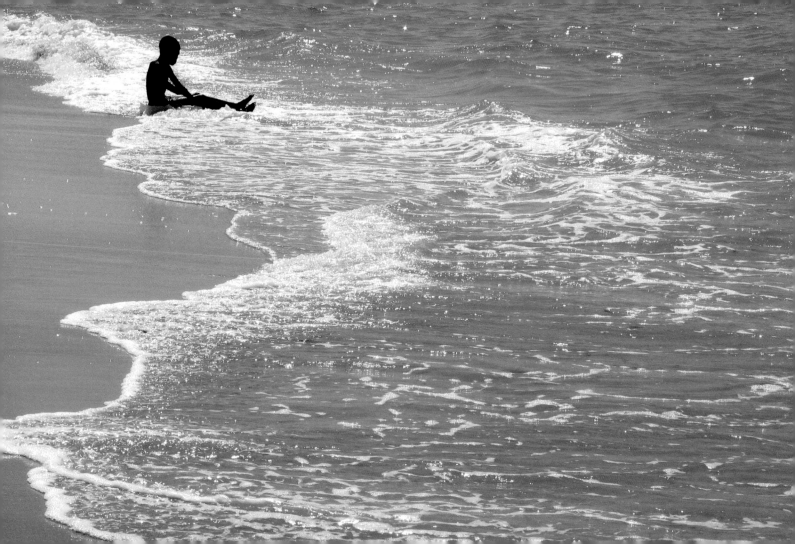

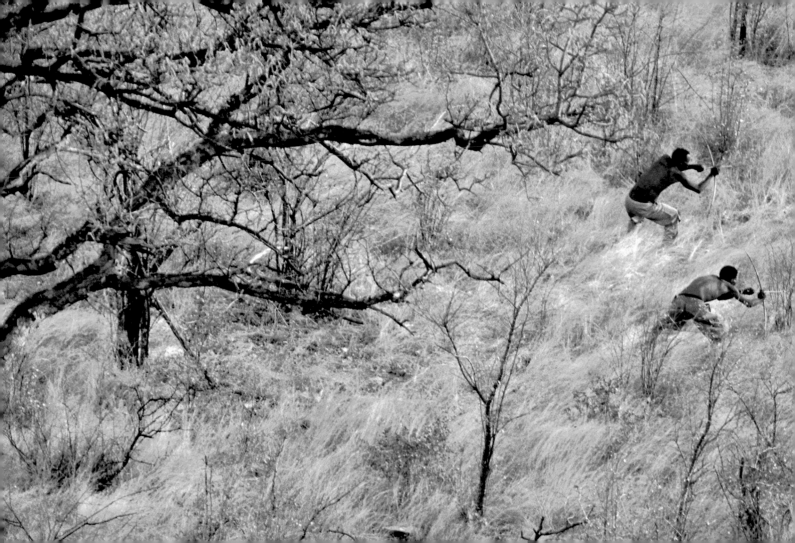

April 8

Those who have destroyed their wild beasts and live without them are incomplete.

—*Spiritual head of the Masai tribe*

Two hunters with bow and arrow, Bushman country, Namibia.

None of us got where we are solely by pulling ourselves up by our bootstraps.

We got here because somebody bent down and helped us.

—Thurgood Marshall

In the alleyways of a Dogon village, Mali.

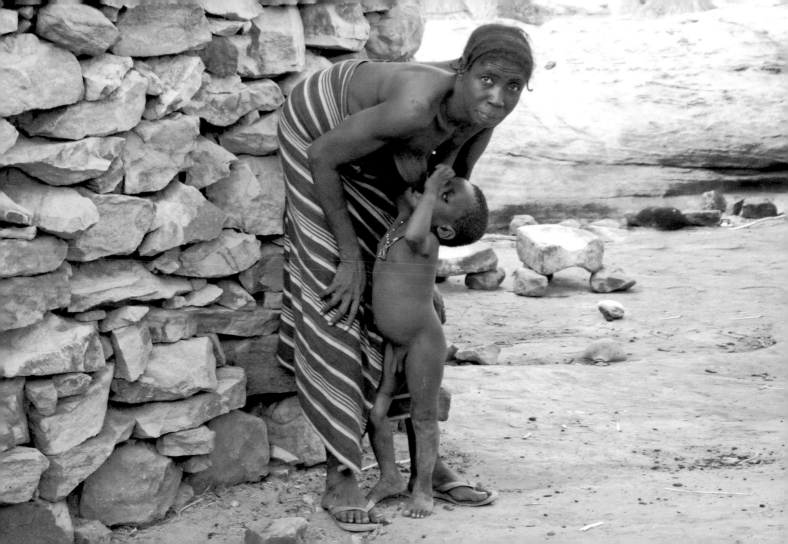

Two friends are like seashells; they murmur endlessly.

—Swahili oral tradition

Addida and her little shepherdess sister, Chad.

The Other is the place of meaning.

Only the Other can hate me or love me,

provoking me to the movement that is life itself.

The silence of objects draws us into a nonexistence that is lifeless,

leaving our hunger for love unassuaged.

—Dr. Raymond Johnson

Friendship in Peul country, Burkina Faso.

Every word and every being come knocking at your door, bringing you their mystery.

If you are open to them, they will flood you with their riches.

—Irénée Guilane Dioh

Dalila, a young Angolan woman.

The first thing you should do when you get up in the morning is to go and see other people.

—Female elder in a Baoule village

Taking a break in the shade, Himba country, Namibia.

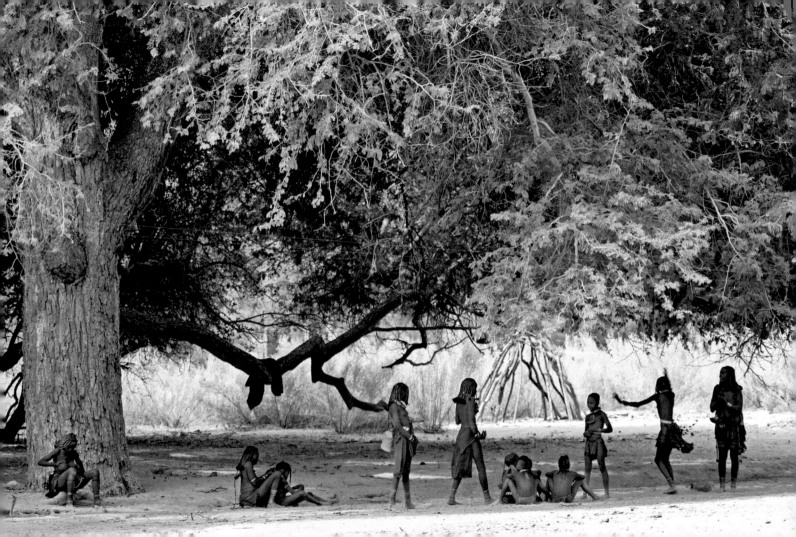

How are we to confront all the dangers that even now threaten life in Africa—the bushfires that engulf

property, the animals that threaten the crops, the rains that either do not come or else come

at the wrong time and bring famine, the endemic diseases that kill or mutilate, and all the rest?

The strongly structured, solid group remains the individual's citadel,

the only guarantee of his meager existence. To join together is to live.

—Seydou Badian

Men arriving to celebrate the wedding of one of their companions, Chad.

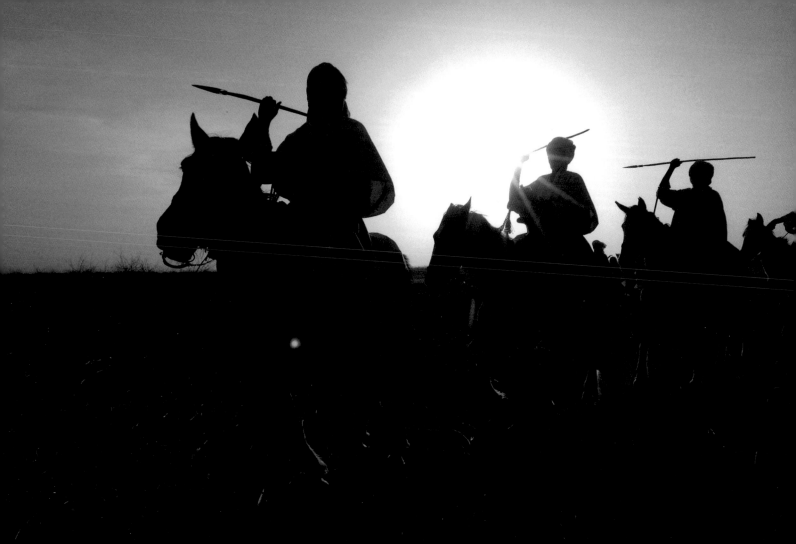

You cannot paint white on white or black on black. Everyone needs the Other in order to be seen.

—Manu Dibango

The Sossusvlei Dunes, Namibia.

There is a spiritual dimension to every relationship.

Two people come together because spirit wants them together.

—*Sobonfu Somé*

Within a Dogon village at dusk, Mali.

With one person, it's hard to see very far. With two people, you can see a little more.

But if you have a whole group of people around really caring about you and telling you,

"You are doing the right thing! We want you to be around! Give us your gifts!" it helps you fulfill your purpose.

—Sobonfu Somé

The school of the Mangetti Dunes, Bushman country, Namibia.

It helps to bring the spirits of other people into your life;

it gives you many more eyes to see and helps overcome limitations.

—Sobonfu Somé

At the feast of Timkat (Epiphany), Ethiopia.

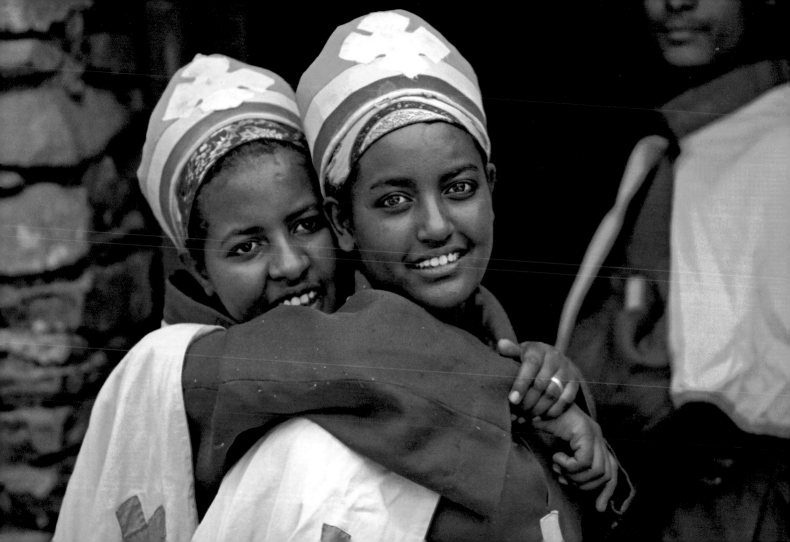

Intimacy should be seen as a privileged meeting of two beings:

man with woman, parent with child, pupil with teacher.

Intimacy also exists between the world of humans and the invisible world,

the world of the ancestors and spirits.

—Marie-Noëlle Anderson

The herd returning to the encampment by Lake Chad, Chad.

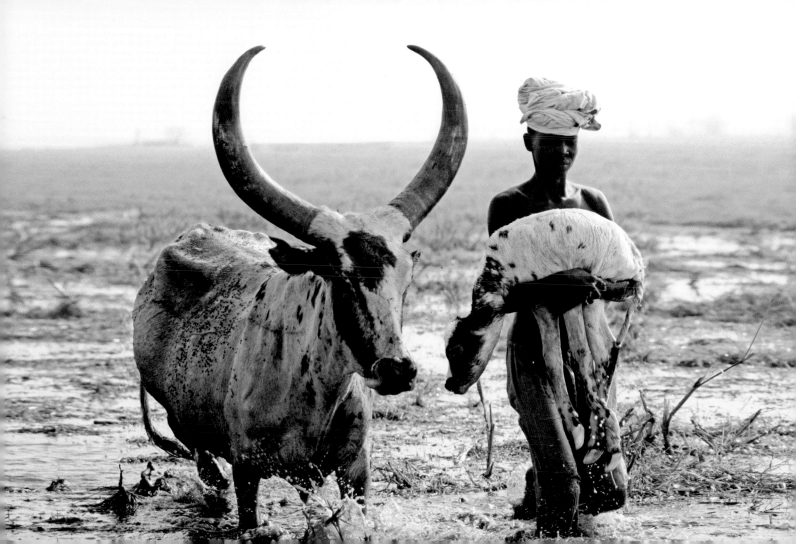

From their parents and grandparents, children learn traditions and morals.

In return, they surround their elders with respect and concern.

From other children of the same age, they learn the notions of equality and of helping one another.

Listening to one another with respect enables them to find their own place and thereby

become aware of their rights and duties in regard to the rest of the world.

—East African schoolmaster

Dolo, 5 years old, Mali.

The family in Africa is always extended.

You would never refer to your cousin as "cousin," because that would be an insult.

So your cousins are your sisters and brothers. Your nieces are your children.

Your uncles are your fathers. Your aunts are your mothers.

Children are also encouraged to call other people outside the family mothers and fathers, sisters and brothers.

—Sobonfu Somé

Returning from the market, Djenne, Mali.

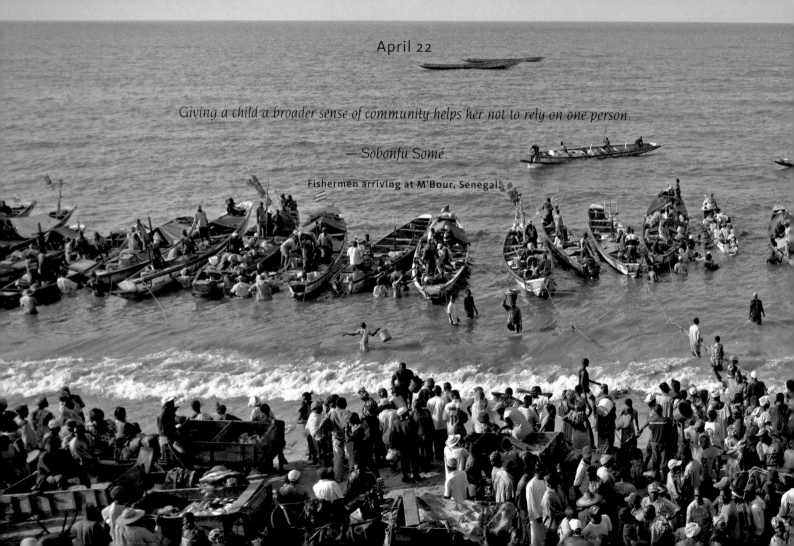

April 22

Giving a child a broader sense of community helps her not to rely on one person.

—Sobonfu Somé

Fishermen arriving at M'Bour, Senegal.

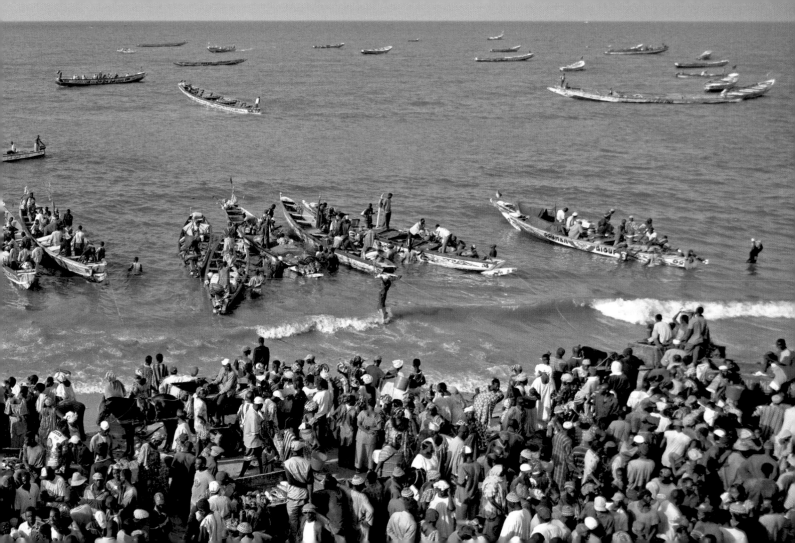

If a child grows up with the idea that Mom and Dad are her only community,

then when she has a problem, if the parents cannot fix it, she doesn't have anybody else to turn to.

—Sobonfu Somé

Fatima, after losing her school pencil, Mali.

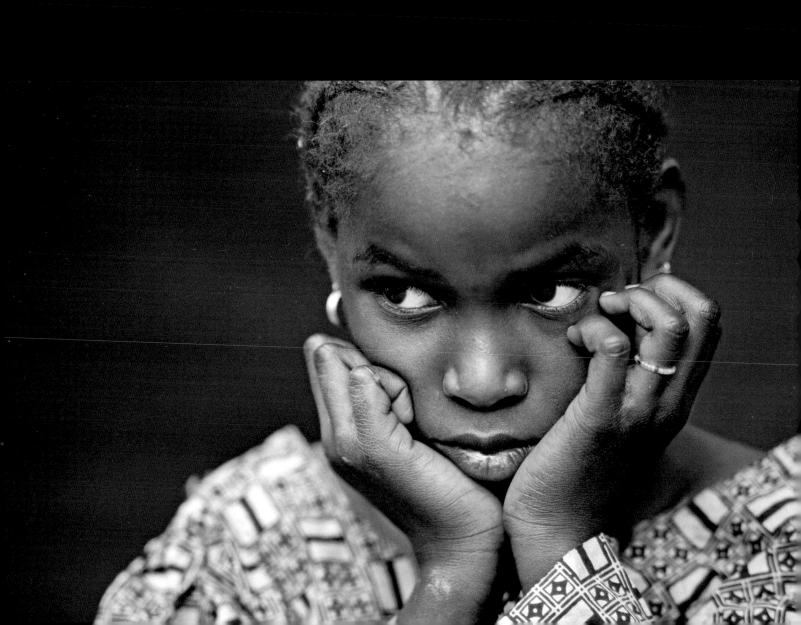

In initiation, one important lesson is learning how to build an intimate connection

with spirit, the self, and others, where the question is usually,

"How do you build a relationship with yourself, with another, or with spirit, for that matter?"

—*Dagara oral tradition*

Waiting for the food to be passed, Himba country, Namibia.

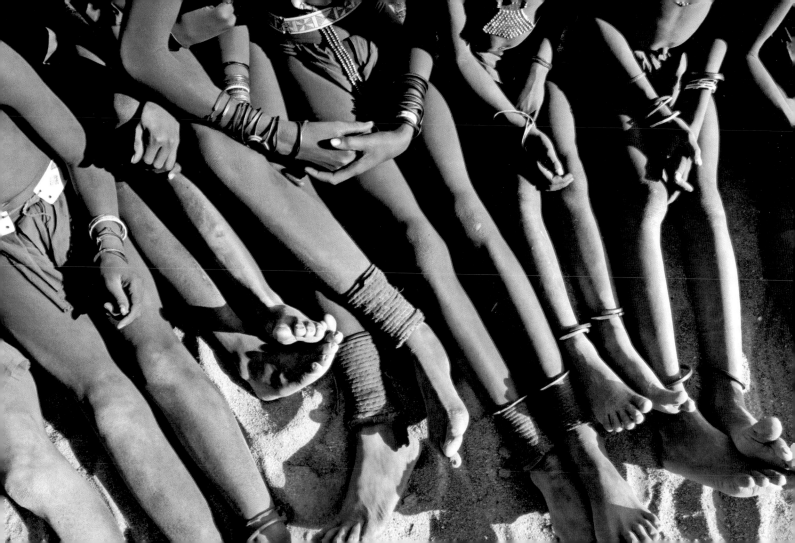

You may call yourself a big elephant, but the bush is much bigger than you are.

—*Mandingo oral tradition*

The white elephants of Etosha, Namibia.

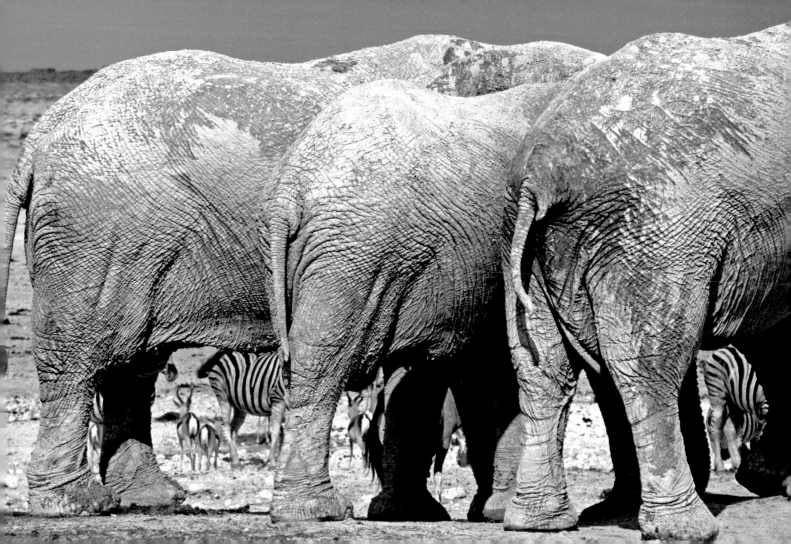

The group is the reality, the sovereign good, the refuge, the citadel without which the individual would be at risk.

Man moves, evolves, actualizes himself within the group. Absolute refusal—schismatic refusal—is heresy.

It fragments the group, undermining and damning the individual: it is a sort of suicide.

—Seydou Badian

The blacksmith's son, Dogon country, Mali.

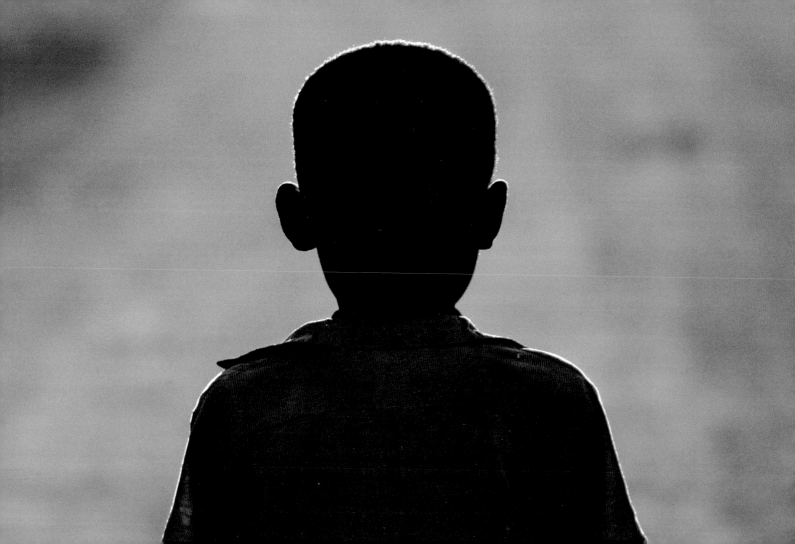

He who puts himself outside the community in one way or another forfeits his human quality

and becomes a sort of reincarnated evil spirit, banned and feared by all.

—Seydou Badian

Sacrifice at a Dogon hunters' festival, Mali.

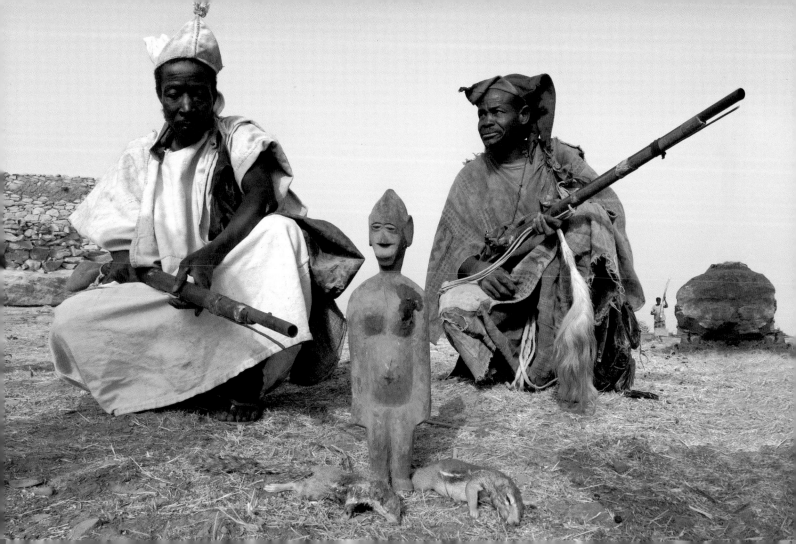

Eating together from the same bowl establishes a communion,

a pact of peace among individuals.

—Dr. Raymond Johnson

A Peul nomadic tribe's festival meal, Burkina Faso.

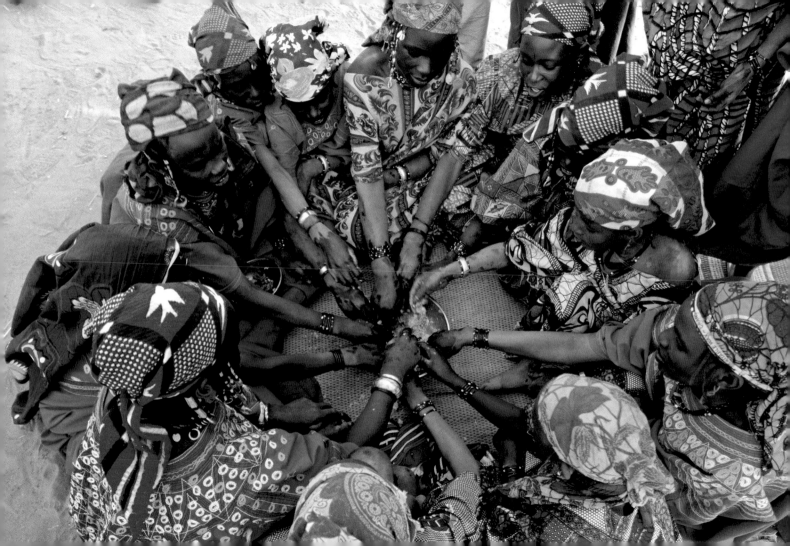

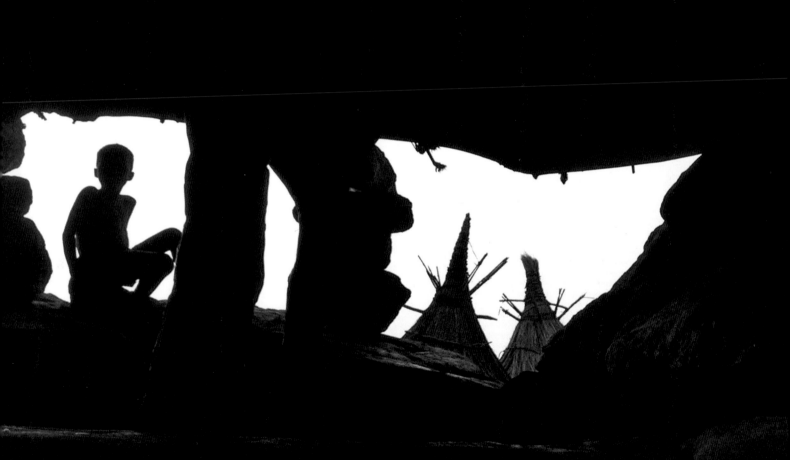

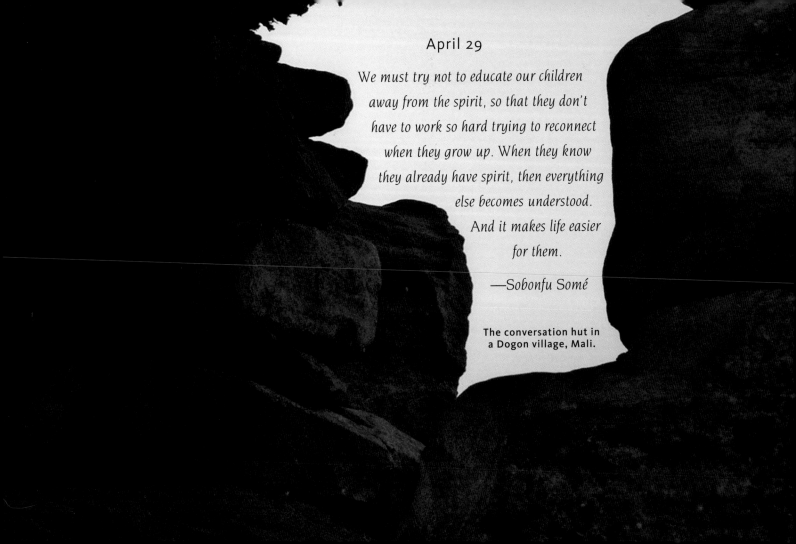

April 29

*We must try not to educate our children
away from the spirit, so that they don't
have to work so hard trying to reconnect
when they grow up. When they know
they already have spirit, then everything
else becomes understood.
And it makes life easier
for them.*

—Sobonfu Somé

**The conversation hut in
a Dogon village, Mali.**

The person within is an unfinished multiplicity whose vocation is to seek order and unity.

God simply begins the work; it is on earth that everyone is created.

—Malinke griot

Moment of grace in Himba country, Namibia.

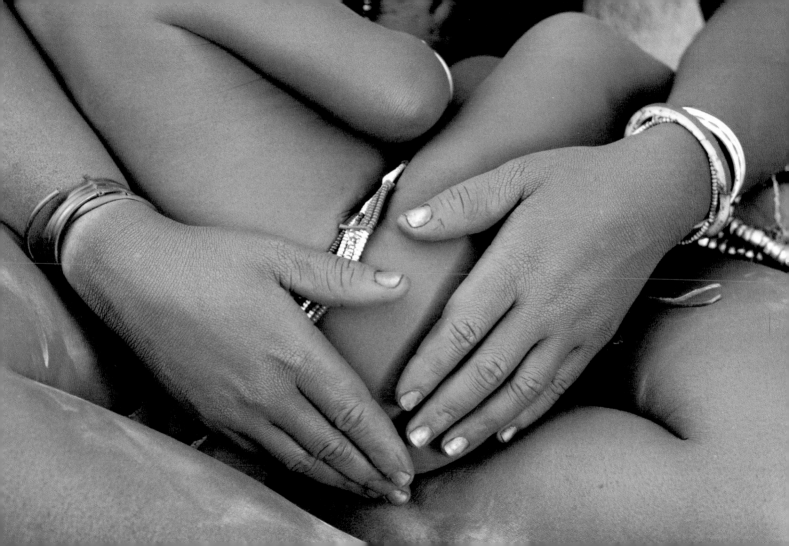

When the Everlasting addressed man, He taught him the law by which all the elements of the cosmos were formed

and continue to exist. He made man the Guardian and Governor of His universe and charged him

with supervision of the maintenance of universal Harmony. That is why being man is a heavy responsibility.

—Mande cosmogony

Daouda, 10 years old, Mali.

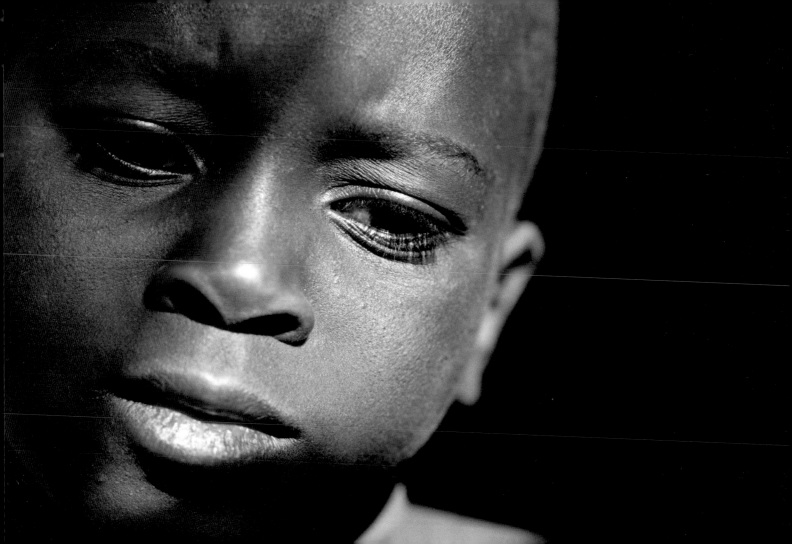

Man is born, grows up, evolves, and fulfills his potential only within a social body that enriches him and that

he is also supposed to enrich. Outside this concept, outside this logic, there is no man.

—Seydou Badian

In a bush school, Chad.

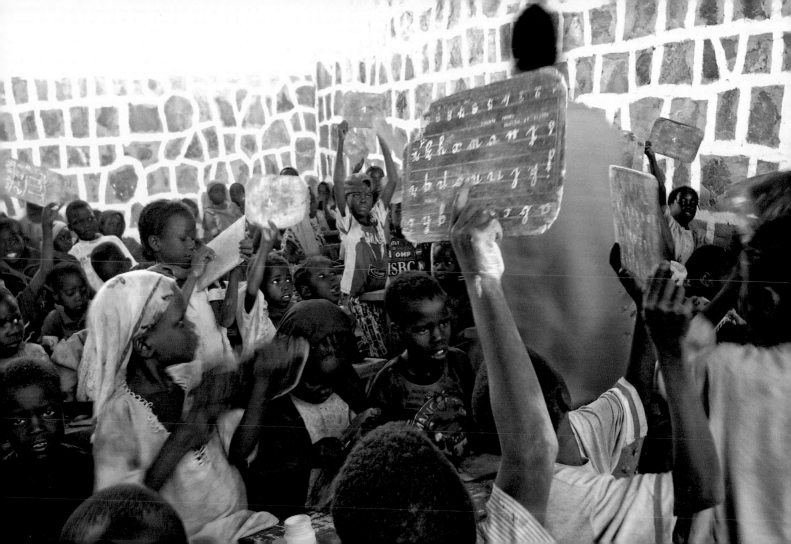

Small domestic tasks are normally entrusted to children,

such as sweeping and putting out the trash in the early morning before going to school,

taking shuttles of thread to the weavers, giving the tontine money to this or that person,

helping the mother to sell her woven skirts and bedcovers at the big market on feast days, and the like.

My integration, through these means, into the women's world to which I belonged

was my parents' way of not trusting entirely to schooling—which, they said,

turned out half-animals, half-birds—if things went wrong.

—Aminata Traoré

The village of Tankassoko, Burkina Faso.

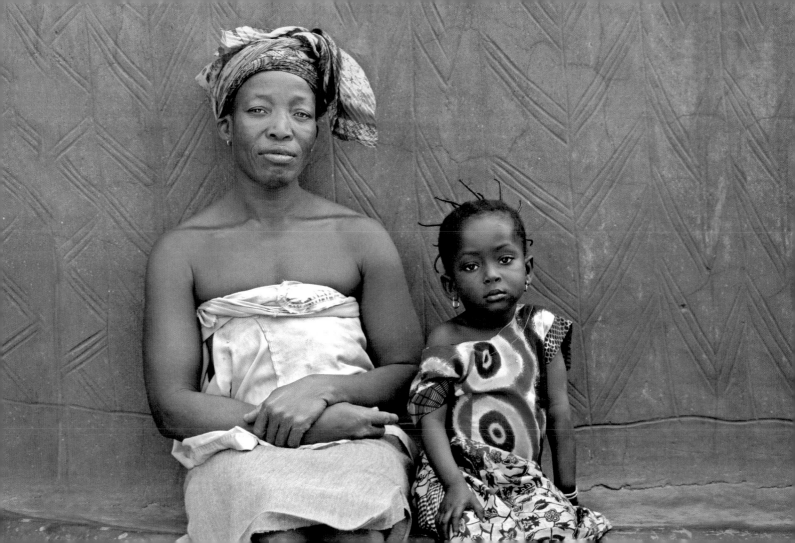

Social education is not distinct from the education of initiation,

for initiation focuses on what constitutes correct behavior in general, be it social, individual, or spiritual.

The distinction between sacred and profane does not exist, for spiritual behavior affects every act of life.

Man's life is enmeshed in the sacred.

—Elder Wolof initiate

Morning calm on the cliff at Bandiagara, Mali.

Writing is the photography of knowledge, but it is not knowledge itself.

Knowledge is a light that is within man.

It is the heritage of everything the ancestors could know,

the germ of which they have passed on to us,

just as the potential baobab is contained within its seed.

—Amadou Hampâté Bâ

Cave paintings, Ennedi massif, Chad.

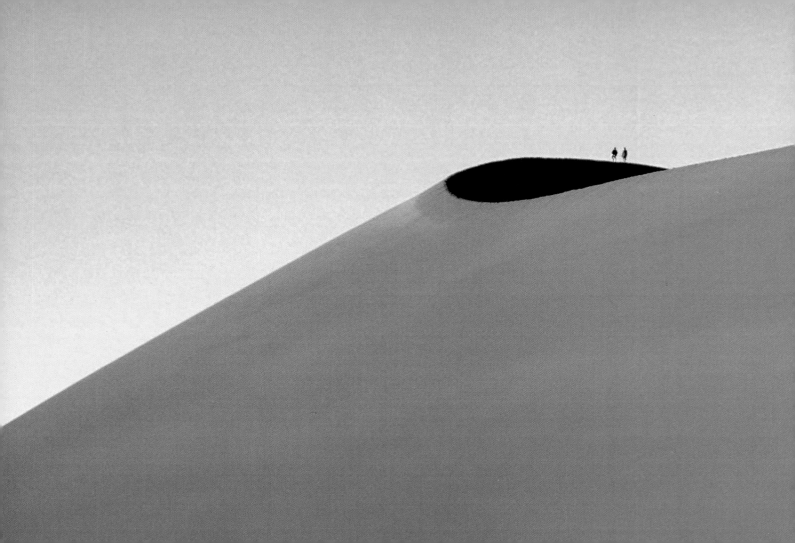

May 6

Man needs to take responsibility for the ties, visible and invisible, that together give direction to life.

—Aminata Traoré

The Sossusvlei Dunes, Namibia.

Initiation rituals are essentially aimed at enabling the individual

to enter adult life by initiating him not simply into the physiological realities

but into those of social life and the world as well,

realities that he will not only need to recognize but also to be able to handle.

And inasmuch as those realities are hard, burdensome, and often worrying, not to say cruel,

so initiation rites need to be all of those things, too.

—Alassane Ndaw

Hunters' dance, Dogon country, Mali.

The land of initiation is a region of sand. If no one guides you there, you will sink into it.

People run into the sand when they fall into the traps that beset their path.

You imagine you've attained a goal when it is only a decoy.

You think you've achieved something when in fact you're just bogged down.

Hence the need for a sure guide.

—Peul oral tradition

The Sossusvlei Dunes, Namibia.

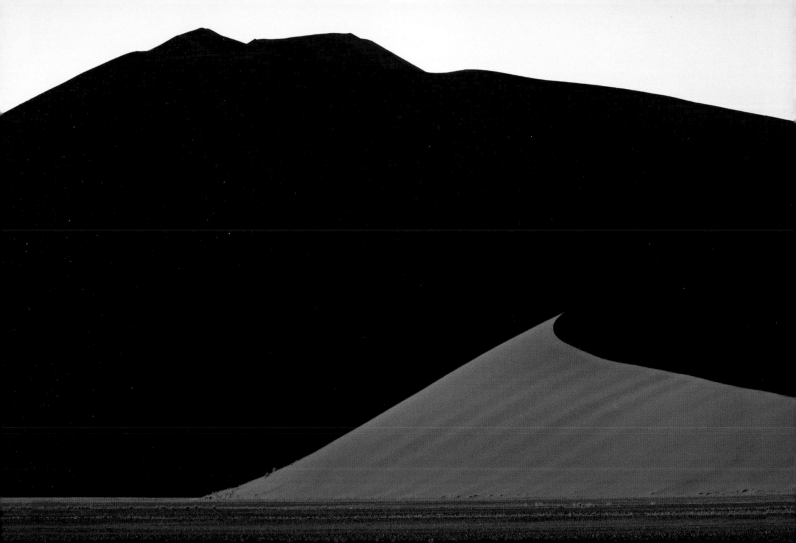

At initiation, elders guide the young deeper into intimacy, sexuality, and ritual

so that they know what is awaiting them.

They do not just wander into the unknown territory of adulthood and get wounded.

—Sobonfu Somé

Morning ceremony during the Timkat festival, Ethiopia.

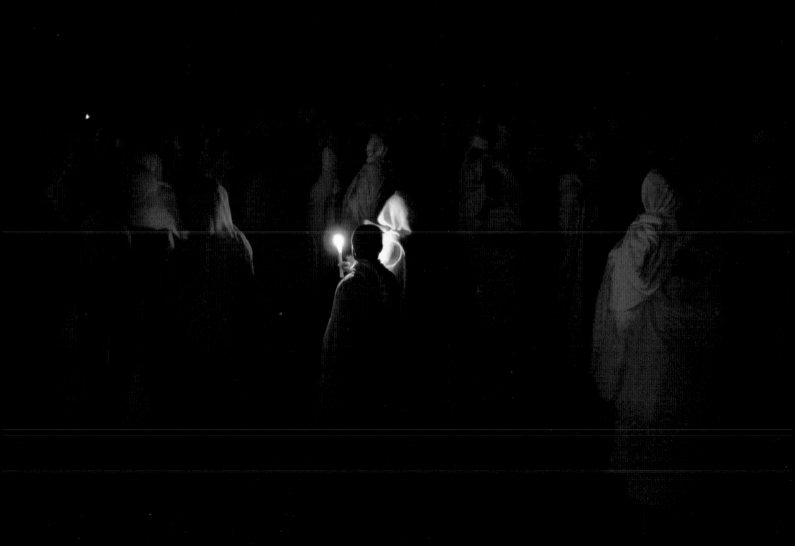

As initiated by his creator, man later passed on to his descendants the sum total of his knowledge.

So began the great chain of initiatory oral transmission.

—Amadou Hampâté Bâ

Marriage celebration, Chad.

With speech, man receives the life force, shares it with other beings, and thereby achieves direction for living.

—Dogon oral tradition

Maidigue Kassogue, Dogon chief of the village of Indelou, Mali.

Childhood Night, blue Night, gold Night, O Moon!

How often have I invoked you, O Night! while weeping by the road,

Feeling the pain of adulthood. Loneliness! and its dunes all around.

One night during childhood it was a night as black as pitch.

Our backs were bent with fear at the lion's roar, and the shifting

Silence in the night bent the tall grass. Branches caught fire

And you were fired with hope! and my pale memory of the Sun

Barely reassured my innocence.

—Léopold Sédar Senghor

Bushman children playing, Namibia.

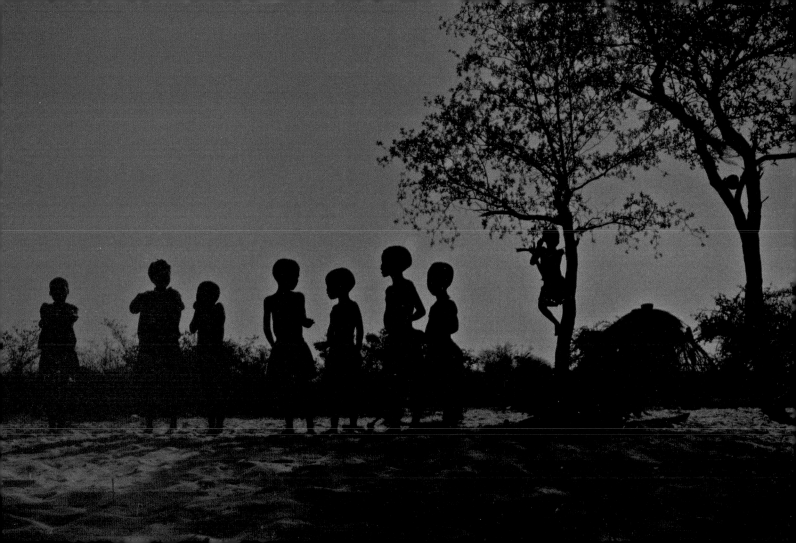

It is through conflict that we gain knowledge

of ourselves and learn new situations

for using our own gifts.

—Sobonfu Somé

A hyena approaches a watering hole, Namibia.

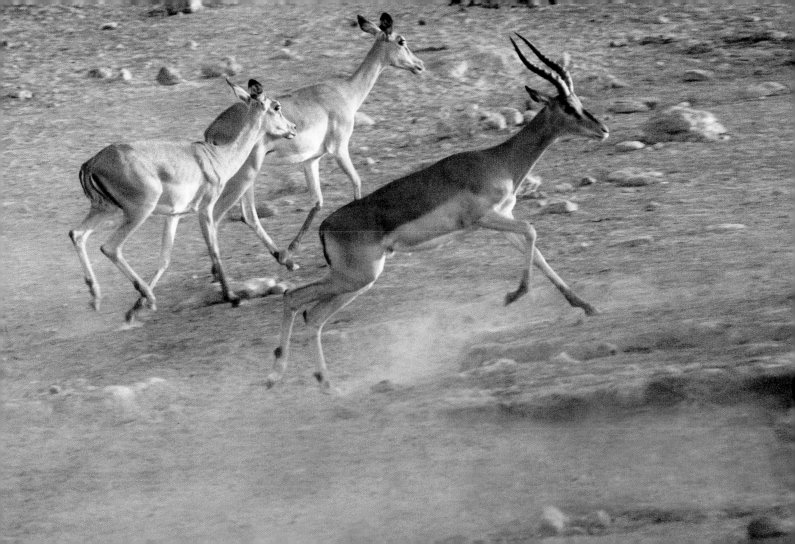

People will always fool themselves about freedom if they imagine that

it comes from the elimination of all possible and conceivable constraints.

—Nsame Mbongo

The churches of Lalibela, Ethiopia, are carved into the rock.

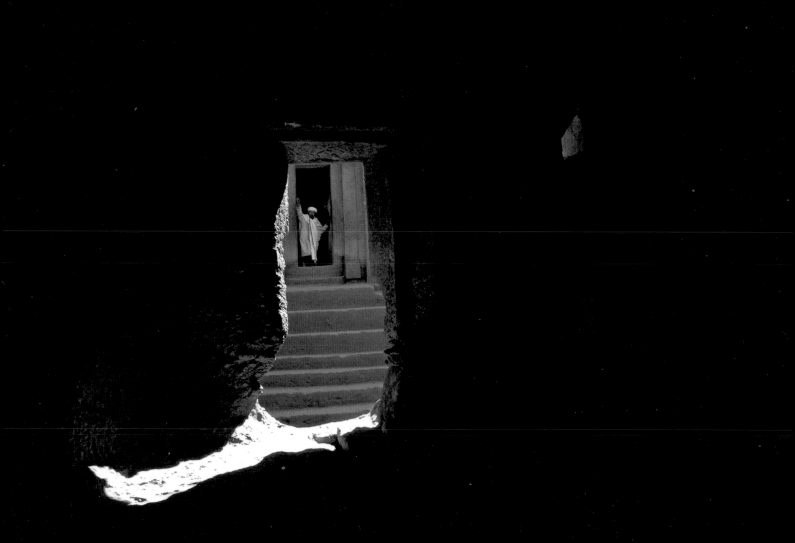

Fear can engender deception because it creates images of things that do not exist.

Fear is one of the grounds for elimination in initiation.

Man needs to have the courage and will to confront everything,

never mind how strange or unexpected.

—African oral tradition

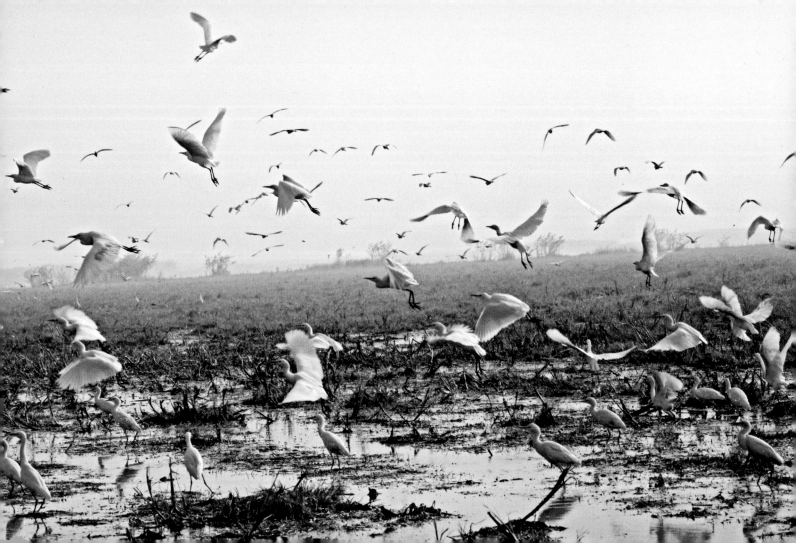

He who wants to live, who wants to remain himself, must compromise.

—Cheikh Hamidou Kane

Returning fishermen, Senegal.

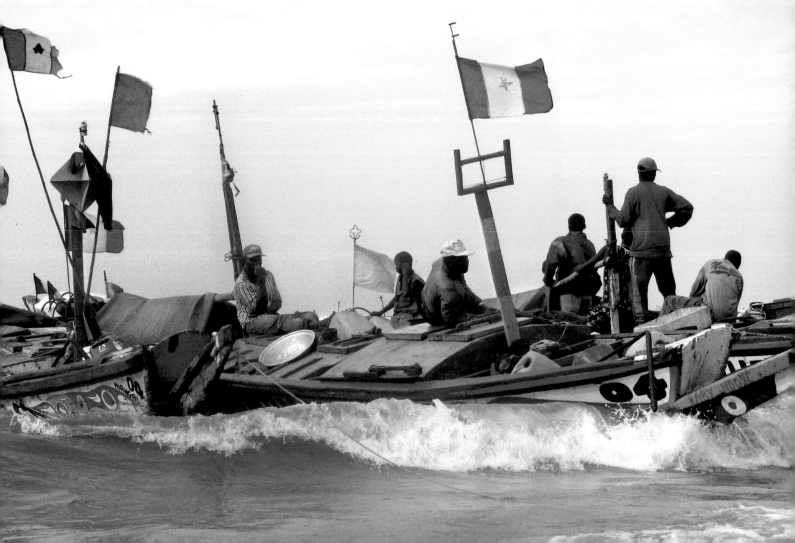

Despair and fear have a nullifying effect upon a man's activity and throw him into confusion.

That is why initiation always contains a test of courage. It is an exercise of the will, a struggle with oneself.

—African oral tradition

A frightened child at Kinisserom on Lake Chad, Chad.

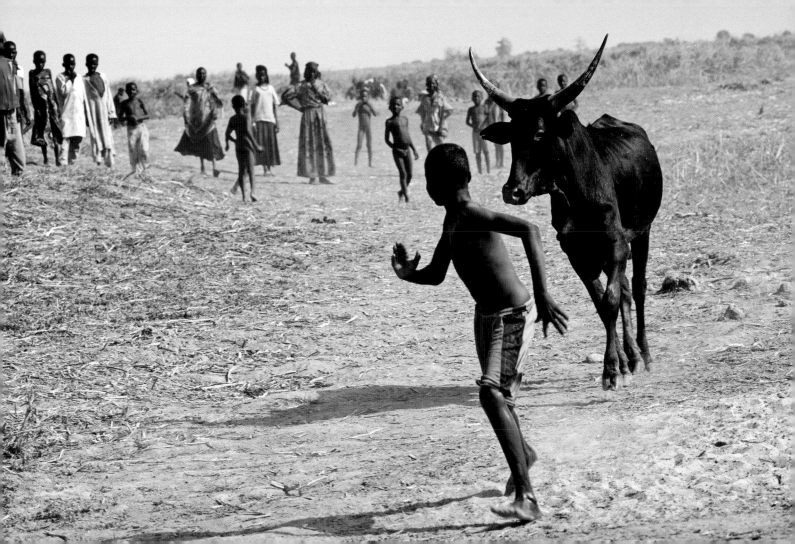

It takes a whole village to keep parents sane.

—*Sobonfu Somé*

A Mossi village, Burkina Faso.

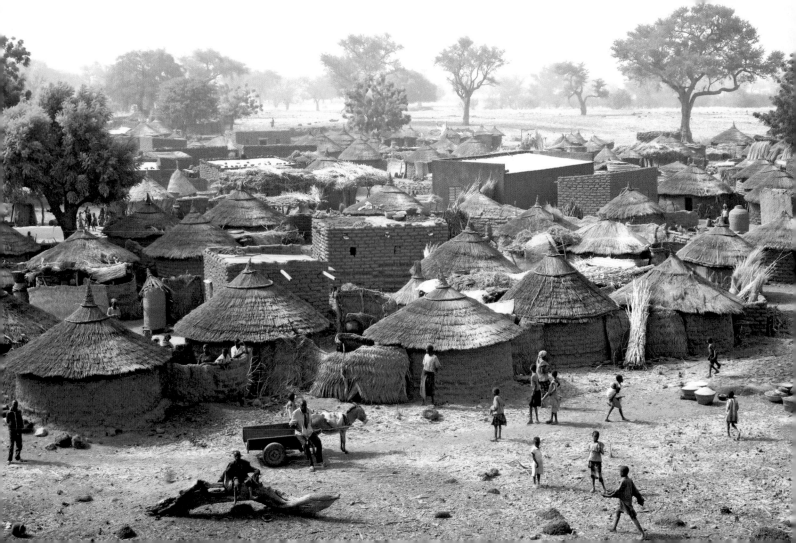

If a man has not discovered something that he will die for, he isn't fit to live.

—Dr. Martin Luther King Jr., *speech at the Great March on Detroit, June 23, 1963*

Timkat ceremony, the church of Bieta Ghiorghis, Lalibela, Ethiopia.

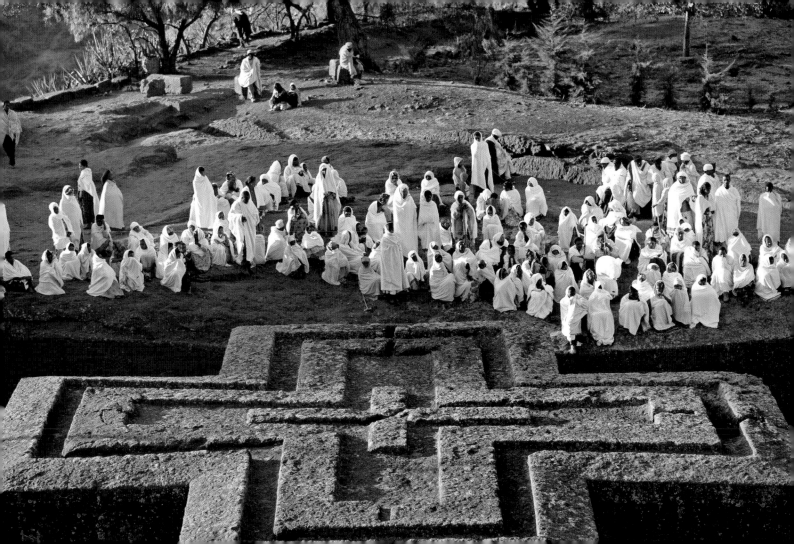

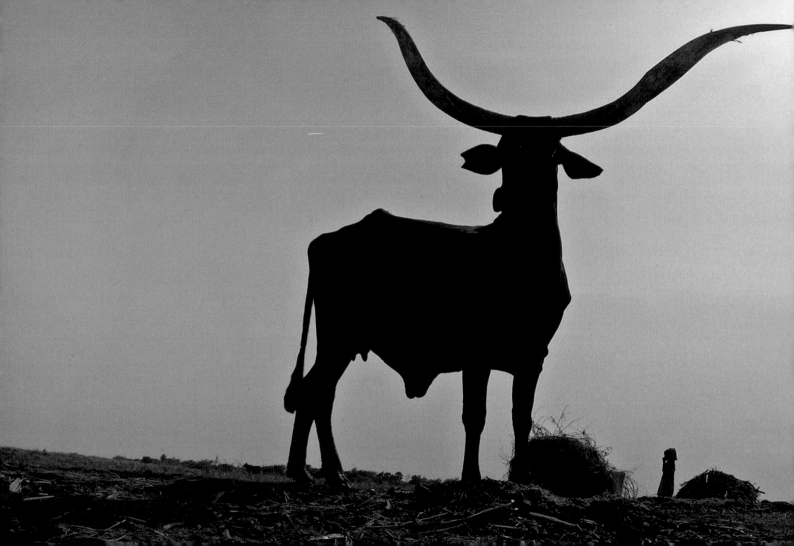

May 20

The fact that courage is expected of you in the face of the unbearable gives you strength for the rest of your life.

—Nelson Mandela

By Lake Chad, Chad.

The first man was both man and woman. He was whole and lived in a state of harmony.

Having transgressed a law, he split in two.

Following this separation, man and woman both felt incomplete and solitary;

they felt the need to recover their initial state of fullness.

The Dogon myth is thus a remarkable vehicle for the idea of complementarity between man and woman.

—Albertine Tshibilondi Ngoyi

Detail of a Dogon door, Mali.

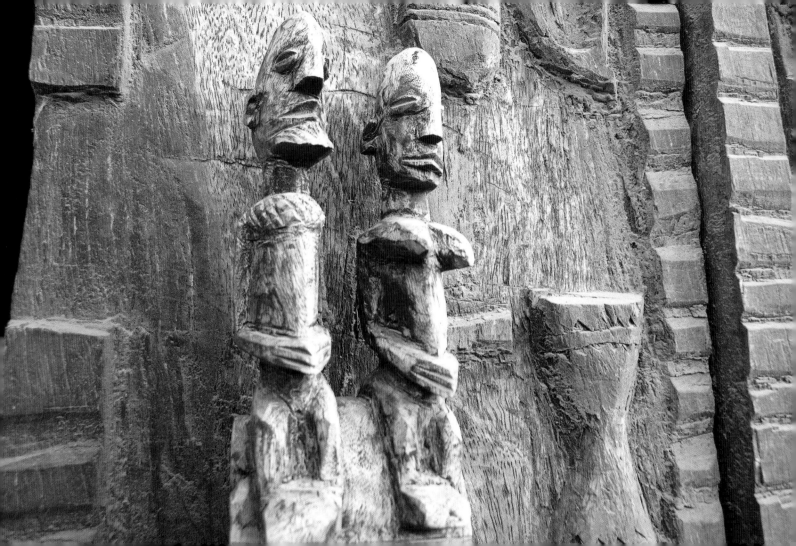

We are both male and female from birth.

Education and rituals enable us to establish our true nature.

—West African oral tradition

Kapika, a young Himba, Namibia.

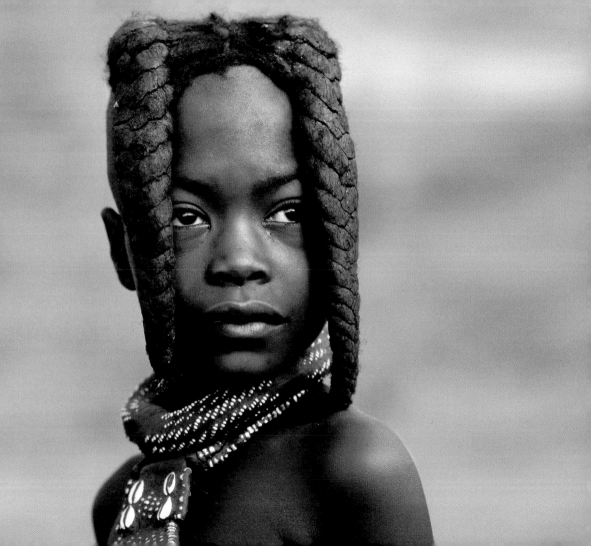

The word for "woman" is soutoura. It refers to self-knowledge, self-esteem, and self-respect.

These are necessary if one is to obtain the respect of others,

something my mother regarded as essential for a woman.

—Aminata Traoré

Djenne market, Mali.

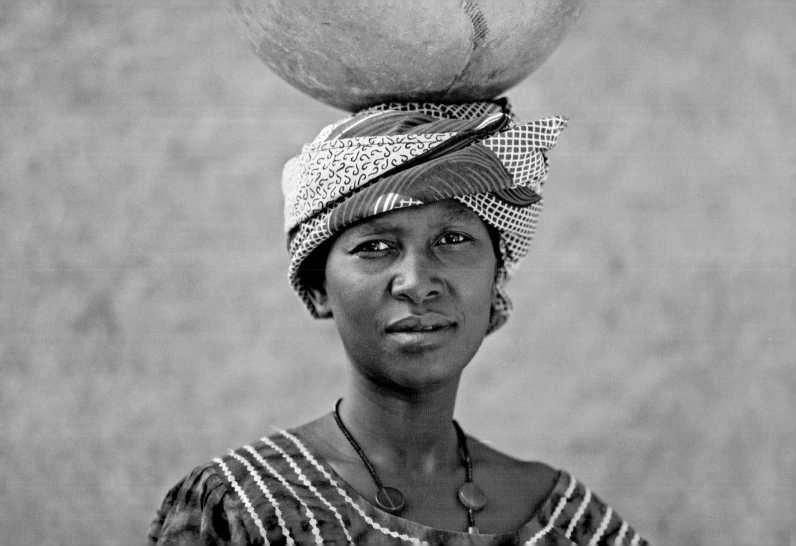

Make me rebellious to all vanity, though obedient to its genius

as the fist is to the outstretched arm

Make me the guardian of its resentment

Make me a man of ending

Make me a man of initiation

Make me the executor of these lofty works

Now is the time to gird the loins as a valiant man.

—Aimé Césaire

Mamadou, a Senegalese athlete.

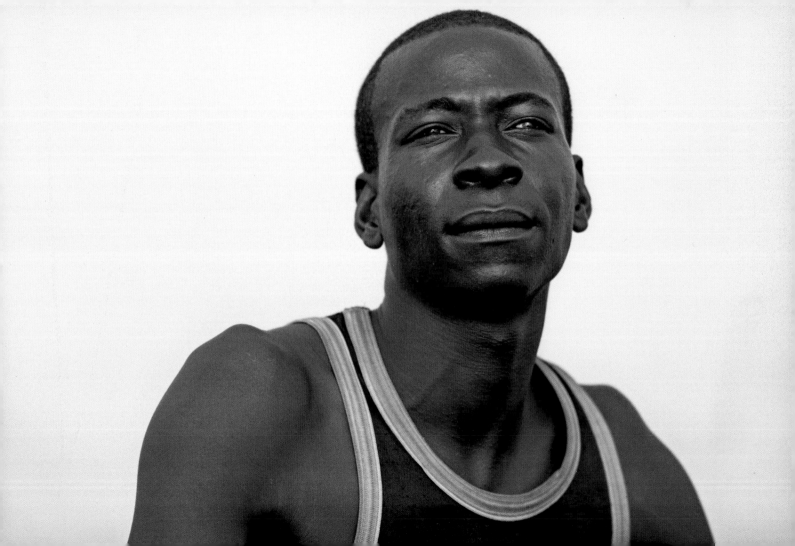

Women should envisage their personal fulfillment, dignity, and vocation in terms of their resources as women.

Being equal does not entail being identical.

The notion of equality is an ethical notion, a moral necessity that is born of the existence of differences.

Indeed, difference is fundamental to the notion of equality.

—Albertine Tshibilondi Ngoyi

Habiza, a young Peul shepherdess, Burkina Faso.

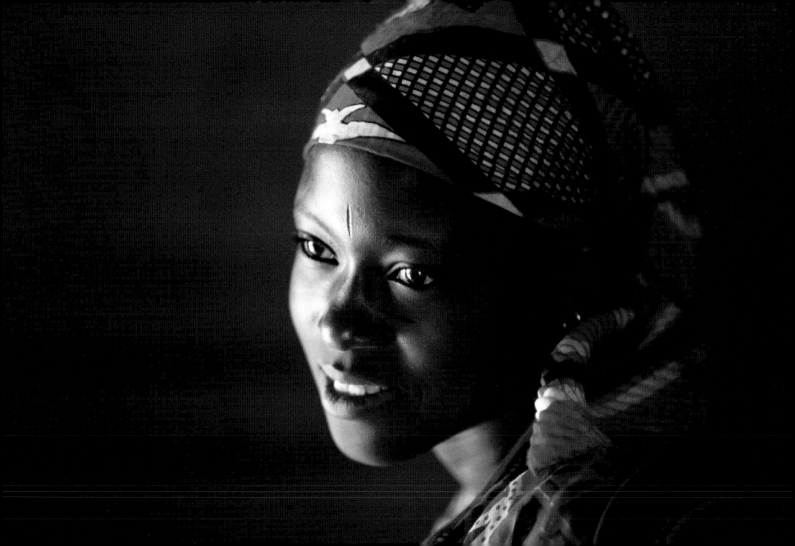

May 26

In the old days, the only men accepted by society were those who were free and strong and possessed

of positive liberty, which is the total acceptance of the burden of real life.

—Father Engelbert Mweng

Ibrahim, at Gorom Gorom, Burkina Faso.

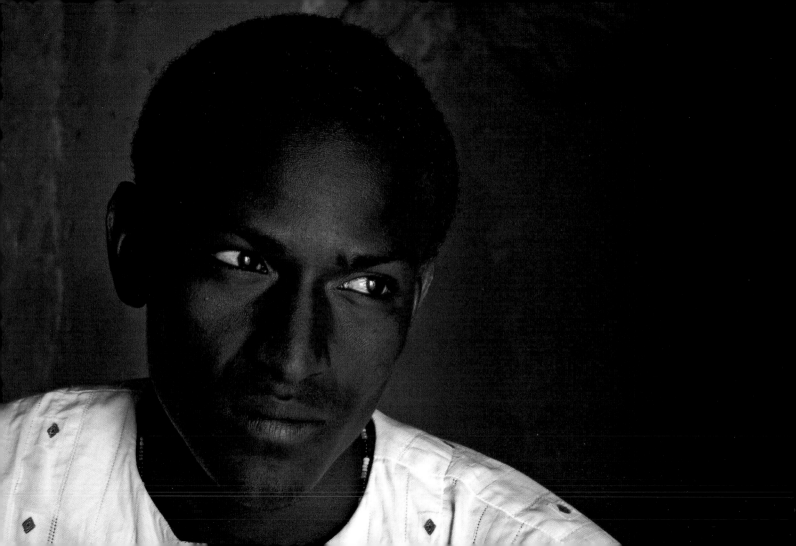

May 27

A clear sense of otherness is essential to a harmonious coming together with your mate.

—Sobonfu Somé

Keeping watch at the Etosha watering hole, Namibia.

To say that man is divided is not simply to speak of a divided genus, but of every individual in that genus.

Consciousness of that generic division requires that everyone know, or ought to know,

that, for the opposite sex, he or she represents the Other.

—Albertine Tshibilondi Ngoyi

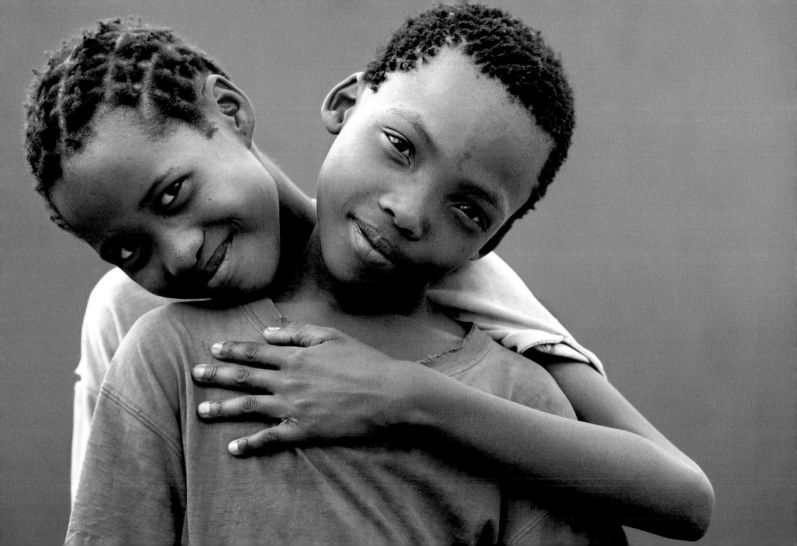

The African woman is neither a mirror image of man nor a slave.

She feels no need to imitate men to express her personality.

Her work, her own genius, her preoccupations, her way of speaking, and her manners mask an original civilization.

She has not allowed herself to be colonized by either men or male culture.

—Albertine Tshibilondi Ngoyi

Kakitu, a young Himba, Namibia.

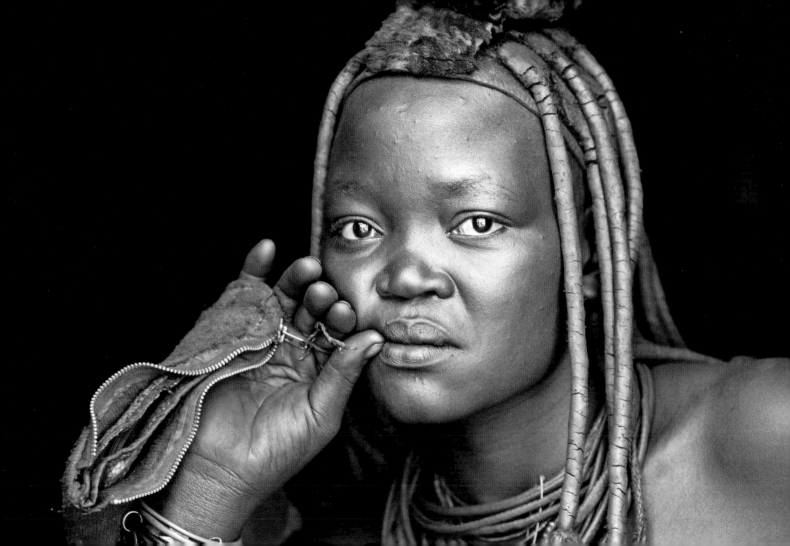

Between the two types that make up human nature and consequently human society,

there is clearly a relationship founded essentially on Otherness.

—Albertine Tshibilondi Ngoyi

In an Ethiopian tavern.

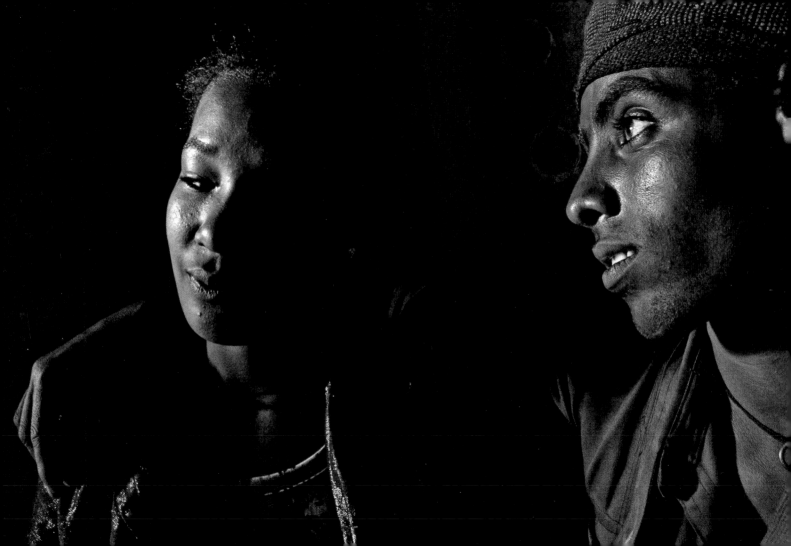

I *do not possess the truth any more than you do. Truth is what unites us in suffering and in joy.*

It is born of our union, in the pain and pleasure engendered there.

Not you or me, but you and me. It is our common product and is a constant marvel.

Its name? Wisdom.

—Irénée Guilane Dioh

Epopa Falls, on the Angola–Namibia border.

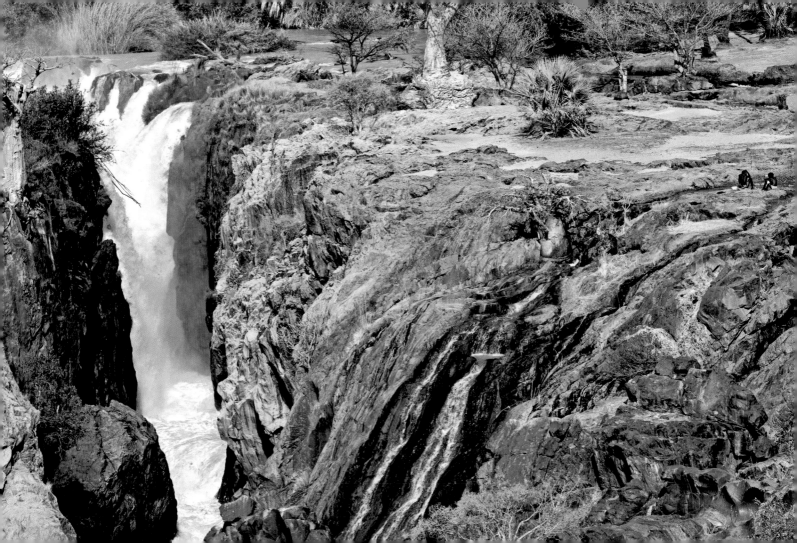

I am nothing without him.

If he takes a false step and trips,

I trip with him, if I cannot hold him back.

—Ritual chant of Mali

Mealtime, Mangetti Dunes, Namibia.

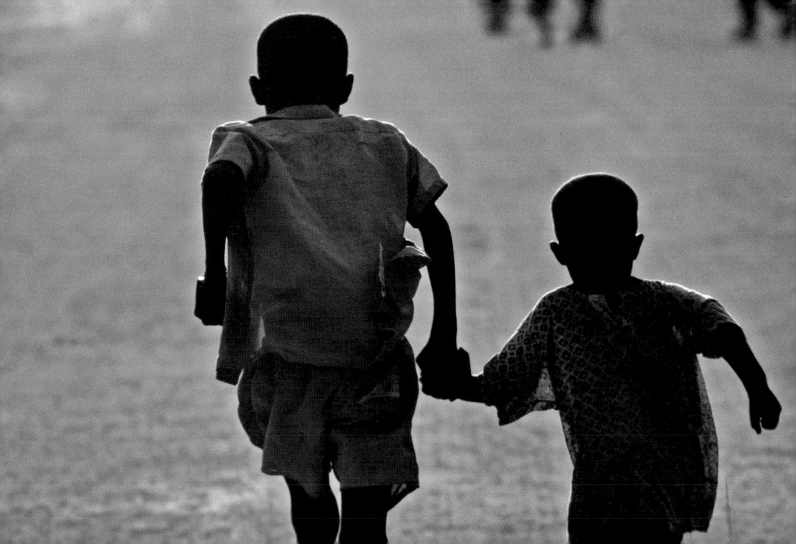

The individual is esteemed essentially for his capacity to act in order to stay in harmony with others.

He is assessed and valued the more for his role in sustaining the community and its togetherness.

—Dr. Raymond Johnson

The Monday market, Djenne, Mali.

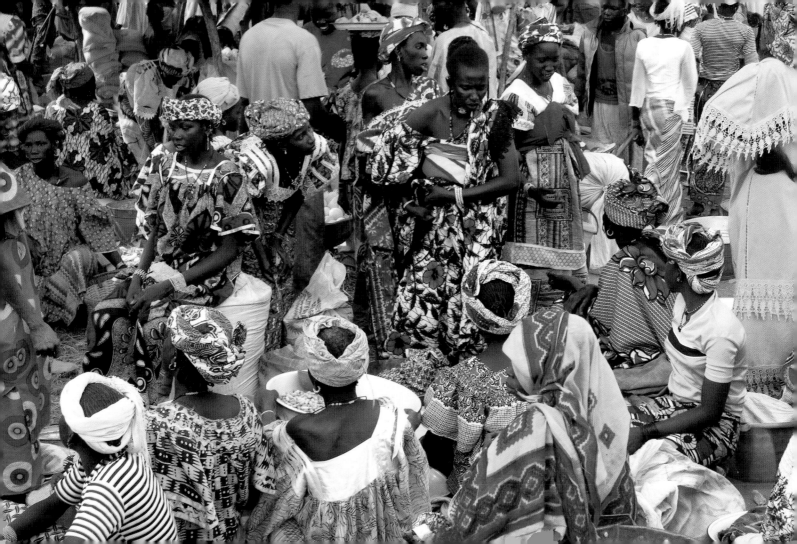

June 3

Relating to others is the basis

of all development.

—Jacques Nanéma

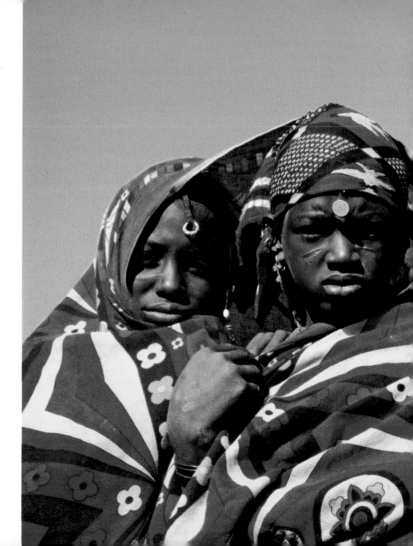

Wedding festivities, Chad.

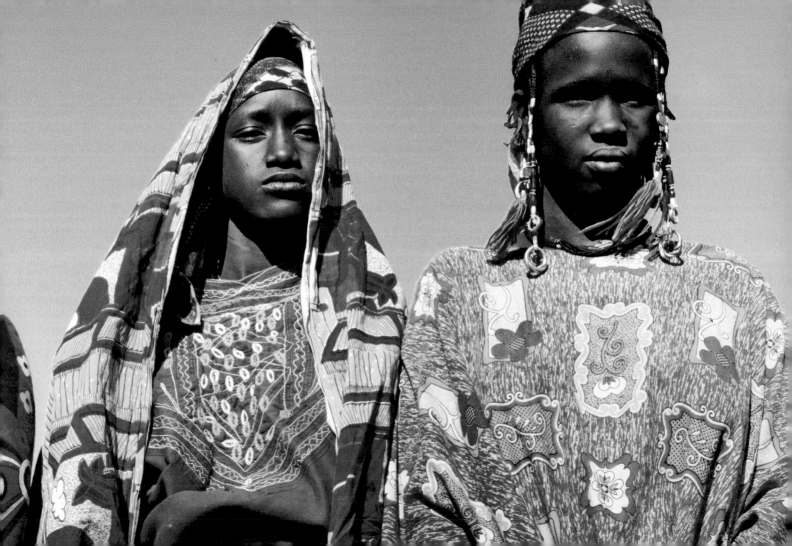

June 4

Keep to the borders of rights and duties.

If you learned only rights

It would corrupt you.

If you learned only duty without rights

It would debase you.

Rise with the sun

And sleep with him

For he is regular.

—Bouna Boukary Diouara

Back from fishing on Lake Chad.

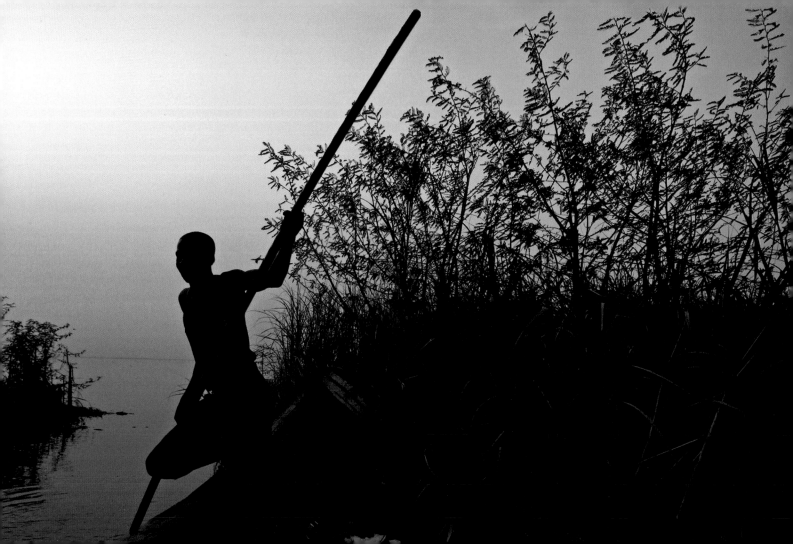

Without identity we are an object of history, an instrument used by others, like a utensil.

Identity is an assumed role; it is like being in a theater where everyone is given a role to play.

—Joseph Ki-Zerbo

Kasimba, a Himba chief, Namibia.

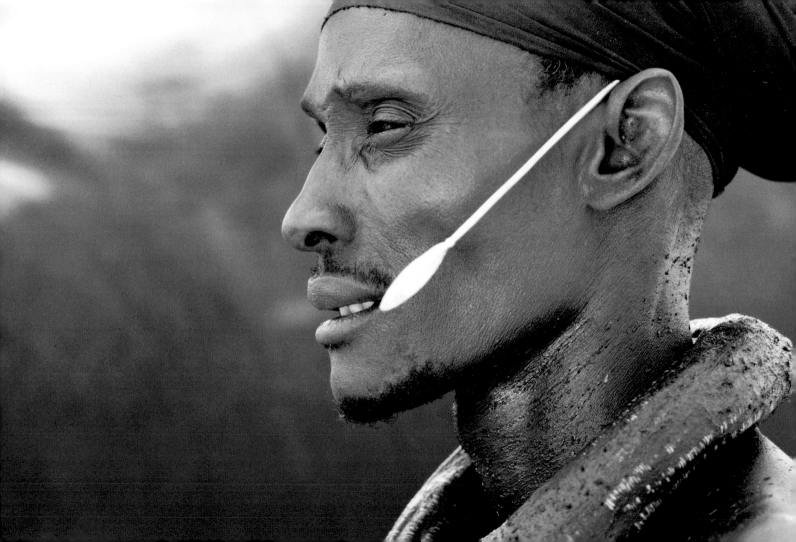

Mineral helps us to remember our purpose and gives us the means

to communicate and to make sense out of what others are saying.

—Central African griot

Pottery of the dead at the Bandiagara cliff-face, Mali.

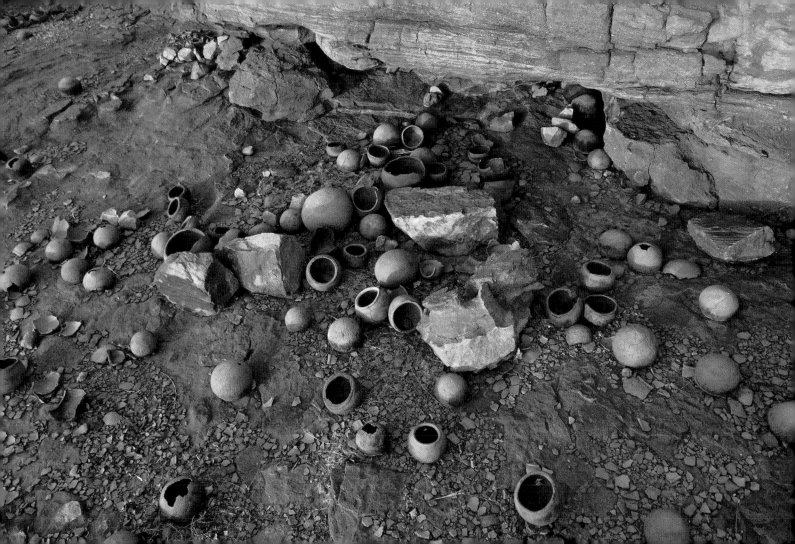

What man is noble?

He who is free, who is self-sufficient in food:

the farmer, for whom there is no intermediary between the land he tills and himself.

—Alassane Ndaw

Growing onions and tobacco, Dogon country, Mali.

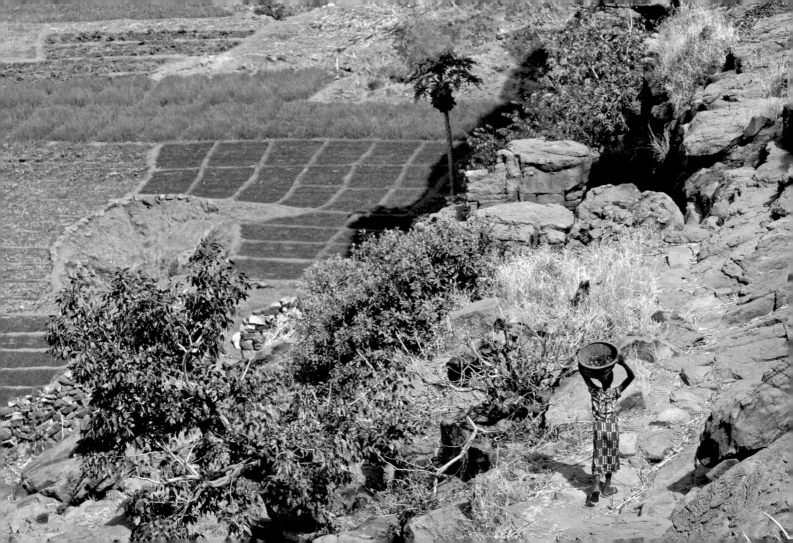

"You cannot do someone's hair when they're away"—No one can replace me unless I let them.

—*African oral tradition*

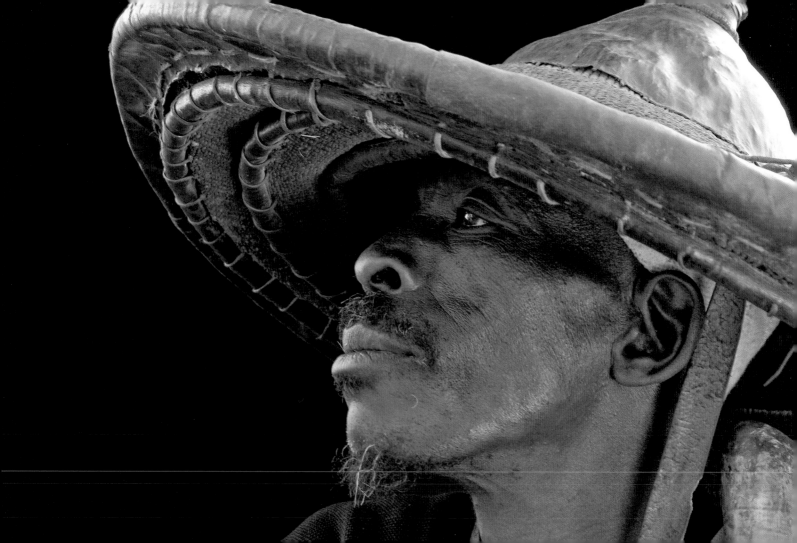

To engage in daily combat with yourself and win,

you need a strong project, strong ambition, and strong passion.

A good means of getting through is defiance, toward yourself and the world.

"By my own means, away from the tracks you have made, I will succeed.

Never mind the ambushes and traps, I will succeed."

—Irénée Guilane Dioh

A young Bushman hunting, Namibia.

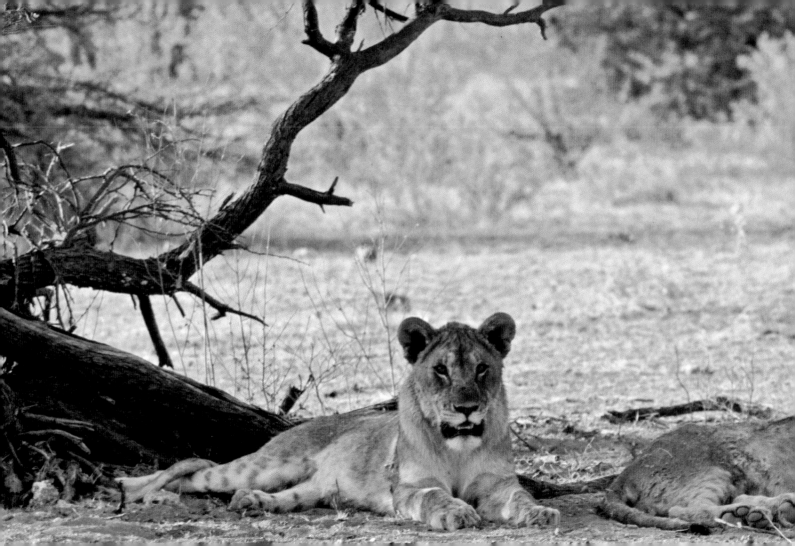

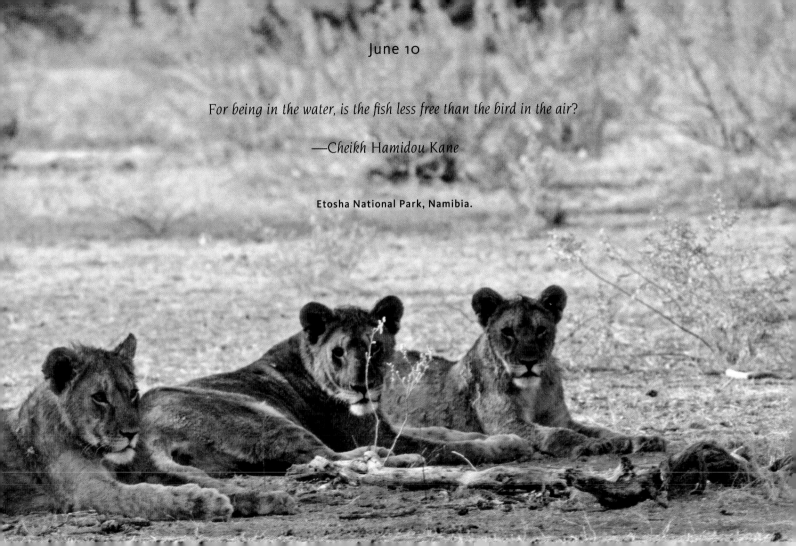

June 10

For being in the water, is the fish less free than the bird in the air?

—Cheikh Hamidou Kane

Etosha National Park, Namibia.

When *boys and girls share in the trials of their age, theirs is a sacred attachment.*

It becomes the tribe's vital bond.

—*Kikuyu witch doctor*

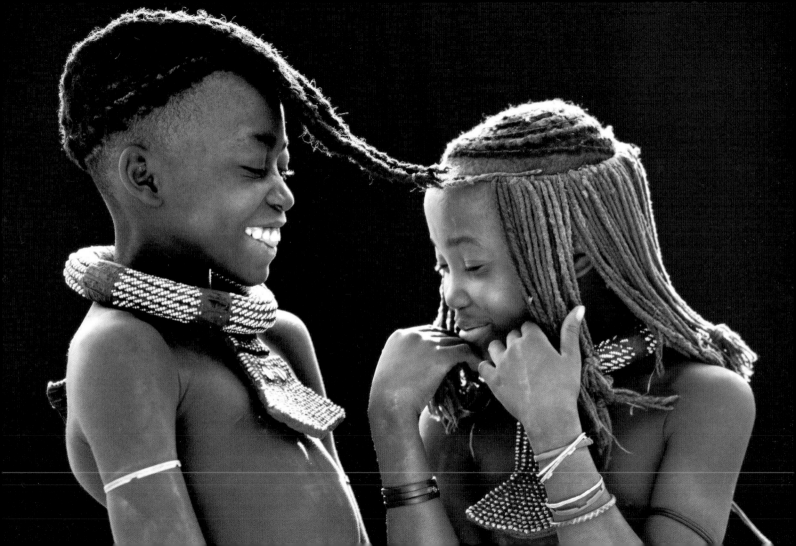

Rites of passage and initiation push people to surmount difficulties and harassments,

to overcome the loss of reference points caused by life's transitions,

and to master changes that are a source of anxiety.

—African oral tradition

Market day, Gorom Gorom, Burkina Faso.

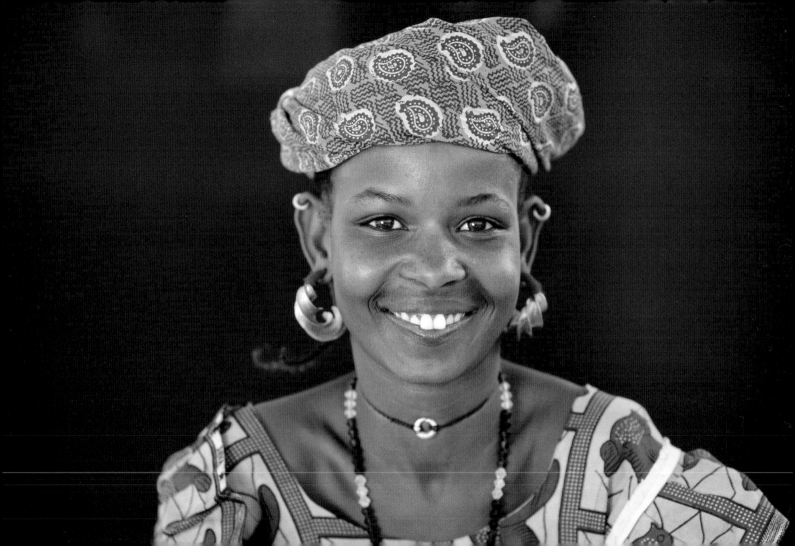

Initiation, by imposing a new order, until now virtually unknown,

establishes a cultural order, the rule of mankind, over the initial disorder of desire.

—African oral tradition

In front of a Himba hut, Namibia.

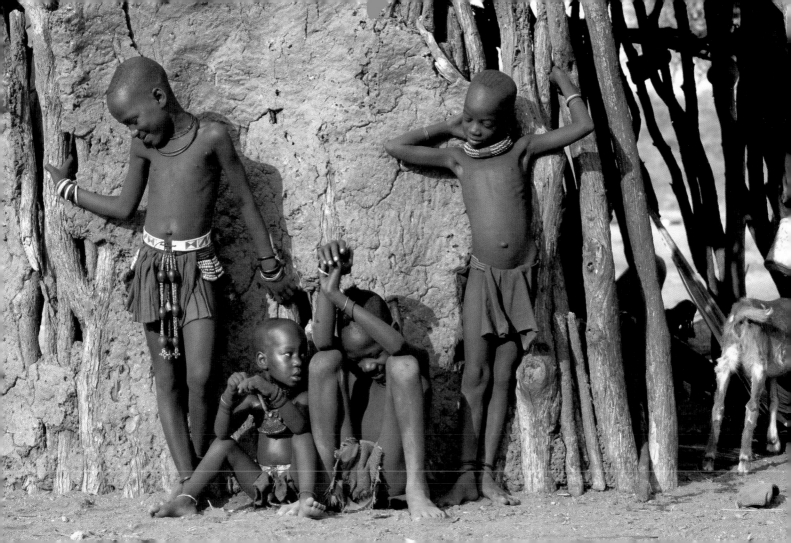

June 14

Ritual codifies, allies, affiliates, structures, and strengthens bonds,

creating community and therefore identity.

—Central African griot

Baqu, a young Bushman, Namibia.

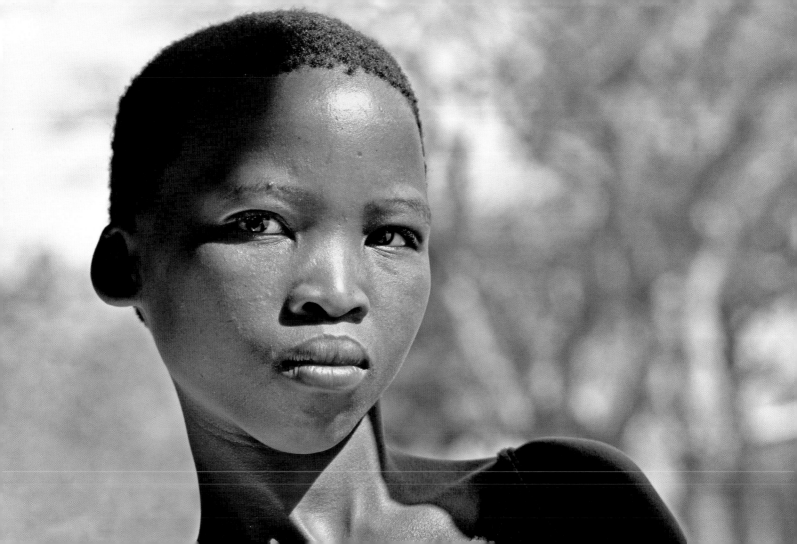

You, *my dear child,*

I can teach all about AIDS, but I cannot protect you from HIV.

I can tell you things, but I cannot be responsible for them.

I can advise you, but I cannot decide for you.

I can talk about drink and about drugs, but I cannot say no in your place.

I can teach you goodness, but I cannot give you morality.

I can teach you respect, but I cannot make you honorable.

I can pass on values, but I cannot make you moral.

I can give you love, but I cannot give you inner beauty.

I have given you life, but I cannot do your living for you.

—Abner Xoagub

Yemrehanna Krestos school, Ethiopia.

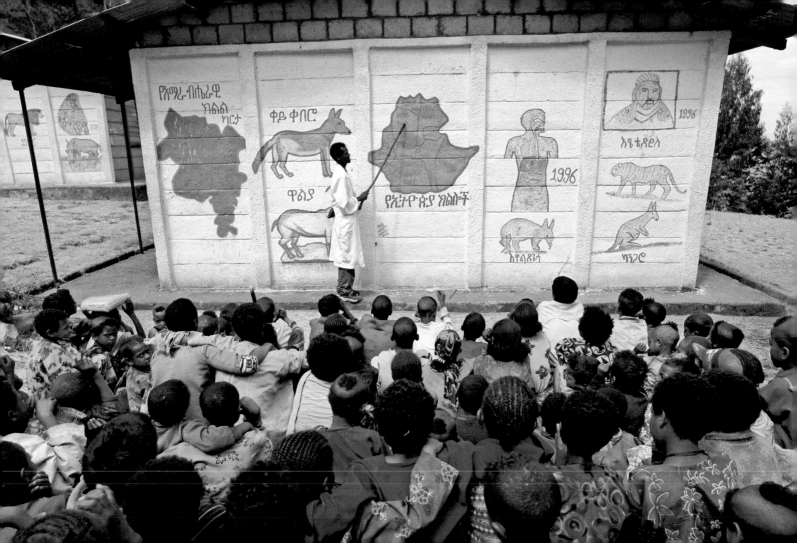

The acceptance of death is the highest point of the way of initiation.

The initiate accepts death that others may live. It is perhaps the greatest form of charity.

Man sometimes needs to know how to imitate the seed, which agrees to die that the plant may grow.

—West African oral tradition

Dogon Tourterail mask, which transmits news, Mali.

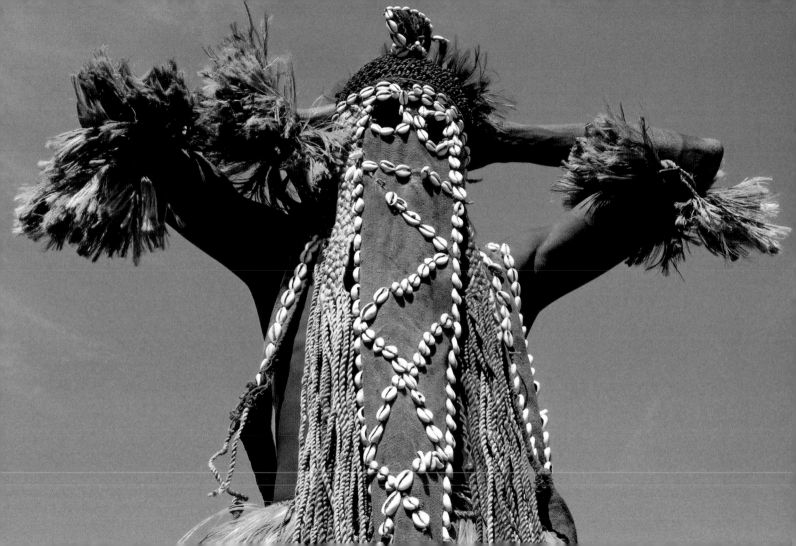

June 17

Rites of initiation teach youth on the verge of adulthood that death is a part of life and that without death there is no life.

—Alassane Ndaw

The Sossusvlei Dunes, Namibia.

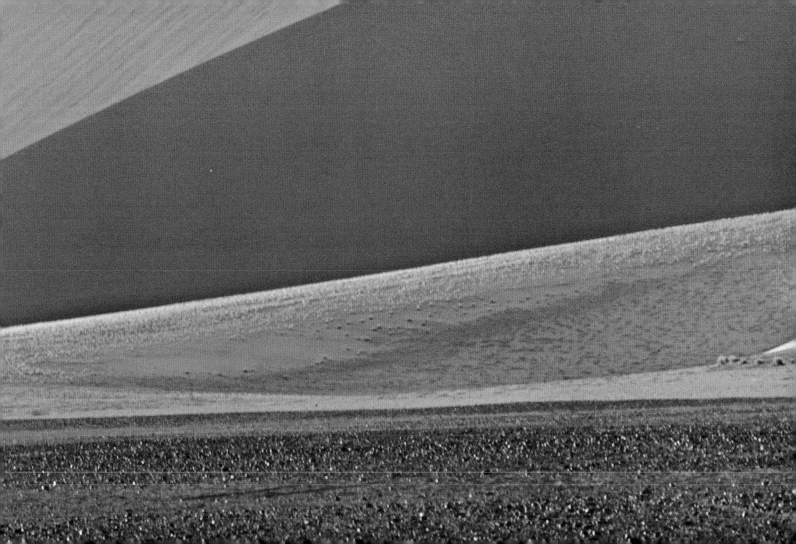

When the weaver lifts one foot, the other descends.

When one foot stops and the movement ceases, no more cloth is made.

His hands launch the shuttle: it goes from one hand to the other; no hand can ever keep hold of it.

As the action of the weaver, so is the union of opposites that weaves our life.

—Peul oral tradition

A Dogon weaver and his granddaughter, Mali.

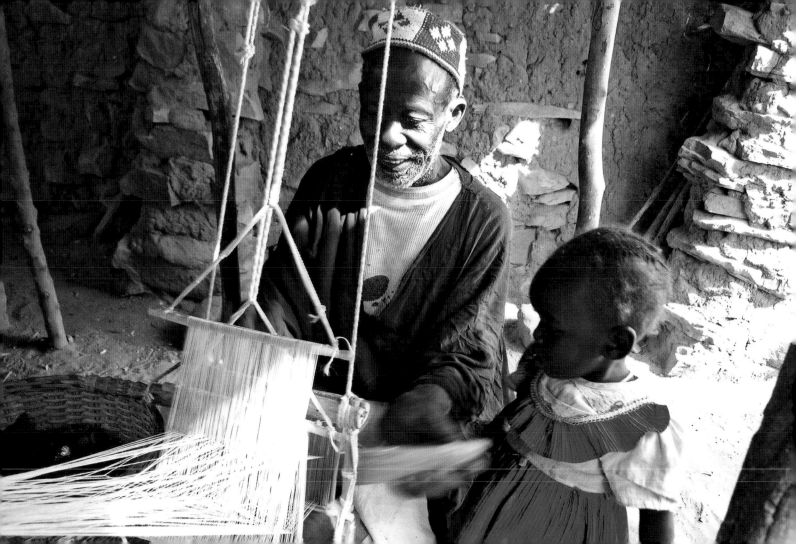

The Word is for everyone in this world;

it must come and go and be interchanged,

for it is good to give and to receive the forces of life.

—Dogon oral tradition

Karamata, a young Himba, Namibia.

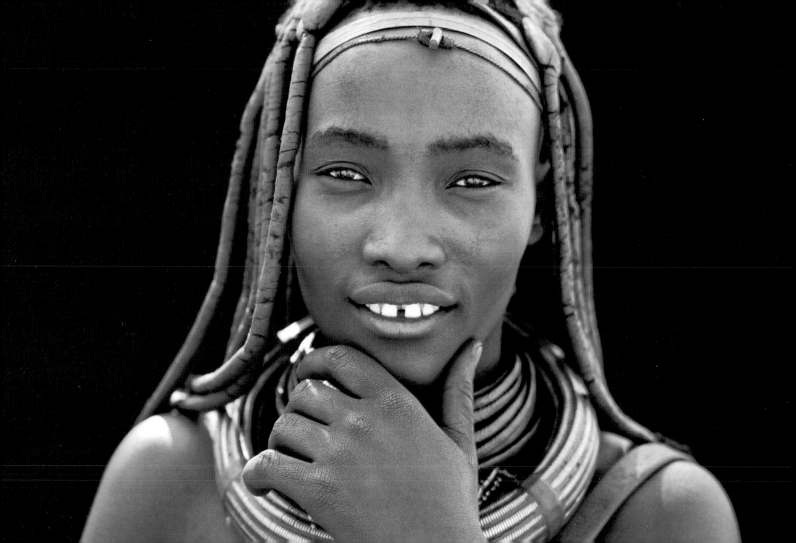

The effectiveness of the spoken word underlies every transformation, every generation, every conception.

"I broadcast throughout the world."

—Bernard Dadié

Rejoicing at a Timkat celebration, Ethiopia.

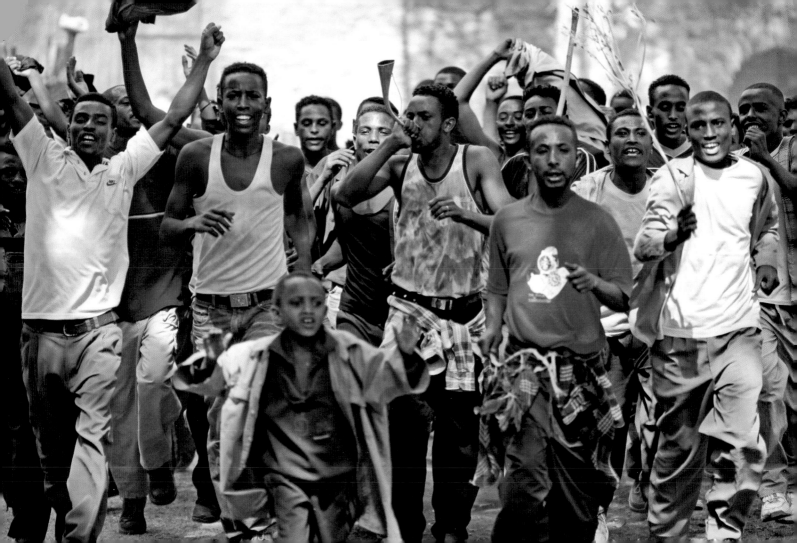

Keep a cool heart and remain patient.

Rushing through things at a gallop, we risk burying someone alive;

and a hasty tongue can ensnare us in troubles we cannot escape by flight.

—Ahmadou Kourouma

A young Malian student doing her schoolwork.

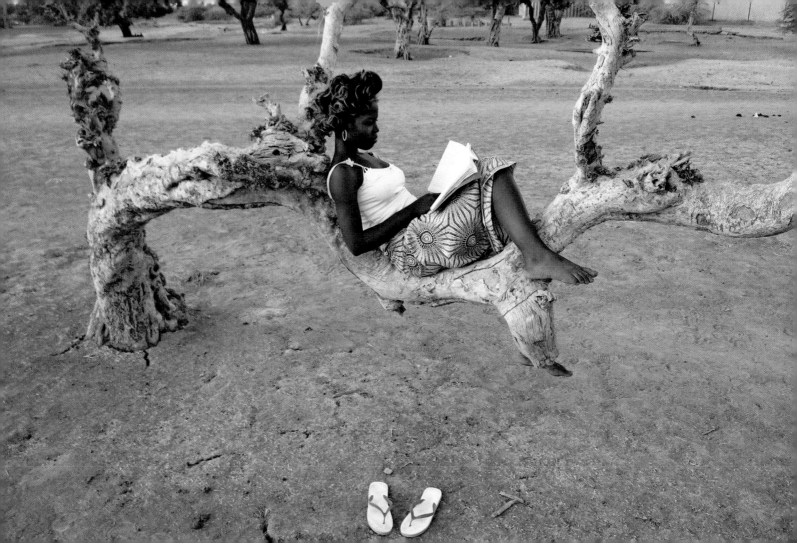

Claim your rights, and say no when things are not right for you.

—Ken Bugul

Dolo, 5 years old, Mali.

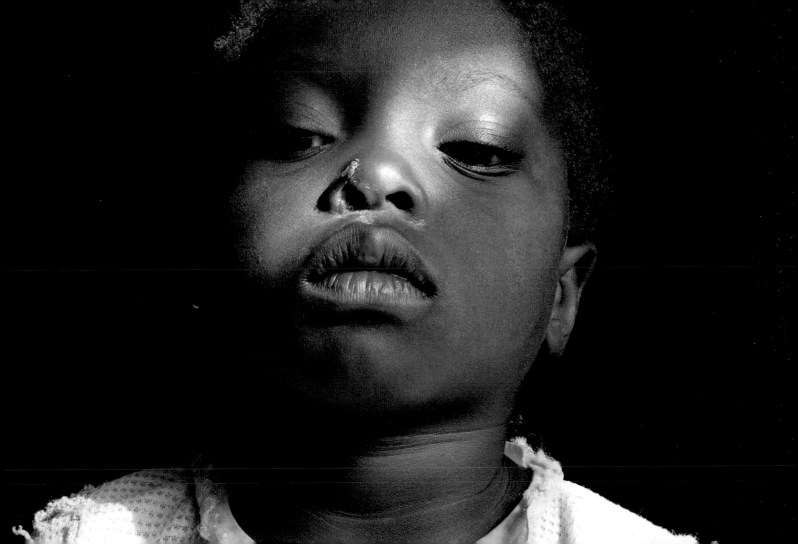

A day will come when you, too, must share your knowledge of things and people.

As the singular witness of a happening uniquely revealed to you, in words as yet unknown,

you will reveal to your brothers the ineffable wisdom of your heart.

—Irénée Guilane Dioh

In the hut of a gold-prospecting family, Burkina Faso.

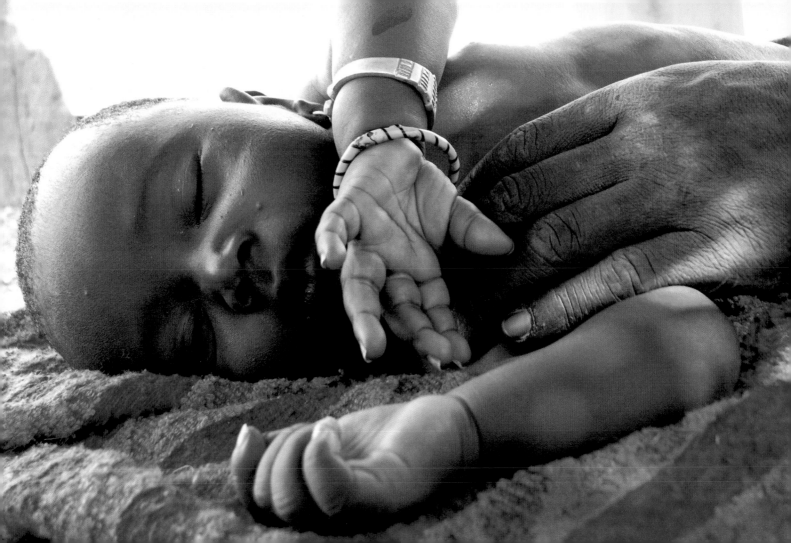

June 24

Every gesture reveals a creation that expresses us.

—West African female elder

Idrissa Guindo, a young Dogon, Mali.

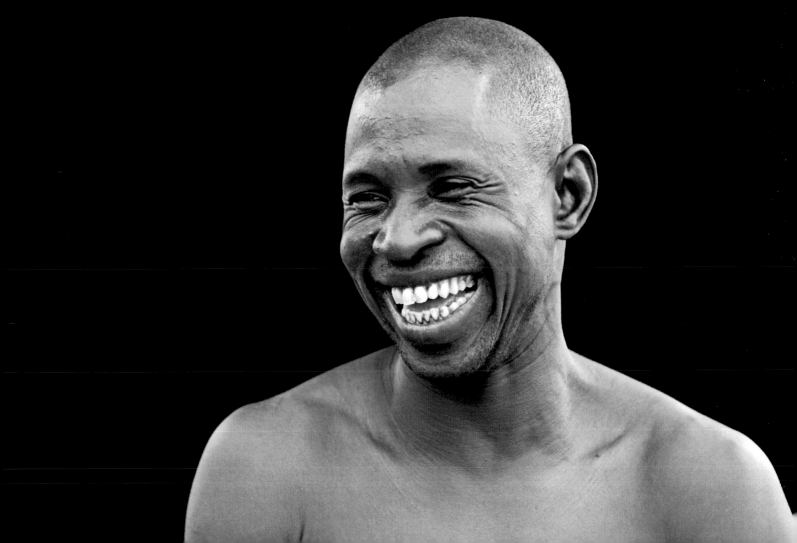

At every stage, one dies to oneself in order to be reborn into the Other:

into child, adolescent, adult, elder, Ancestor, God—to be reborn

wiser, stronger, lovelier, happier, because of being more.

—Alassane Ndaw

Kakitu, a young Himba, Namibia.

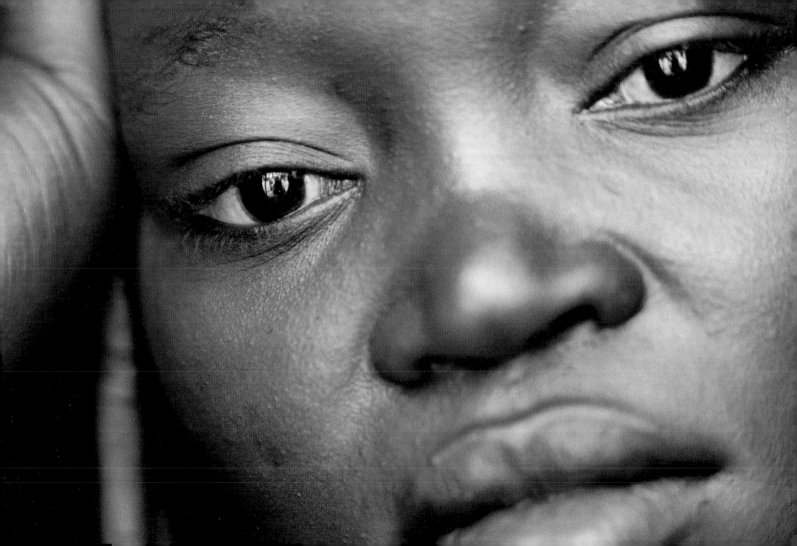

Practical education develops through ritual ceremonies in which art is created,

and builds the person in his or her fullness.

—Alassane Ndaw

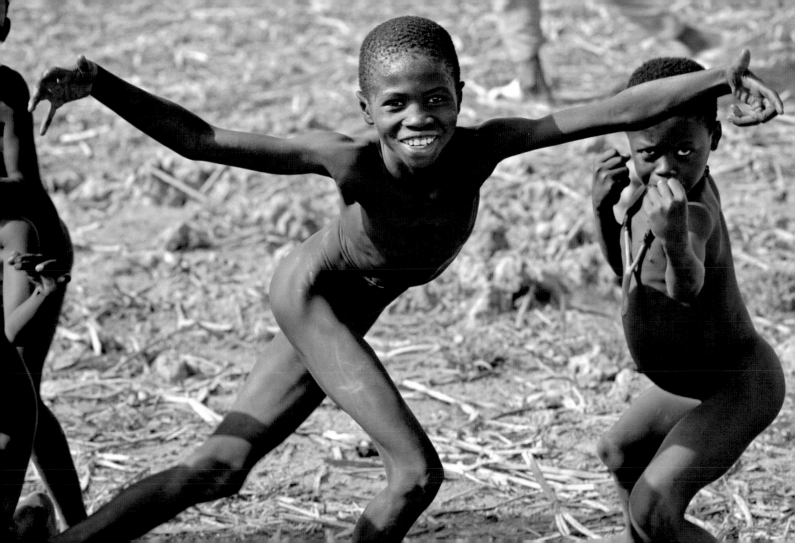

Chants, dances, and rhythms are the final stage; they are about vibration and vitality.

This stage is about the rhythmic imperative that shares in the cyclical organization of the world.

Dance, the mistress of vital movement, appeals for rain, love, fertility.

It is coincident with the conjunction of opposites;

it symbolizes creation, appeasement, preservation, destruction, reintegration.

It charms even the most fearsome wild animals, and allows grace to descend.

It enables release from material and spiritual limits.

—Cheikh Oumar Bâ

A surprise meeting, Namibia.

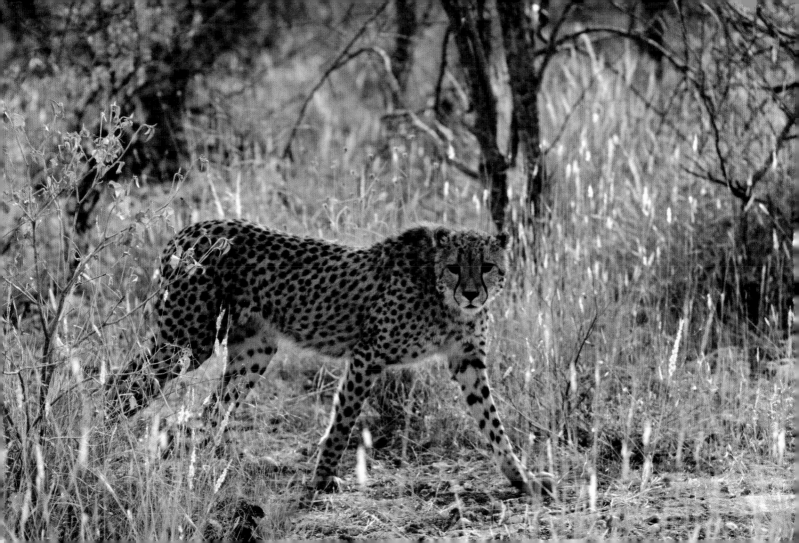

All morality is founded upon this concept:

namely, that what increases the life force is good, and what diminishes it is bad.

There are acts that must not be committed, because they diminish it, create disorder,

and destroy the social order as much as the human order.

—Alassane Ndaw

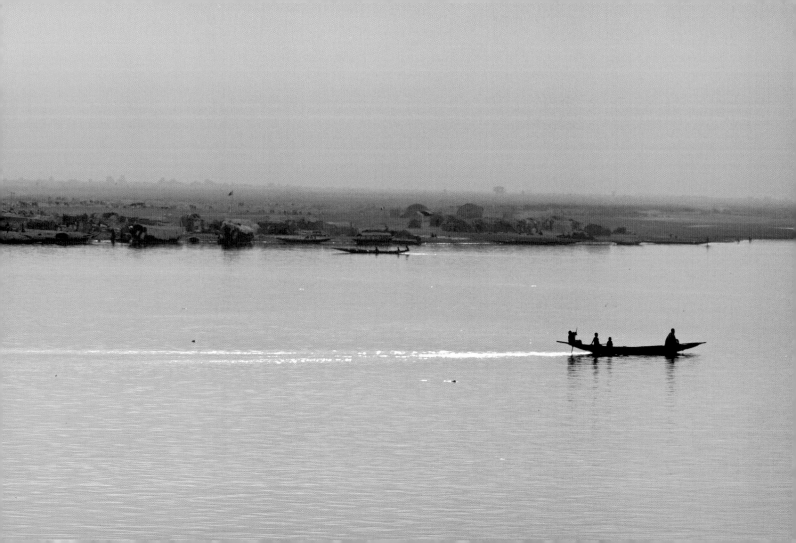

Fire is about dreaming, keeping our connection to the self and to the ancestors, and keeping our visions alive.

—Central African griot

Herd of cows by Lake Chad, Chad.

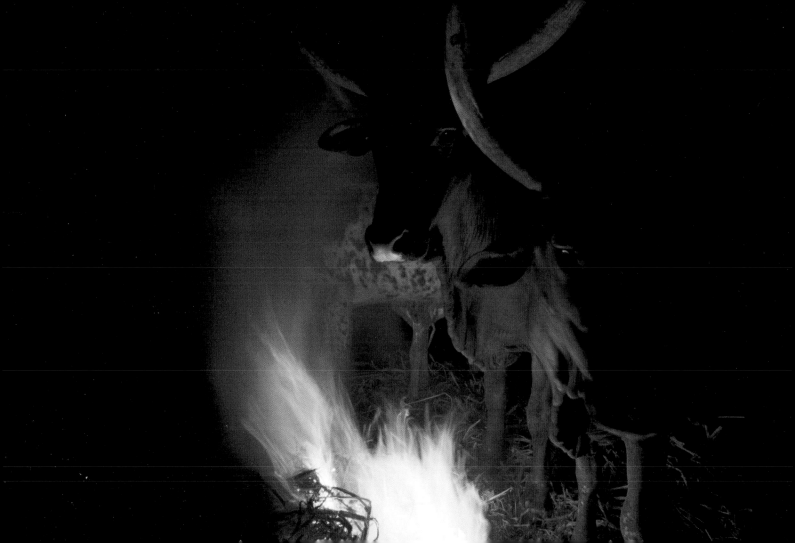

June 30

Exterior initiation consists of "eye-opening,"

meaning all the teaching given in the course of traditional ceremonies or the periods of retreat that follow.

Yet this teaching needs to be lived and assimilated;

it needs to bear fruit through the addition of personal observation, understanding, experience.

—African oral tradition

Amadi, 8 years old, Mali.

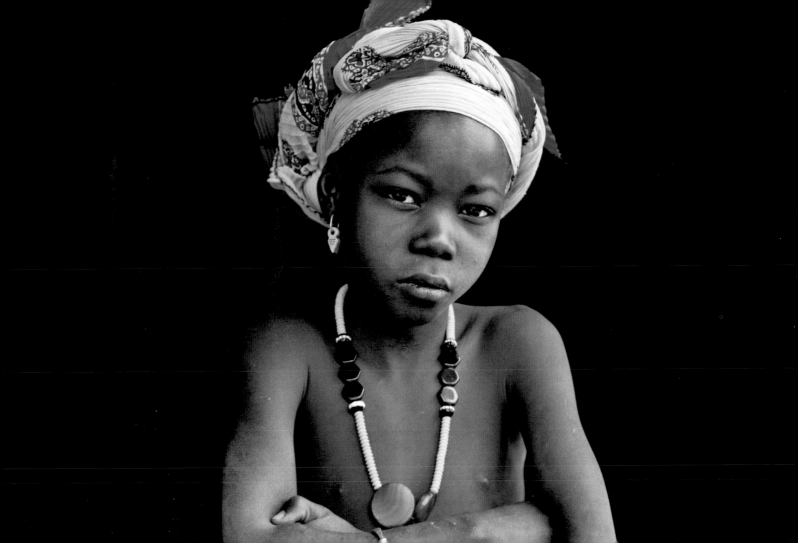

As in life itself, opposites coexist everywhere:

in social organization and in emotional life,

in the exchanges between individuals.

To live and actualize the contradiction,

that is the essential.

—Alassane Ndaw

A feast day, Senegal.

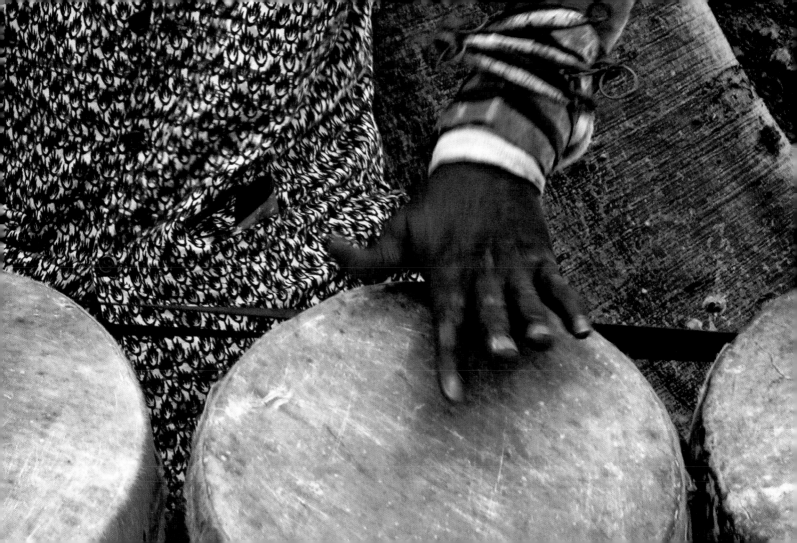

The cooperation of man and woman, in storing the seeds, sowing and growing the cotton,

has the same meaning as spinning and weaving, symbols of love.

—*Dogon oral tradition*

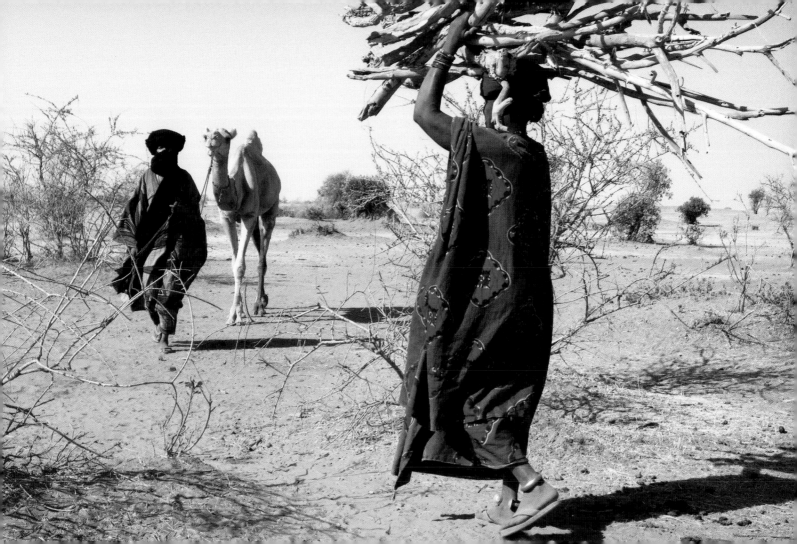

July 3

The relationship to others is the true basis of existence.

The Other is unavoidable.

The role of the Other, with whom people have always learned to live in community,

is so important that the question could be asked whether the sacred is the relationship with the Other or,

indeed, simply the Other itself.

But the sacred is preeminently the relationship with the Other that people have in regard

to what is identical in themselves, that is, their spirit.

We venerate in the Other, through our spirit, what we have in common,

what ultimately links us all.

—Dr. Raymond Johnson

Daouda, 10 years old, Mali.

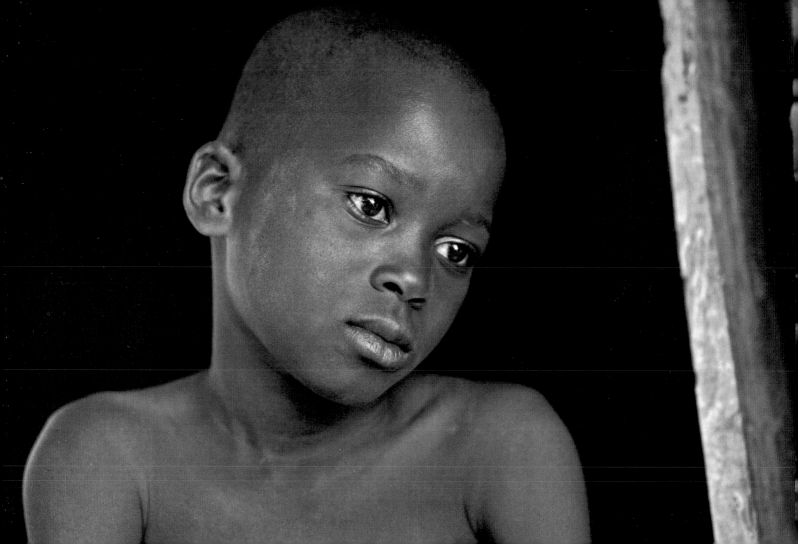

Dear white brother
When I was born, I was black,
When I grew up, I was black,
When I am in the sun, I am black,
When I am ill, I am black,
When I die, I shall be black,
Whereas you, white man,
When you were born, you were pink,
When you grew up, you were white,
When you are cold, you are blue,
When you are frightened, you are green,
When you are ill, you are yellow,
When you die, you will be grey.
So, of the two of us,
Which one is the man of color?

—African oral tradition

A young shepherdess from the Ennedi plateau, Chad.

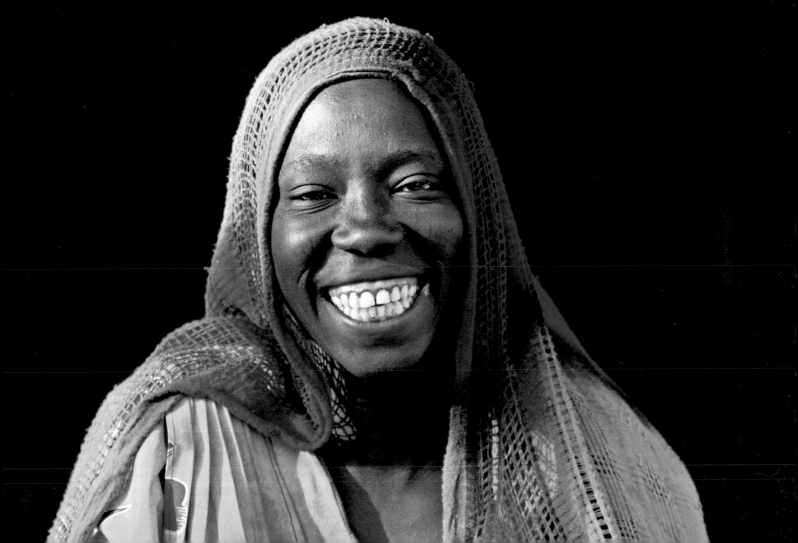

Intimacy in general terms is a song of spirit inviting two people to come and share their spirit together.

It is a song that no one can resist.

—Sobonfu Somé

Dikoré, 2 years old, Mali.

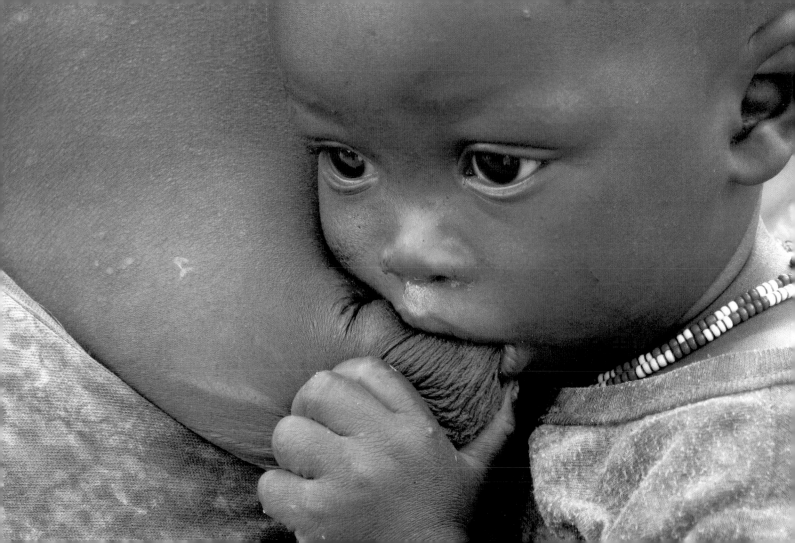

Every relationship is a gift of the spirit that seeks our gratitude and

our openness to listen to why the spirit has brought us together.

—Marie-Noëlle Anderson

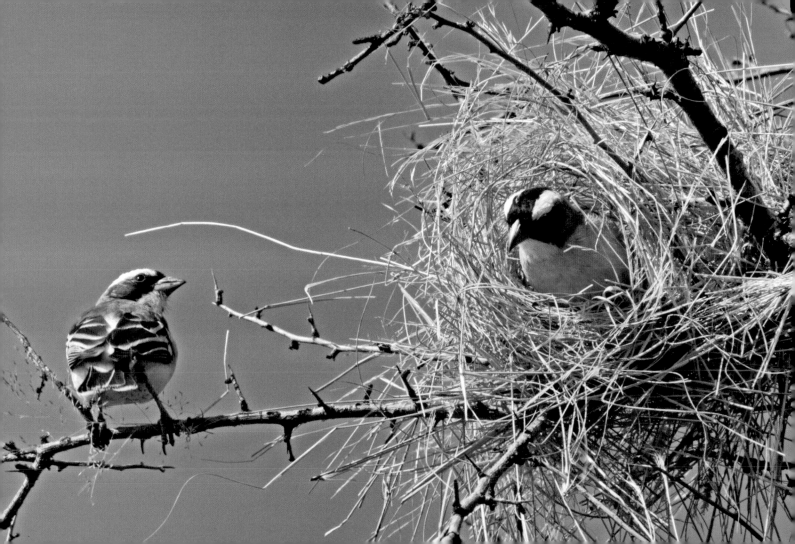

And I was speechless

Before the golden riddle of your smile. A brief twilight

Fell over your face, like a divine joke.

—Léopold Sédar Senghor

Karamata, a young Himba, Namibia.

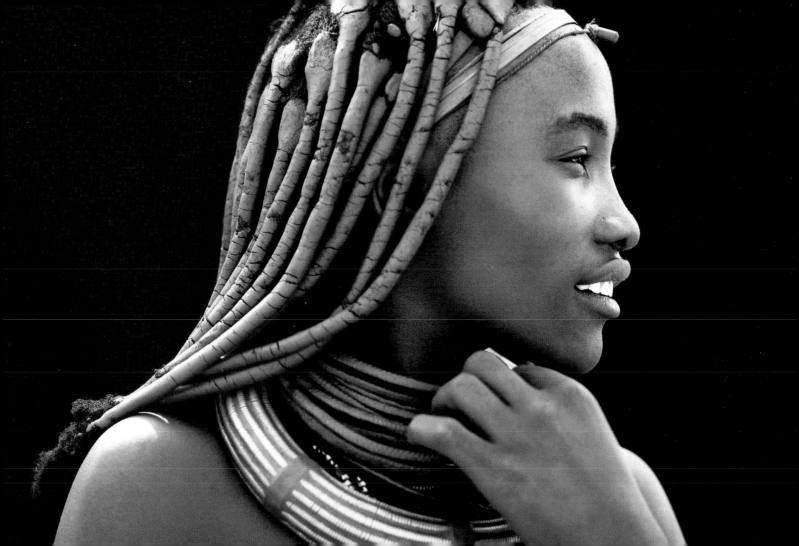

July 8

When we come together with another person,

we create a foundation that allows us to fulfill the life purpose with which we were born.

Our partner, if chosen well, will have been born to a purpose along the same path.

—Sobonfu Somé

At the Okaukuejo watering hole, Etosha, Namibia.

The spoken word is everything.

It cuts, it flays.

It models, it modulates.

It disturbs, it maddens.

It heals or kills outright.

It is louder or softer as willed.

It excites or calms souls.

—Bambara oral tradition

Djenne market, Mali.

The kind of passion, the kind of emotion and connection that Westerners look for from a romantic relationship,

village people look for from spirit.

—Sobonfu Somé

Twyfelfontein, Namibia.

Romantic love is an attraction that cuts off spirit and community.

—Sobonfu Somé

Mamy, a young Senegalese.

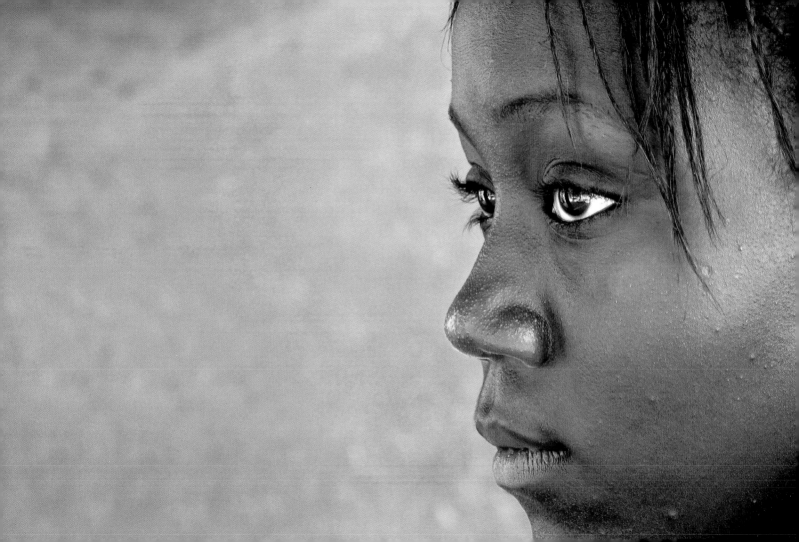

When we keep our crises private,

they grow fatter every day,

and then they start to strangle us.

—Sobonfu Somé

A goat pen, Namibia.

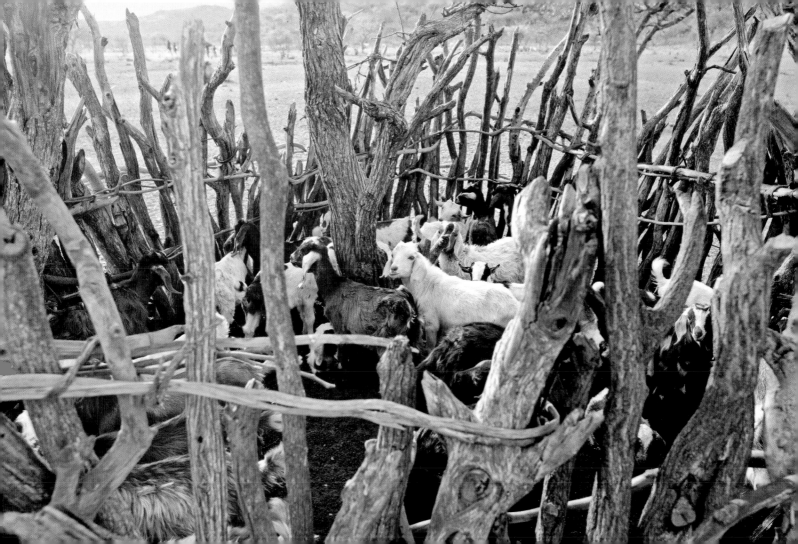

Modern culture, in its advertising of sex, is actually

in a misguided fashion advertising its longing for the sacred.

—Sobonfu Somé

Ageritu, a young Ethiopian Christian.

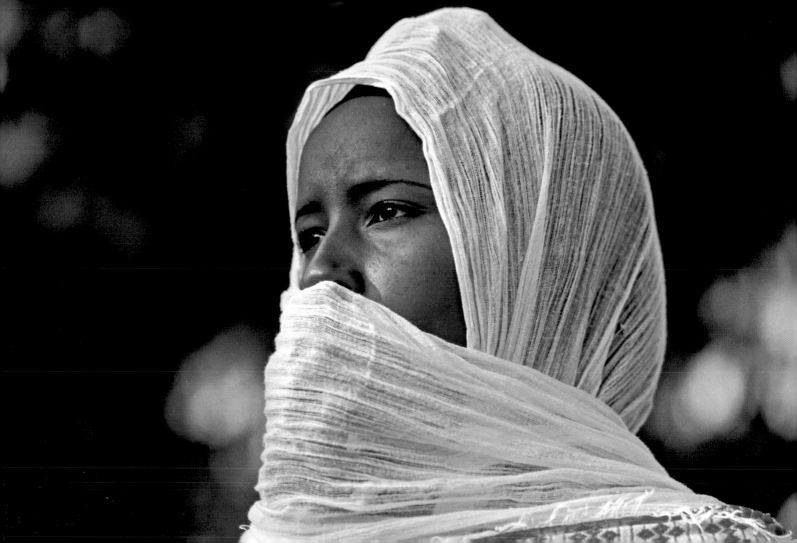

When people recognize that they are spirit in a human body and that other people are spirits,

they begin to understand that our bodies are sacred and that sexuality is far more than a means of pleasure;

it is a sacred act.

—Sobonfu Somé

Himba girl at the Epopa Falls, Namibia.

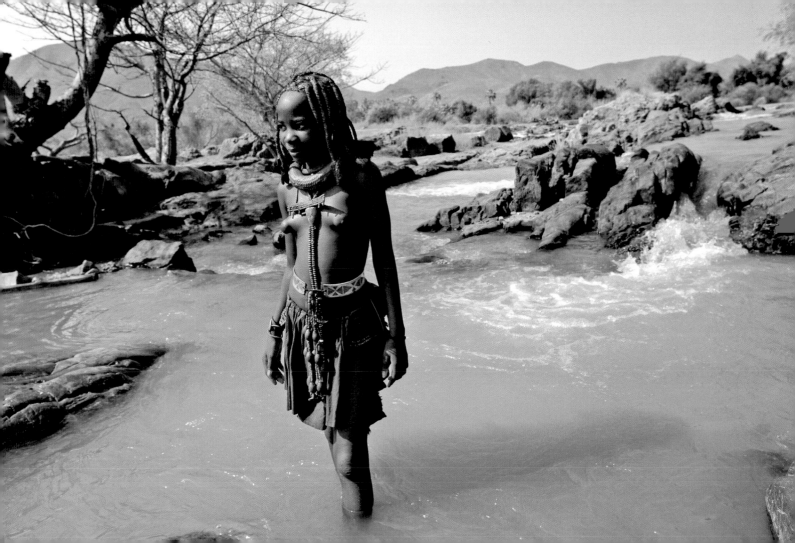

July 15

Look at the body

not as a source of physical attraction

but as a shrine.

—Sobonfu Somé

Makarukasa, a young Himba mother, Namibia.

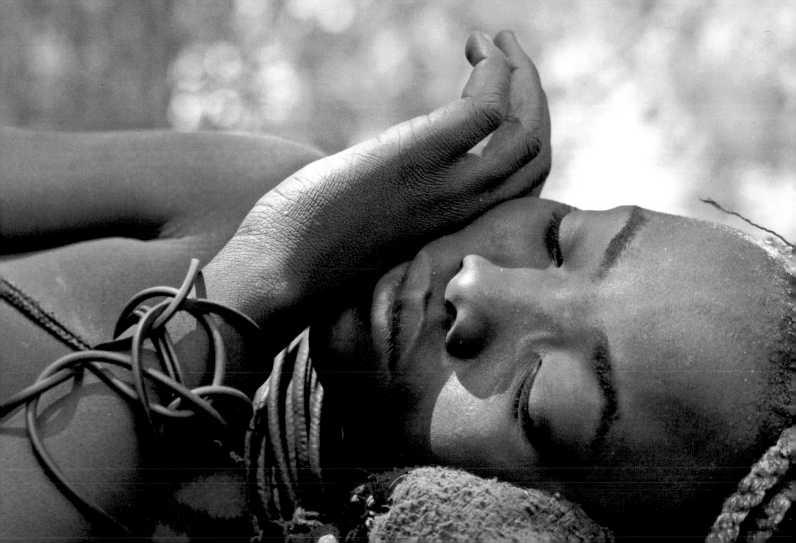

Marriage is a way of taking the call of the spirit further.

It brings two souls, two purposes, two worlds together,

and allows them to bring their gifts forward to benefit the community.

—Sobonfu Somé

Going to market at Djenne, Mali.

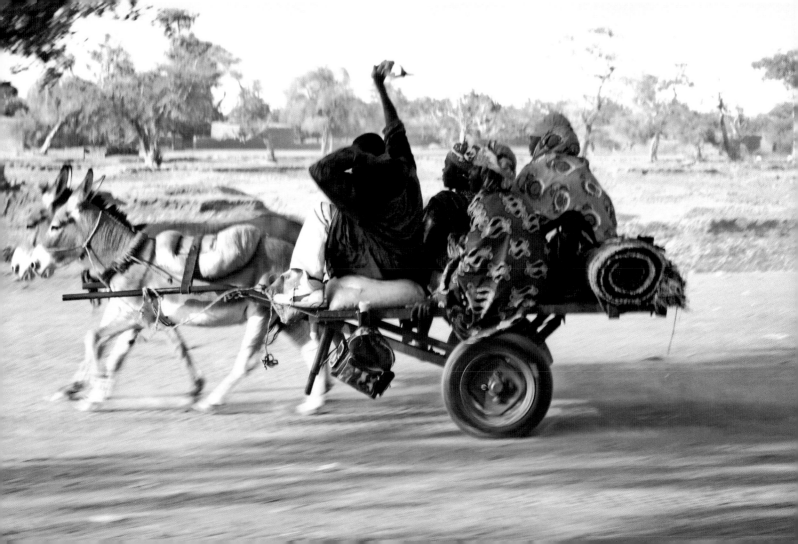

Marriage is not so much the creation of a couple as the joining of two or more lineages,

and its aim is their survival and expansion, together with the strengthening of their mutual links.

—Dr. Raymond Johnson

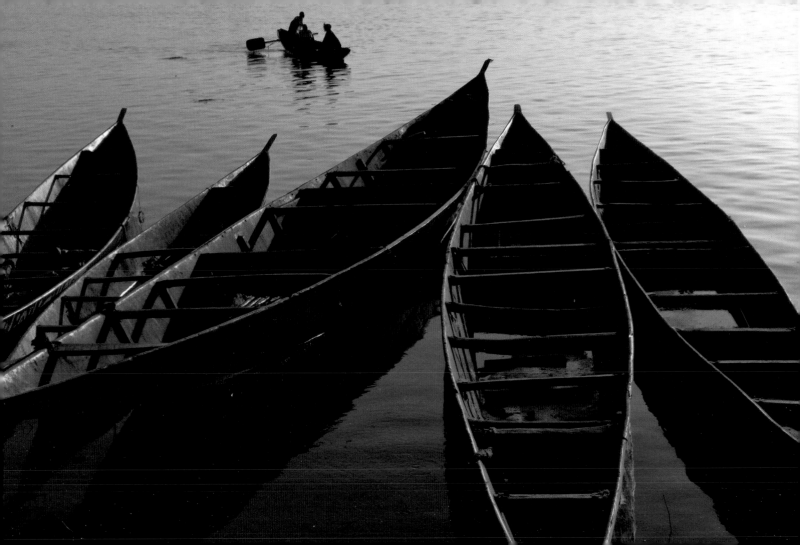

Marriage is two souls coming into one soul—still distinct but forming one entity.

It is a way of bringing two people's gifts together in order to strengthen them and make them even better.

It acknowledges that two people are embarking on something that is bigger than them and bigger than the tribe.

—Sobonfu Somé

Bota Mountain, Mali.

The ability of two people to discover each other must first be honored with a ritual thanksgiving to the spirit.

Because it is through spirit that two people manage to meet.

And these two people must find a way to ritualize their encounter and

give thanks to the very spirit that has brought them together.

—*Sobonfu Somé*

A Guro fetish, Ivory Coast.

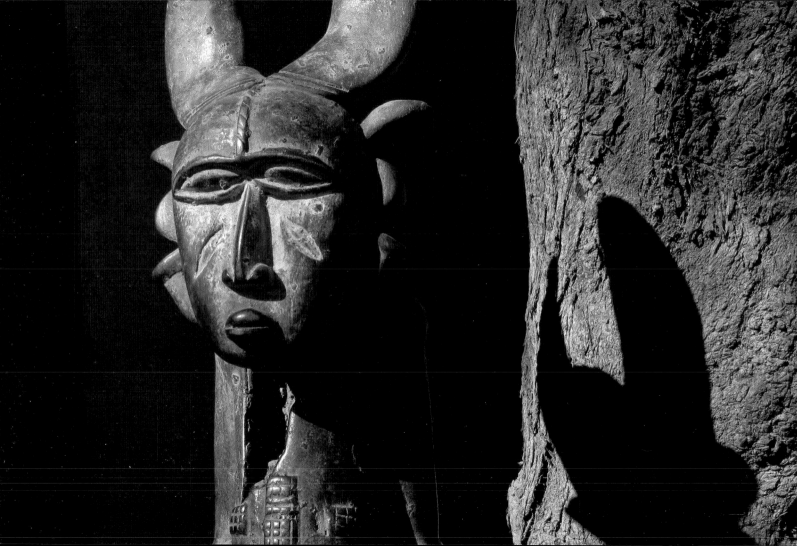

Delicacy of gestures attests to delicacy of feelings.

—*Young Peul bridegroom*

At the feast of Epiphany, Ethiopia.

Union is the essence of the individual, because it is everywhere in nature and in the cosmos.

The universe is a living unity; everything depends on and participates with everything else.

Just as the human race is an atom of that organism, so the individual is a cell of the social body.

—Alassane Ndaw

Nesra, in an Ethiopian tavern.

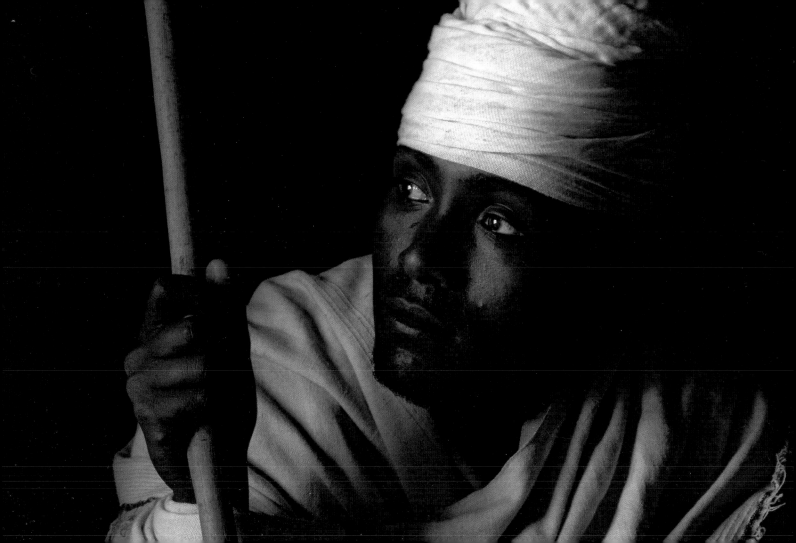

Ritual is not the sterile "repetition" of unchanging gestures, but the everlasting recommencement of something that is the same, yet indefinitely novel.

—African oral tradition

Morning tea among the Bushmen, Namibia.

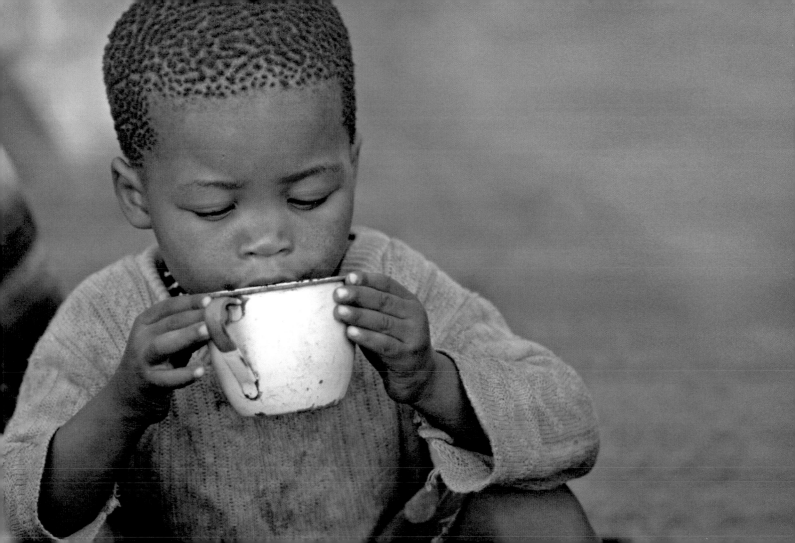

Mothers are there to grasp the inexplicable.

We are there to light up the darkness.

We are there to cosset when the lightning strikes and streaks across the night sky,

when the thunder shakes the ground, when the mud slides and swallows.

We are there to love without beginning or end.

—Mariama Bâ

A mother's fourth baby, Burkina Faso.

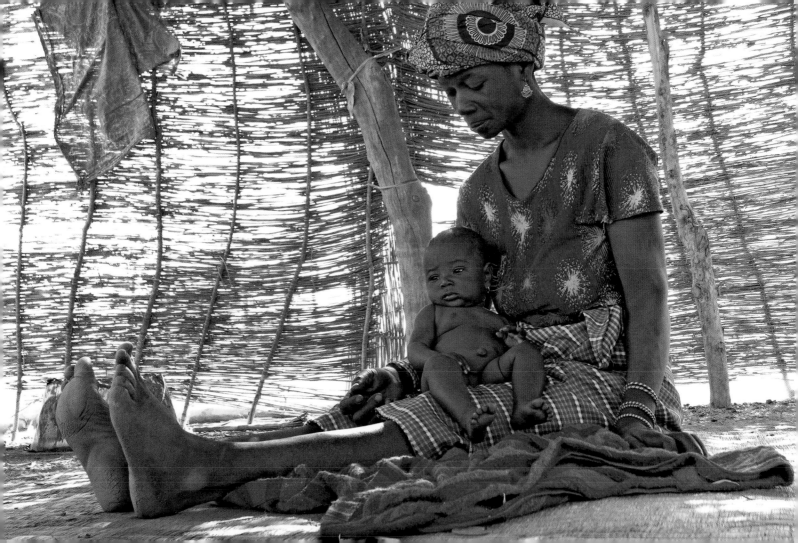

A *man lives again through his children,*

the trees that he has planted,

the words that he has uttered.

—*Massongo oral tradition*

Habiza, mother of ten children, Mali.

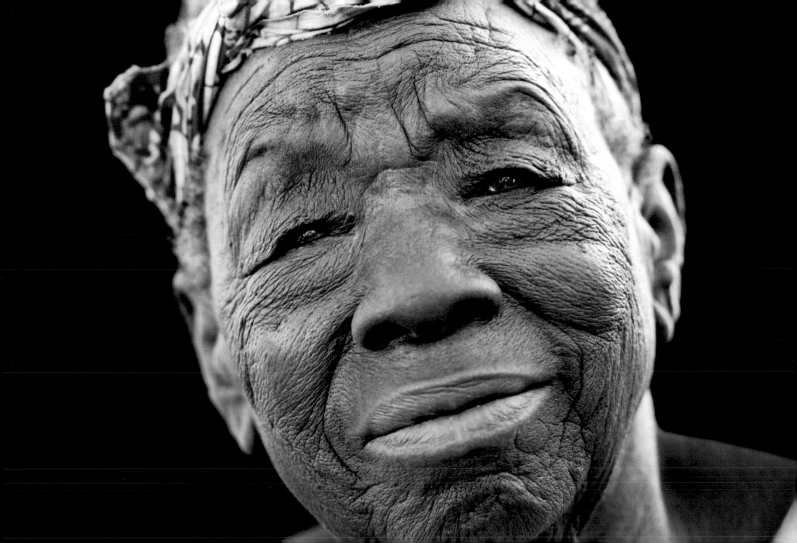

Fatherhood is more than just a fleeting act of procreation.

The father is the channel through which the life force, which originates everything, comes to the child;

the father is the intermediate link that joins the child to God;

he himself is blessed with a greater life force inasmuch as he is closer to the source of life.

To be a father is not simply to beget;

it is to go on giving life, to fertilize, to drive toward fulfillment: it is to go on and on transmitting existence.

—Alassane Ndaw

Peul shepherd at Gorom Gorom market, Burkina Faso.

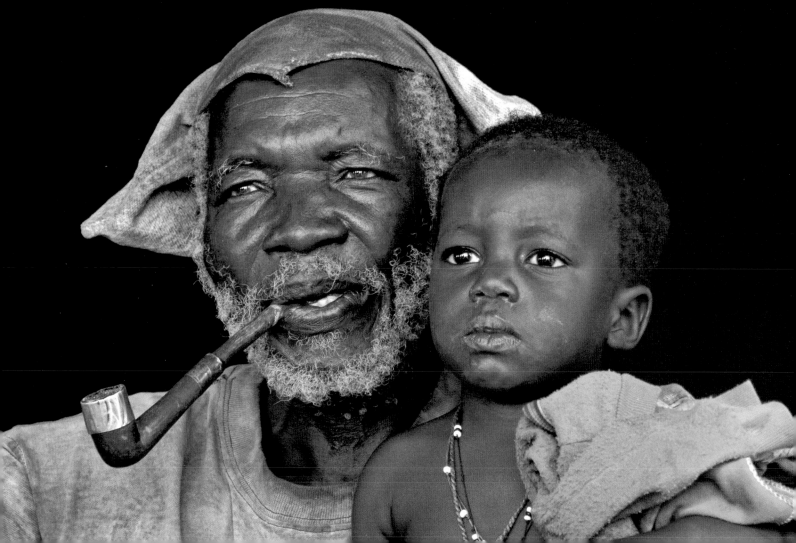

With the family, the father has more life force than the son, and the eldest has more life force than the youngest.

And chiefs must have a life force that makes them the guardians of the safety of their villages.

—Alassane Ndaw

An unexpected encounter, Namibia.

Marriage and fatherhood enable a man to contribute to the good of the community;

but he is not permitted to take part in government of the tribe until his children are adolescent.

By then, experience will have given him true maturity, qualifying him to administer the community's interests

with wisdom, intelligence, and equity, just as he will have done on a smaller scale within the family group.

—Jomo Kenyatta

Guegnemo Kassogue initiates children into the society of masks in Dogon country, Mali.

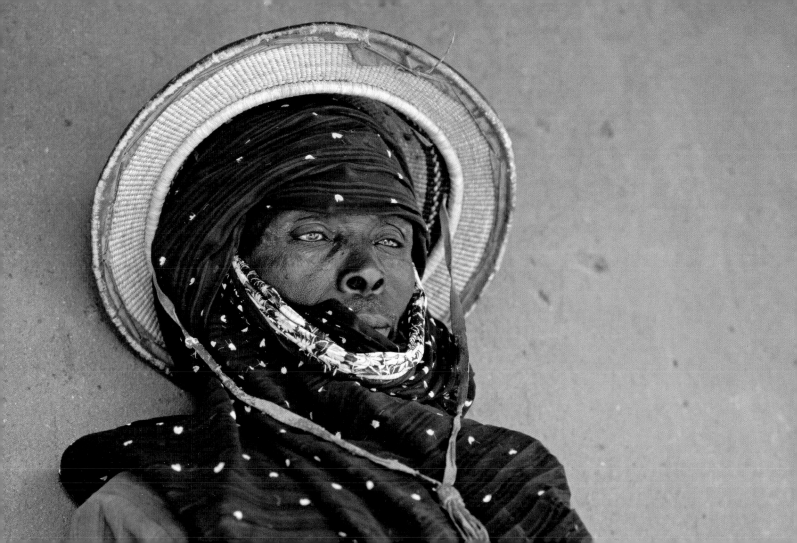

Without the community, the individual is left without a place where he can contribute.

The community is that grounding place where people come and share their gifts and receive them from others.

—Sobonfu Somé

The sorghum granaries, Burkina Faso.

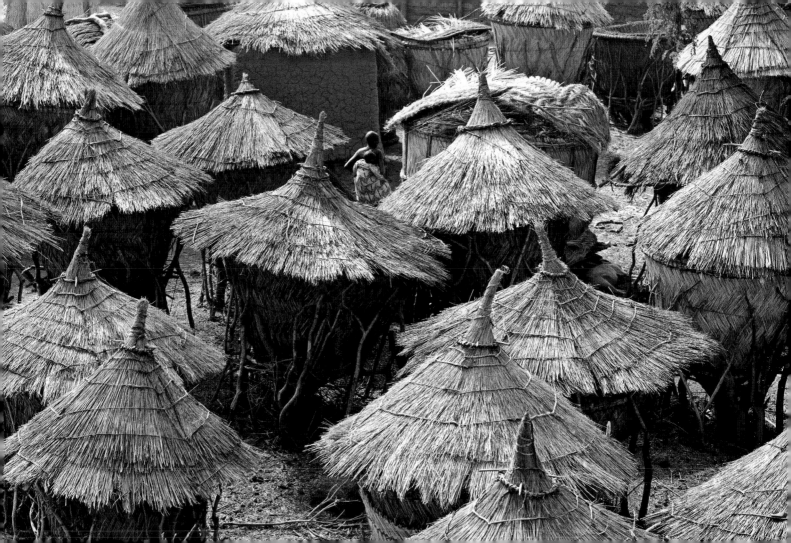

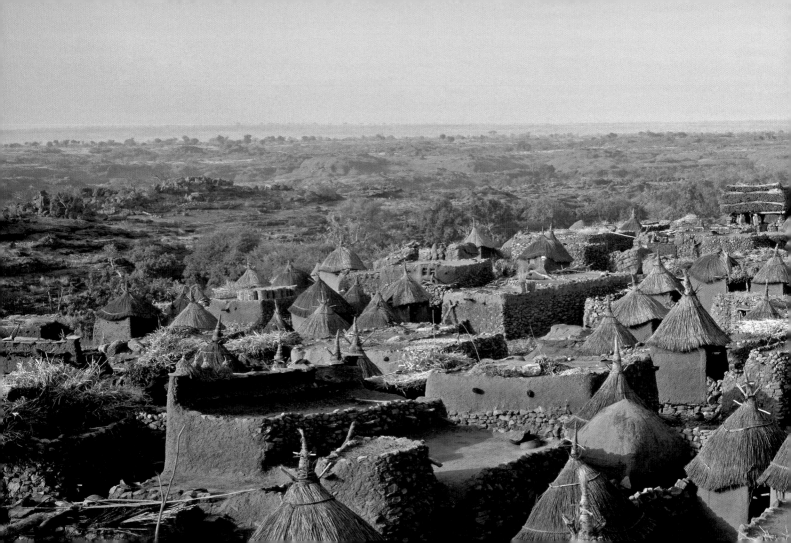

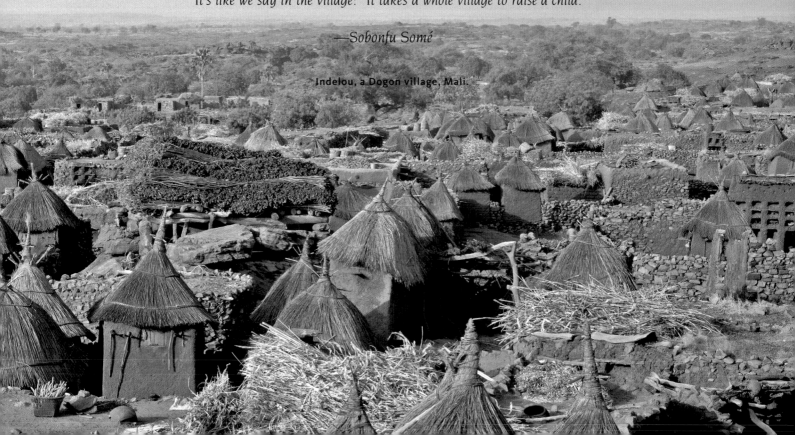

July 29

In raising children, we definitely need the support of other people.

It's like we say in the village: "It takes a whole village to raise a child."

—Sobonfu Somé

Indelou, a Dogon village, Mali.

People come together because there is a strong moment that binds them.

And that strong moment must be held, so that in the midst of crisis it can be one's principal ally.

—Sobonfu Somé

Gennete Maryam church, Ethiopia.

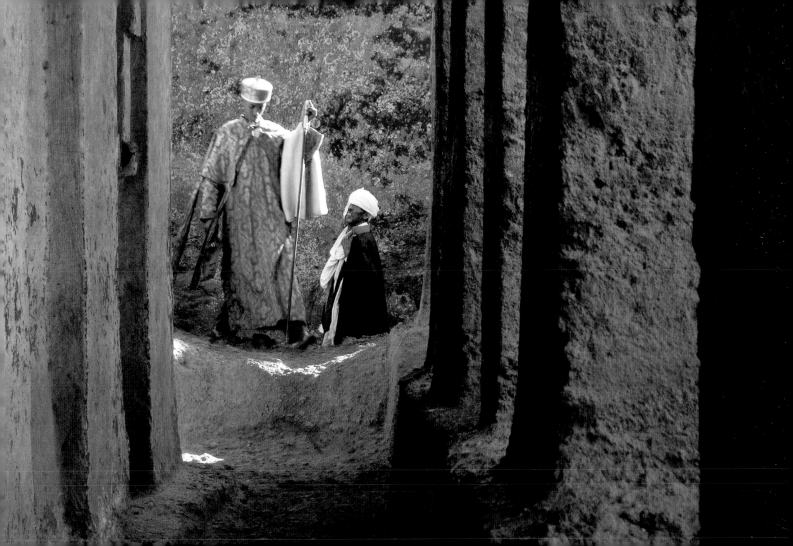

When two people live together, they don't necessarily always see each other's good qualities.

Somebody else often has a better eye.

—*Sobonfu Somé*

In an Ethiopian tavern.

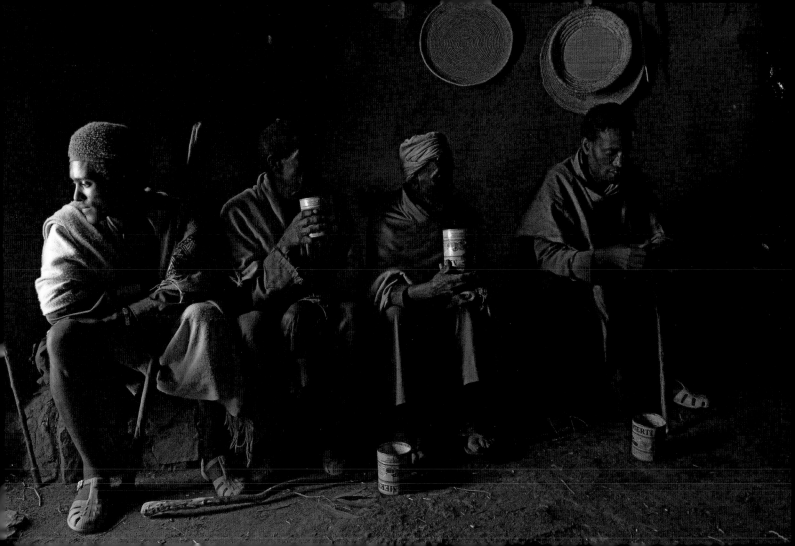

When we don't listen to the little things happening around us, we end up having huge earthquakes.

—Sobonfu Somé

Returning from market, Chad.

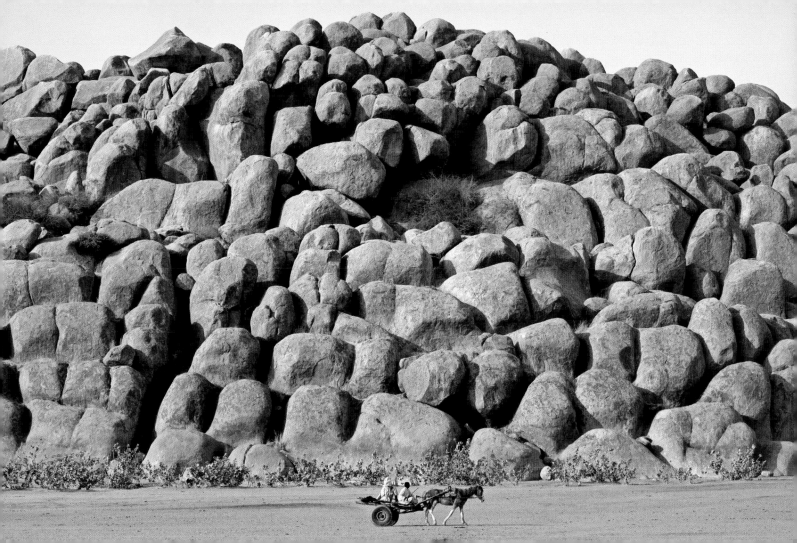

Romance means hiding our true self in order to gain acceptance.

It begins with doing every little thing for our partner, neglecting our true feelings,

until we reach a point of serious depletion.

—Sobonfu Somé

A young Ethiopian on a feast day.

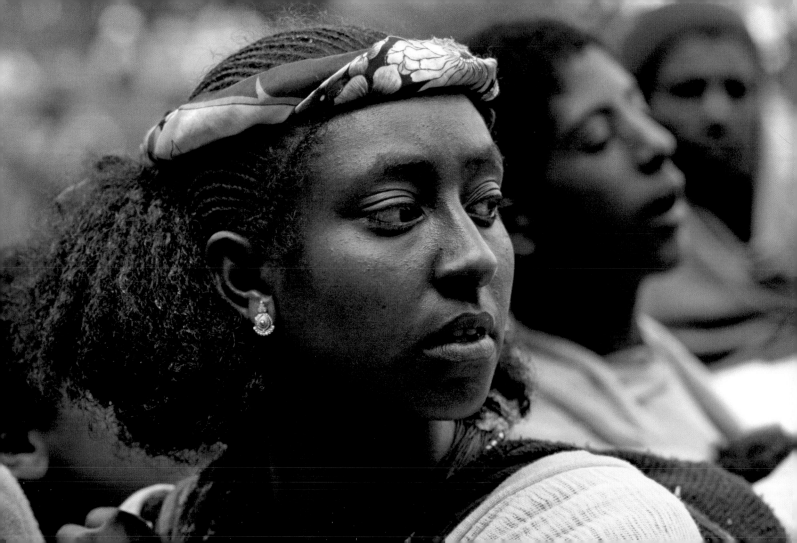

In sacred matters such as relationships, how free are we when we cannot build the kind of relationship we want?

—Sobonfu Somé

A feast day, Ethiopia.

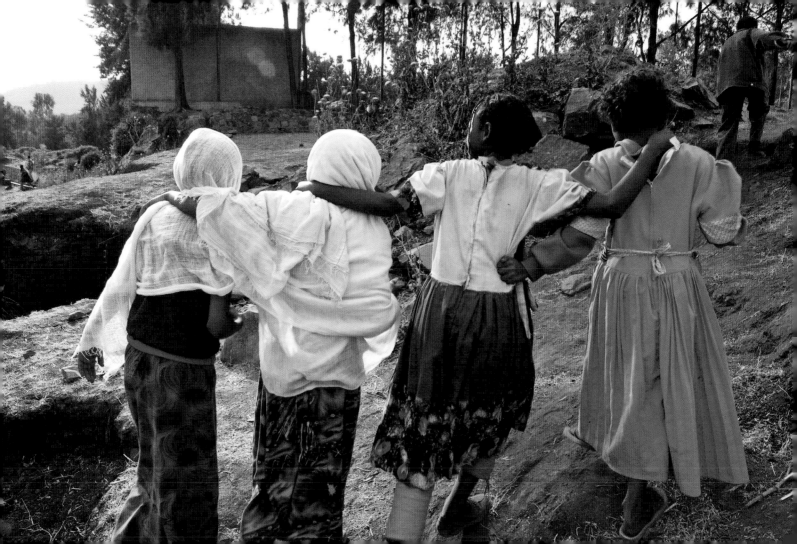

Before we can communicate in deeper states of intimacy,

we must address the subtle things that our partner has done that we didn't like.

Because of some rule of gentility, we tend not to respond to them and they pile up.

Our thoughts take us to places of uncertainty and the postponement of confrontation,

and then we become very passive. It is fine to be polite,

but where is the place for us to speak our frustration and disappointment?

—Sobonfu Somé

Prayers during the Timkat ceremony, Ethiopia.

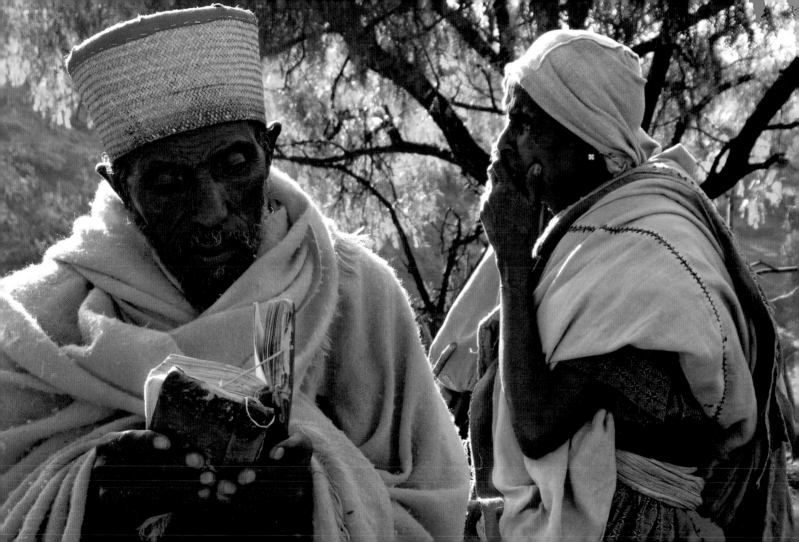

August 5

When the sea is raging, it reflects the passions
and emotions that agitate our own inner world;
we need to learn first how to recognize them,
and then how to control them. It is a world of
intoxicating highs and headspinning descents.
Without a sure guide or a reliable means of
passage, we are exposed to grave perils.

—West African griot

The cold waters of the western coast of Namibia.

Creating a ritual space to release tensions helps us to be open to our partner's concerns,

and it creates in us an ear that can listen without being defensive.

—Sobonfu Somé

Prayer book in an Ethiopian church.

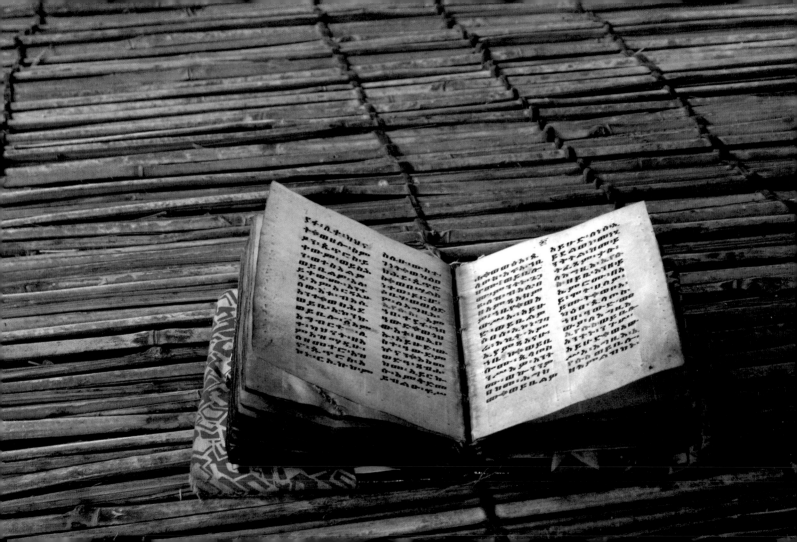

It is common for the originator of a benefit to forget his good act, and that is fine.

What is damnable and unspeakable is for the beneficiary of that good act to forget it.

—Amadou Hampâté Bâ

A young Himba mother and her first child, Namibia.

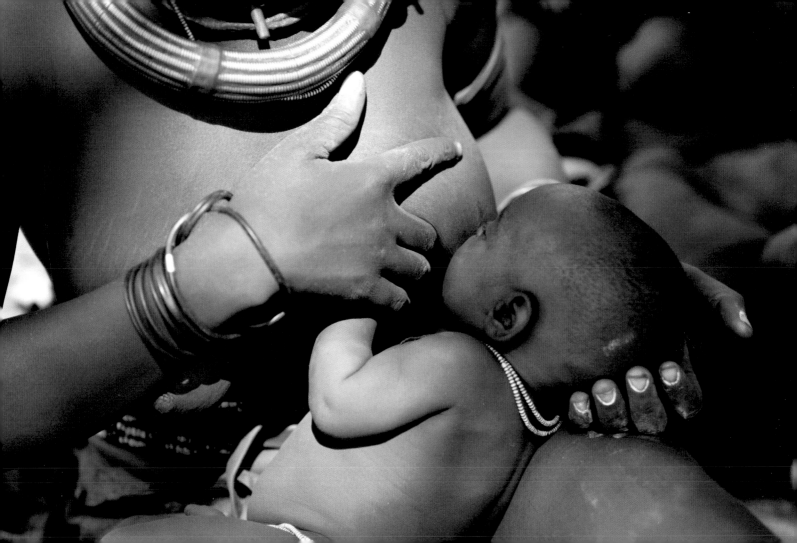

I should not reject a stick that has accompanied me for another, more finely carved, found in the afternoon,

for the first already contains a part of my history.

—*Female elder in a Dogon village*

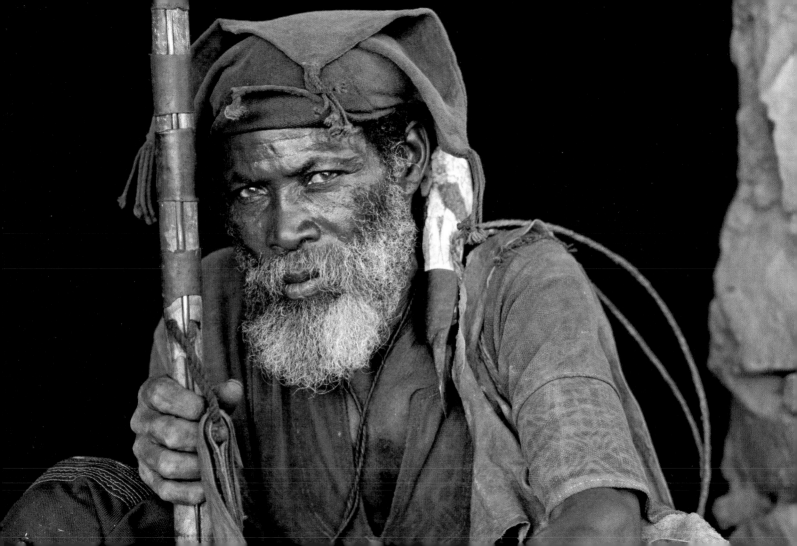

When problems arise, we tend to forget about the strong foundation we have in our relationship.

Remember where and when you and your partner felt the strongest, the closest, and the most intimate.

When you are at the lowest point of your relationship, you can have that as a frame of reference.

—Sobonfu Somé

A hunters' dance on the Dogon plateau, Mali.

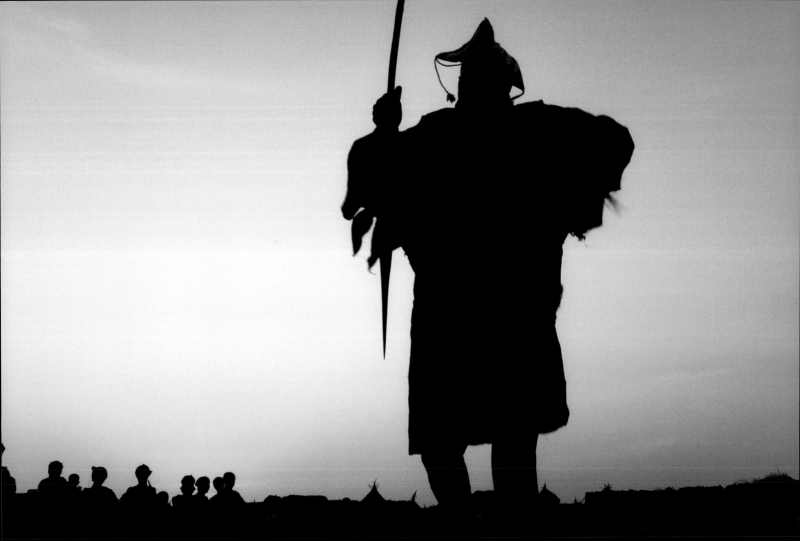

We might think that the confusion we experience in our daily life happens in isolation,

but in reality it has something to do with our lack of connection to our ancestors.

—Sobonfu Somé

A family Timkat celebration, Ethiopia.

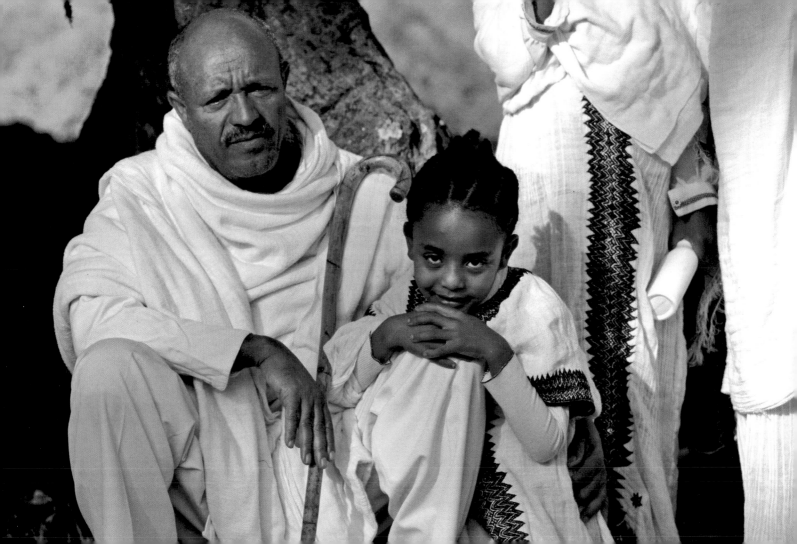

To keep a marriage healthy, the first thing is to honor the relationship itself.

Come to it as something led by spirit.

The next step is to acknowledge each other's soul,

acknowledge each other not just as human beings

but as spirits who have chosen a body to come into.

Then, through ritual, bring these two souls together.

—Sobonfu Somé

A young Peul shepherdess mother, Burkina Faso.

Happiness is not acquired;

it does not consist in appearances.

We each have to build it during every moment

of our lives, working through our hearts.

—Female elder in a Dogon village

An encampment of Peul shepherdesses, Burkina Faso.

Select a place where you can build a shrine and light candles.

Take ash, and make a circle as big as you think it needs to be.

You can use that special place to draw energy from, especially when things become hard.

You can go back to that source,

access the time before problems came,

and really draw energy from that.

—*Sobonfu Somé*

Morning prayer before the church of Ura Kidane Mehret, Ethiopia.

Water is peace, focus, wisdom, and reconciliation,

the state of peace we would like to have in our life.

—West African griot

Fishermen on Lake Chad, Chad.

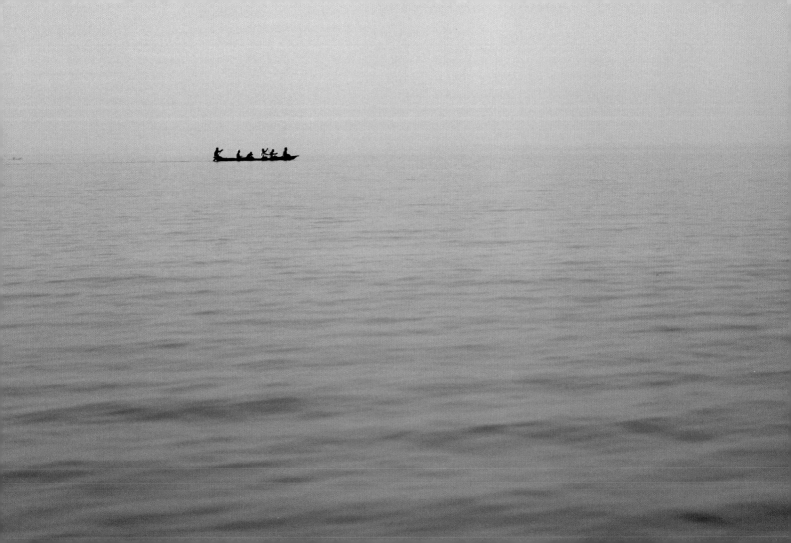

When you don't have a community of friends and family involved in a relationship,

it makes you base all your intimate expectations on your marriage.

And that is really hard; that is too much to ask of any one relationship.

Of course, your partner is your friend and family,

but to receive everything from that person is absolutely impossible.

—Sobonfu Somé

A Herero family, Namibia.

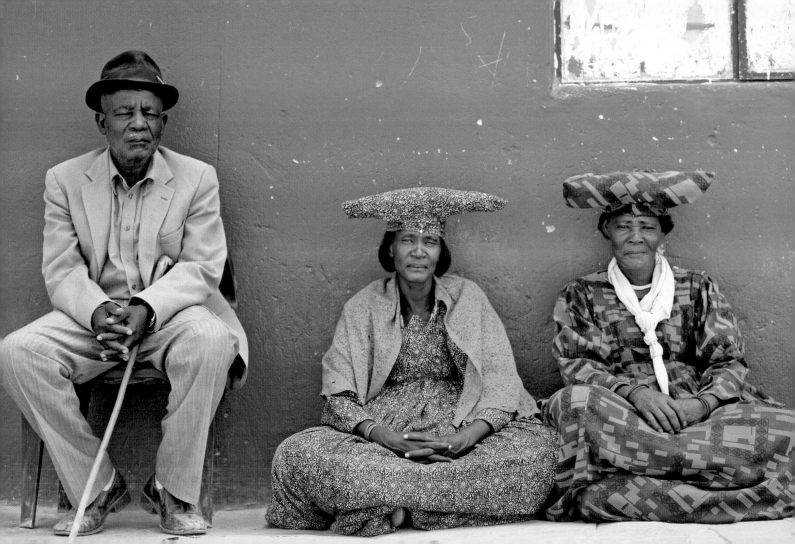

In West Africa, there is a yearly atonement ritual that is a communal ritual, with its focus on the couples.

It helps people be concerned about other people's problems.

—Sobonfu Somé

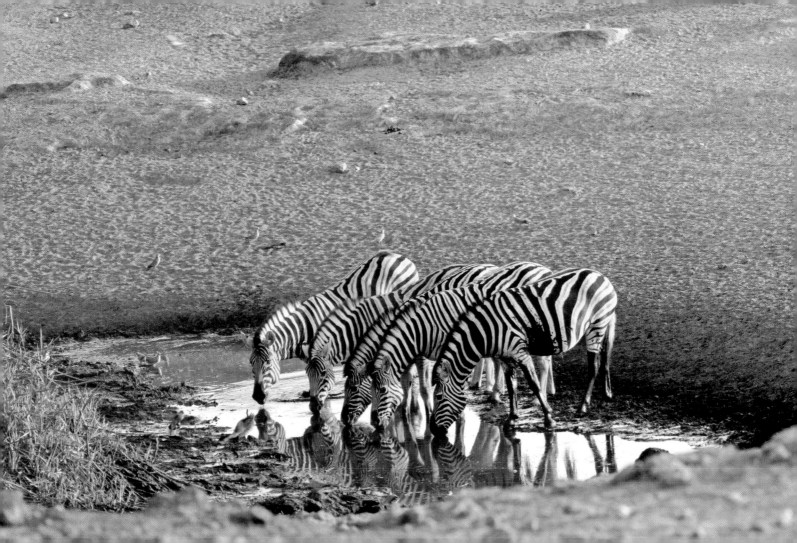

These are the kinds of smart things we can do, nurturing many small relationships

so that one day community can happen.

—Sobonfu Somé

Baobab in Gura, Namibia.

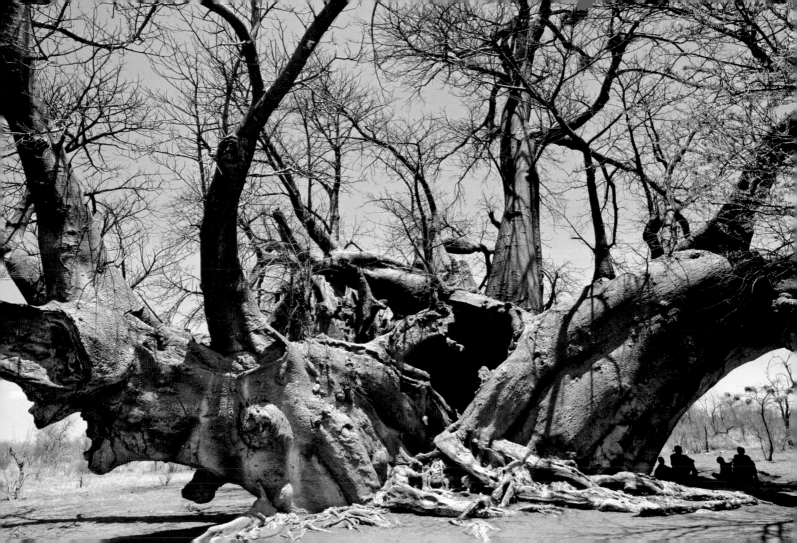

People who know us and care about us usually have an open channel for us at all times.

If we are clear in our message, however we send it, they can send us the kind of help we are looking for.

—Sobonfu Somé

Kumbare, a young Malian.

Since children are a group responsibility,

a man may not marry and found a household

before he has a hut and tillable land.

—African oral tradition

The chief's villa, Oudjilla, Cameroon.

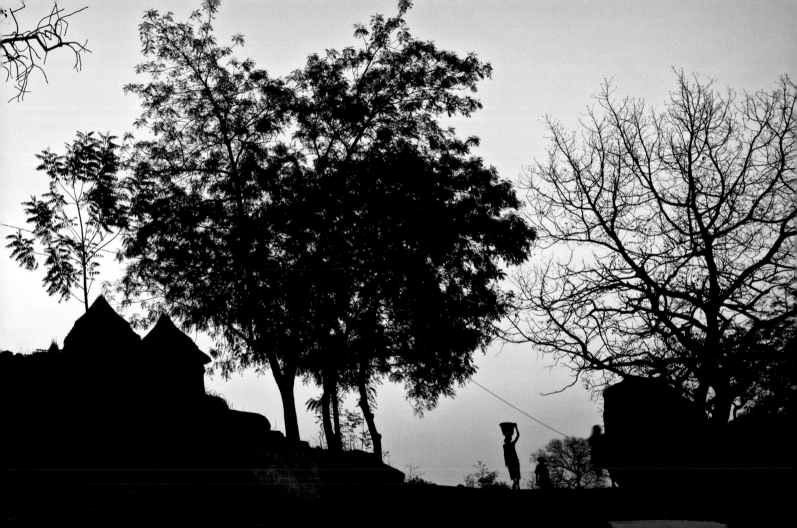

Men who are truly strong and whose Self is well structured

fully realize that no one can be self-sufficient,

that every one of us needs the Other so as to become a link in the universal chain.

—Dr. Raymond Johnson

Timkat celebration, Ethiopia.

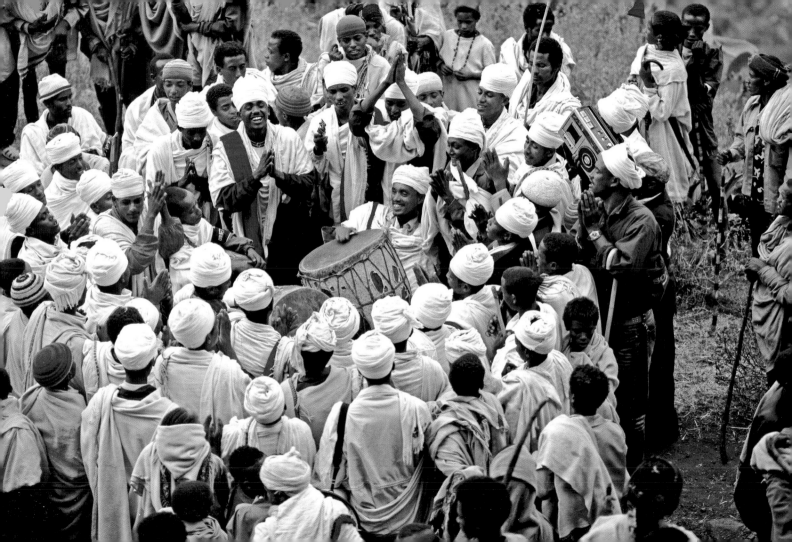

August 21

At every level, the African is first and foremost a social being.

All stages of life are marked by meetings under the conversation tree,

where all are not just free but actually duty-bound to express themselves.

—Joseph Ki-Zerbo

A Bushman village council, Namibia.

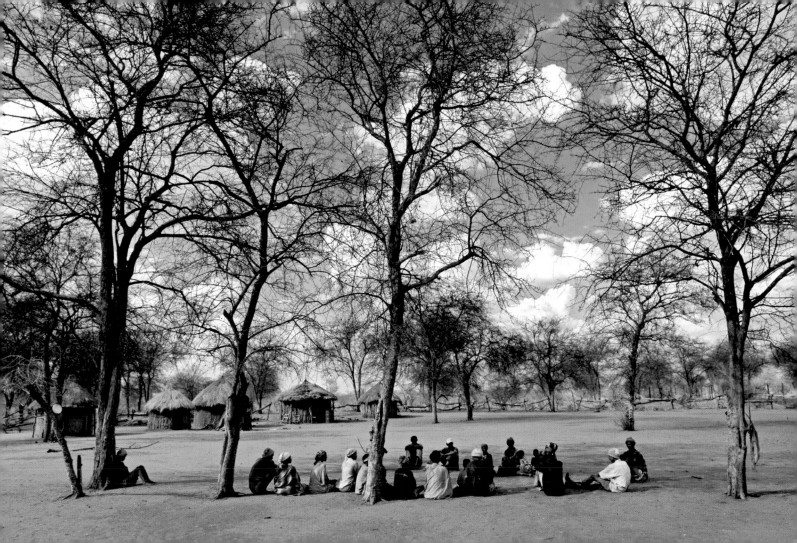

The markets have an order that is one of inclusion, regardless of one's class and origin,

regardless of whether one is a buyer or a flâneur [just looking].

—Manthia Diawara

Djenne market, Mali.

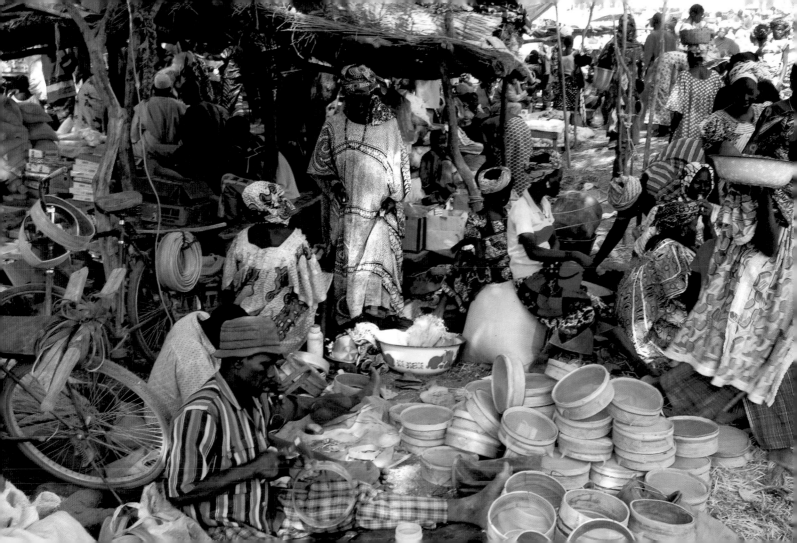

In the local assemblies, the relations between men and women, young and old,

between different ethnic groups and religions are reexamined,

prejudices challenged, discrimination discouraged, and conflicts defused.

—Aminata Traoré

Time for a Bushman gathering, Namibia.

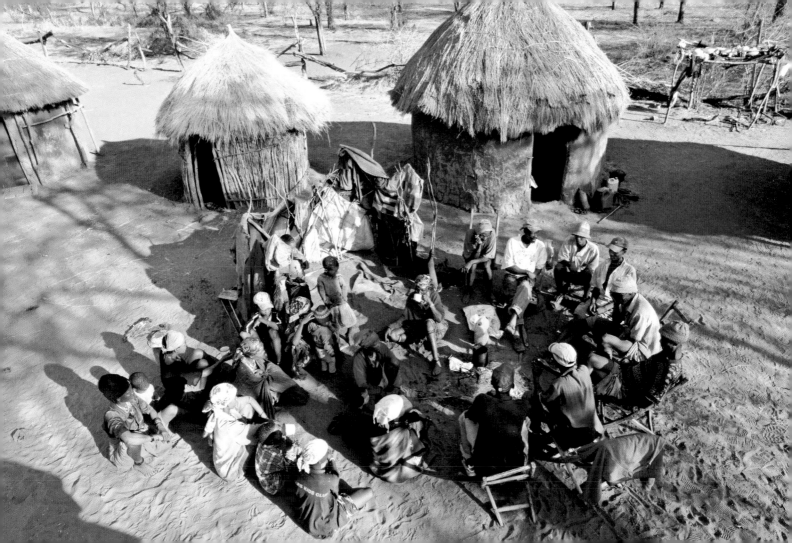

Everyone has to give an opinion about the problems set down for discussion.

The eldest, or most authoritative, speak last in order to create a synthesis.

When the best and most consonant decision is chosen, it is incumbent upon all.

—Joseph Ki-Zerbo

Amadou, the Songho witch doctor, Mali.

When you don't have community, you are not listened to.

You don't have a place you can go to and feel that you really belong.

You don't have people to affirm who you are and to support you in bringing forward your gifts.

This disempowers the psyche, making you vulnerable to consumerism and all the things that come along with it.

—Sobonfu Somé

Waiting for the river ferry, Mali.

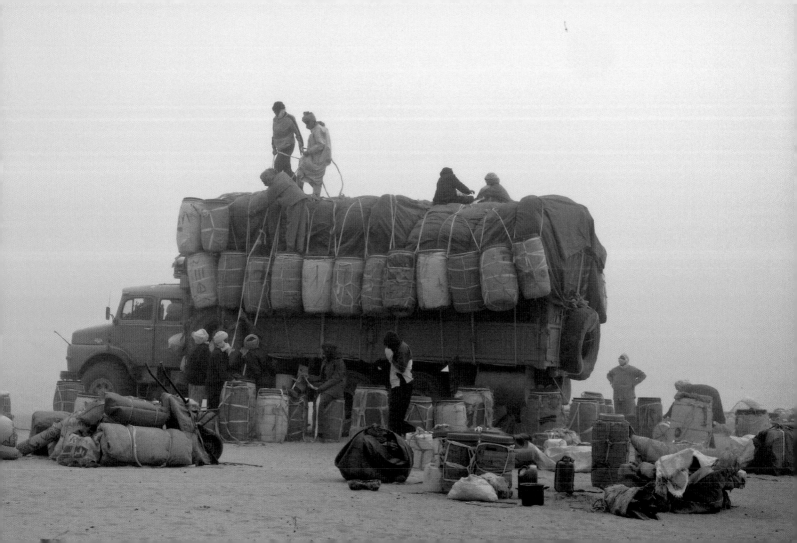

In African societies, the true pauper is

the individual without descendants,

since the spirit of family and

the principle of reciprocity work to

mitigate economic strictures via the network

of social relations.

—Jean-Marc Éla

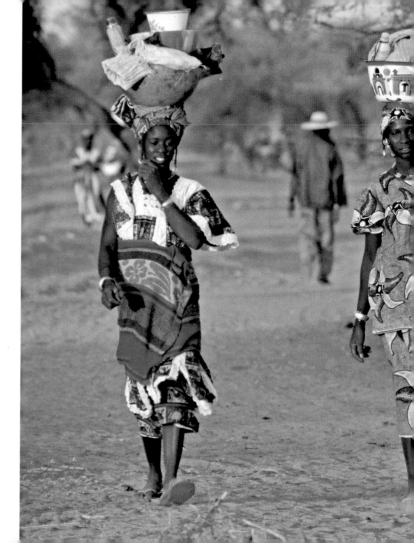

Returning from the Gorom Gorom market, Burkina Faso.

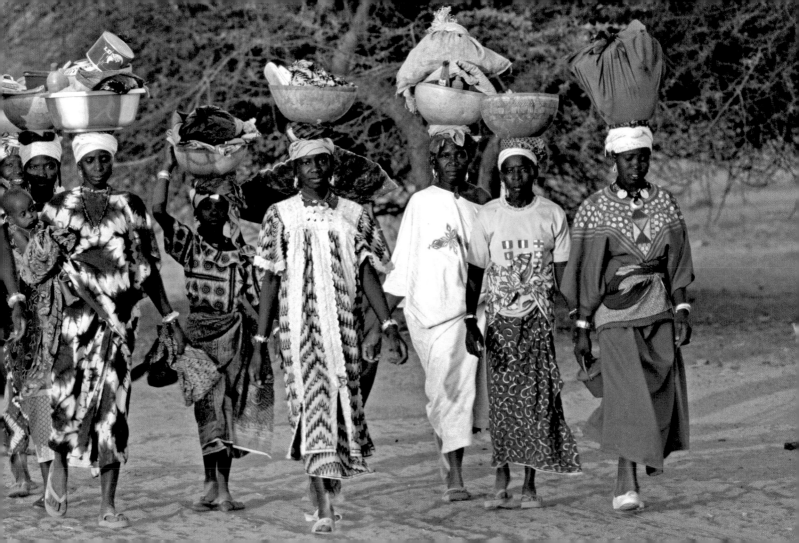

Life in society is a cosmic mission.

—Chief of a Central African tribe

Djenne market, Mali.

When you eat the fruit of a large tree, do not forget to thank the wind.

—*Bariba oral tradition*

The fishermen return, Senegal.

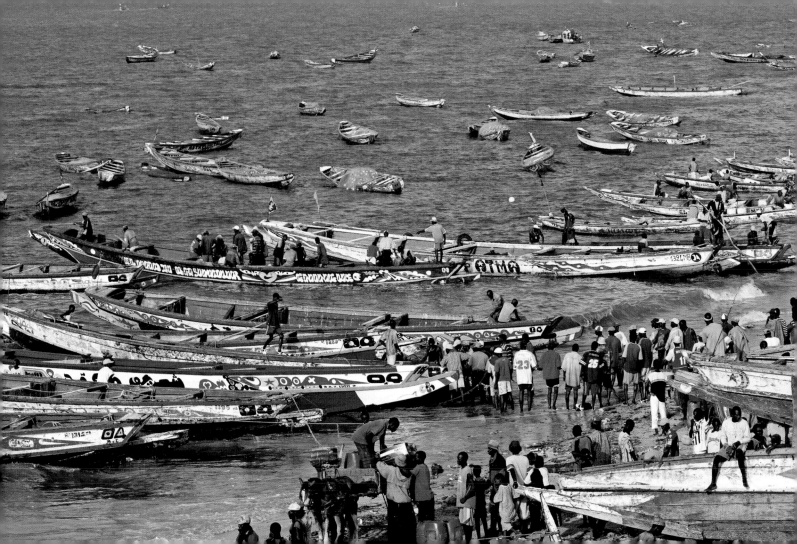

The follower is forbidden to quarrel with any human being and, in particular,

must not be so subservient to his anger as to stop speaking to any of his fellows for more than three days.

—Amadou Hampâté Bâ

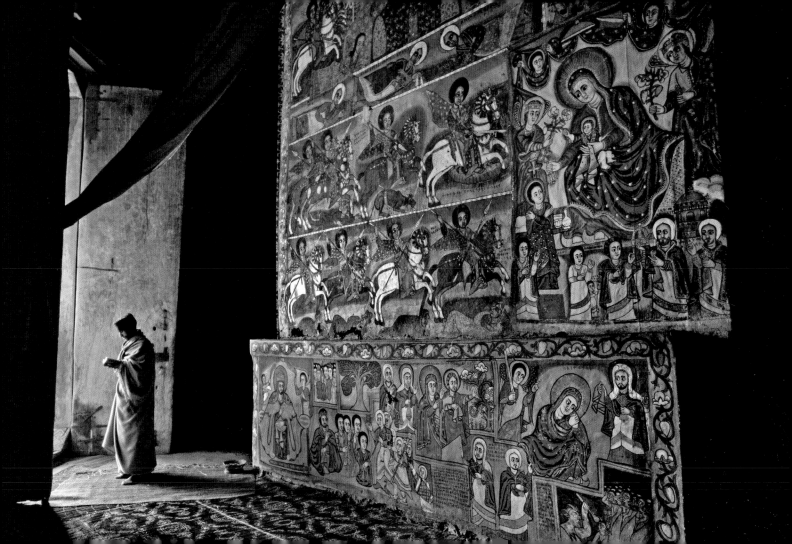

Vertically, the black African personality is rooted in the family and in the primordial Ancestor, if not in God. Horizontally, it has links with the group, with the society, with the cosmos. Because of its nonoppositional nature, this personality is enriched and blossoms through the bonds of reciprocity, which it actively maintains.

—Alassane Ndaw

Wedding festivities, Chad.

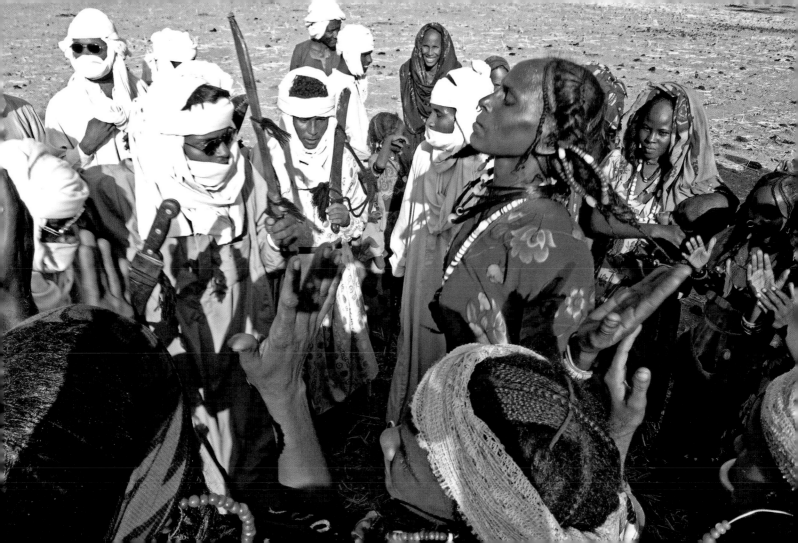

Consciousness is responsibility.

It is the guide that governs the glowing hearth of the human spirit.

—Joseph Ki-Zerbo

Church prayers, Bieta Ghiorghis, Ethiopia.

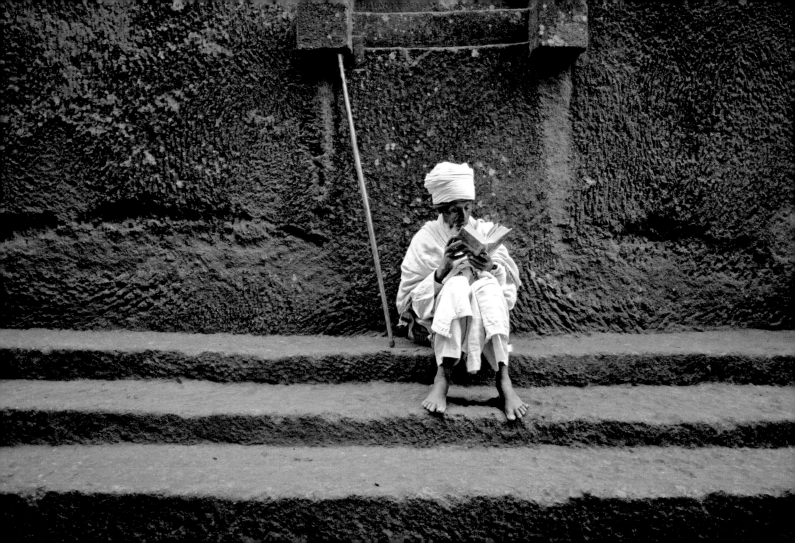

The death-drive seeks to return to an earlier state, to a past identical to what used to be,

by destroying all that came after. This death-drive will instill what we shall call sterile repetition that simply idles

and goes nowhere. It only hampers the easing of tensions and kills the ritual.

Yet when this repetition is powered by the life-drive, it becomes formative.

—Françoise Héritier-Auger

Ngau, a Bushman hunter, Namibia.

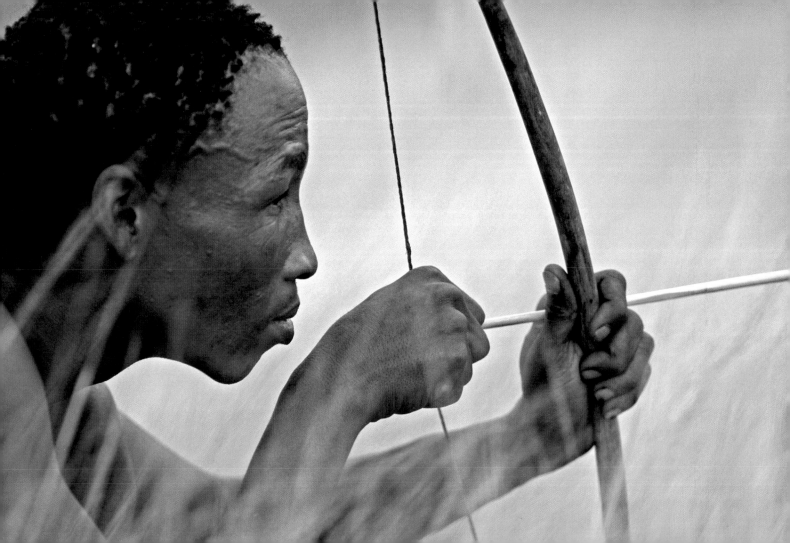

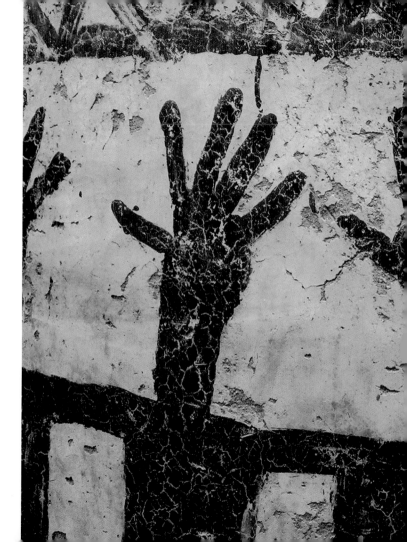

September 2

We do not pray to have more money but to

have more kinsmen.

—Chinua Achebe

Mural in a house in the Tiebele region, Burkina Faso.

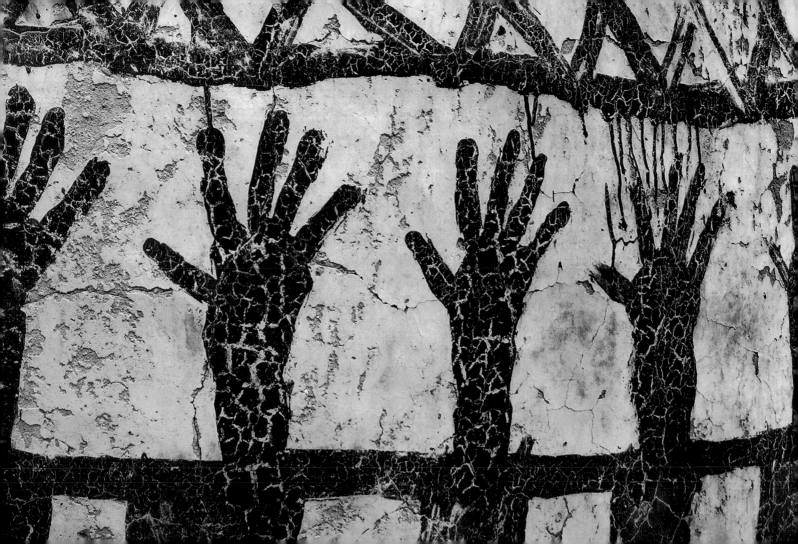

September 3

In an unwell person, it is most often not the body that is sick but the soul.

Such a soul demands something from the soul of the community,

and the treatment needs to be sought at the level of the relationship with others.

—Dr. Raymond Johnson

In an Ethiopian hut.

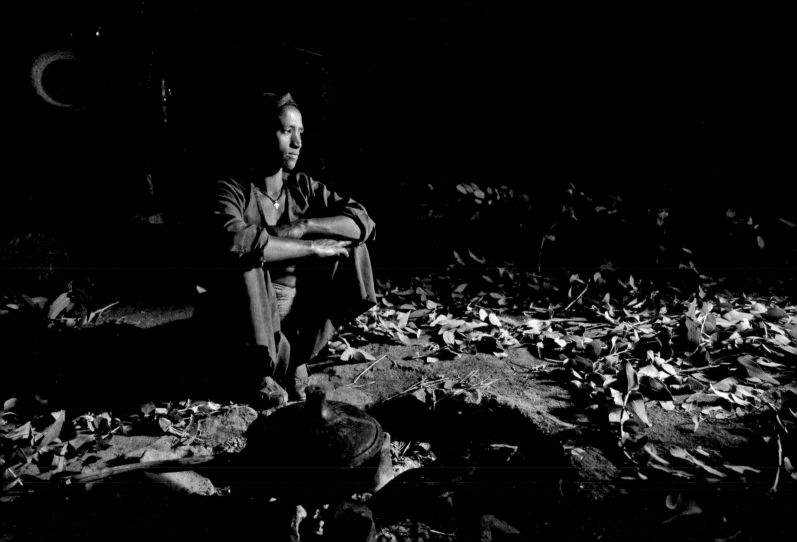

If a man falls ill or hurts himself, he needs, at first,

no supernatural treatment; a simple medical intervention will suffice.

But if this does not work, communion with the ancestors is indicated.

—African oral tradition

Ashanti statuette, Ghana.

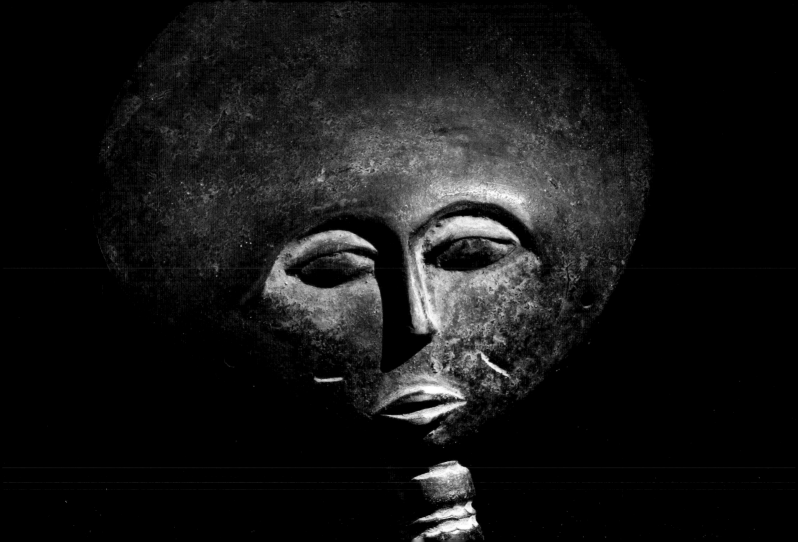

The village or the tribe is seen as a huge tree with thousands of branches.

When a part of this living entity is diseased, there is a need to reexamine the whole tree.

This is why when somebody is sick in the village, everybody is worried;

it reminds everybody that there is something present that is potentially dangerous for all.

—Sobonfu Somé

Start of the short rainy season, Namibia.

There is always something in the self that is either overcompensating, pretending, giving in, or pushing too hard.

The only way one can reach that and move it out is through ritual.

—Sobonfu Somé

A young Himba bridegroom, Namibia.

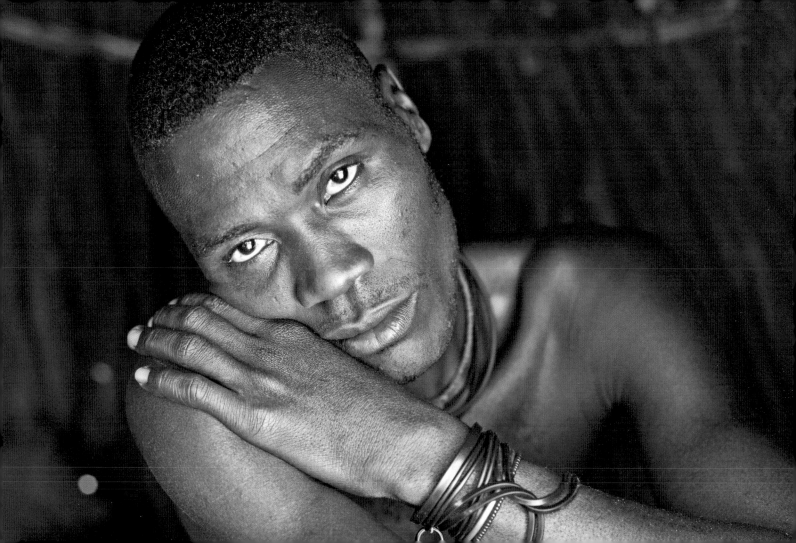

In cases of affective deficiency, often related to mental illness, recourse is again made to the family as the forum

of treatment, in order to reintegrate the individual in his own environment.

Healing can only be judged real insofar as the individual concerned can again pursue his usual activities.

—Dr. Raymond Johnson

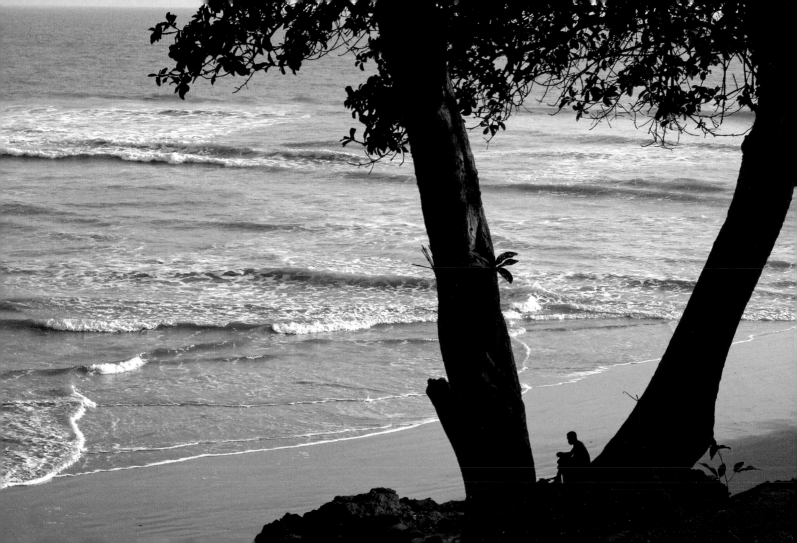

Healing sometimes requires ceremonies of reconciliation, especially in cases of mental illness

where the patient needs to make peace with his milieu to be reintegrated.

Traditional medicine thus contributes to family cohesion since, as the Malians say,

"There are no mad people in united families."

Hence, everything possible is done to resolve communication problems between the patient and the family.

—Dr. Raymond Johnson

Calabash improvised for drawing water, Mali.

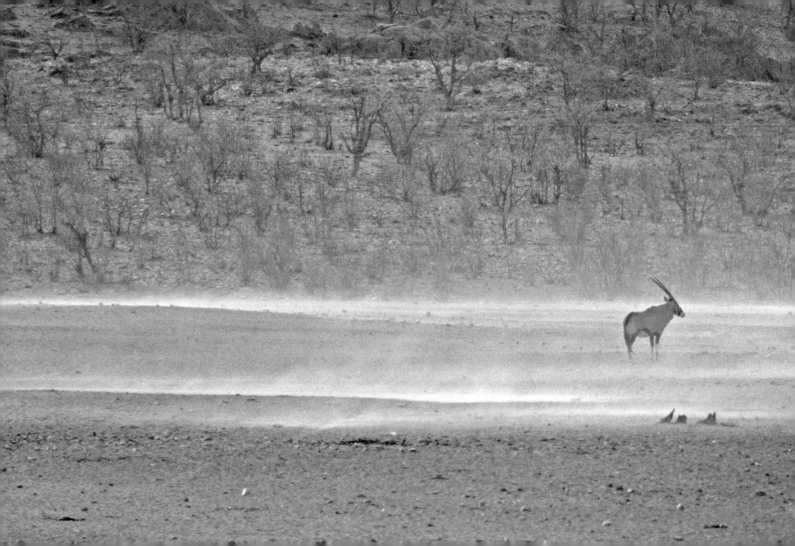

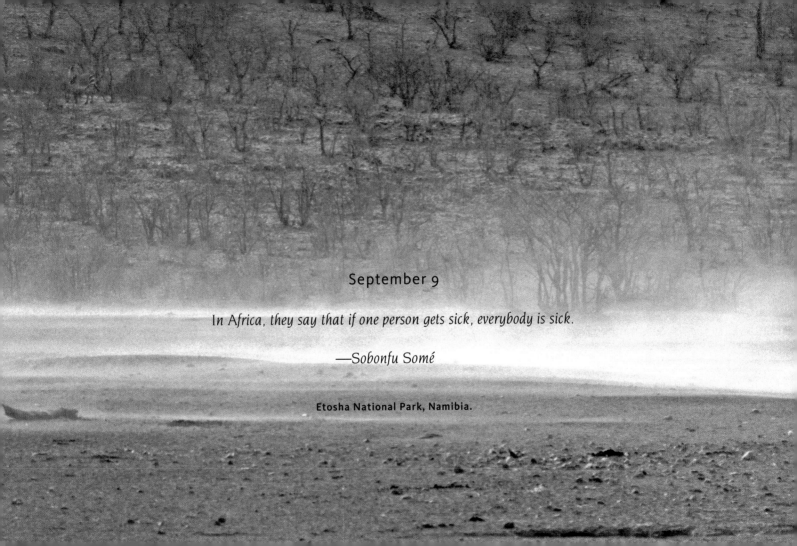

September 9

In Africa, they say that if one person gets sick, everybody is sick.

—*Sobonfu Somé*

Etosha National Park, Namibia.

Instead of thinking yourself ridiculous, I bet you reckon that I am.

—Amadou Hampâté Bâ

No one will show pity for the pitiful!

No one will show shame for the shameful!

Man will work only for himself.

He will view himself as always in the right,

accusing his neighbor of his own faults.

Everyone will laud himself and denigrate others,

praising his own work and criticizing that of others.

—Amadou Hampâté Bâ

Al Ebel well, Chad.

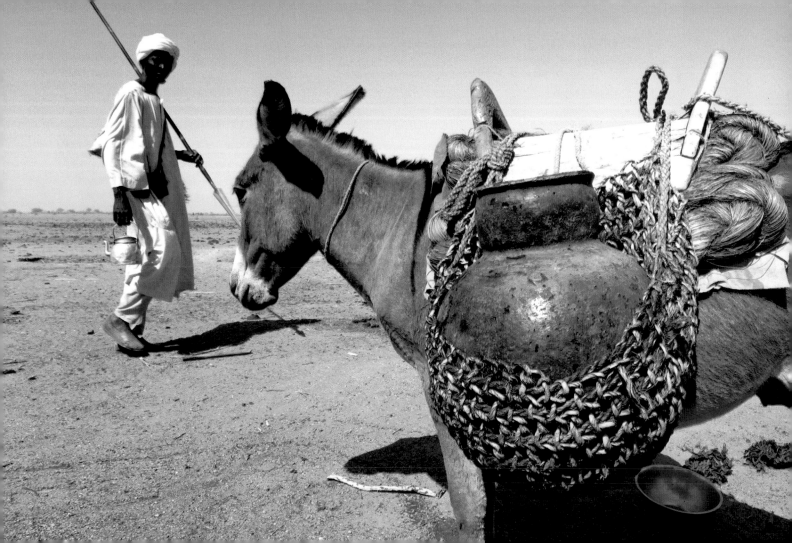

Our problem in Africa is that the different ethnic groups do not speak the same language.

Then we have the World Bank, Coopération Française, the International Monetary Fund, USAID, and so on.

—Village chief, southwest Mali

Songho, a Dogon village, Mali.

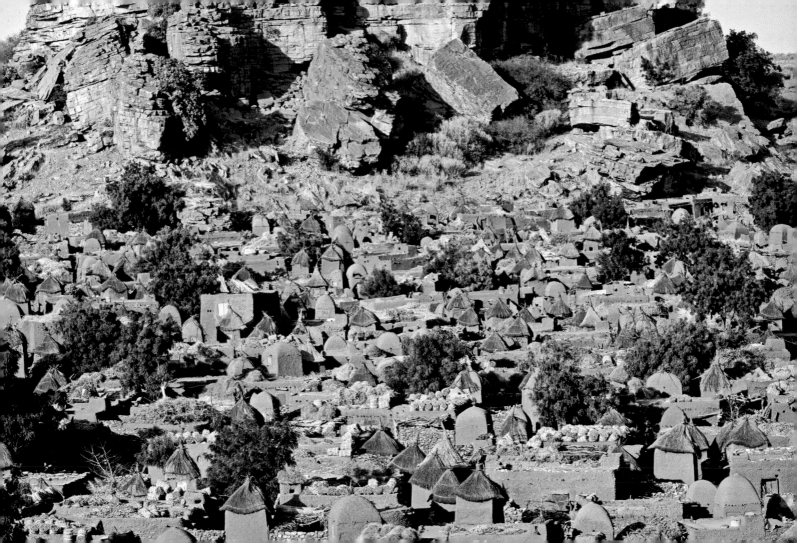

Africa has been emptied of its substance, and what has been imported is empty, too.

—Joseph Ki-Zerbo

Children's toys, on the border between Mauritania and Mali.

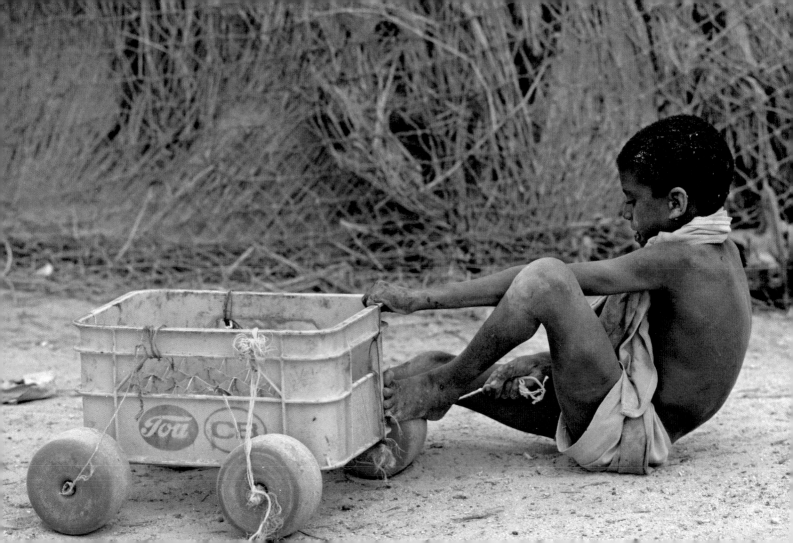

Mankind is immeasurably rich.

Africa is not poor,

and we Africans are not, either.

—Aminata Traoré

Women of the village of Songho, Mali.

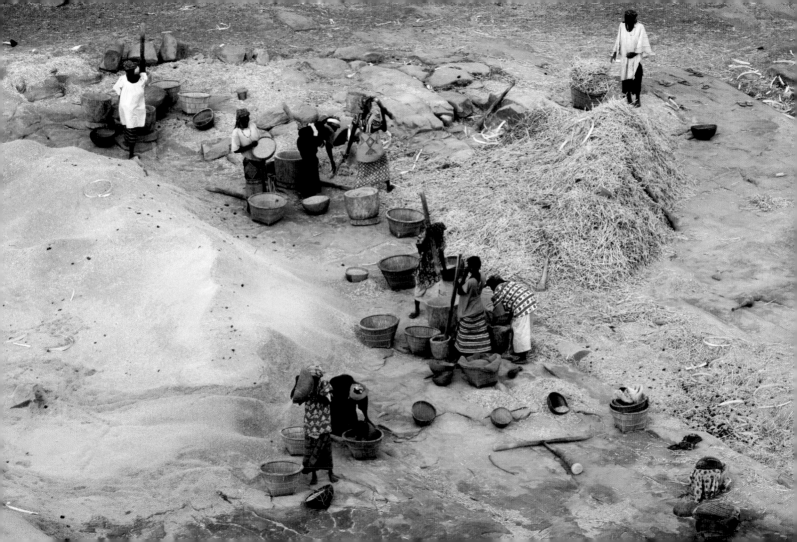

September 15

Our century is one of the most terrifying.

Sages of all epochs have wished to avoid such an era, one during which—

Good is not attractive,

Evil is not repulsive,

Truth is ineffective,

Lies are not damaging.

Contemporary man lives in sorrow and worry.

—Amadou Hampâté Bâ

Bamum mask, Cameroon.

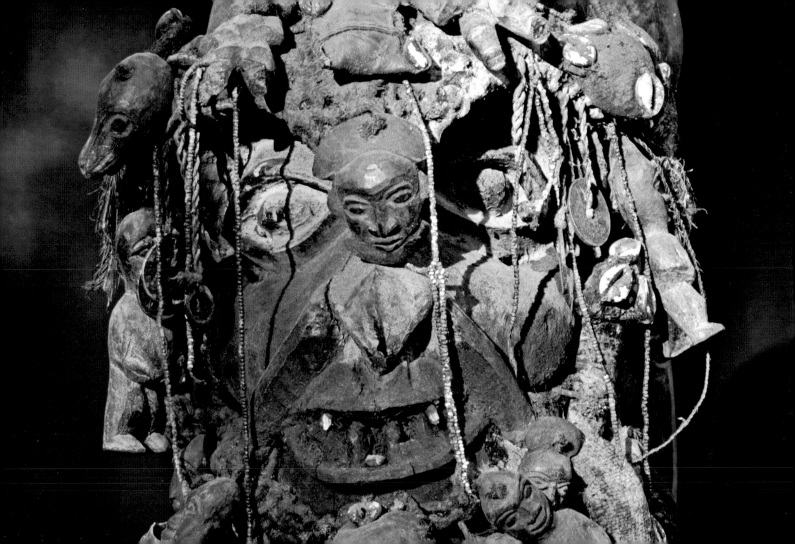

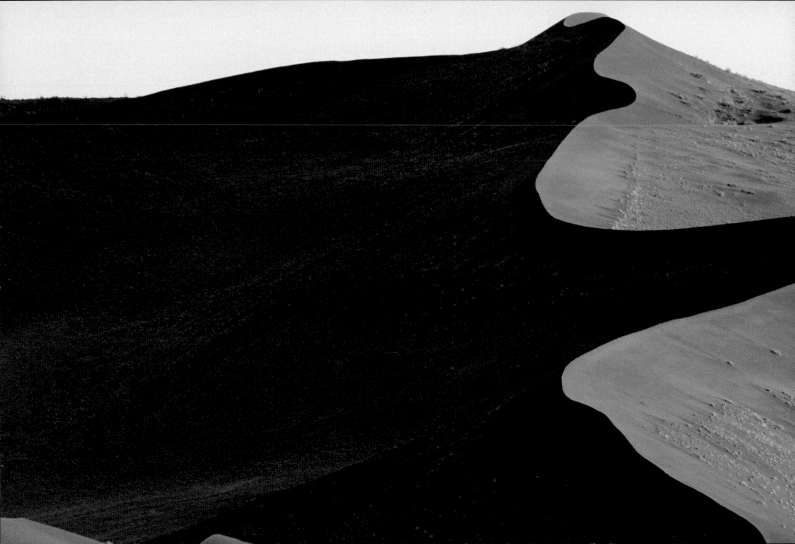

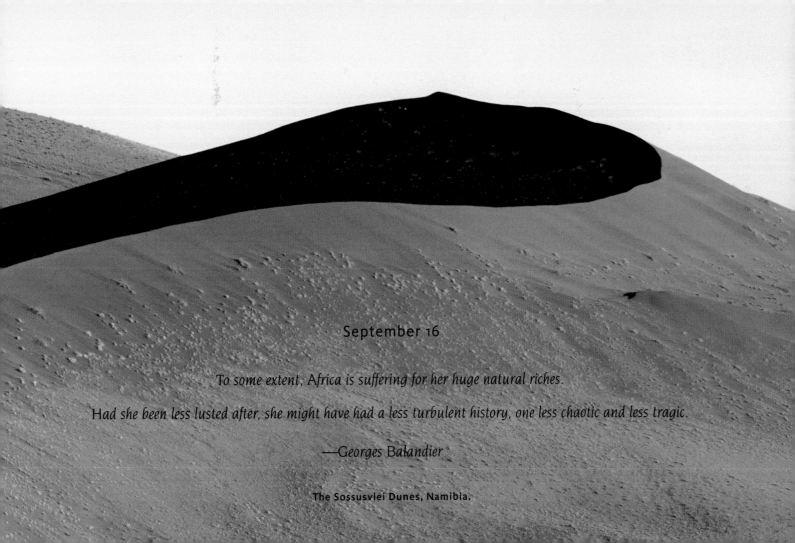

September 16

To some extent, Africa is suffering for her huge natural riches.

Had she been less lusted after, she might have had a less turbulent history, one less chaotic and less tragic.

—Georges Balandier

The Sossusvlei Dunes, Namibia.

They are so fascinated by the productivity of the tool that they have lost sight of the limitless immensity of the building site.

—Cheikh Hamidou Kane

Returning from fishing on Lake Chad, Chad.

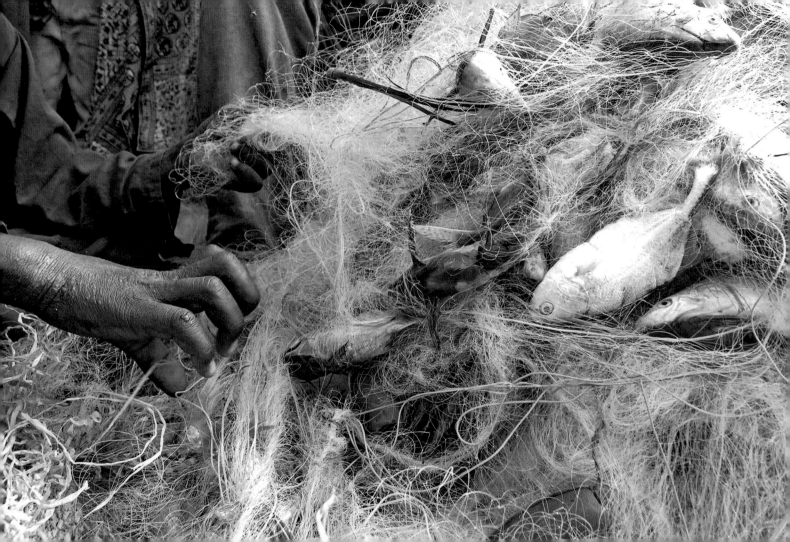

In the final analysis, what is sought in material accumulation is the regard of others,

and thereby domination over them.

—Dr. Raymond Johnson

Saliou, a Senegalese model.

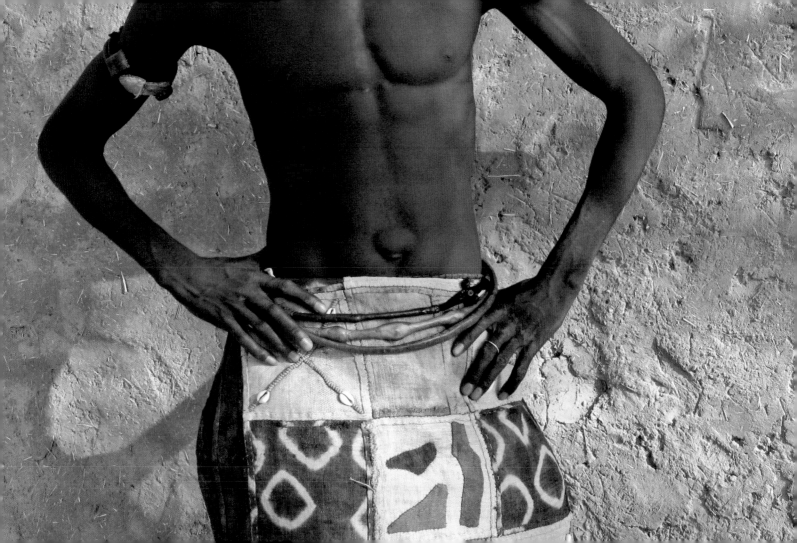

If you see wild animals attacking a man, say not, "Leave that man alone!" but "Leave us alone!"

If you see birds of prey devouring a man's body, say not, "Leave that man's body alone!" but "Leave us alone!"

For there is solidarity among men.

This is virtually a text of commandment, a solemn injunction, an ethical point of reference.

—*Bambara oral tradition*

Kouri cows with their horns honeycombed for buoyancy, Chad.

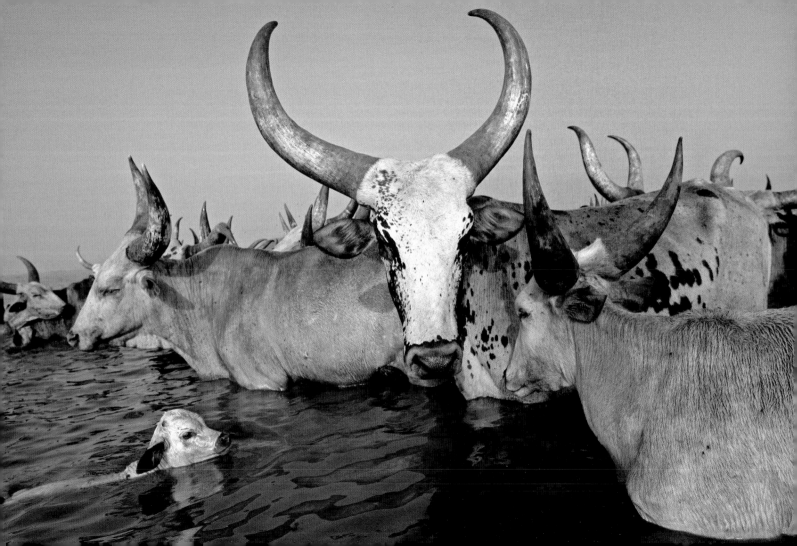

Injustice anywhere is a threat to justice everywhere.

—Dr. Martin Luther King Jr., *letter from Birmingham jail, April 16, 1963*

Al Ebel well, Chad.

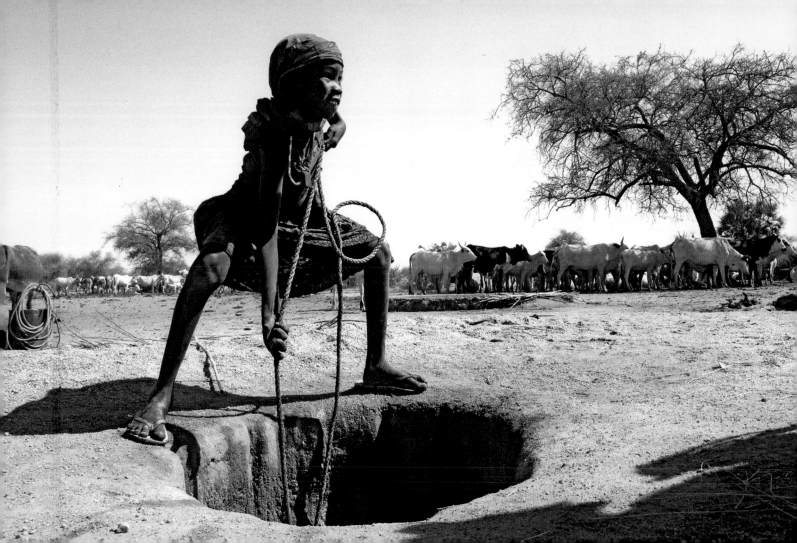

I am not truly free if I am taking away someone else's freedom,

just as surely as I am not free when my freedom is taken from me.

The oppressed and the oppressor alike are robbed of their humanity.

—Nelson Mandela

White elephants in Etosha National Park, Namibia.

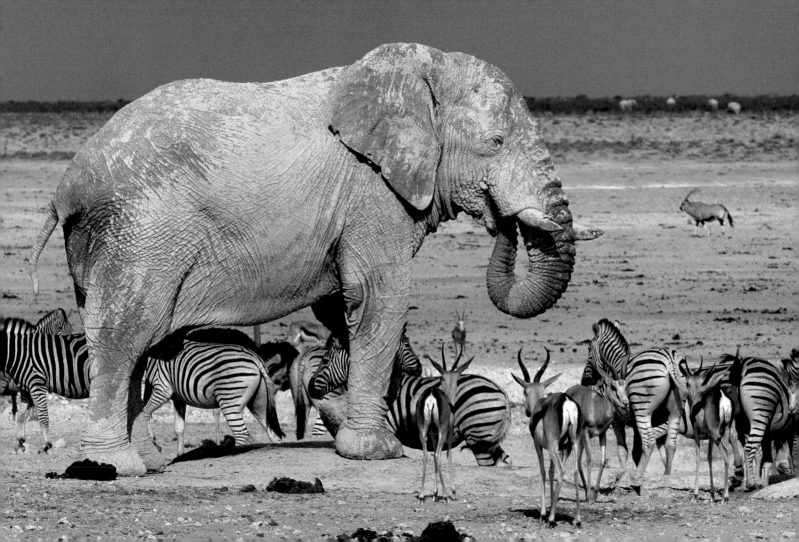

True dialogue assumes the recognition of a certain moral equality among all the parties concerned.

In other words, dialogue assumes respect of "the Other."

However, such respect is absent from both head and heart in some partners in discussion.

—Kwasi Wiredu

Meeting on the high plateaus of Ethiopia.

True dialogue assumes recognition of the Other in terms both of his identity and of his difference.

—Alassane Ndaw

Coyambo, a young Himba, Namibia.

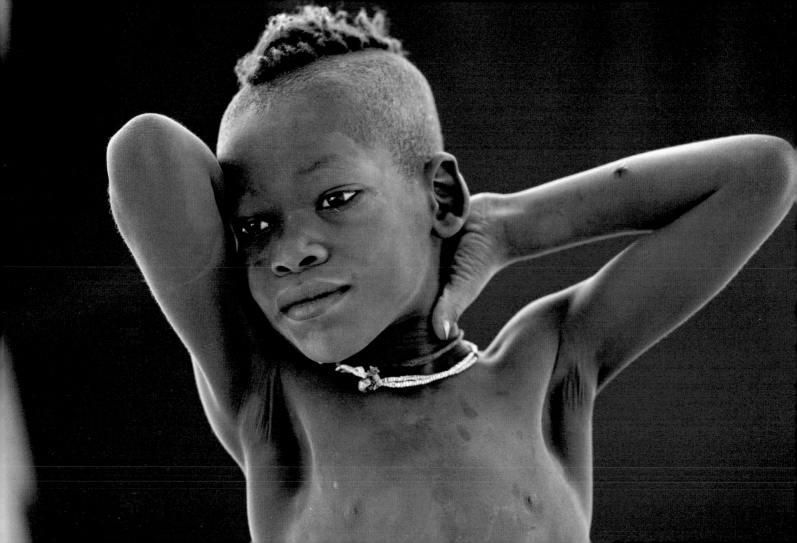

September 24

Only free men can negotiate.

—*Nelson Mandela*

Oil mill in a village in Chad.

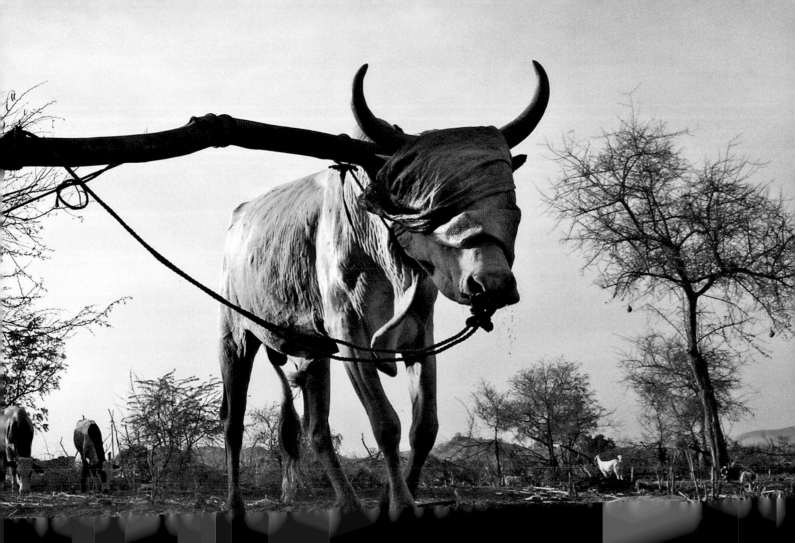

The materialistic point of view distracted men to the point where they envisaged

underdevelopment as a situation that could be defined in terms of privations.

This approach interpreted everything about underdevelopment in terms of a lack

of possessing rather than of being. And this was a serious illusion.

Underdevelopment in terms of possessions is not the main issue:

true underdevelopment is that of human beings as such.

—Nsame Mbongo

Waking up in Bushman country, Namibia.

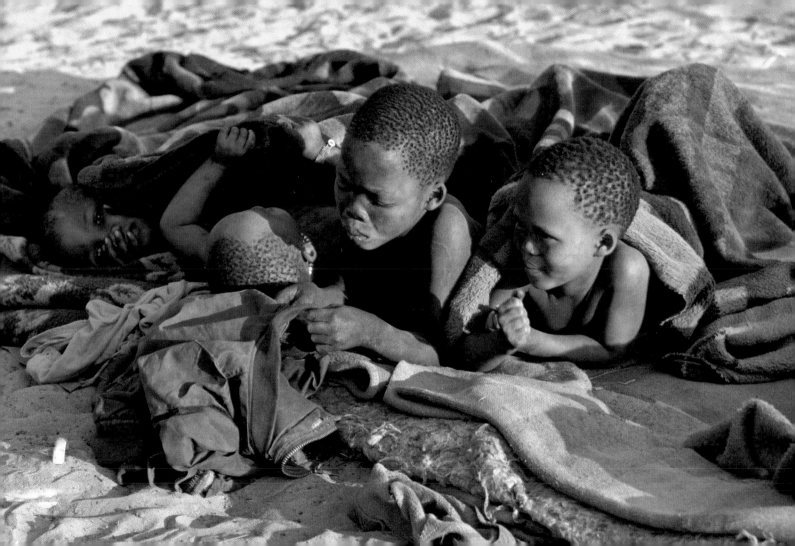

Man *no longer perceives properly, desires properly, understands properly, or acts properly.*

—*Bantu oral tradition*

Dead vlei, Sossusvlei Dunes, Namibia.

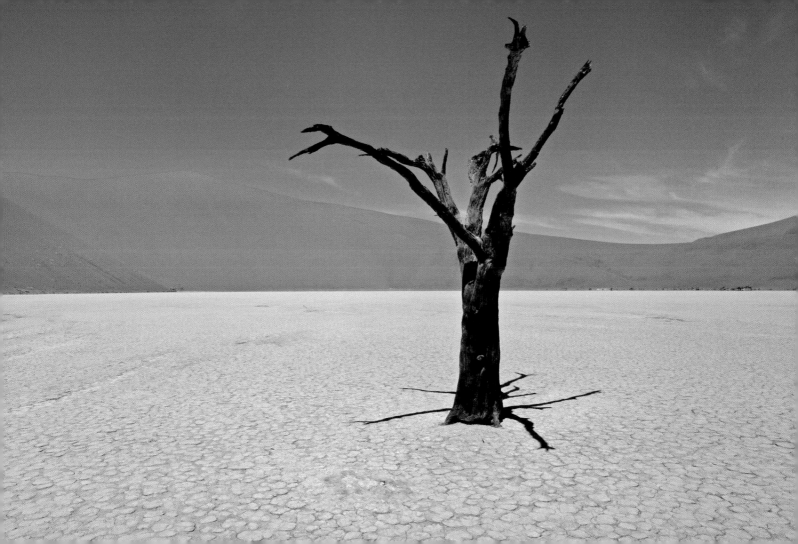

So, the idea is to leave it to the market to decide

whether a particular category of the population is to survive or not?

Who, exactly, is the market?

—Joseph Ki-Zerbo

Djenne market, Mali.

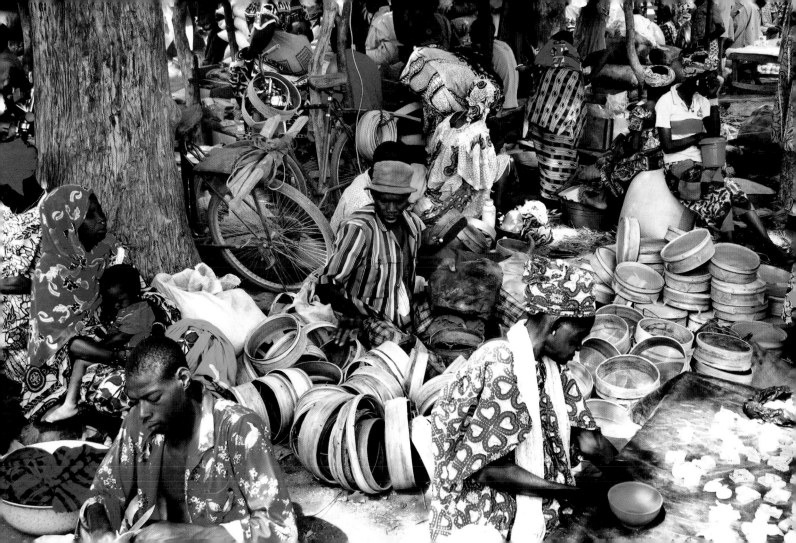

What is consciousness? It is thinking at a remove.

It is not just the understanding or analysis of a phenomenon.

It involves taking events and classing them not simply in some sort of intellectual order,

but in an ethical order; having regard to duty, acceptability, and legitimacy,

which is more than mere legality.

—Joseph Ki-Zerbo

Coming back from the well in the Sahel, Mali.

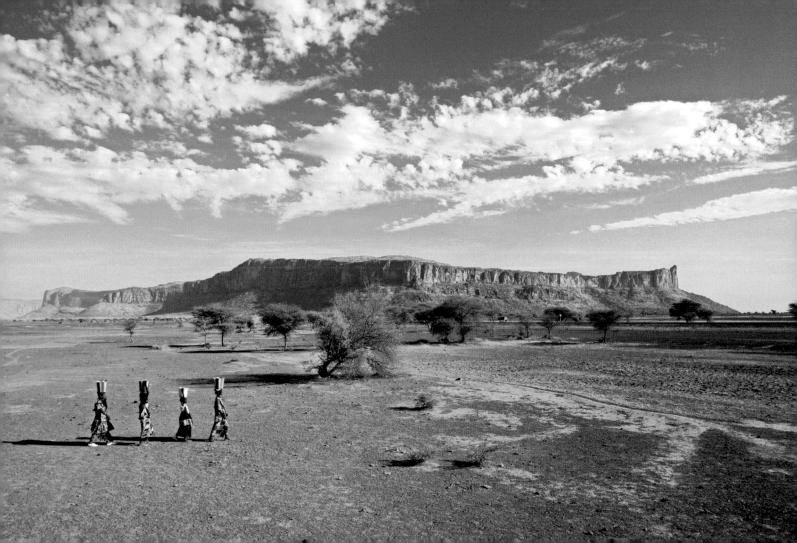

I consider progress—that which is called "development"—to be about fulfilling one's full potential

as a human being in order to be a broadcaster or receiver of values.

—Joseph Ki-Zerbo

Akabou Kapiou, Burkina Faso.

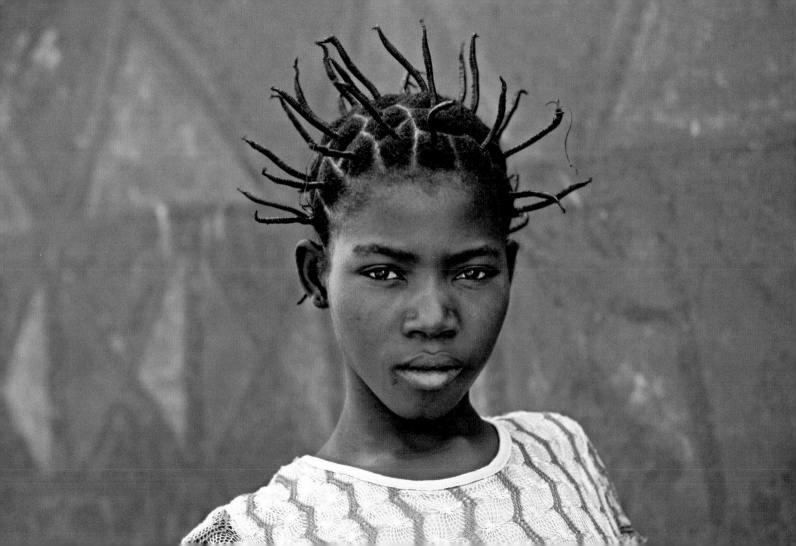

What is "excellence" in a man? It is when he engages resolutely in the process of liberation,

the dual liberation of himself and of others.

The excellent man is eminently responsible: he understands that

the welfare of others depends on his own welfare and vice versa.

—Ebénézer Njoh-Mouelle

Mealtime among the Peul shepherds, Burkina Faso.

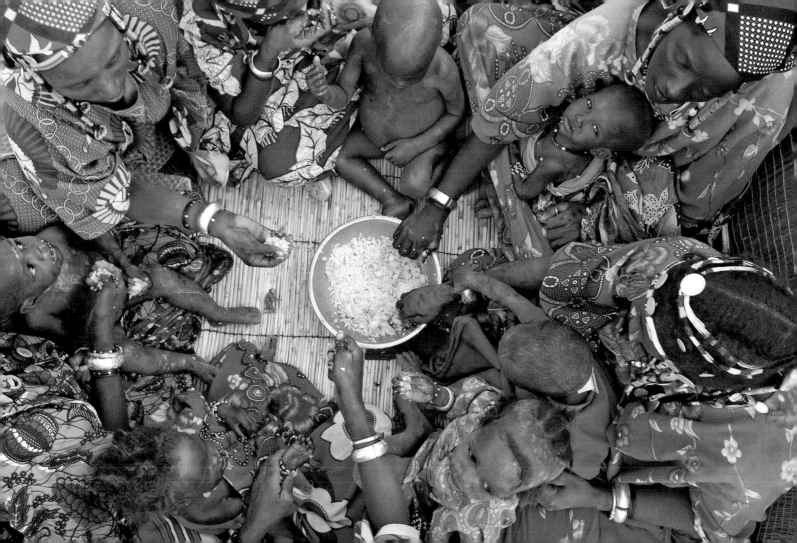

October 1

Man should be the end of all development.

—Ebénézer Njoh-Mouelle

A newborn, Burkina Faso.

Knowledge and consciousness are two different categories.

The thing that distinguishes the human being from the animals is consciousness.

—Joseph Ki-Zerbo

Going to the Al Ebel well, Chad.

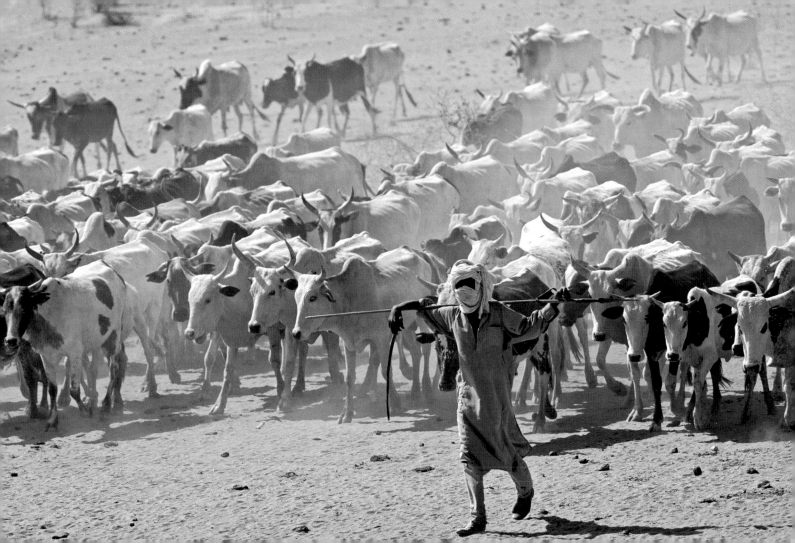

Culture is one of the most important levers to pull in order to rehabilitate and relaunch an economy;

it also provides direction.

—Aminata Traoré

Fishing boats, Senegal.

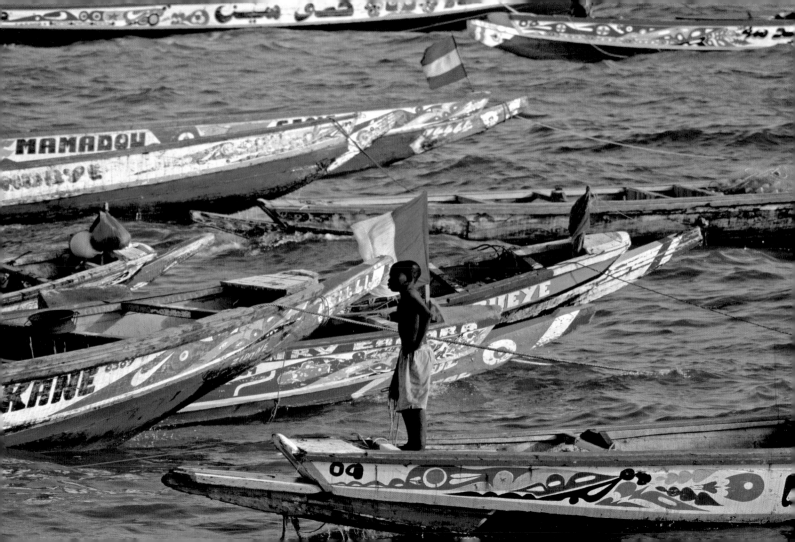

October 4

Acts that run counter to law, ethics, duty, or respect for human dignity burden the heart of man.

—Joseph Ki-Zerbo

Going to market, Nigeria.

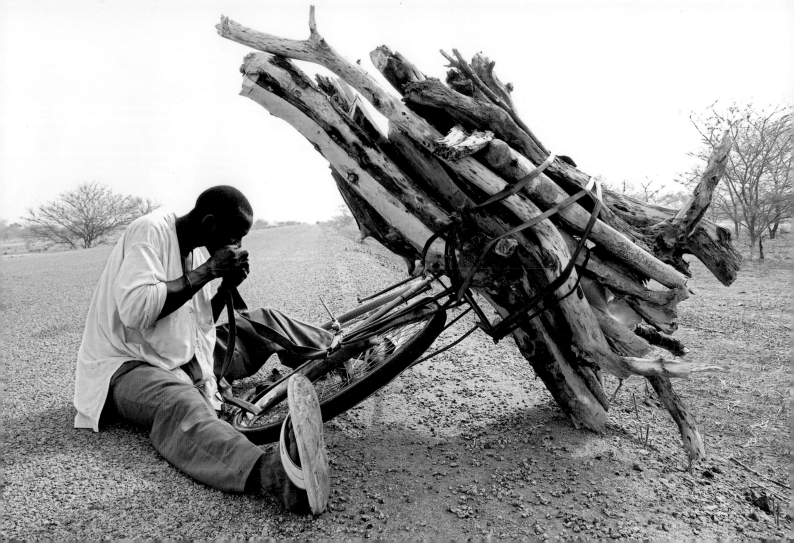

Human consciousness should be cultivated, sown, and watered, for it relates to life.

It touches on ethics, aesthetics, and play.

Like life itself, consciousness is not a machine that is set up according to logic to give forseeable results.

—Joseph Ki-Zerbo

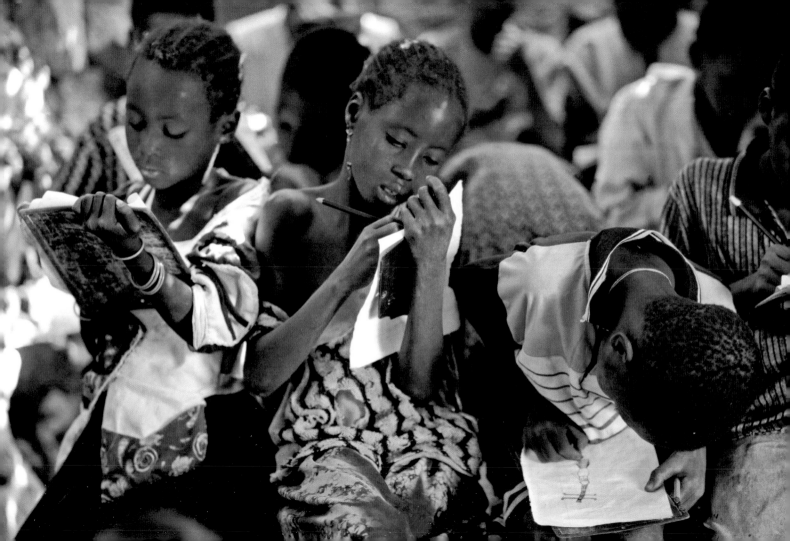

Will we be extremists for hate, or will we be extremists for love?

Will we be extremists for the preservation of injustice, or will we be the cause of justice?

Maybe the South, the nation, and the world are in dire need of creative extremists.

—Dr. Martin Luther King Jr., *letter from Birmingham jail, April 16, 1963*

Dan fetish, Ivory Coast.

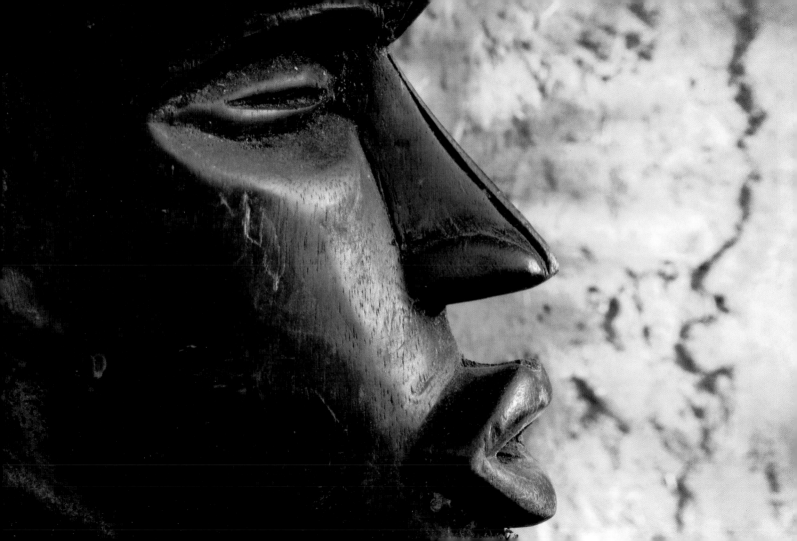

Today's globalization is based on competition and profit.

It will achieve a truly human face only when everyone can say "I" while thinking "we."

—Aminata Traoré

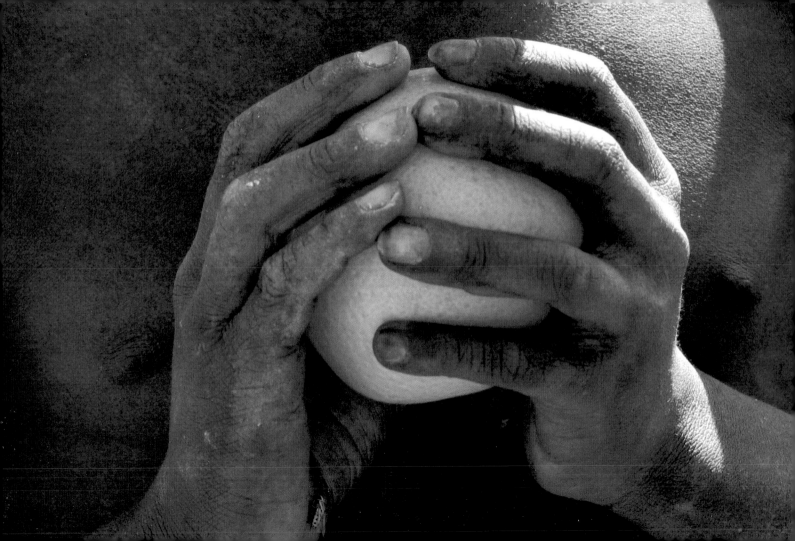

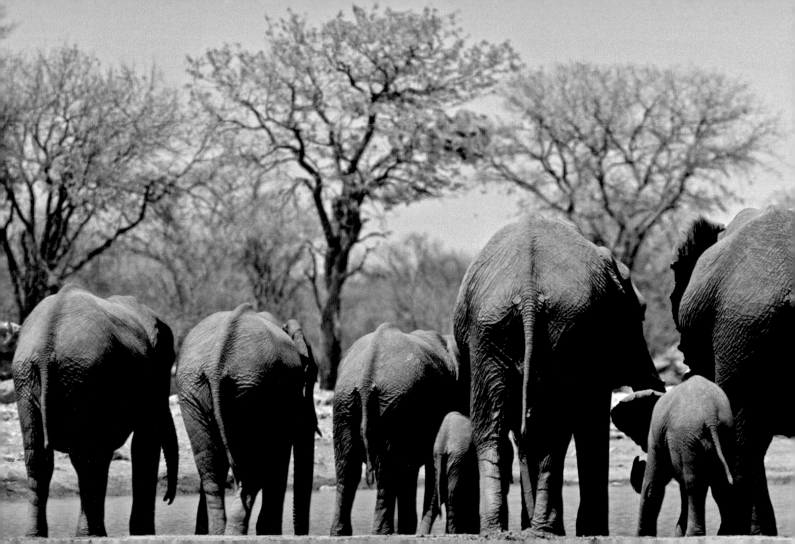

October 8

The crime is before the court. But what do the jurors make of it? Who are the jurors? And who is humanity's prosecuting attorney?

—Djibril Tamsir Niane

The Goas watering hole, Namibia.

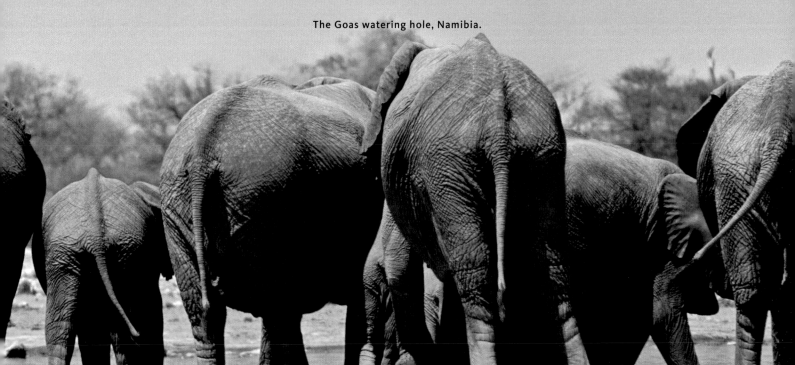

The whole collection of fields around a village, together with the village itself,

may also be said to recall a large coverlet.

—*Dogon oral tradition*

Tigray Province, Ethiopia.

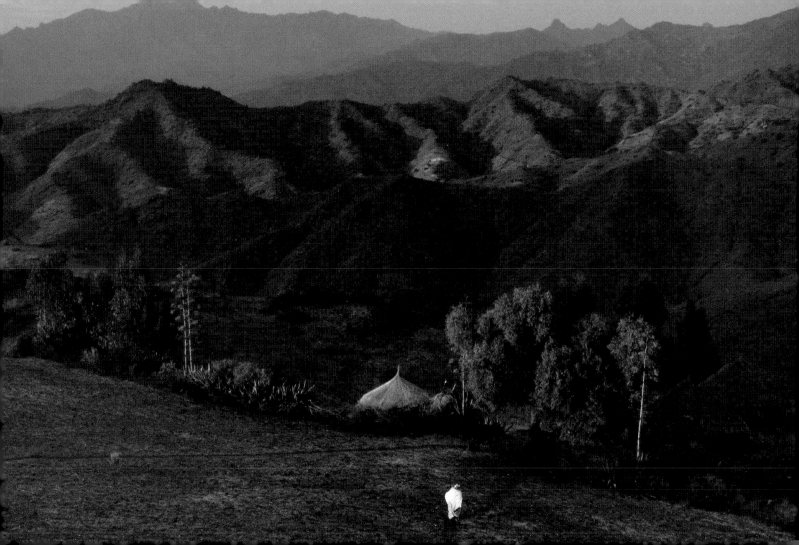

The land has always been the land of the people. Still, people did not consider it their own.

They saw it as a spirit, as something that they were just borrowing.

—Sobonfu Somé

End of harvest, Ethiopia.

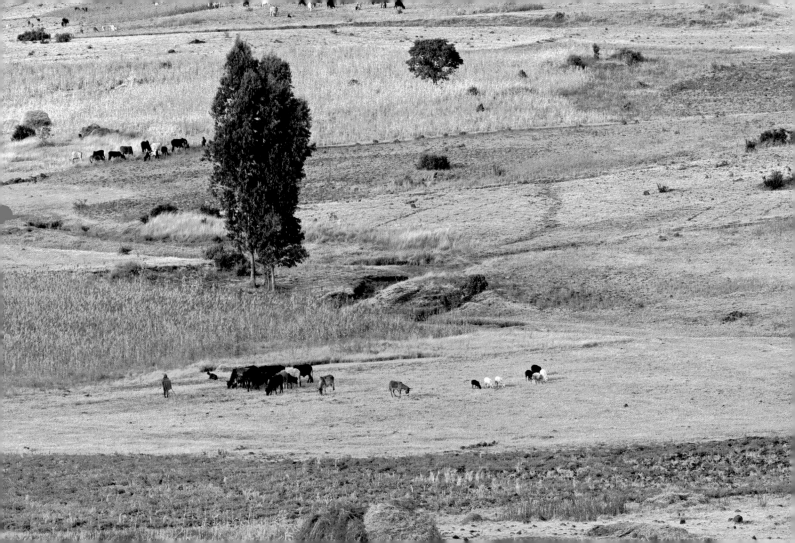

It is the land that ultimately owns the man.

—Mossi oral tradition

The Choudop watering hole, Namibia.

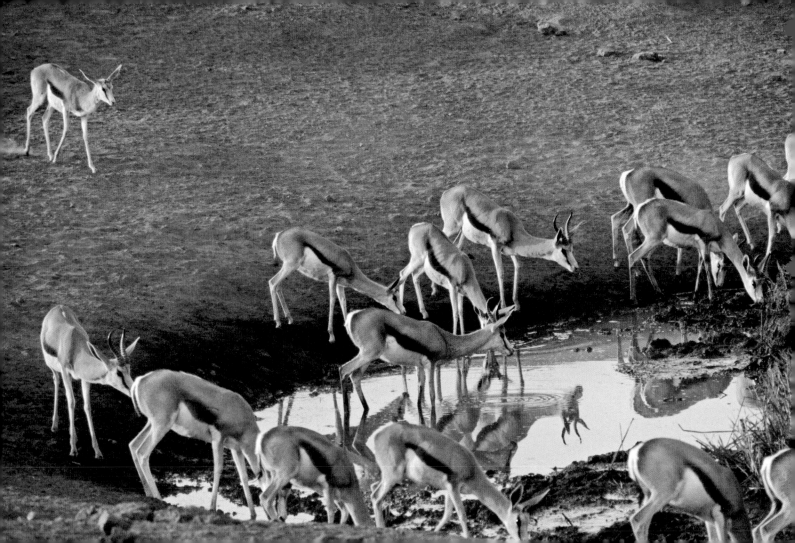

When we acknowledge that the earth we walk upon is not just dirt,

that the trees and animals are not just resources for our consumption,

then we can begin to accept ourselves as spirits vibrating in unison with all the other spirits around us.

Our connection to all these living spirits helps determine the kind of intimate life we live.

—Sobonfu Somé

Market's end, Djenne, Mali.

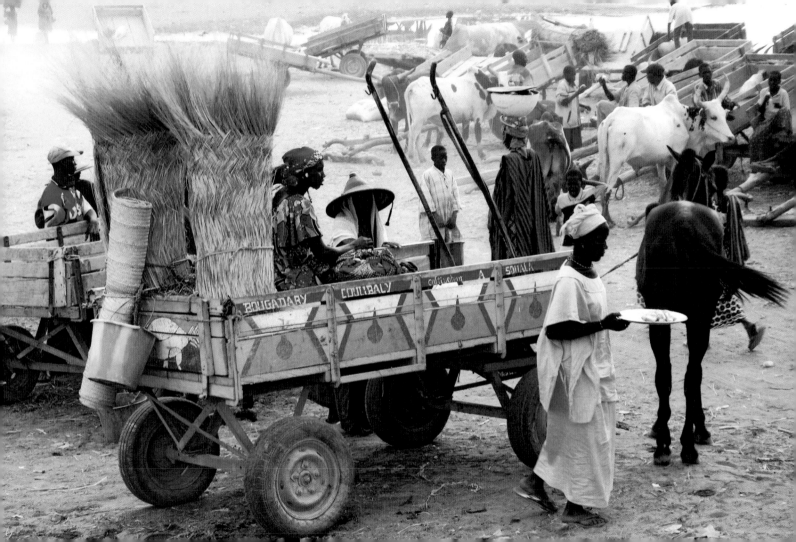

We produce only the food we need to live on.

—*Sobonfu Somé*

The last catch, Lake Chad, Chad.

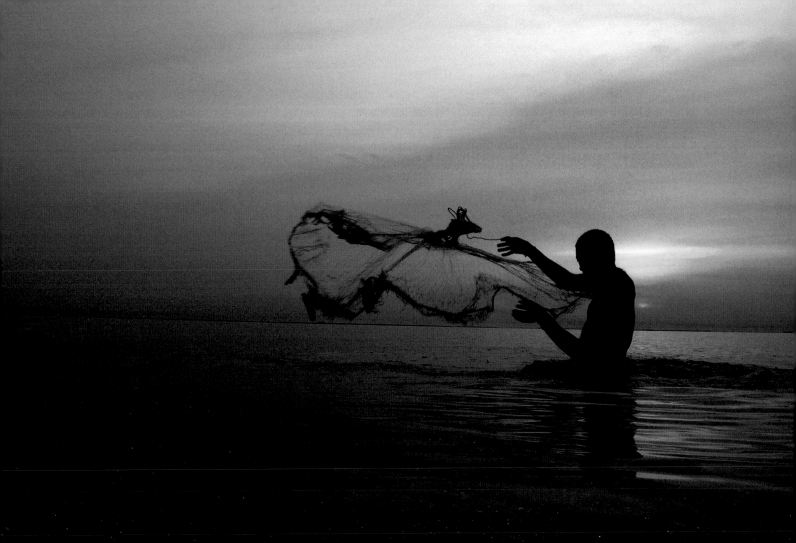

The era of separate destinies has run its course.

In that sense, the end of the world has indeed come for every one of us,

because no longer can anyone live by the simple carrying out of what he himself is.

—Cheikh Hamidou Kane

Herds at night, Chad.

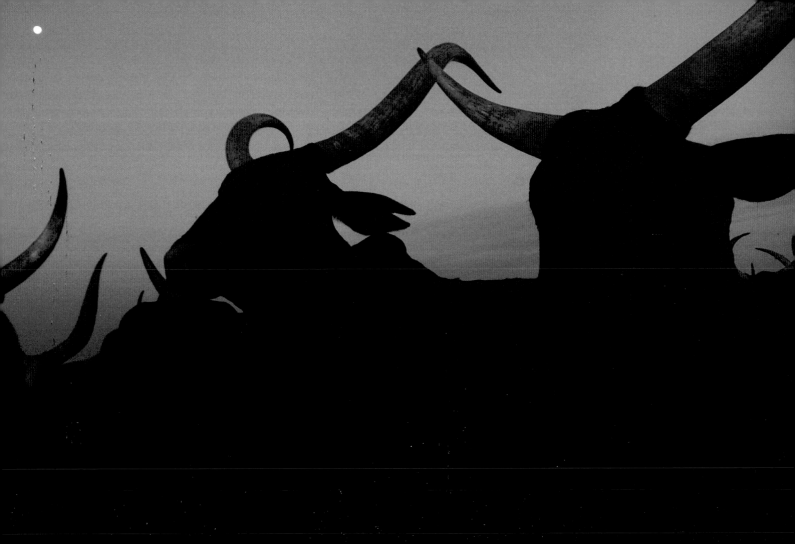

October 15

Everything is linked. Everything is alive. Everything is interdependent.

—Amadou Hampâté Bâ quoted by Aminata Traoré

Epopa Falls, on the Angola–Namibia.

As work progressively makes do without human life, so it ceases to make human life its ultimate end, that is,

to bother with mankind. Man has never been as unhappy as now, when he is accumulating so much.

Nowhere is he so despised as where this accumulation is taking place. That is why the history of the West seems

to me to be so revealing of the insufficient guarantee that man constitutes for man.

—Cheikh Hamidou Kane

Returning from market, Burkina Faso.

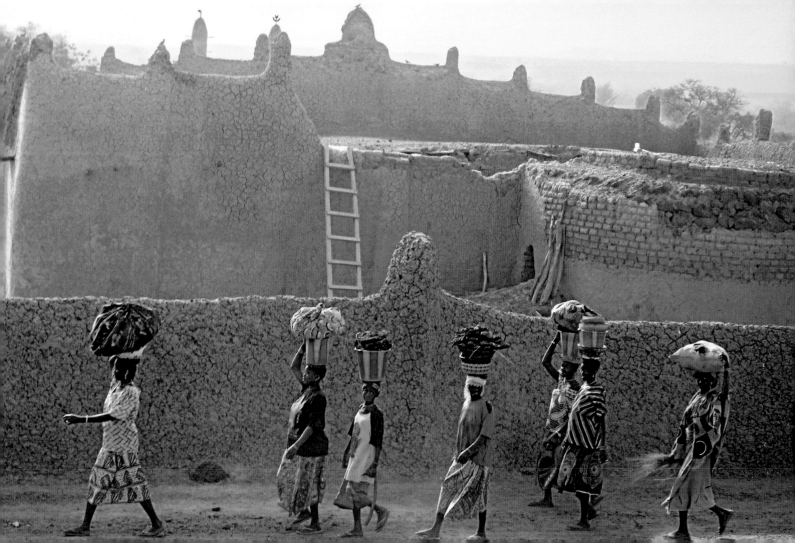

—But if the life does not justify itself before God? I mean to say, if the man who is working does not believe in God?

—Then what does it matter to him to justify his work in any other way than by the profit he gets from it?

—Cheikh Hamidou Kane

At the Djenne market, Mali.

The huge production of a variety of consumer goods will probably not improve mankind as such—quite the opposite;

and production for production's sake will soon be followed by consumption for consumption's sake.

—Ebénézer Njoh-Mouelle

The bus stops at Tonkar, Mali.

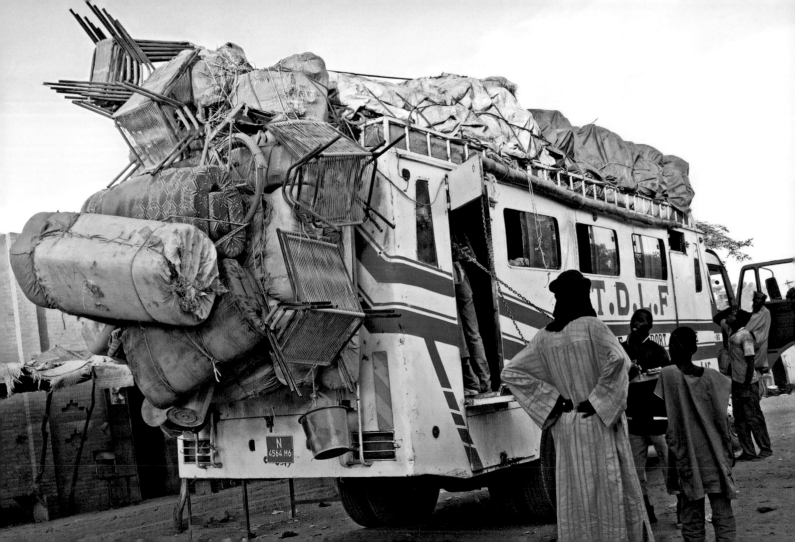

One accumulates frantically, believing that in multiplying riches one multiplies life.

Finally, one can work from a mania for working—I do not say to distract oneself, it is more frenzied than that;

one works like a stereotype. It is with work as with the sexual act: both are aimed at the perpetuation of the species;

but both may have their perversion when they do not justify themselves by this aim.

—Cheikh Hamidou Kane

Meal preparation in Himba country, Namibia.

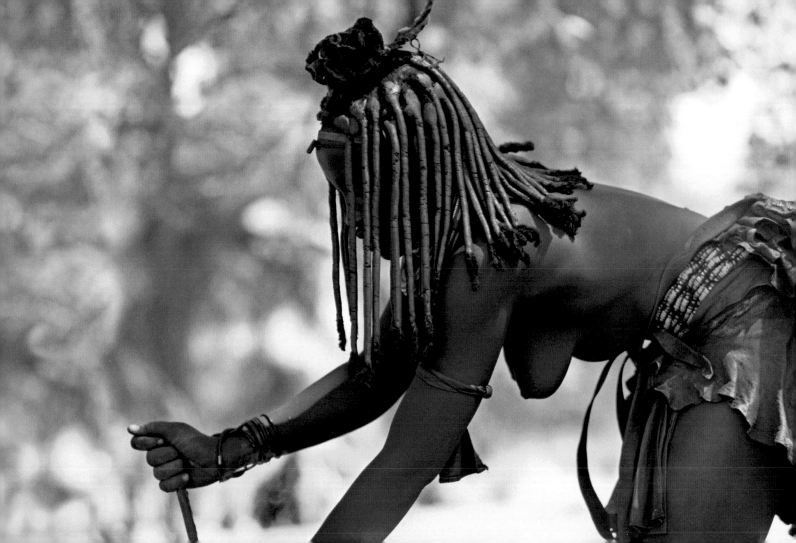

Money is good, but man is better, because he answers when you call.

—West African oral tradition

The fishermen return, Lake Chad, Chad.

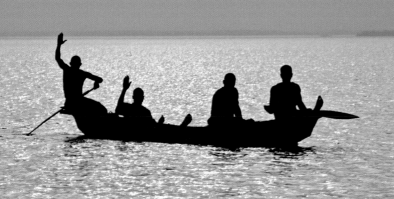

Life and work are no longer commensurable.

In former times there existed a sort of iron law, which decreed, in action,

that the labor of one single life was able to provide for only one single life.

Man's art has destroyed this law.

The work of a single being supplies nourishment for several others, for more and more persons.

But now see: the West is on the point of being able to do without man in the production of work.

There will no longer be need of more than a very little life to furnish an immense amount of labor.

—Cheikh Hamidou Kane

A fishing catch, Senegal.

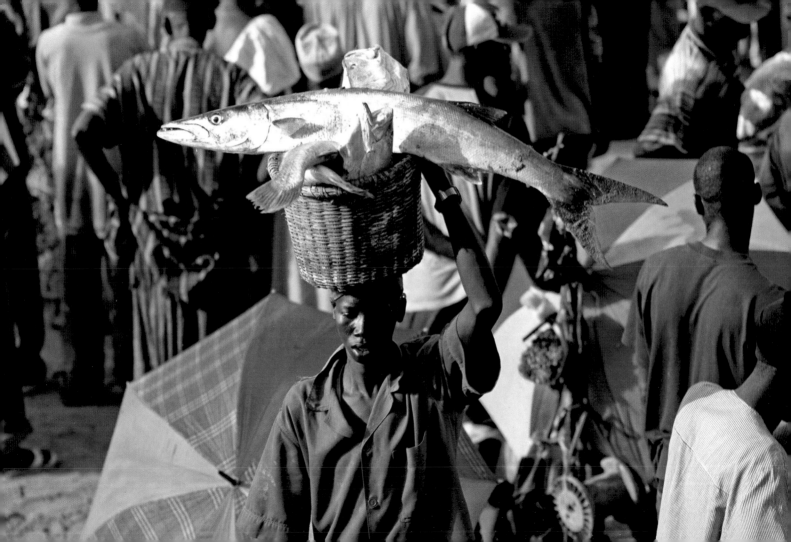

Man is the medicine for Man.

—*Wolof proverb*

School at the Mangetti Dunes, in Bushman country, Namibia.

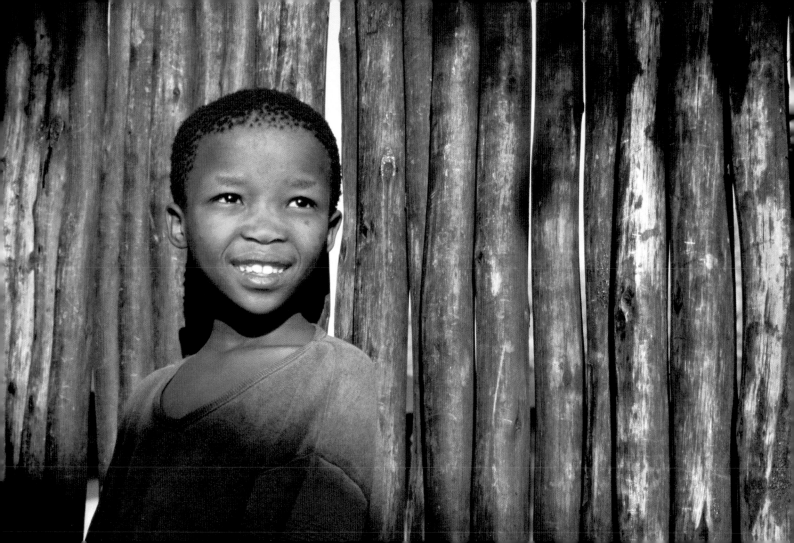

The most intimate aspects of development are virtually indefinable or impalpable,

like happiness, health, and joy.

—Joseph Ki-Zerbo

Feast day in Dogon country, Mali.

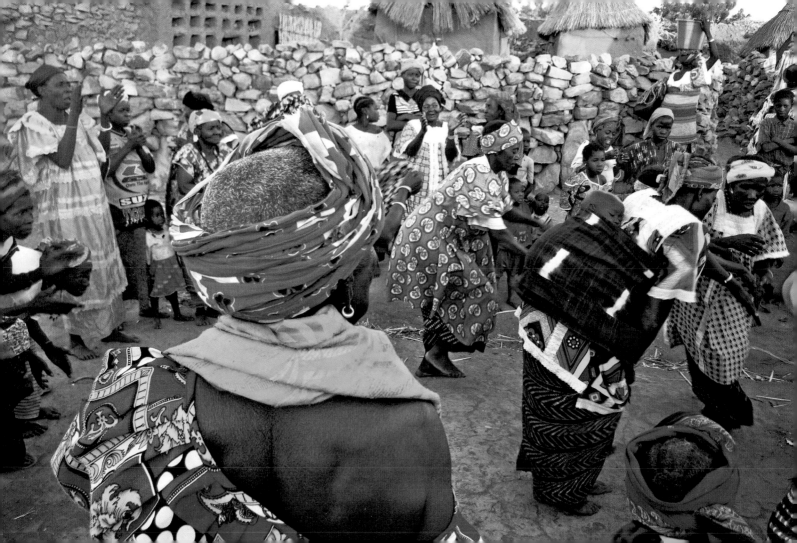

One of our strongest weapons is dialogue.

—Nelson Mandela

Final bargaining, Djenne, Mali.

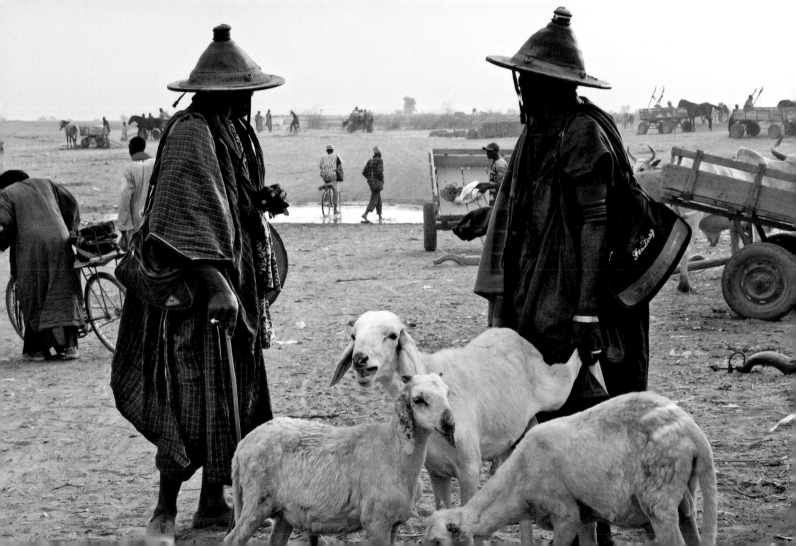

The African mentality consists not of being and/or producing, but of seeming and distributing.

—Joseph Ki-Zerbo

Onion harvest, Mali.

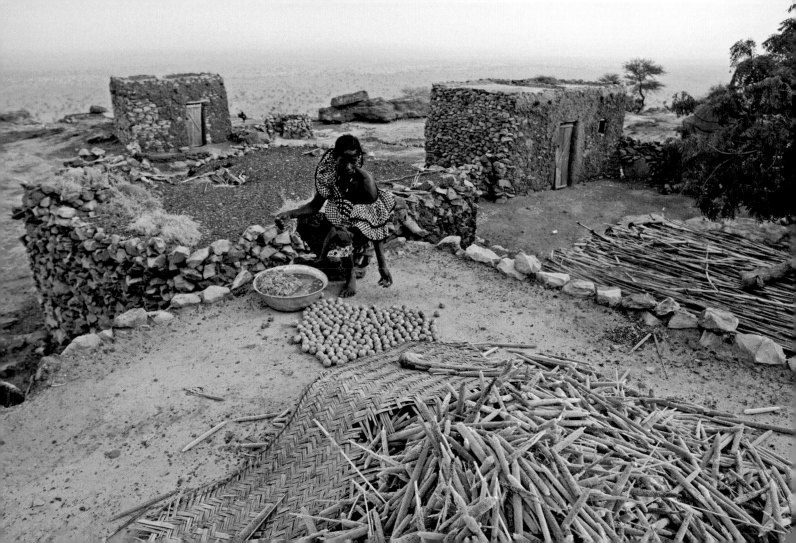

If you are rich and not generous,

it is as if you had nothing.

—*Bassar oral tradition*

Djenne market, Mali.

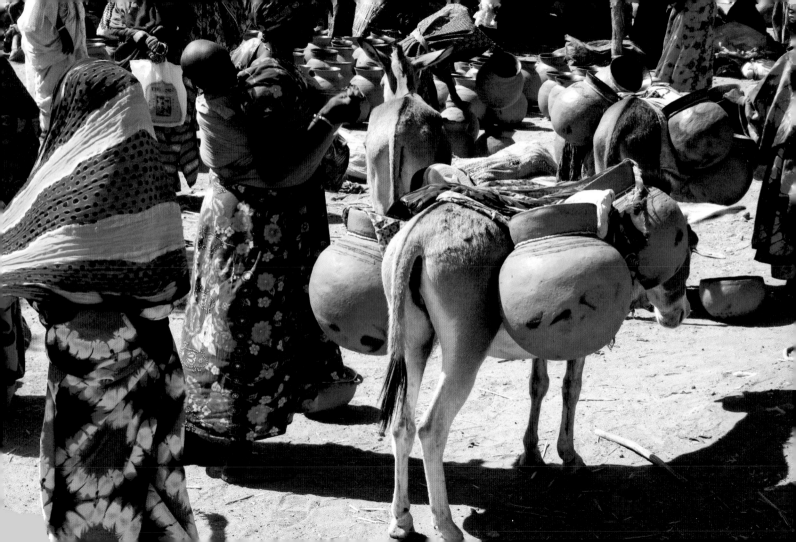

In truth, it is not acceleration that the world needs.

What we must have is a bed, a bed upon which,

stretched out, the soul will determine a respite, in the name of its salvation.

Is civilization outside the balance of man and his disposability?

The civilized man, is he not the expandable man?

—Cheikh Hamidou Kane

Returning to the village, Mali.

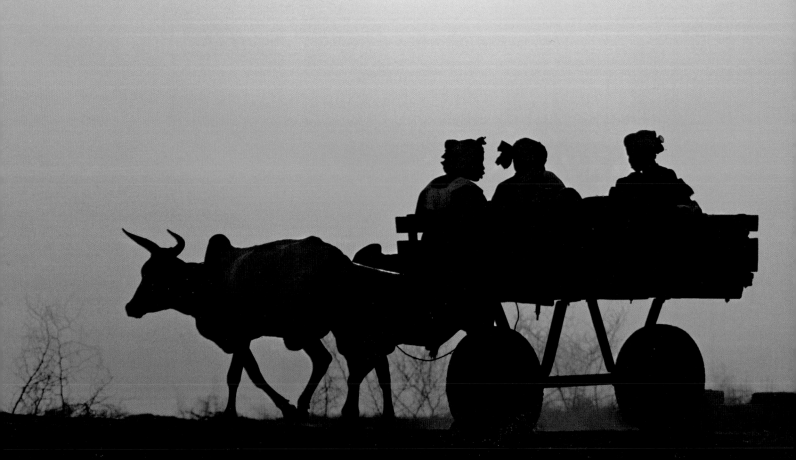

Share!

That's the key word,

The word we can't avoid!

—Ken Bugul

A good fishing day, Nigeria.

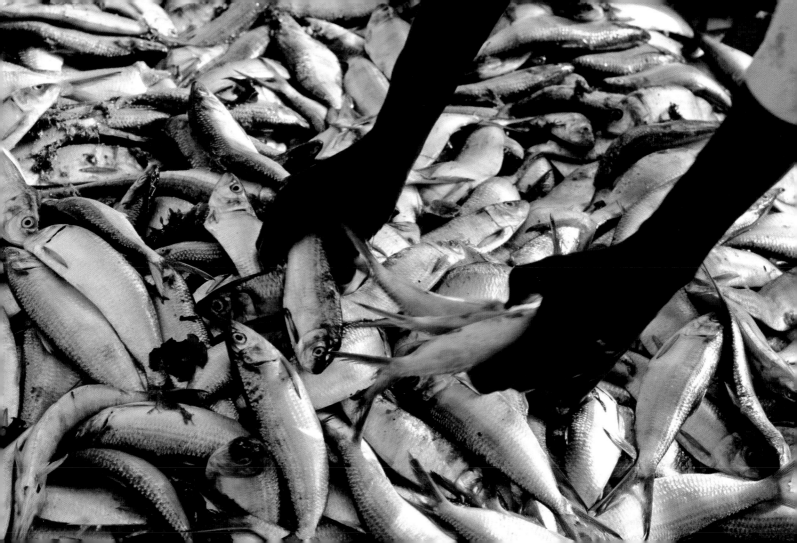

I *am calling a feast because I have the wherewithal.*

—*Chinua Achebe*

Children of Kinisserom;
Lake Chad is the border between Chad, Niger, Nigeria, and Cameroon.

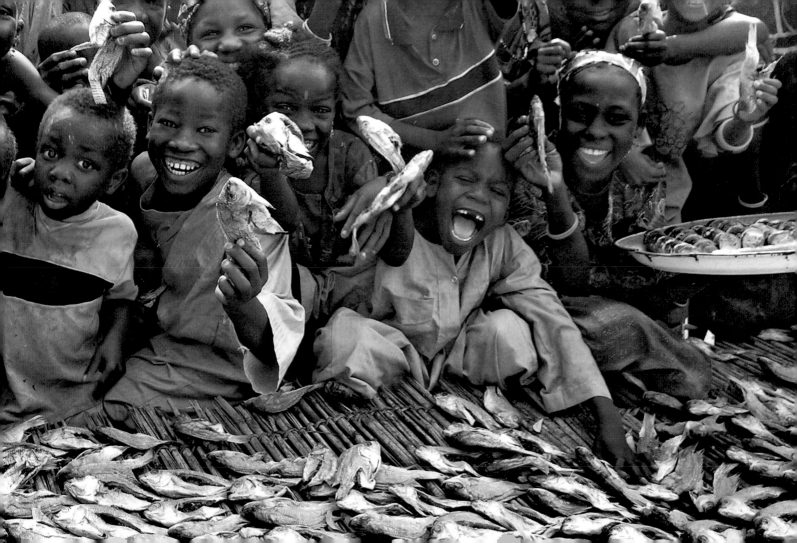

On this side and that I hear "Africa is poor," "Africa is an enigma,"

"Africa is a millstone around humanity's neck."

To these voices deciding whether we belong in the world, I reply,

"Africa is generous," "Africa is a martyr," and nonetheless,

"Africa is the solution."

—Aminata Traoré

Amadou, 10 years old, Mali.

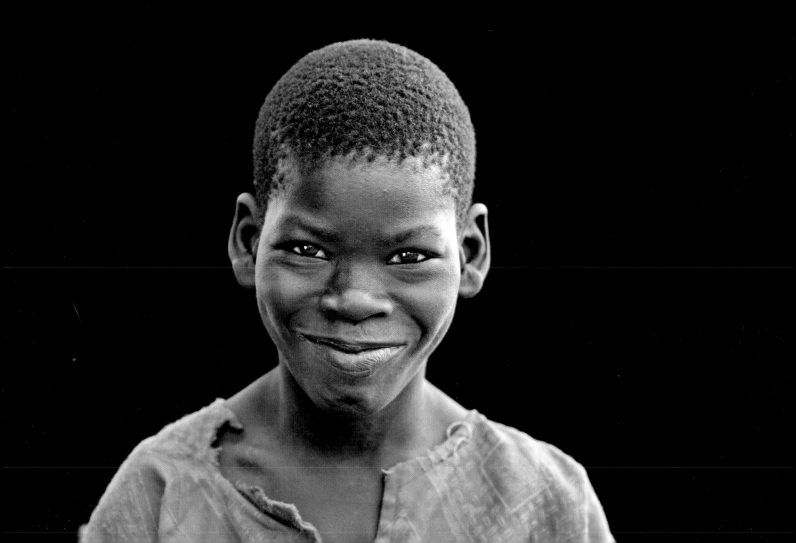

Realize that you are involved in a situation that is a lot greater than who you are.

—*Sobonfu Somé*

A father and son returning from the fields, Bushman country, Namibia.

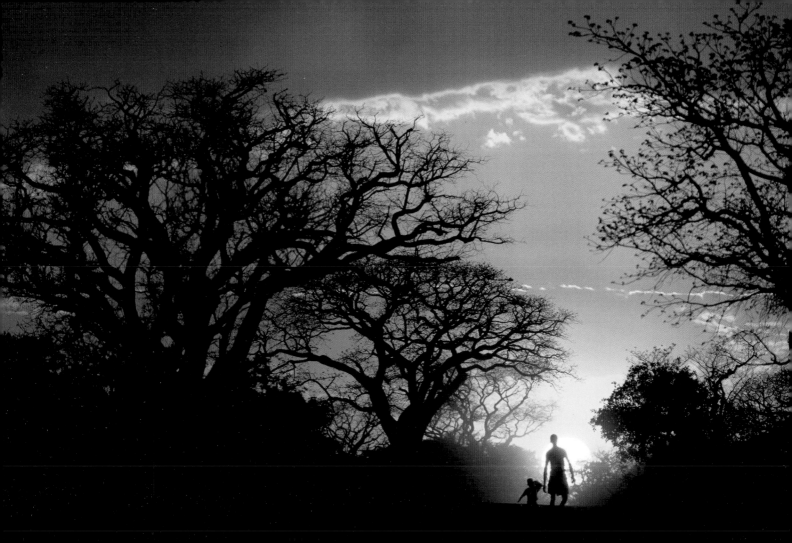

At a village level, communication is the most important thing,

that of addressing everyone with those problems that are common.

—Joseph Ki-Zerbo

Villagers of the Ethiopian plateaus.

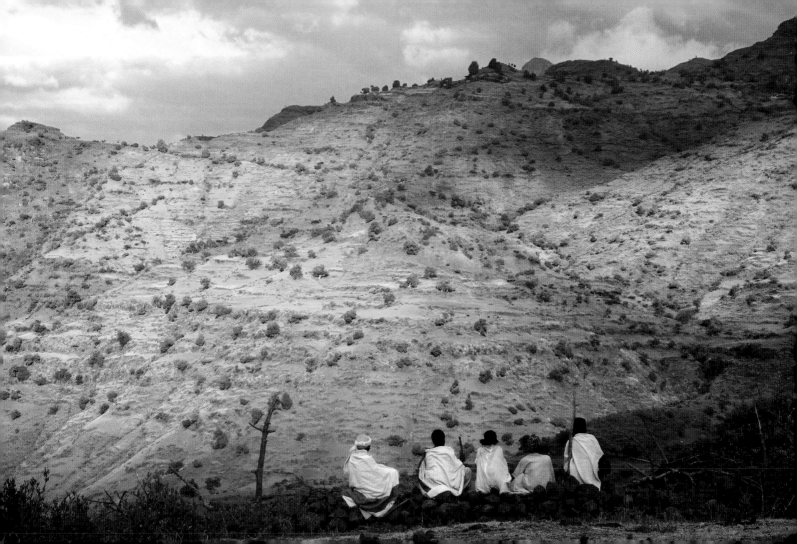

Culture is the possibility to create, renew, and share values.

It is the oxygen that enhances humanity's vitality.

It has to do with spirituality, something that the state is not always concerned about.

—Jacques Nanéma

A sandstorm, Chad.

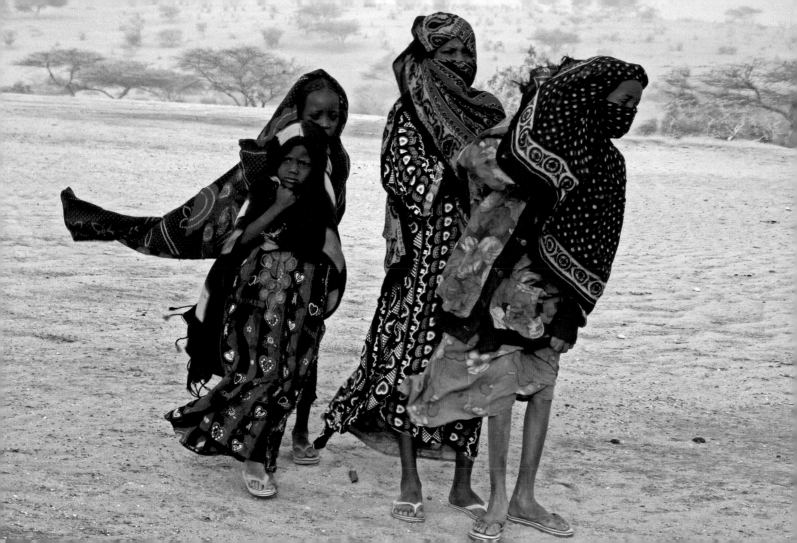

The man of culture should be a finder of souls.

—Aimé Césaire

Yemrehanna Krestos school, Ethiopia.

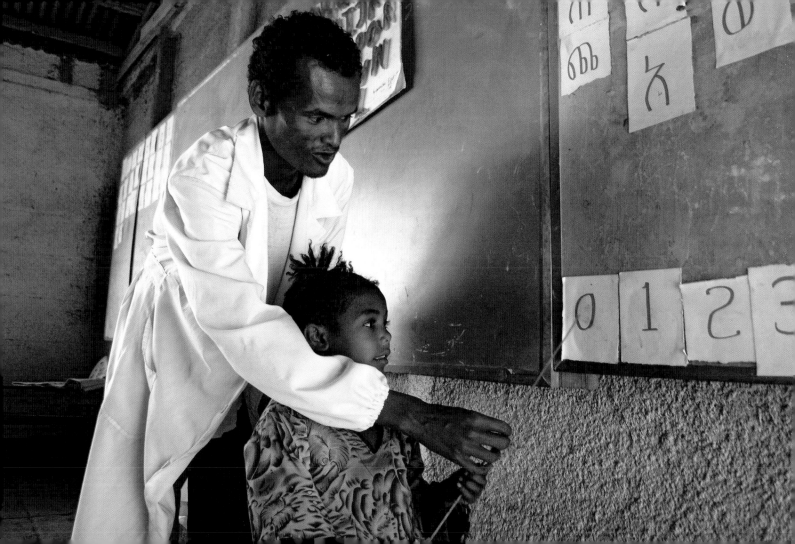

All work directed toward culture is equally directed against war.

—Sigmund Freud quoted by Aminata Traoré

Kazumo, a young Himba, Namibia.

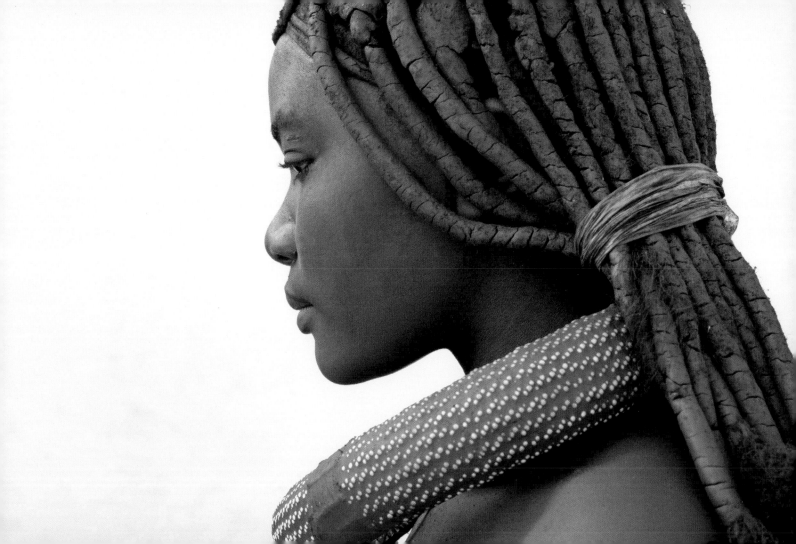

November 5

A man without culture is like a zebra without stripes.

—Ancient Masai proverb

Etosha National Park, Namibia.

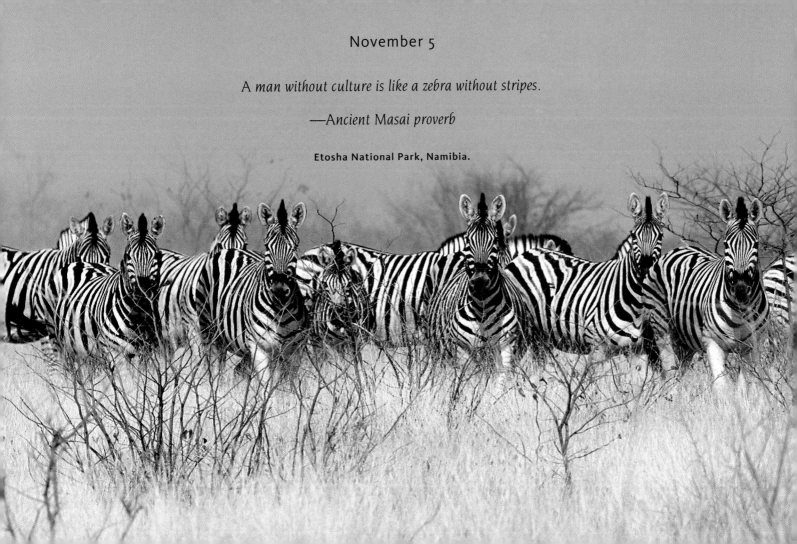

Power is like an egg: if you hold it too tightly, it will break in your hand;

if you do not hold it firmly enough, it will slip out of your hand and, again, break.

Power needs to be exercised with neither too much severity nor too much laxness.

It is a profound image that compares power to something as precious as an egg, which carries the germ of life.

For it is true: those who are in power hold the lives of people in their grasp.

—Joseph Ki-Zerbo

Protective gesture, Senegal.

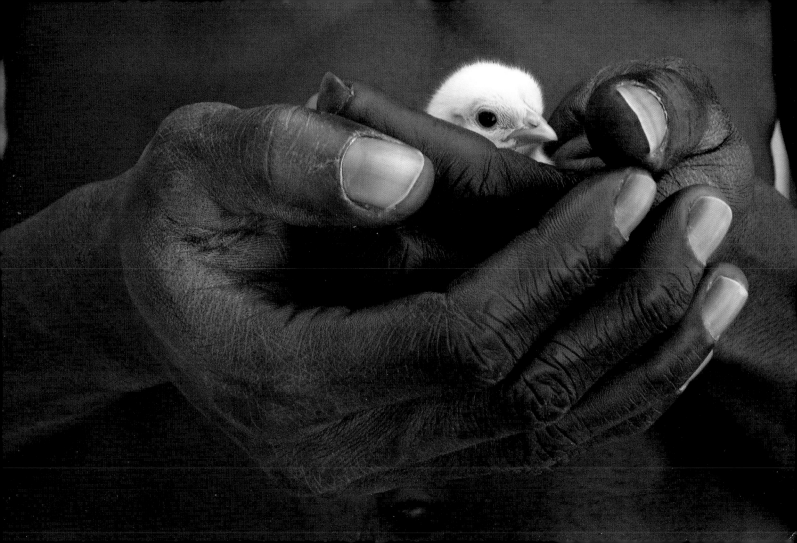

In the village we do not have police;

we rely mainly on spirit and on the elders for justice.

—Tukulor village chief

Bambara statue on a Senegal beach.

For us, in the western savanna, there are four sorts of persons to whom we may never say no:

our procreators, our initiation master, our king, and the stranger whom God sends us.

—*Peul oral tradition*

A sandstorm, Chad.

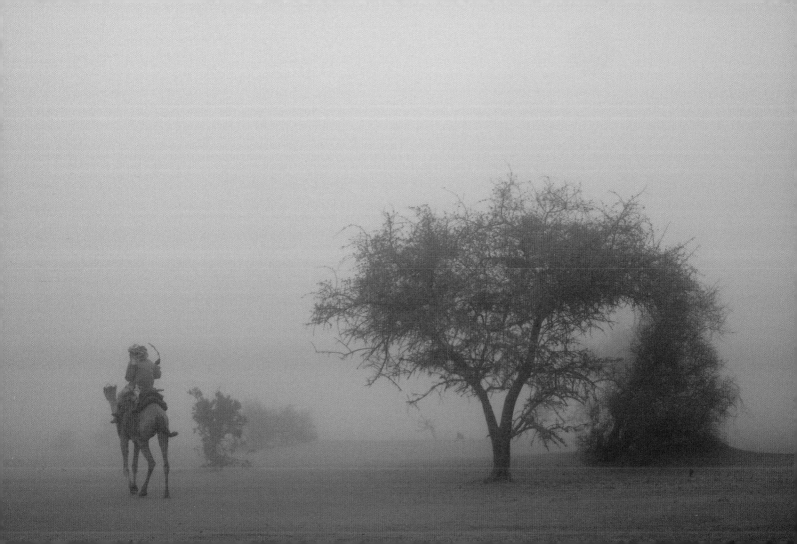

The basic idea is to distribute power as much as possible, so that everyone has a piece of it and feels involved.

That is what has enabled these systems to survive through so many centuries.

—Joseph Ki-Zerbo

Popular rejoicing, Ethiopia.

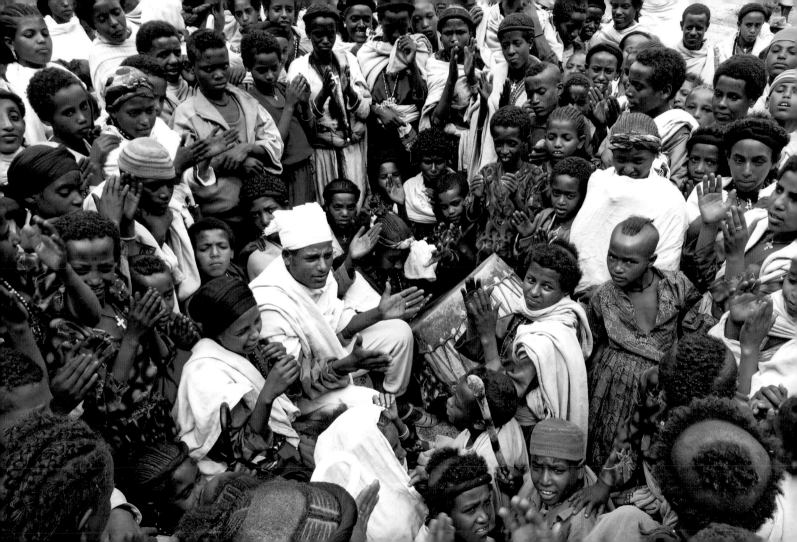

In Benin, if you see an earthenware jar of water placed under a tree in front of a house,

it is for you, the passing stranger. No need to knock at the door to ask permission to drink.

If no one is around, you need only open the jar, seize the gourd, drink, and go on your way.

(The passing stranger may be the representation or avatar of a god coming to check out how he may be received.)

—Dr. Raymond Johnson

Tea and conversation, Chad.

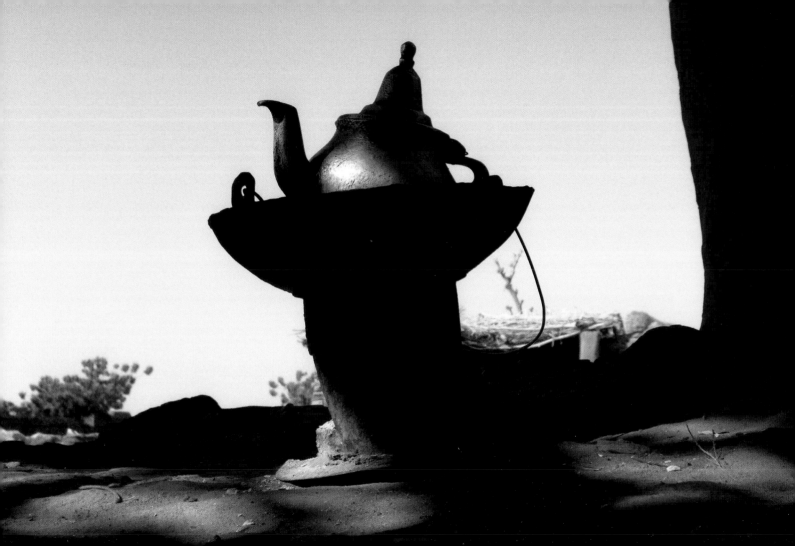

The stranger! The one who is served plenteously with food.

It is for the stranger that the fat calf is killed.

If you see a stranger, regard him as a king.

—African oral tradition quoted by Diatta Nazaire

Alemayehu, in her earthen kitchen, Ethiopia.

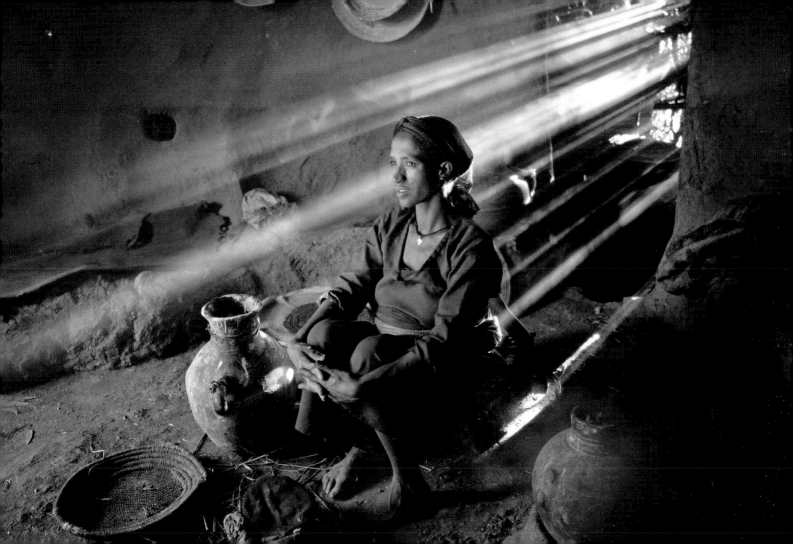

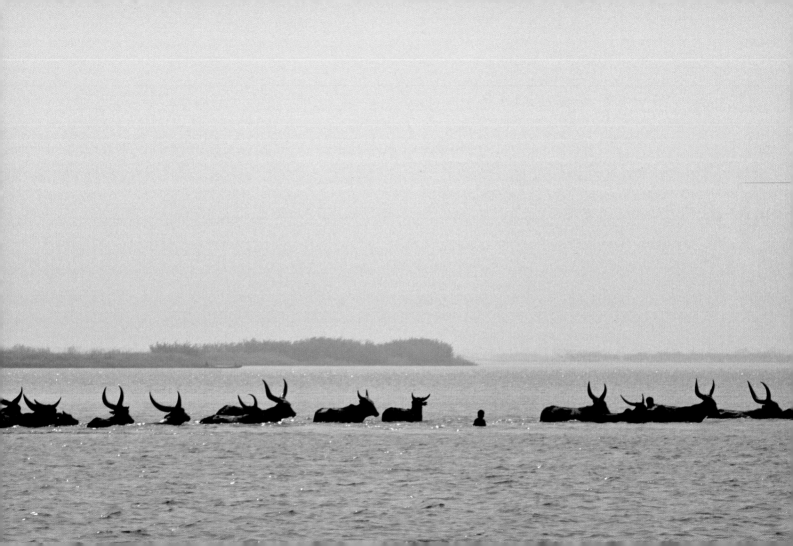

November 12

Rank does not confer privilege or give power. It imposes responsibility.

—Louis Armstrong, Paris, June 1975

The return of the Kouri cows, Lake Chad, Chad.

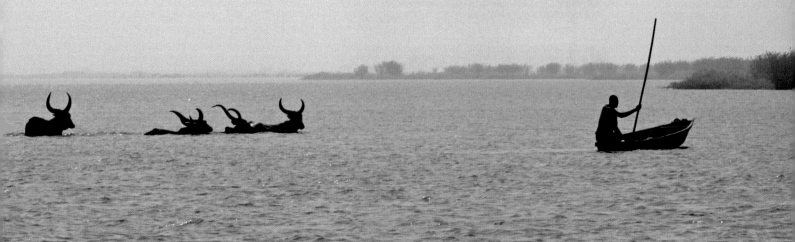

Nobles are duty-bound to be generous to the point of prodigality;

courageous to the point of heroism;

discreet and restrained in their manners;

and totally in control of their animal instincts, drives, and passions.

That is the very precise definition of the Pulagu ideal.

It is such a noble, the champion of Pulagu,

who will win through the course of trials that will bring him royal status.

—Amadou Hampâté Bâ

Timkat prayers, Ethiopia.

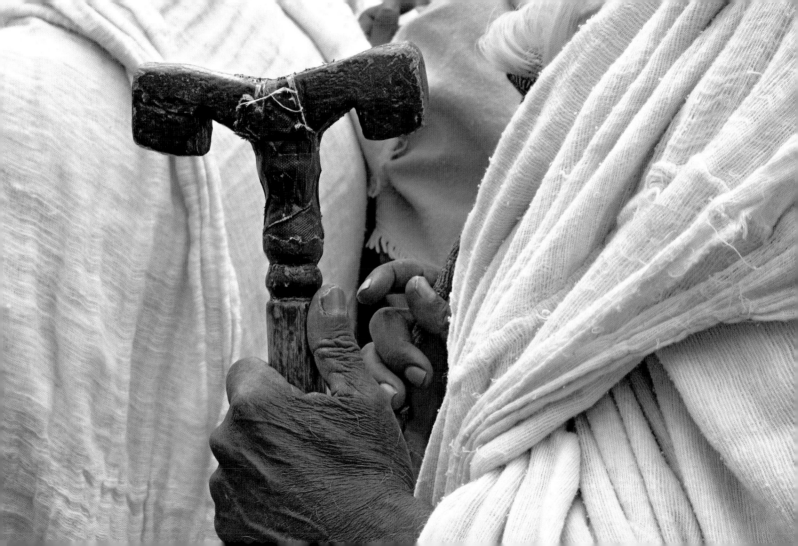

Among the Mossi, the candidate for chief used to present himself in the simplest possible gear

before he was designated or invested. He wore modest breeches, and was bare-chested, with a sheepskin covering.

This signified at the outset that the king was stripped of everything; he came to power with nothing,

and was expected to conduct himself without profiting at his subjects' expense.

—Joseph Ki-Zerbo

Tjimbwariuwo, a young Himba, Namibia.

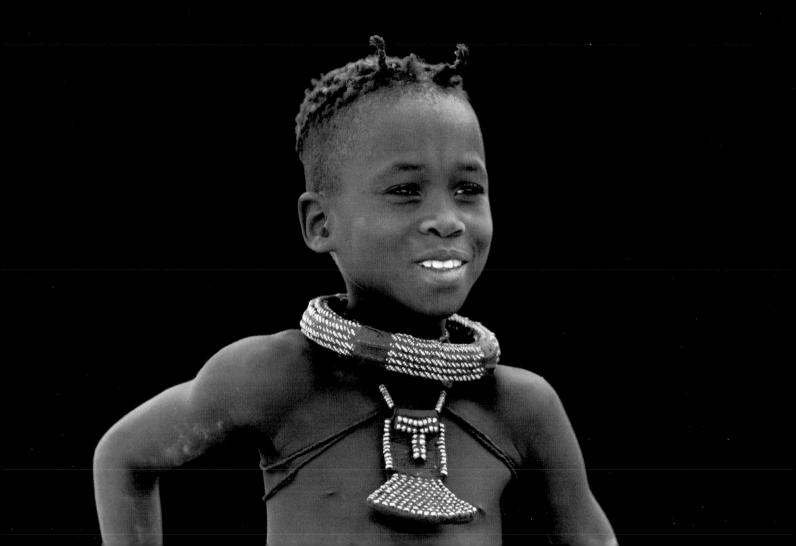

Your house is the most scantily furnished in the countryside,

your body the most emaciated, your appearance the most fragile.

But no one has a sovereign authority over this country that equals yours.

—Cheikh Hamidou Kane

Puros, northern Namibia.

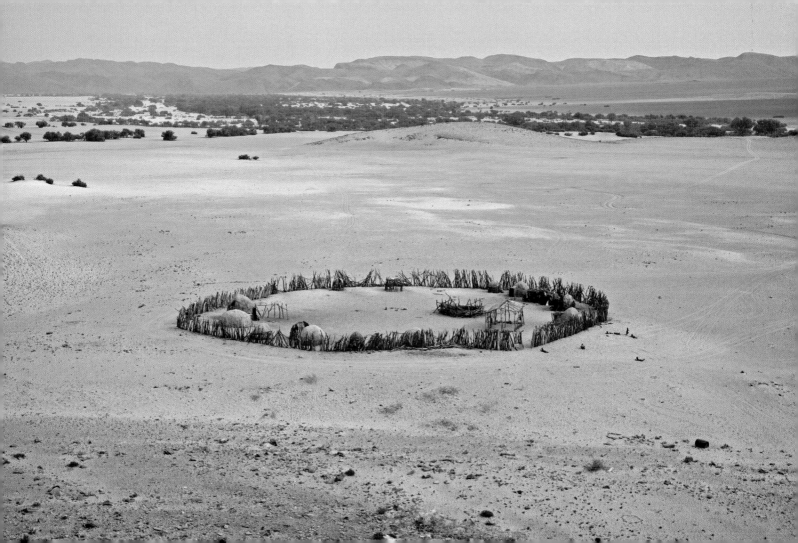

No one, whatever their social status, ever sees the top of his or her own skull.

There always comes a time when you need someone else in order to see clearly.

—*Peul oral tradition*

The Choudop watering hole, Namibia.

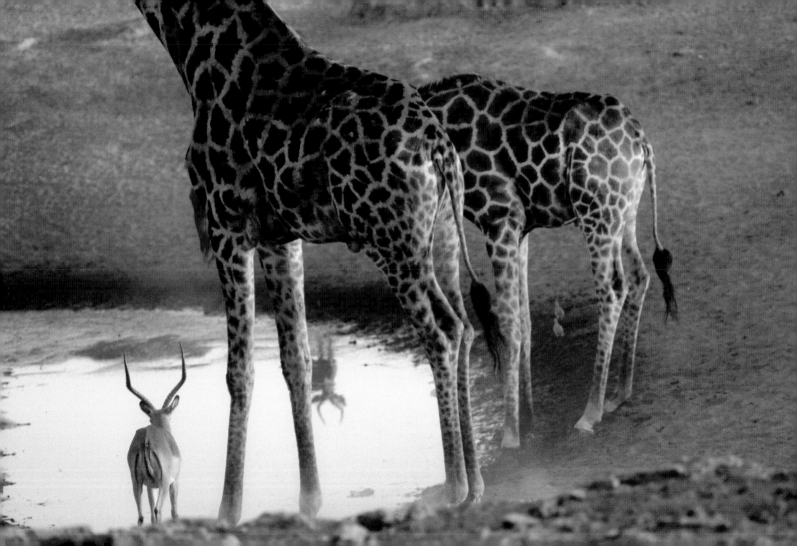

But I, Titinga,

I *know that a man,*

Though *he be tall,*

He *cannot be any taller*

Than *his hair.*

—Titinga Frédéric Pacere

Nouhoum Toumoute, of the Dogon village of Indelou, Mali.

Here is what ritual probably is, an incomparable feat of sublimation.

Just as "strength is violence guided and tamed," a rite is probably subdued violence:

by channeling and softening deadly impulses, it can act powerfully on our natures

to make them serve socially valuable practices that call forth good sense and mental creativity.

—Vladimir Jankelevitch

Feast day, Ethiopia.

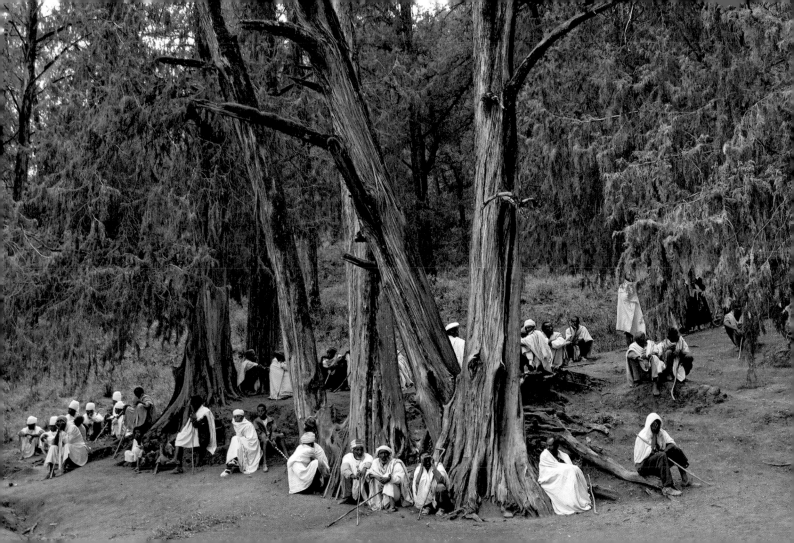

There is no absolute master;

you are always both pupil and master

at the same time. The master teaches others,

but he also learns with them.

—Dogon village chief

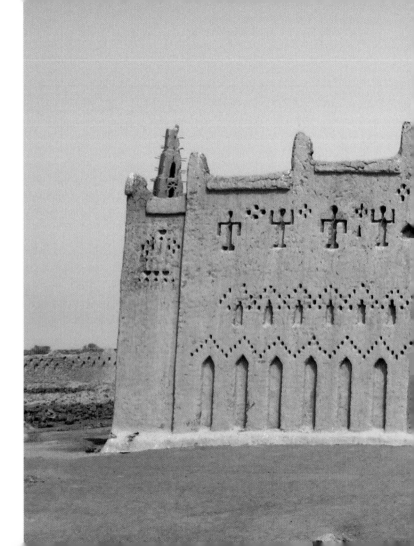

One of Bani's seven mosques, Burkina Faso.

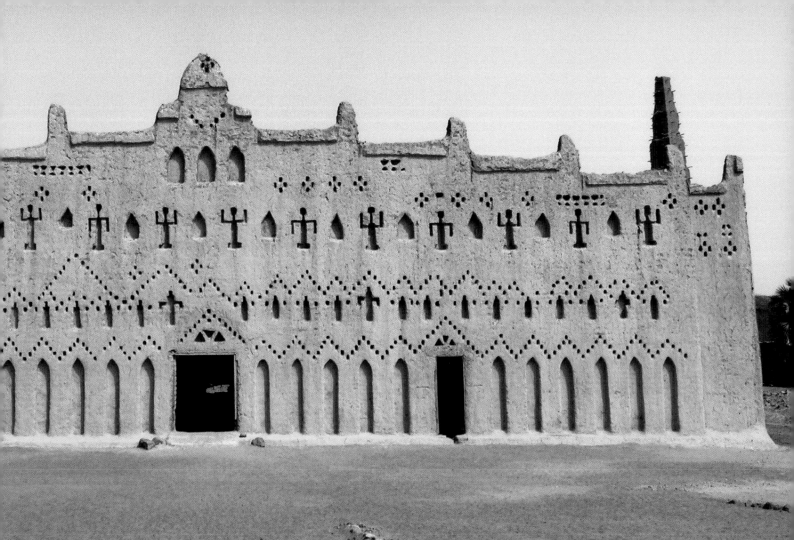

No important act relating to the life and customs of a family is properly sealed or has a good prospect of success

unless it opens with the name of the most important elder, followed by the lower elders, and finally everyone.

—Bantu oral tradition

A great-grandmother whose age escapes her, Mali.

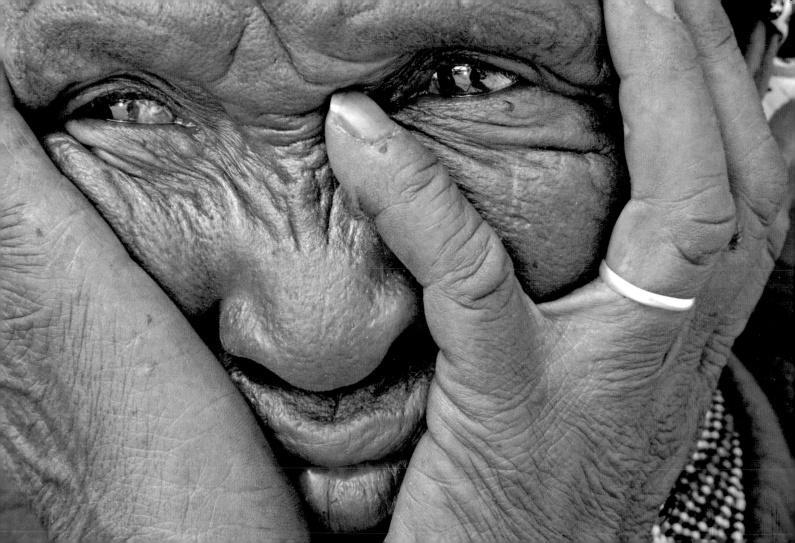

What is the point of worshiping at the shrine of security,

when everything reminds you that you are only a fleeting passenger on this ship of the world,

buffeted by every wind? Everything around you gives you the same message:

"Do not settle down; this is not your home."

—Irénée Guilane Dioh

Returning to the village, on the Niger River, Mali.

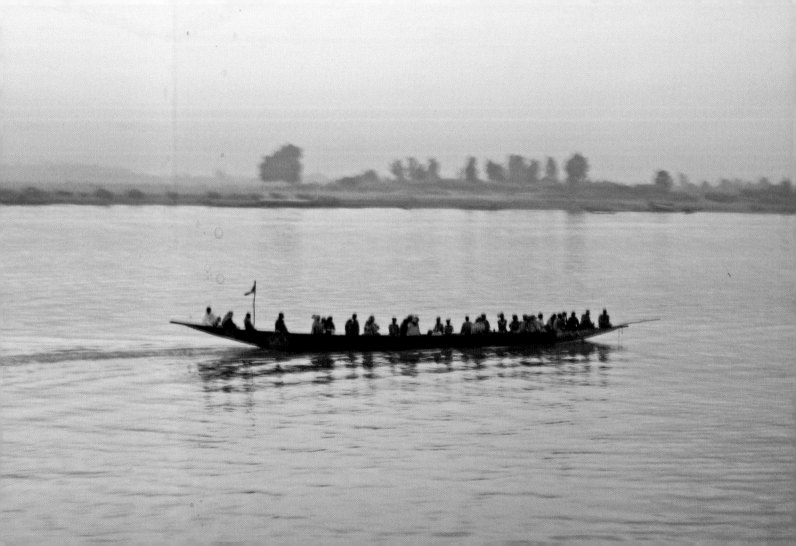

When somebody dies, it is said of him, "His two feet are in agreement."

—West African oral tradition

Going to church, Ethiopia.

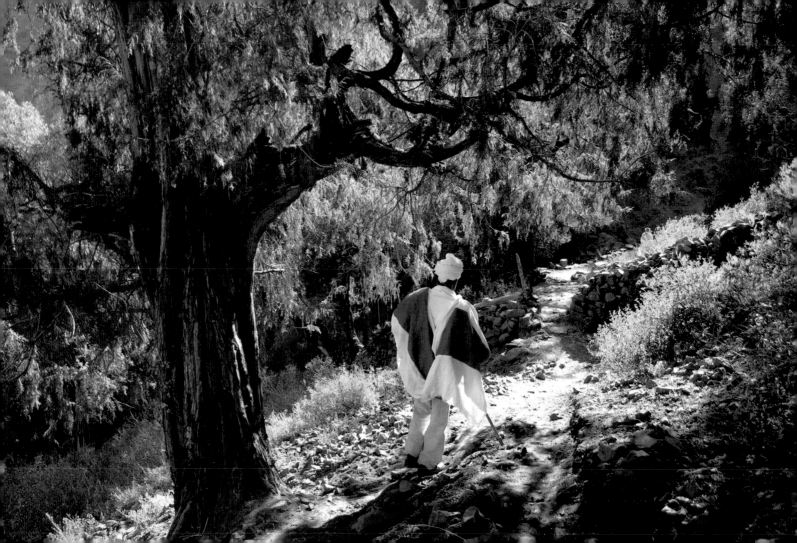

The sage fades away; he does not die.

—Bernard Dadié

Rain at last, Ethiopia.

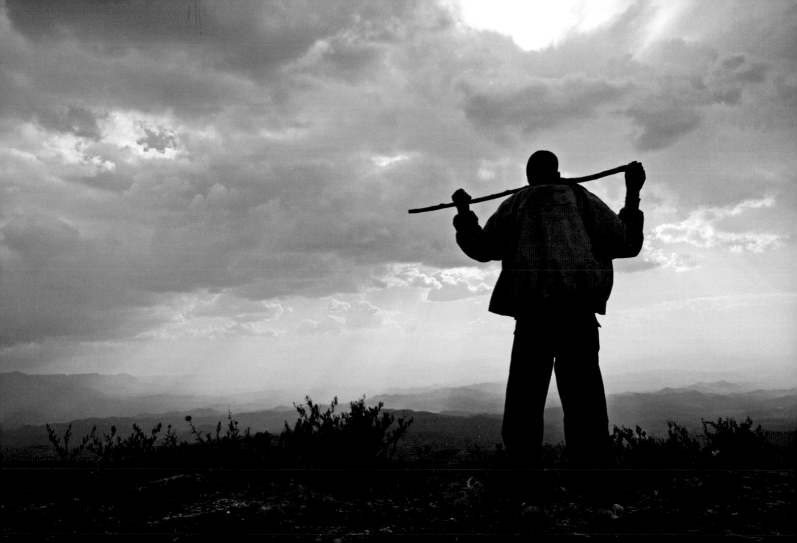

The dead stay upon the earth: they are on the other shore, certainly, but they continue to be on the same level;

nothing is happening in heaven. The only difference is that the other shore cannot be seen with the naked eye.

It is felt: the presence and influence of the dead are surmised.

From within the afterlife, the deceased continue to protect and support the community.

—Dr. Raymond Johnson

Waiting for the fishermen to return, Senegal.

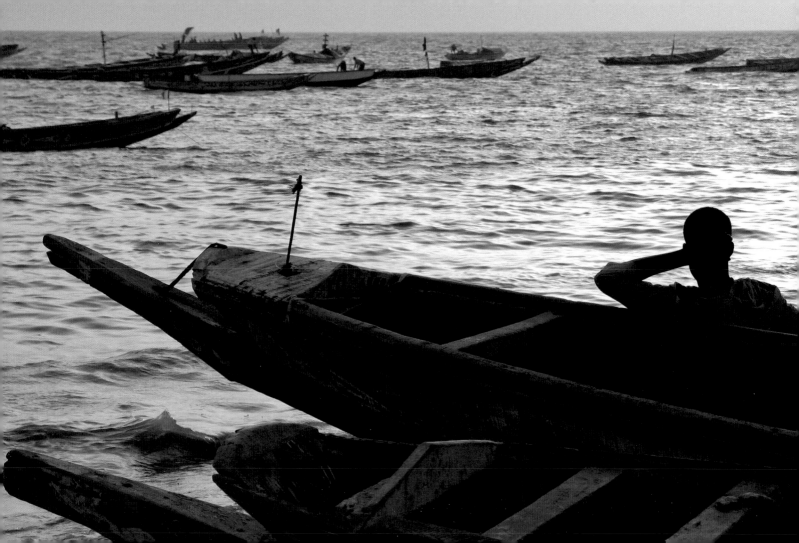

Death may represent a break with one's surroundings,

but it preserves an essential function of continuity in existence.

—Dr. Raymond Johnson

Ashanti statuette, Ghana.

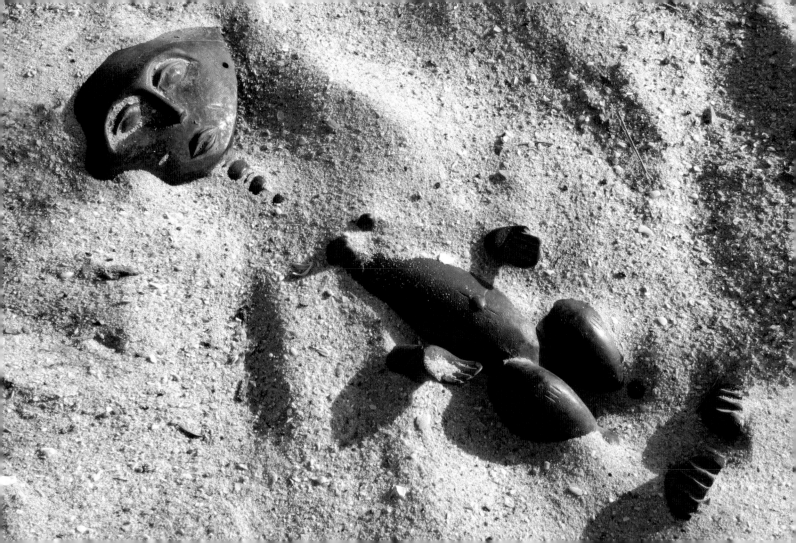

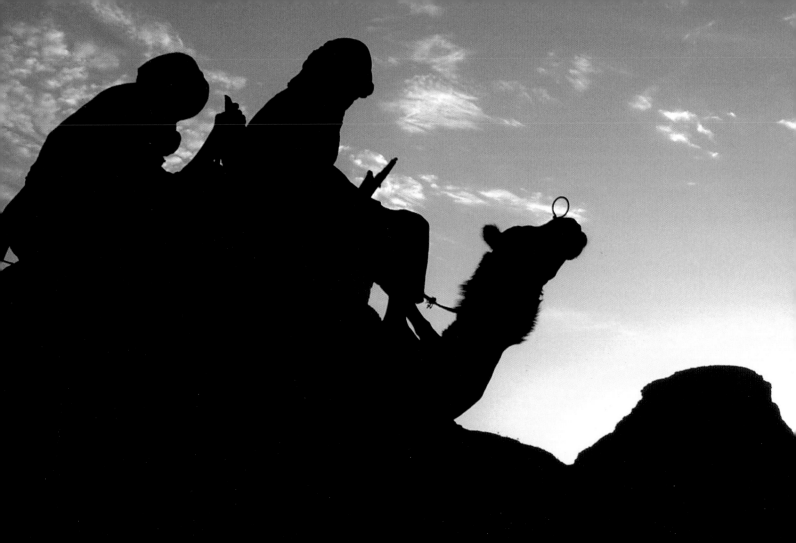

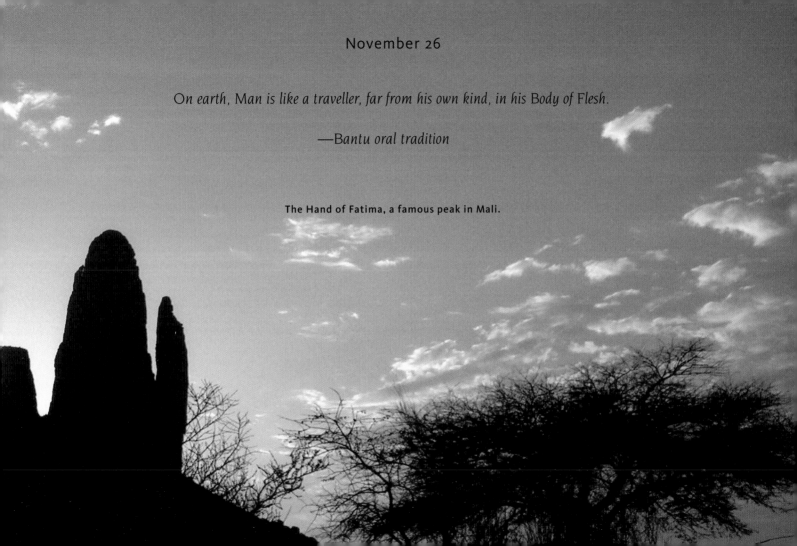

November 26

On earth, Man is like a traveller, far from his own kind, in his Body of Flesh.

—Bantu oral tradition

The Hand of Fatima, a famous peak in Mali.

Liberated from his earthly condition, the ancestor was taken in charge by the regenerating Pair.

The male led him into the depths of the earth, where, in the waters of the womb of his partner,

he curled himself up like a fetus and shrank to germinal form, and acquired the quality of water,

the seed of God, and the essence of the two Spirits.

—Dogon oral tradition

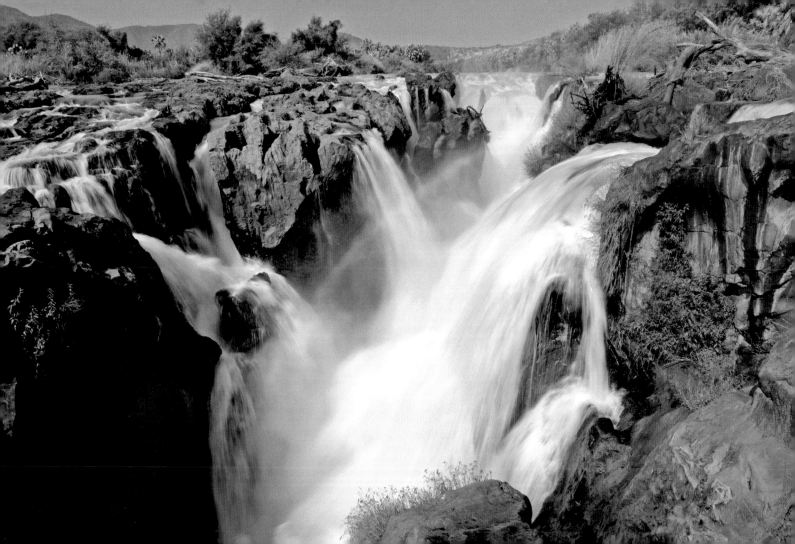

When I join myself to the totemic and legendary ancestors, I create a harmony of beings embracing the animal and plant worlds.

—African oral tradition

Mask dance, Dogon country, Mali.

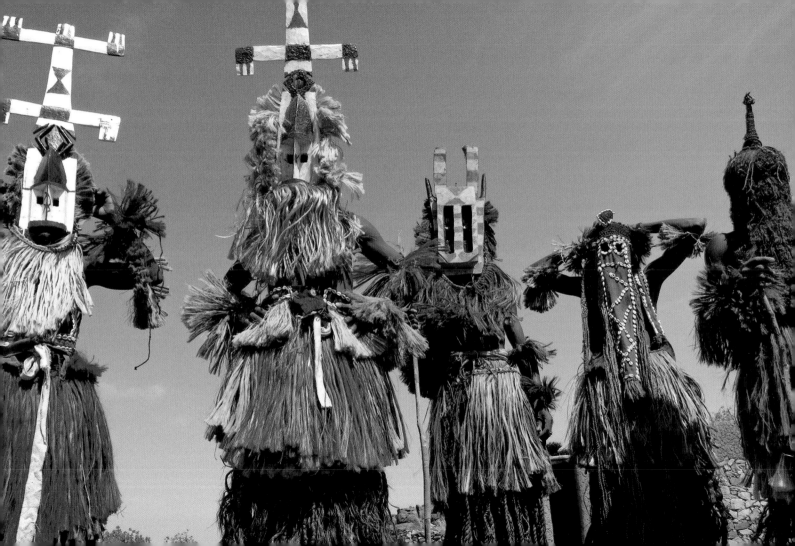

Those who are dead are not dead—

They are not under the earth.

They are in the tree that shakes.

They are in the water that flows.

They are in the water that is still.

They are in the hut; they are in the crowd.

The dead are not dead.

—Birago Diop

Twyfelfontein region, Namibia.

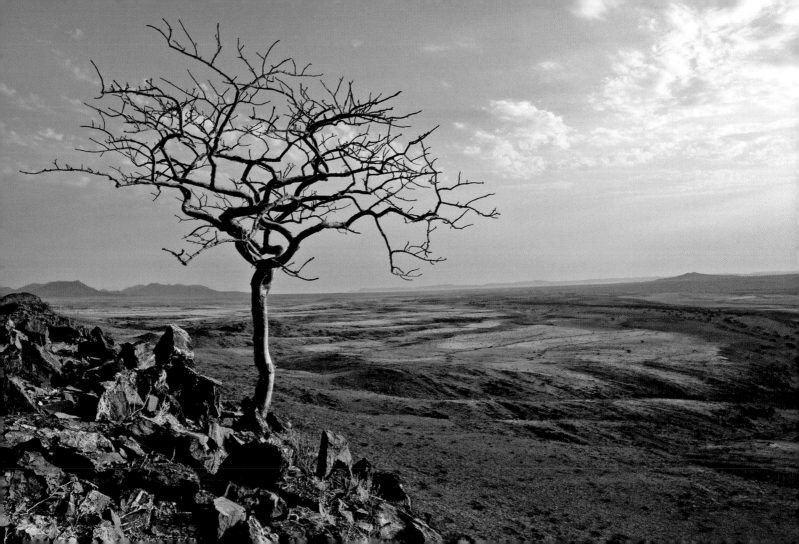

Man has a changing relationship with nature.

Nature lives off us and we live off nature.

I eat nature to live, and nature eats me to live.

Neither nature nor I die. We simply change places.

—African oral tradition

The Duineveld watering hole, Namibia.

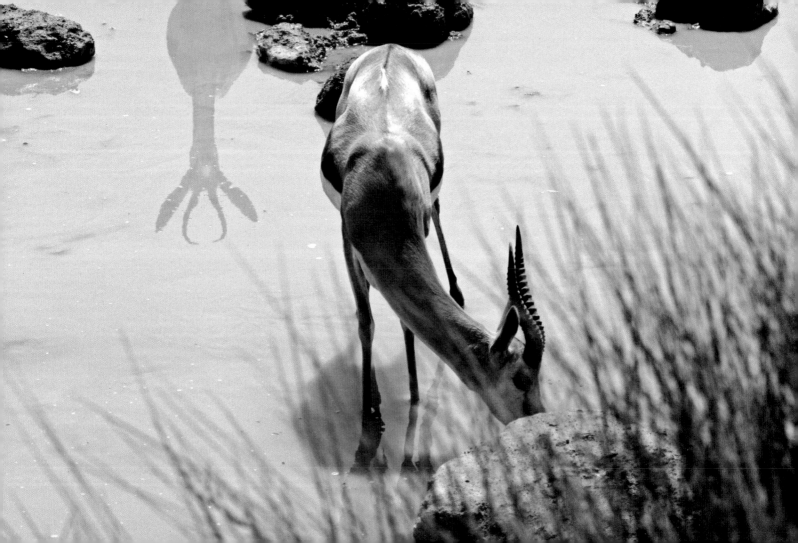

There is no such thing as an old man, for we are always young compared to the earth.

—Tukulor village chief

The patriarch visits the Goas watering hole, Namibia.

It is necessary to honor the memory of the deceased

so that memory of him is lastingly written into the collective memory.

The funeral honors the departure.

—Dr. Raymond Johnson

Timkat ceremony, Gondar, Ethiopia.

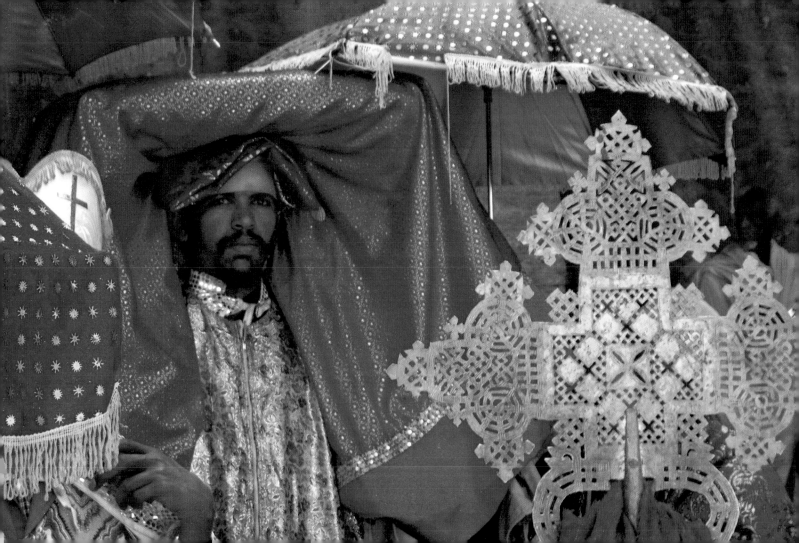

December 3

Let us love our birth, our living, our dying:

nothingness does not exist.

—Bernard Dadié

Day's end at the Mangetti Dunes, Bushman country, Namibia.

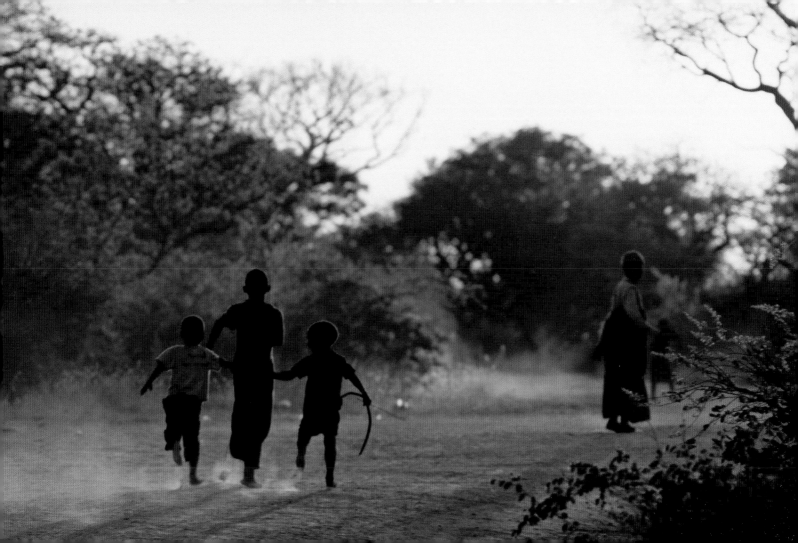

In the forest, when the branches quarrel, the roots embrace.

—West African oral tradition

Water duty, Ethiopia.

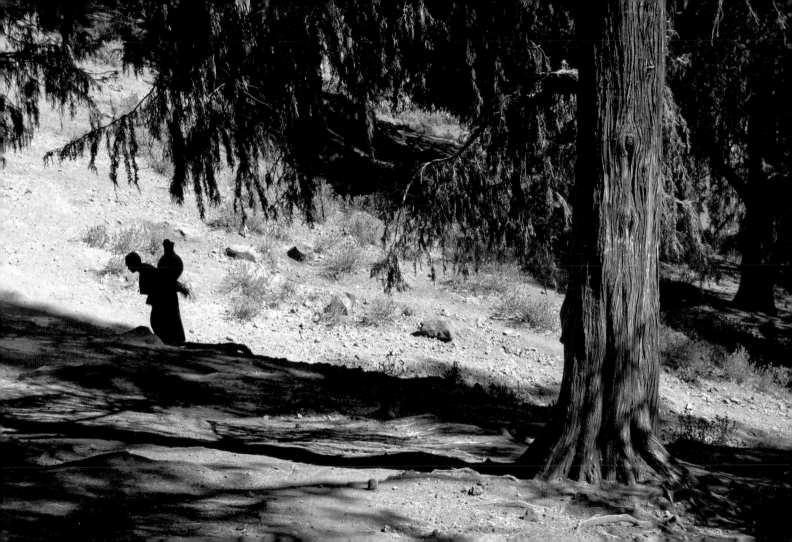

Forbearance is the ornament of the magnanimous man. He is familiar with his own limits.

He knows that wherever the child endeavors to walk, he risks failure, that falling is twinned with rising,

that tension is twinned with release, that man needs to be loved for what he is and not for what

others would have him be. Oh, the goodness of the magnanimous man!

He is never disillusioned, being ever enraptured by the miracle of life.

—Irénée Guilane Dioh

Glaece Gisse, an old Bushman, Namibia.

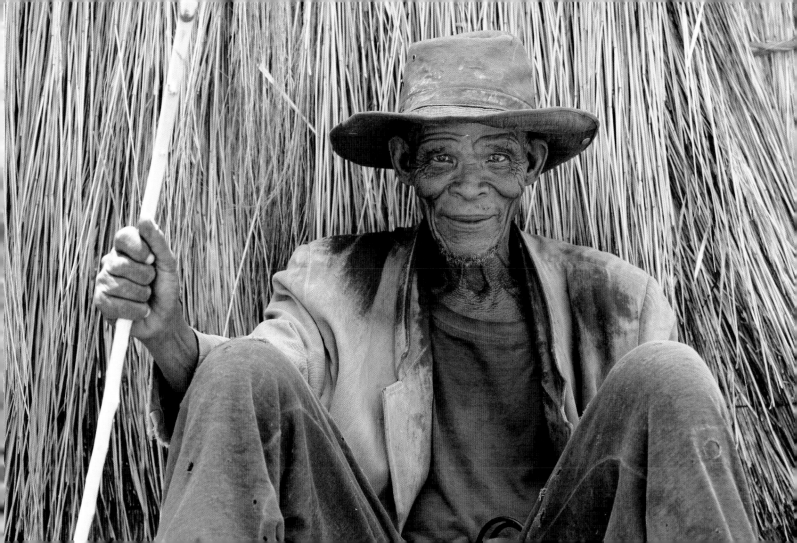

Life was good. People grew old with the time and never before time. They slept well and enjoyed themselves.

They did not have to rush in accordance with the hands of a clock, still less constantly jump when a siren went off.

They took time to enjoy everything. No one hurried. Life was there, before them, rich and generous.

They had a philosophy that allowed them to behave like that.

They knew they were members of a community that would never die out…

—Bernard Dadié

Returning from market, Mali.

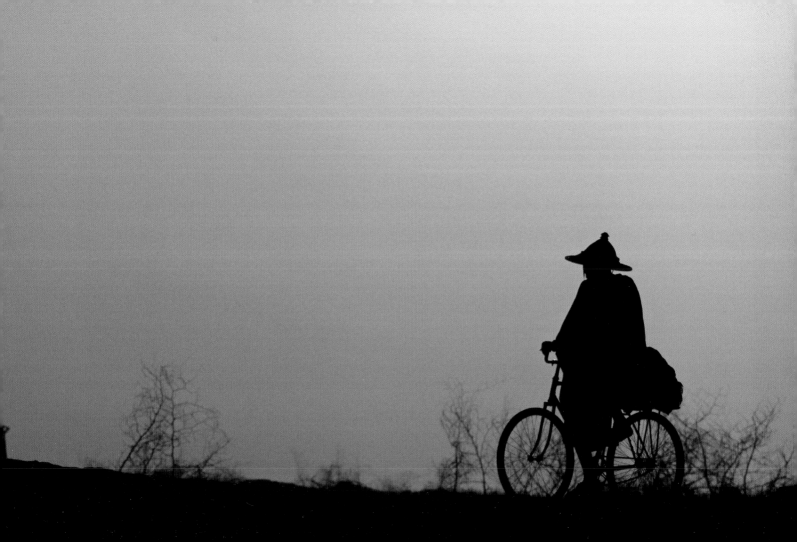

December 7

The sage is a sizable portion of divinity released upon the earth to improve the masses.

—Bernard Dadié

Kauusora, a Himba mother, Namibia.

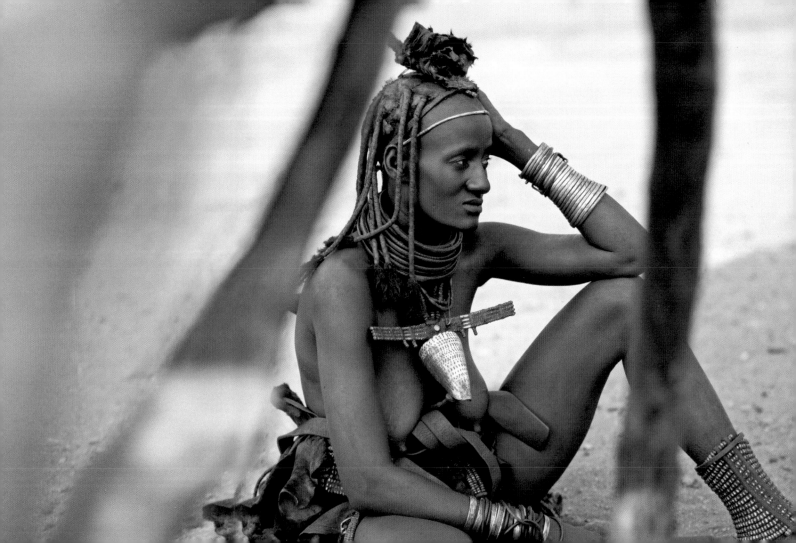

Never be in too much of a hurry:

nature is patience.

—Elder West African female initiate

Huts at Tama Lodge, Senegal.

In tribal life, one is forced to slow down, to experience the now and commune with the earth and nature.

Patience is a must; no one seems to understand the meaning of "hurry up."

—Sobonfu Somé

En route for Makena Medhane Alem, on the Ethiopian plateaus.

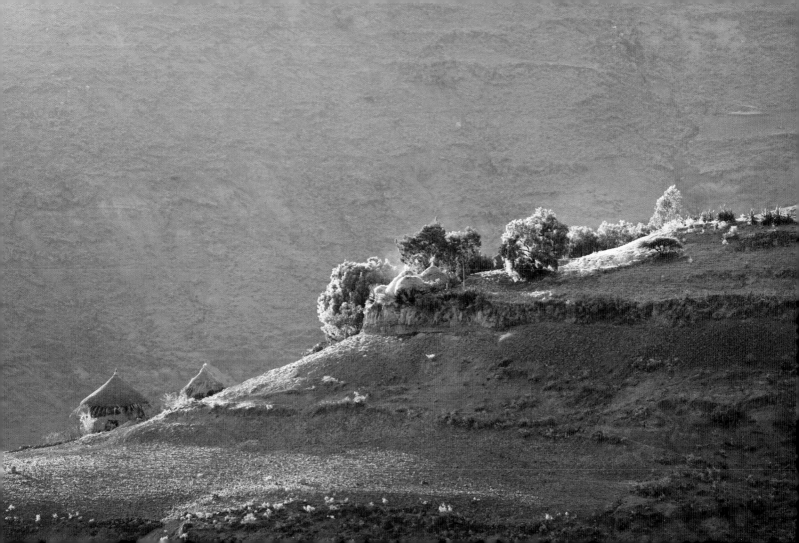

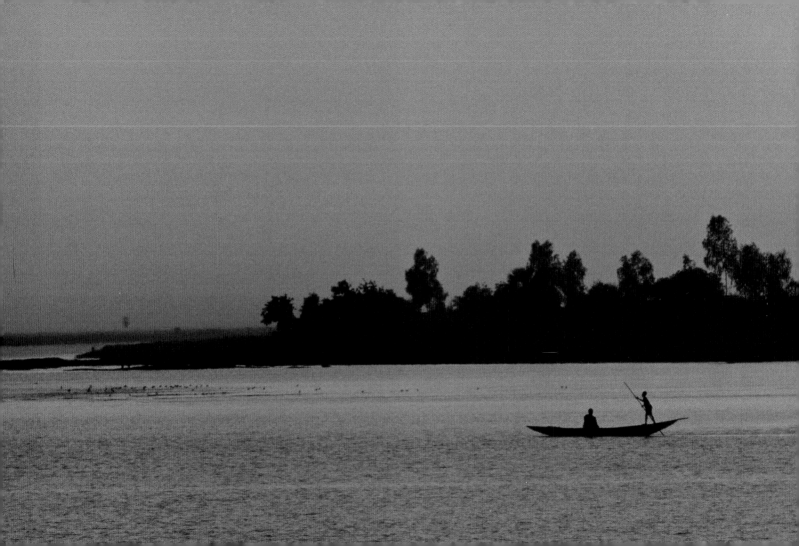

December 10

The purity of the moment is made from the absence of time.

—Cheikh Hamidou Kane

The Niger River, Mali.

Everything that we see is a shadow cast by that which we do not see.

—Dr. Martin Luther King Jr.

At the Okaukuejo watering hole, Namibia.

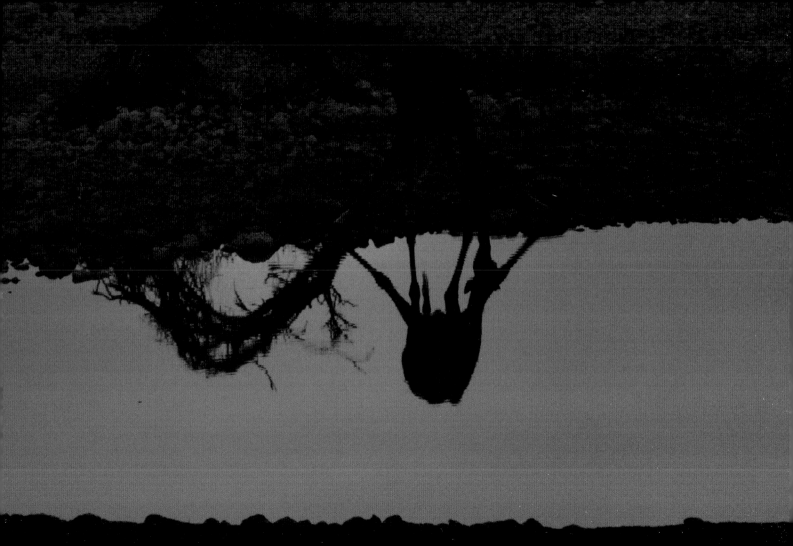

It is more through its spirituality, its works of the spirit, and art rather

than its economic prowess that a community shows its eminence, its nobility.

—Jacques Nanéma

Peul women's finery, Burkina Faso.

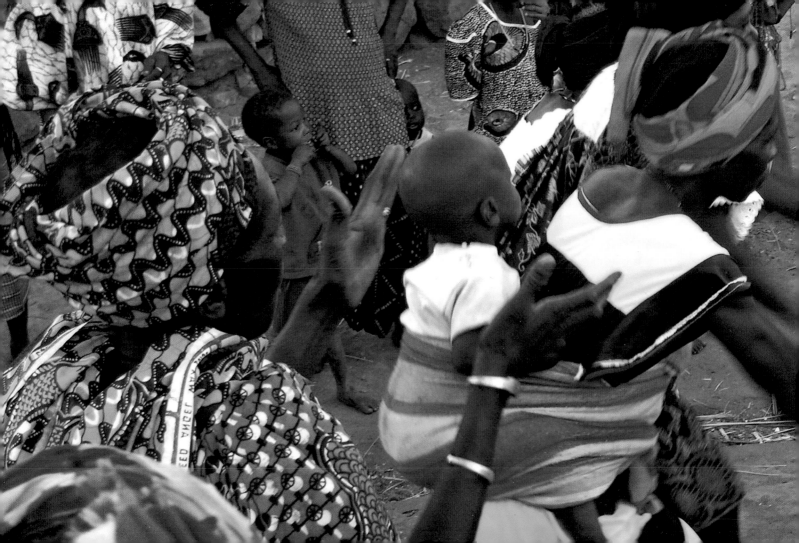

Many poor countries in the world are creative in exquisite and refined articles.

Think of such areas as cuisine, apparel, craftsmanship, art, or indeed

the finesse and refinement of expression inherent in certain languages.

These are things that perfect mankind on a humanist level,

even if they cannot be taken into account in identifying or classifying development.

—Joseph Ki-Zerbo

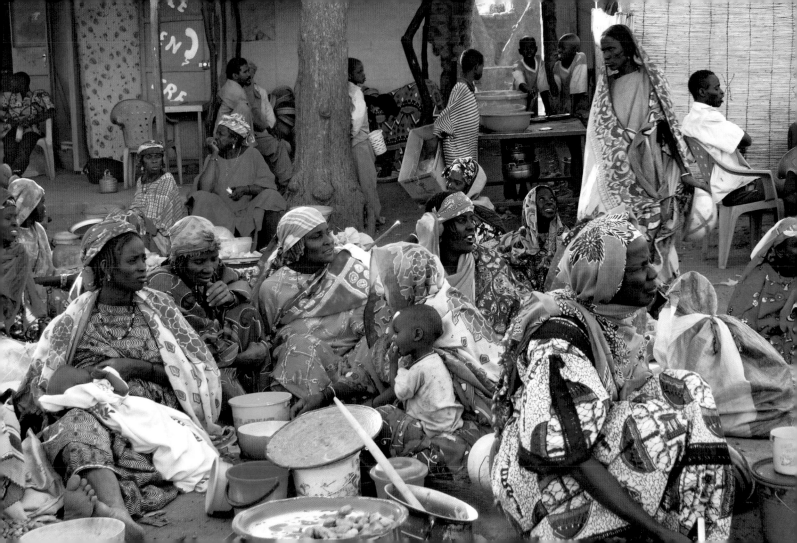

Art makes visible the need for change and social transformation.

Art is functional, collective, and committed.

—Manthia Diawara

Market day before the Djenne mosque, Mali.

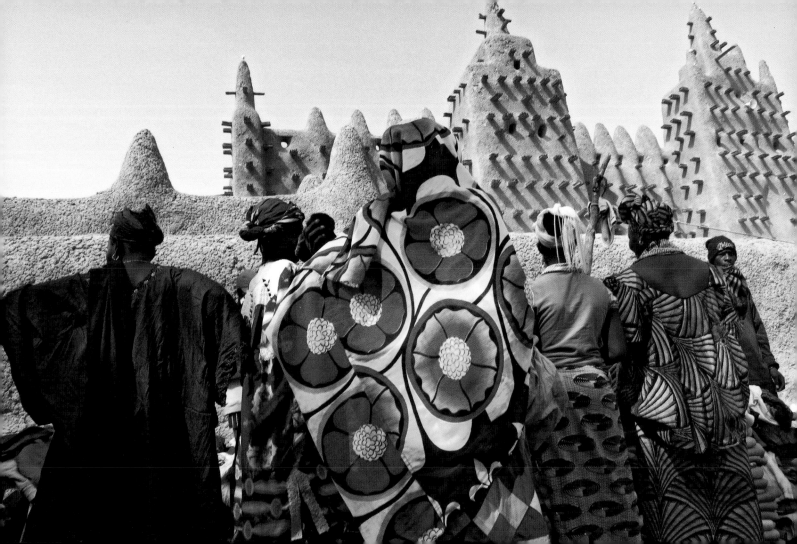

Art is a magical means through which the essence of the vital force from the ancestors is called up

and made to empower the performers and the spectators.

—Léopold Sédar Senghor

Dan Bassa fetish, Liberia.

Masks and dances, the blend of music and chants, symbols, melody, and rhythm

all are poetry in the etymological sense of the word, namely, creation.

—Alassane Ndaw

In Tiebele village, Burkina Faso.

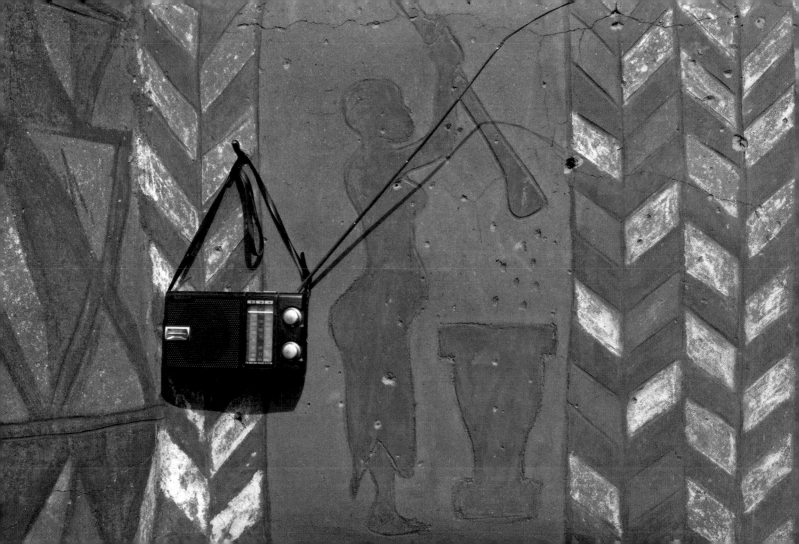

December 17

What is culture, after all, if not a series of acts of communication?

—Barnabé Laye

Women pounding millet on the cliff at Bandiagara, Mali.

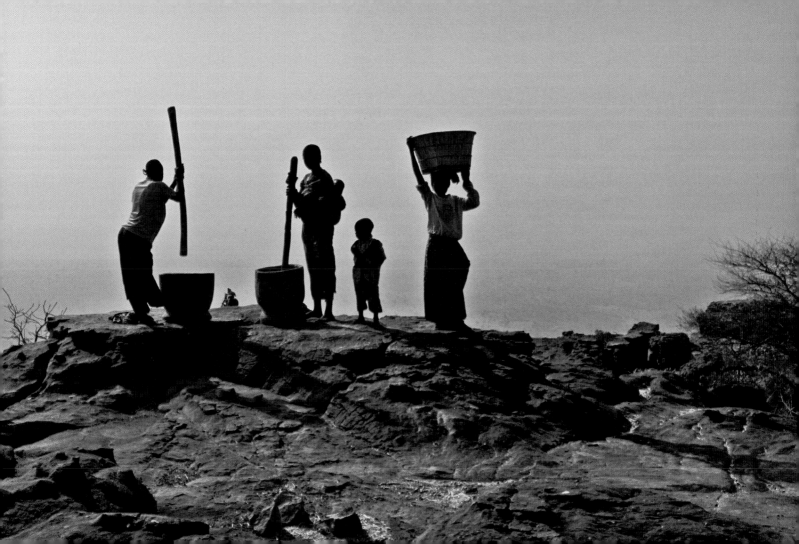

Words have an intrinsic power. When they are true, sensible, and sincere, they heal "the hearts that mourn."

They help to settle disputes between husbands and wives, parents and children, brothers and sisters.

They help to establish and realize initiatives by the community and relieve suffering.

Words are sacred.

—Aminata Traoré

Maidigue Kassogue, a Dogon village chief, advising a villager, Mali.

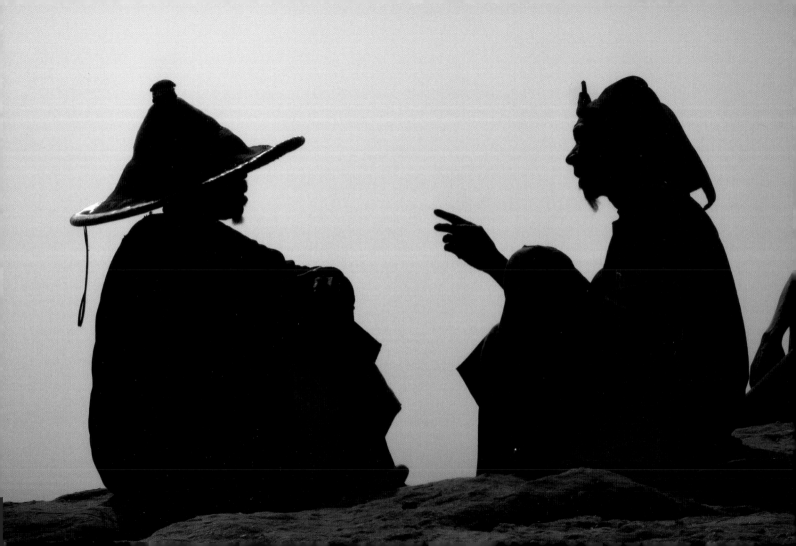

In Africa, when an old man dies, it is like a library burning.

—Amadou Hampâté Bâ

A very old Himba woman, in her hut, Namibia.

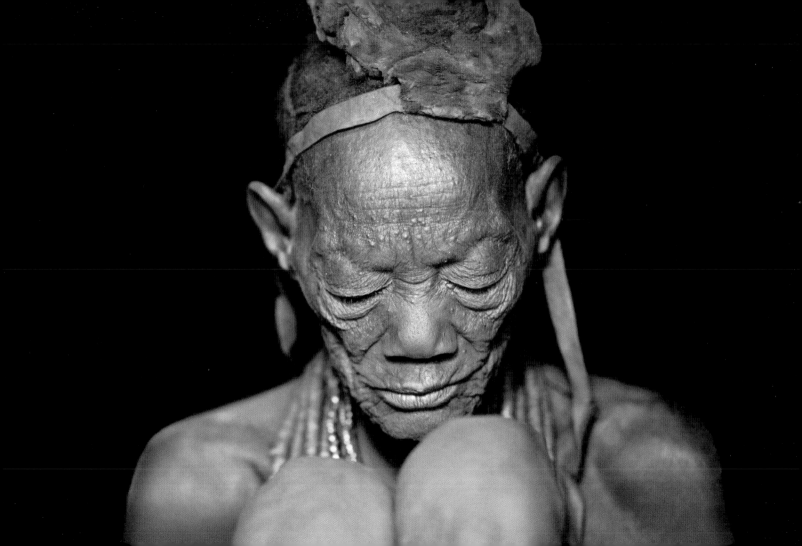

The goal of our journey, our quest, is to penetrate the mystery of life's events.

—African oral tradition

Public riverboat linking the villages of the Niger River, at dawn, Mali.

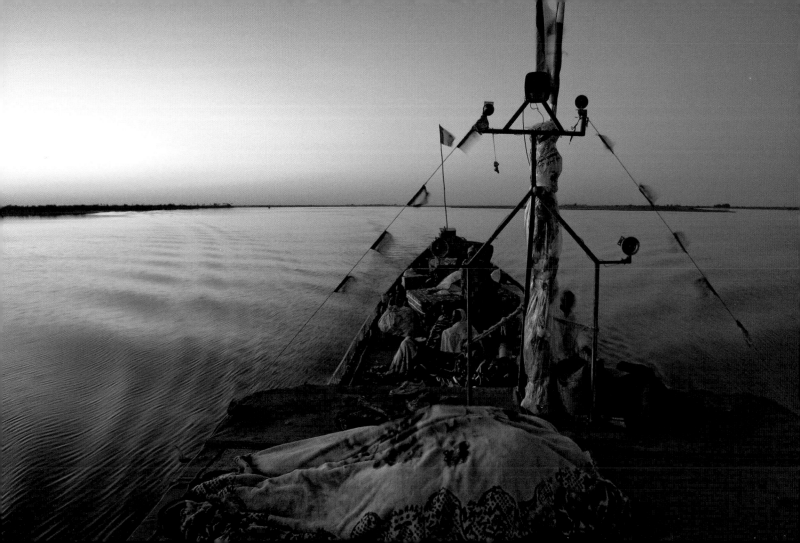

Human beings have mastery of the spoken word;

theirs, then, is the responsibility to direct the life force.

—African oral tradition

Bate, a young Malian.

Why is the spoken word so special?

Its function is to evoke the breath of the Supreme Being, of his omnipotence.

It is the ideal vehicle of the divine, of cosmic energy.

—Alassane Ndaw

Serigne, a young Senegalese.

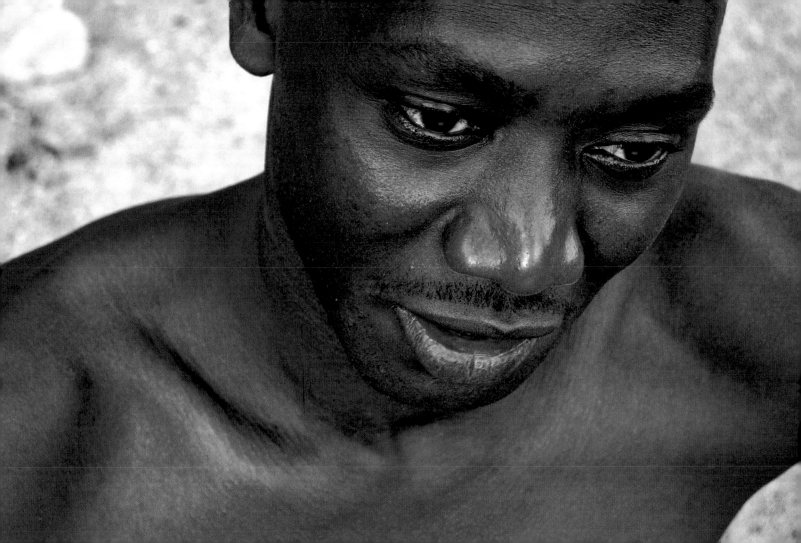

There is no music having a single sound. Different sounds are needed to give music harmony.

—*Dogon oral tradition*

In the port of Mopti, on the Niger River, Mali.

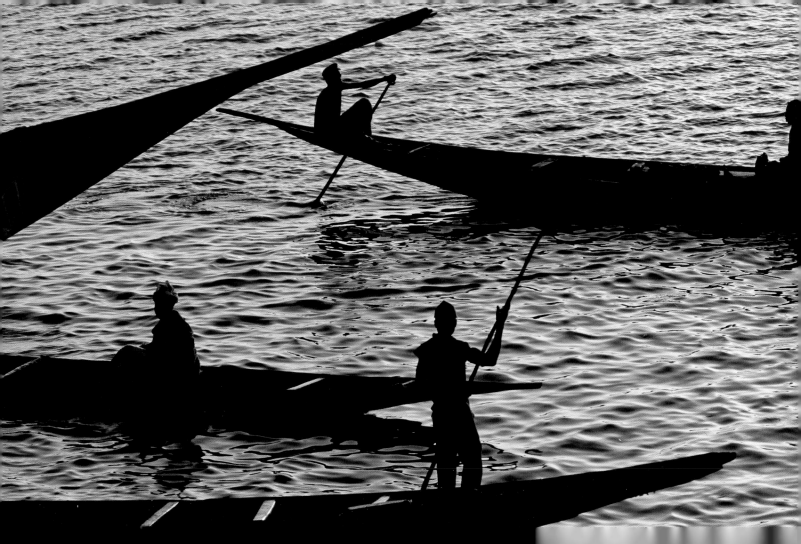

Poetry must not perish. Otherwise, what hope for the world?

—Léopold Sédar Senghor

Dusk over the high plateaus of Ethiopia.

Without the soaring spirit, we are nothing.

And the quest that raises mankind above man is the only one that honors humanity.

—Irénée Guilane Dioh

Salamanta, a young Peul shepherdess, Burkina Faso.

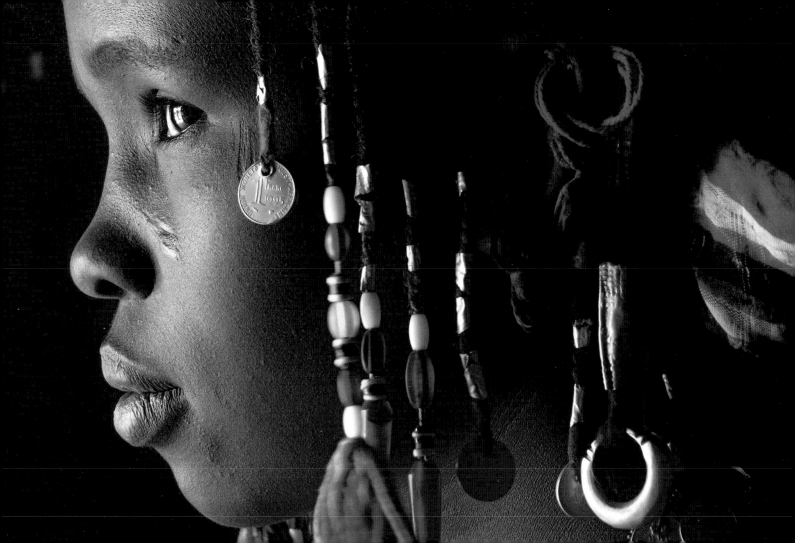

The spoken word becomes rhythmic as soon as men are stirred, become truly themselves, authentic.

Yes, poetry comes from speech.

—Léopold Sédar Senghor

Wedding festivities, Chad.

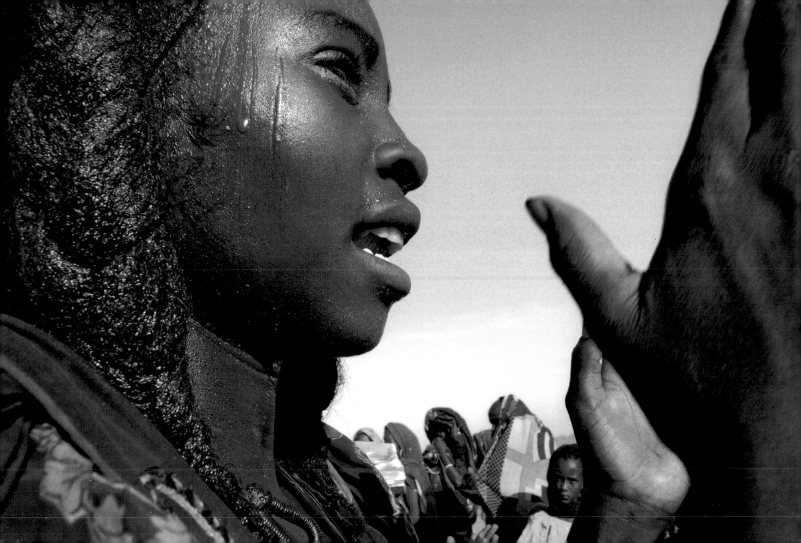

Getting lost in the verbal dance, the rhythm of the drum, and ending up in the Cosmos…

—Léopold Sédar Senghor

Himbas, joyous on their return from the well, Namibia.

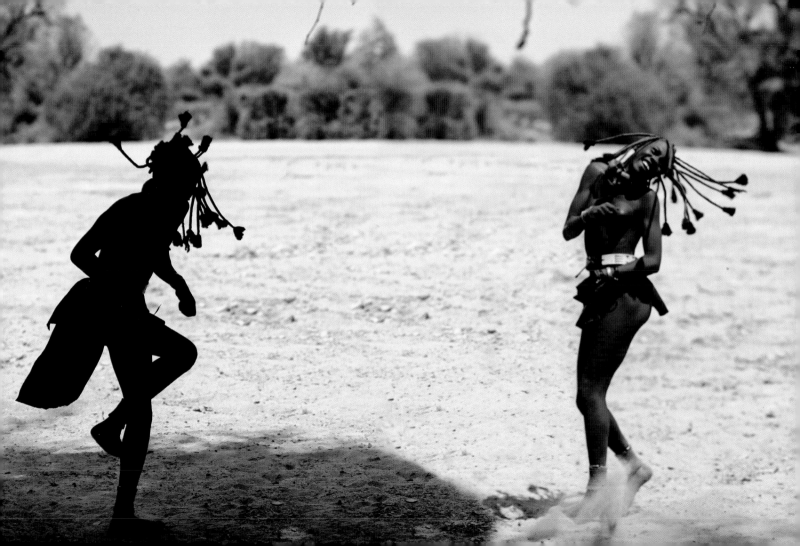

I pay homage to the point of the sun's rise, its zenith, and its setting!

to the Spirits of Africa and the world!

May our hands and our hearts come closer.

So that, joined to the past, we may continue into the future.

—Ritual prayer of West Africa

Dancing to the sound of the djembe drum, Senegal.

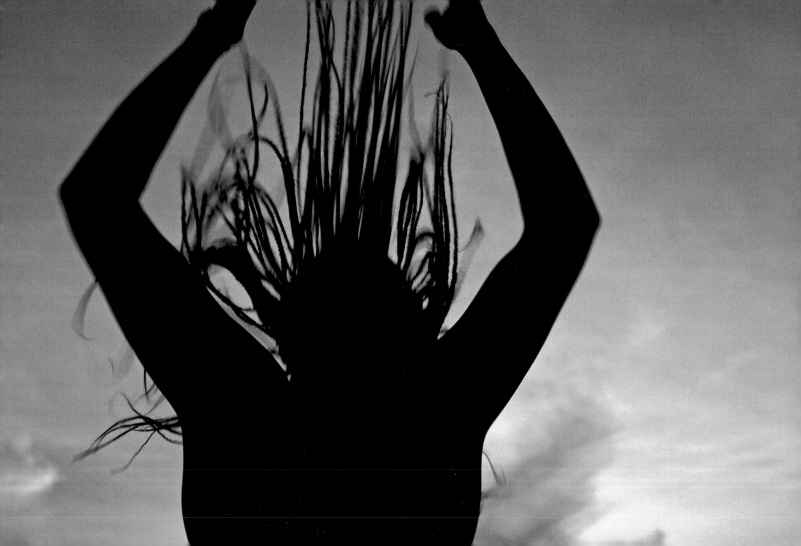

May the gods, the masks, and the statues keep us together;

may our children grow up proud, self-sufficient, and generous toward the rest of the world.

—Manthia Diawara

Moussa N'diaye, a Senegalese dancer.

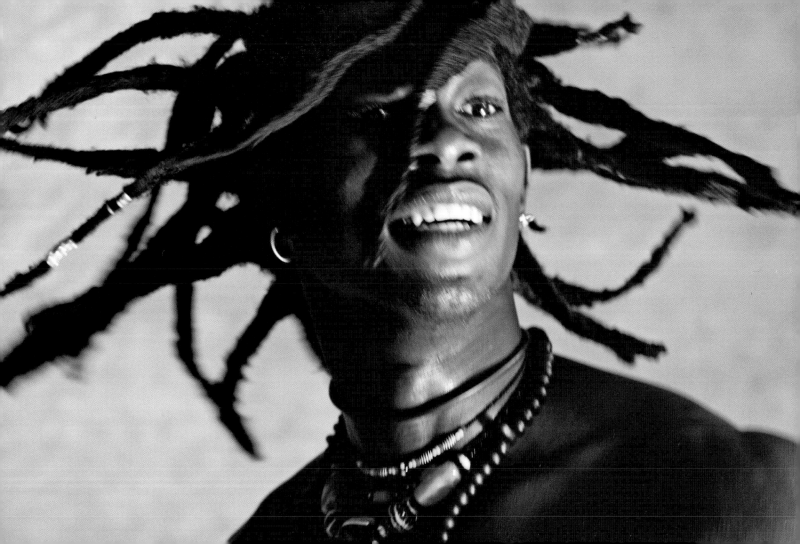

It is because the Negritude poets sang their love song from within that
it echoed worldwide and inspired other liberation songs.

—Manthia Diawara

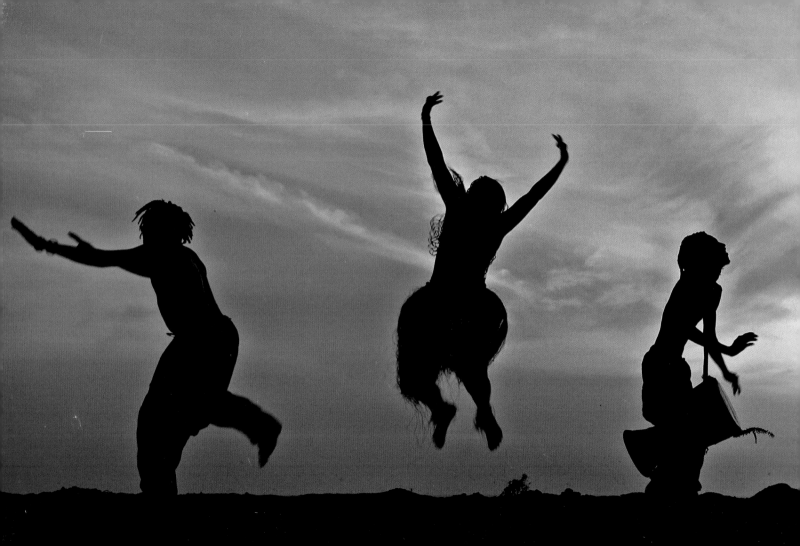

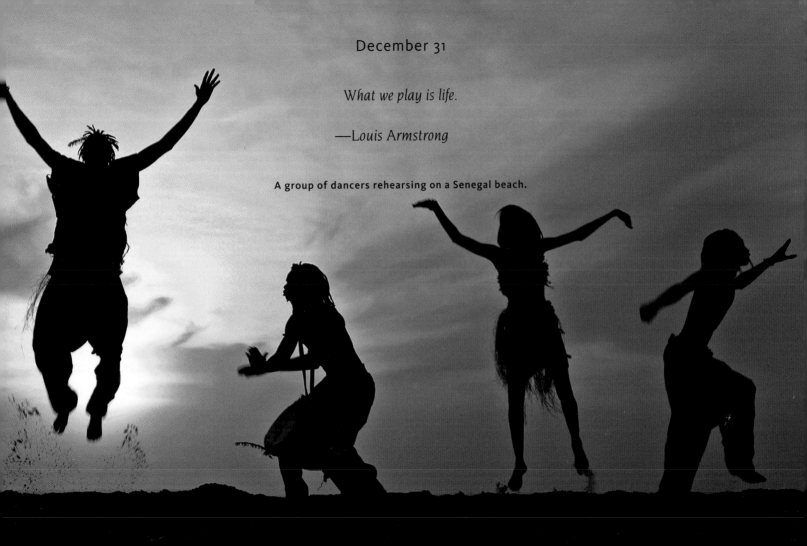

December 31

What we play is life.

—Louis Armstrong

A group of dancers rehearsing on a Senegal beach.

Biographies

Danielle Föllmi is an anesthesiologist of Latin-American origin. Having lived in Latin America, worked in Europe, and adopted her children in Asia, she speaks six languages. Her inquiring mind and knowledge of every continent have enabled her to work with university professionals and literary teams within the framework of the Offerings for Humanity project. Through the association HOPE, cofounded with Olivier Föllmi, she supports education projects and mutual aid among villages throughout the world.

The photographer **Olivier Föllmi**, of Latino-Germanic origins, was born in 1958. At the age of 18 he became passionate about the Himalayas, where he lived for twenty years. Since 2003 he has traveled the world with his assistants, trying to capture the essence of different peoples through his photographs for the Offerings for Humanity series. In the tradition of *Buddhist Himalaya* with Matthieu Ricard, and *Offerings: Buddhist Wisdom for Every Day* and *Wisdom: 365 Thoughts from Indian Masters* with his wife, Danielle, *Origins: African Wisdom for Every Day* is the twenty-first book to contain his photographs.

A Nigerian novelist and poet born in 1930, **Chinua Achebe** is the cofounder of a new style of African literature that draws its main inspiration from oral tradition and the rapid social changes at work in contemporary society. He is regarded as one of Nigeria's greatest novelists.

Born in South Africa in 1946, **Marie-Noëlle Anderson** has worked since 1990 with the healers and sangomas (ecstatic healers) of Zimbabwe and South Africa. She has taken part in numerous scientific, academic, and cultural debates on topics such as traditional medicine, the protection of biodiversity, and the informal acquisition of knowledge. In 2001, Anderson was a Slowfood prizewinner; in 2002, she established ONG Afrika Viva. She is also a member of the International Traditional Healers Organization.

The talented trumpeter and black American singer **Louis Armstrong** was born in 1901 in a poor district of New Orleans. He began his musical career in the brass band of a reform school. On leaving, he joined the Creole Jazz Band. He worked in Chicago and subsequently New York, recorded with Bessie Smith, and set up a recording band, the Hot Five, with whom he cut his earliest disks. At his death in 1971 he had a worldwide reputation, and he is regarded as one of the all-time great jazz artists.

Amadou Hampâté Bâ was born into an aristocratic Peul family in Bandiagara, Mali, in 1901. Raised as a chief's son, after numerous relocations he became a low-level official in Burkina Faso. In 1933, however, he returned to Bamako, where he undertook a long spiritual retreat under Tierno Bokar, whose esoteric teaching he committed to writing. Appointed to the ethnology department of IFAN (Institut Fondamental d'Afrique Noire), Dakar, Bâ embarked upon a university career, during which he worked to create a huge collection of material from the oral tradition. In 1958, when Mali became independent, Bâ founded the Institut de Sciences Humaines. In 1960, he became Mali's delegate to the United Nations and subsequently joined the Executive Council. It was at UNESCO, in 1962, that he made his most-quoted statement: "In Africa, when an old man dies, it is a library burning." Bâ's last few years were spent writing and working on the possibilities of rapprochement between Christianity and Islam. He died in 1990.

Mariama Bâ was born in Senegal in 1929 and died in 1981. The daughter of Senegal's first minister of health, she was brought up by her grandparents, and was much influenced by Islamic beliefs and traditional customs. A brilliant graduate of the École Normale, her novel *Une si longue lettre* (translated into English as *So Long a Letter*, 1982) contains political ideas very close to feminism.

Cheikh Oumar Bâ has been since 2003 the Secretary General of the Western European section of FLAM (Forces de Libération Africaines de Mauritanie—African Forces for the Liberation of Mauritania), an organization that fights discrimination against black Mauritanians in their own country.

Seydou Badian was born in Bamako, Mali, in 1928. He went through medical training before becoming Malian Minister of Development in the government led by Modibo Keita. This highly technical post did not prevent him from tackling the psychological problems of a changing society. Badian recommends synthesis rather than a strict choice between traditional and modern that would cut the African soul off from its essential needs.

Born in 1920, **Georges Balandier** is a professor emeritus of the Sorbonne and director of studies at the EHESS (École des Hautes Études en Sciences Sociales) in Paris. To his many books, most of them landmarks, he has recently added an intellectual autobiography, *Civilisés, dit-on* ("Civilized, They Say," Paris: PUF, 2003). He is series editor of *Sociologie d'aujourd'hui* at the Presses Universitaires de France.

Ken Bugul was born in Senegal in 1948. Her father was an 85-year-old marabout (a teacher in a Koranic school); her mother left her when she was only five. Born Marietou Mbaye Biléoma, Bugul signs her books "Ken Bugul," which in Wolof means "of interest to no one." Her stance on the status of women, Islam, and North/South relations, plus her uncomplicated half-angry, half-humorous tone, have made her one of contemporary African literature's most influential voices.

Born on Martinique in 1913, **Aimé Césaire** is a playwright and politician who has played a considerable role in the consciousness-raising of black intellectuals in both Africa and the Caribbean. Creator of the journal *Tropisme* in 1939, Césaire has been a developer and definer of the notion of negritude. In 1958, he founded the Progressive Party of Martinique. A member of Martinique's parliament until 1993, Césaire is today the mayor of Fort-de-France.

Bernard Dadié was born in Ivory Coast in 1916. He has been an administrative clerk, a member of the African Democratic Rally (RDA) in the fight for independence, a militant journalist, political prisoner, cultural affairs inspector, Minister of Culture (1977–1996), and at the same time a playwright (first play, 1933), poet, and novelist.

Born in Mali, **Manthia Diawara** spent his youth in Guinea. He studied in France, teaches and lives in the United States, and has traveled throughout Africa. Multilingual, he speaks Sarakole, Malinke, Bambara, French, and English. He is interested in literature of many different origins—French and English as well as African, Caribbean, and Afro-American.

One of Africa's most famous artists in Europe, **Manu Dibango** was born in Cameroon in 1933. As a saxophonist during the 1970s, he set up the group Soul Makossa, and invented the musical style that would come to be called world music. A leading personality in African music, Dibango has also been an active journalist, ethnologist, philosopher, and musician.

Born in 1948, **Irénée Guilane Dioh** is a Senegalese of the Serere tribe. He is particularly renowned for his serious linguistic research among the Serere of Faajut, Senegal.

Birago Diop was born in Dakar, Senegal, in 1906 and died in 1989. Though a veterinary surgeon by profession, Diop occupied the post of ambassador at Tunis. He is the author of the famous *Contes d'Amadou Koumba* (first published in English as *Tales of Amadou Koumba,* Oxford, 1966), in which the magical and the real are intimately interwoven.

Bouna Boukary Diouara is director of the National Library of Mali.

Born in 1936, **Jean-Marc Éla** has published many books. He has long taught at the University of Yaoundé, Cameroon, and has been a visiting professor at the Catholic University of Louvain-la-Neuve, Belgium.

Of Dogon origin, **Ali Guindo** is a professor of philosophy at Bamako, Mali. He presides over an association working to advance education, health, sanitary improvements, heritage, and environmental protection in Dogon country. Concerned that tourism should be adapted to his people's values, he organizes and supervises travel over his ancestors' territory.

The psychiatrist and psychoanalyst **Dr. Raymond Johnson** is a pioneer of psychiatry in his native country of Togo. Having established a number of psychiatric services on the African continent in which he has occupied the post of medical director, he is a World Health Organization (WHO) expert.

Of Peul origins, **Cheikh Hamidou Kane** is the author of a great classic of African literature, *Ambiguous Adventure* (1962). He has been a minister in the government of Senegal and a high functionary abroad. Kane received a traditional Muslim education and has studied philosophy in France.

The Kenyan statesman **Jomo Kenyatta** was born in Gatundu in 1893, a member of the Kikuyu tribe, the most populous ethnic group in Kenya. From his position as leader of KANU (the Kenya African National Union), Kenyatta became prime minister and first president of the Republic of Kenya from 1964 to 1978. Viewed by many as the man who knew how to lead Kenya to independence, he died in 1978.

Lilyan Kesteloot is a renowned specialist in African literature. A research fellow at IFAN (University of Dakar) and a seminar leader at the Sorbonne-Paris IV University, she has published a history of black African literature, the *Histoire de la littérature négro-africaine* (2001) which is likely to become a standard reference.

Leader of the civil rights movement in the United States and an apostle of nonviolence, **Dr. Martin Luther King Jr.** was a Baptist minister born in Atlanta, Georgia, in 1929. He devoted his life to the struggle against segregation and the fight for social justice. Awarded the Nobel Peace Prize in 1964, he was assassinated in Memphis, Tennessee, on April 4, 1968, as he prepared to lead the city's underpaid sanitation workers on a protest march.

Joseph Ki-Zerbo was born in Upper-Volta in 1922. Exiled for many years after a verdict by a popular revolutionary tribunal, Ki-Zerbo returned to Burkina Faso in 1992. At various times he has been a member of UNESCO's executive council, professor of history at Dakar University, director of CEDA (Study Center for African Development) at Ouagadougou, and a politician and member of Burkina Faso's national assembly.

Ahmadou Kourouma, born in 1927, was an author of international repute. In his life as well as in his works, Kourouma never ceased to denounce the destruction wrought by colonization as well as the excesses of the political regimes that followed it. He died in 2003.

Born in 1941, **Barnabé Laye** is one of the most important poets and novelists of Benin.

Nelson Mandela was born in 1918. In 1944, he joined the ANC (African National Congress), a moderate party of the black middle class. Imprisoned for nine months in 1952 following the success of a first civil-disobedience campaign, he was subsequently acquitted. Thereafter he established an armed movement within the ANC, traveling for a time in Africa and visiting London. On his return to South Africa, he was arrested and sentenced to five years in prison. A second trial led to a verdict of life imprisonment. Having rejected all offers of parole, he was nonetheless released in 1990. His goal was the creation of a united South Africa, with a parliament elected by all on a nonracial basis. Mandela began negotiations with the white government in spite of violent protests by white minority extremists. An agreement led to a general election with a universal franchise in 1994, after which Mandela became South Africa's first black leader.

Born in 1908, **Thurgood Marshall** was the first black justice on the U.S. Supreme Court. President John F. Kennedy nominated Marshall to the court in 1967; he died in 1993.

Nsame Mbongo is a lecturer in philosophy and sociology at the Faculty of Letters and Human Sciences in the University of Douala, Cameroon, Department of Philosophy and Psychology.

Born in 1930, **Father Engelbert Mweng** was a Jesuit priest in Cameroon, a specialist in African art and the theology of the Third World. He died in 1995.

Jacques Nanéma is a research lecturer in philosophy, education, and development, with teaching duties at the University of Ouagadougou, Burkina Faso.

Diatta Nazaire was born at Casamance (Senegal) in 1942. Having studied philosophy and theology at the grand seminary of Sébikotane, he was ordained a priest in 1972 after theological studies in Rome.

Alassane Ndaw is a Senegalese philosopher, dean of the Faculty of Letters at Cheikh Anta Diop University, Dakar.

The Cameroon philosopher and politician **Ebénézer Njoh-Mouelle** was once a student at the Sorbonne. His activities widely ranged from academic administration and teaching to politics, and he has been an advisor to the president, the secretary general of the party in power, a deputy in the National Assembly, and a member of the executive council of UNESCO. Njoh-Mouelle remains one of Cameroon's most productive intellectuals, with more than ten books published on philosophy and politics.

Born in 1943, **Titinga Frédéric Pacere** is a lawyer in Ouagadougou who is just as well known for his poetic works. He has taken a leading role in research into the African oral tradition.

Liliane Prévost is a specialist on the West African cultural environment, and Sorry Bamba's collaborator on the book *De la Tradition à la World Music* ("From Tradition to World Music," Paris, 2000).

Léopold Sédar Senghor, one of the greatest of all African writers, was born in Joal, Senegal, in 1906. As a dominant worldwide influence and a politician, he became "the minstrel of negritude." Standing at the crossroads of the civilizations of Africa and the West, he defended in both his life and works the values of the mixed race and the universal. Senghor died in 2001.

Ousmane Socé was born in Dakar, Senegal, in 1911. Having attended a Koranic school, he was educated in a French university. Both a politician and an author, Socé was one of Senegal's great novelists. He died in 1974.

Sobonfu Somé belongs to the Dagara people of West Africa. She was brought up traditionally and taught by elders. She is a bearer of Africa's message, one of great richness and sensitivity.

Born in Ghana in 1924, **Efua Theodora Sutherland** devoted herself to a number of different genres: biography, poetry, prose, and theater for both radio and stage. She put on her own plays and established several theatrical companies. She also inspired a generation of young Ghanaian writers and actors. A tireless campaigner for women's rights, Sutherland helped make cultural life in Ghana more dynamic. She died in 1996.

Born in 1932, **Djibril Tamsir Niane** is an eminent historian of Africa who has specialized in black civilization and social scientific research. In addition to a variety of publications, plays, and articles, he is the author of several books on the history of West Africa.

Aminata Traoré, a psychosociologist by training, is the founder/director of the Centre Amadou Hampâté Bâ in Mali, which is known for its internationally assertive stance concerning Africa's critical situation. She has been Mali's Minister of Culture and Tourism. An intellectual, Traoré fights on all fronts against the tragic results of imposed globalization. A believer in the power of culture, she has launched the African Initiative for Ethics and Aesthetics.

Albertine Tshibilondi Ngoyi, originally from the Democratic Republic of Congo, is now a professor of philosophy at the Catholic Institute of Yaoundé in Cameroon. In addition to her research in semiotics, she also studies problems concerning the philosophy of education and the emancipation of women in Africa.

Kwasi Wiredu was born in Ghana. He studied and taught philosophy at the University of Ghana for twenty-three years before continuing his work at Oxford University. He is currently professor of philosophy at the University of South Florida.

Abner Xoagub is responsible for the anti-AIDS program in Namibia, the National AIDS Coordination Programme (NACOP).

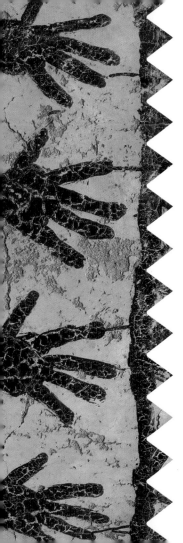

Bibliography

Chinua Achebe, *Things Fall Apart*, New York: Anchor Books (Random House), 1959. Reprinted by permission of Harcourt Education: February 26; September 2; October 29.

Alternatives Sud, *Pour une pensée africaine émancipatrice, points de vue du Sud*, Paris: L'Harmattan, 2004: May 21, 25, 28, 29, and 30; June 3; August 26; September 22; October 16 and 18; November 2; December 12.

Amadou Hampâté Bâ, *Aspects de la civilisation africaine*, Paris: Présence africaine, 2000: May 5.

———, *Contes initiatiques peuls*, Paris: Pocket, 1994: January 1, 2, 20, and 22; February 12, 15, and 18; March 5; May 1, 4, 8, 10, and 15; June 16 and 30; July 20; August 5 and 7; September 10 and 11; November 8, 13, and 16; December 19; back endpapers.

———, *Vie et enseignement de Tierno Bokar : Le Sage de Bandiagara*, Paris: Le Seuil, 1980: January 18 and 25; March 31; August 29; September 15.

Cheikh Oumar Bâ, *Odes sahéliennes*, Paris: La Pensée universelle: June 27.

Seydou Badian, Bernard Dadié, and Marcel Griaule, *Littérature africaine, l'engagement*, Dakar: Nouvelles éditions africaines du Sénégal: June 1 and 20; December 21.

Georges Balandier, *Civilisés, dit-on*, Paris: Presses Universitaires de France, 2004: September 16.

Ken Bugul, *De l'autre côté du regard*, Paris: Le Serpent à Plumes, 2003: June 22; October 28.

Aimé Césaire, *The Collected Poetry*, Clayton & Annet Eshleman, tr. and ed., Berkeley: University of California Press, 1983. Copyright © 1983 The Regents of the University of California: April 7.

Jennifer Crwys-Williams, ed., *In the Words of Nelson Mandela*, Secaucus, N.J.: Birch Lane Press, 1998: May 20; September 24; October 24.

Bernard Dadié, *Légendes africaines*, Paris: Éditions Seghers, 1966: December 6.

———, *Opinions d'un nègre*, Dakar: Nouvelles éditions africaines du Sénégal, 1979: November 23; December 3 and 7.

Manthia Diawara, *In Search of Africa*, Cambridge: Harvard University Press, 1998. Reprinted with permission of the publisher. Copyright © 1998 by the President and Fellows of Harvard College: August 22; December 14, 15, 29, and 30.

Irénée Guilane Dioh, *Éphémérides (mars-juin 1995)*, Nice: Fasal, 1998: January 16; February 10 and 17; March 15 and 22; April 12; May 31; June 9 and 23; November 21; December 5 and 25.

Birago Diop, *Leurres et lueurs*, Paris: Présence africaine, 1960: January 11.

Emmanuel Malolo Dissaké, ed., *L'aspiration à être autour du philosophe Ebénézer Njoh-Mouelle. Autobiographie intellectuelle*, Chennevières-sur-Marne: Éditions Dianoïa, 2002: May 14; September 25 and 30; October 1.

Tiarko Fourche and Henri Morlighem, *Une bible noire, cosmogonie bantu*, Paris: Les Deux Océans, 2002: January 3 and 6; February 14; September 26; November 20 and 26.

Marcel Griaule, *Conversations with Ogotemmêli: An Introduction to Dogon Religious Ideas*, London: published for the International African Institute by Oxford University Press, 1965: June 19; July 2; October 9; November 27.

Dr. Raymond Johnson, *Propos sur les pères et mères d'Afrique : « Regard d'un psychiatre noir »*, Paris: Éditions de santé, 2001: February 4 and 28; March 11 and 16; April 3, 11, and 28; June 2; July 3 and 17; August 20; September 3, 7, 8, and 18; November 10, 24, and 25; December 2.

Cheikh Hamidou Kane, *Ambiguous Adventure*, Portsmouth, N.H.: Heinemann, 1963: March 21, 28, 29, and 30; May 16; June 10; October 14, 17, 19, 21, and 27; November 15; December 10.

———, *L'Aventure ambigüe*, Paris: Éditions Julliard, 1961: September 17.

Lilyan Kesteloot, *Anthologie négro-africaine : panorama critique des prosateurs, poètes et dramaturges noirs du XXe siècle*, Vanves: Edicef, 1992: January 17; March 2 and 13; April 5, 14, 26, and 27; May 2 and 24; June 4; July 23 and 27; August 19; November 3, 6, 9, and 17.

Dr. Martin Luther King Jr., *The Measure of Man*, Minneapolis: Fortress Press, 1988: December 11.

Joseph Ki-Zerbo, *À quand l'Afrique ? Entretien avec René Holenstein*, La Tour d'Aigues: Éditions de l'Aube, 2003: February 20; June 5 and 8; August 21, 24, and 31; September 13, 27, 28, and 29; October 2, 4, 5, 23, and 25; November 1, 6, 9, and 14; December 13.

Ahmadou Kourouma, *The Suns of Independence*, Adrian Adams, tr., New York: Africana Publishing Company (an imprint of Holmes & Meier), 1981: June 21.

Nelson Mandela, *Long Walk to Freedom*, Boston and New York: Little Brown, 1994: September 21.

Diatta Nazaire, *Proverbes jóola de Casamance*, Paris: Karthala/Agence de la francophonie, 1998: November 11.

Alassane Ndaw, *La Pensée africaine : Recherches sur les fondements de la pensée négro-africaine*, Dakar: Neas, 1997: January 4, 5, 8, 12, 13, 23, and 27; February 1, 19, and 24; March 8; April 6 and 20; May 7 and 26; June 7, 13, 17, 25, 26, and 28; July 1, 21, 25, and 26; August 30; September 23; December 16 and 22.

Marion Péruchon, ed., *Rites de vie, rites de mort. Les pratiques rituelles et leurs pouvoirs : une approche transculturelle*, Paris: ESF Éditions, 1997: June 12; July 22; September 1; November 18.

Liliane Prévost and Barnabé Laye, *Guide de la sagesse africaine*, Paris: L'Harmattan, 1999: March 27; December 17.

Anne-Cécile Robert, *L'Afrique au secours de l'Occident*, Paris: Éditions de l'Atelier and Éditions ouvrières, 2004: September 12.

Léopold Sédar Senghor, *Œuvre poétique*, Paris: Le Seuil, 1990: December 24, 26, and 27.

———, *The Collected Poetry*, Melvin Dixon, tr. and ed., Charlottesville and London: University of Virginia Press, 1991. Reprinted with permission of the University of Virginia Press: March 14; May 12; July 7.

Sobonfu Somé, *The Spirit of Intimacy*, New York: Quill (HarperCollins), 1997, copyright © 1997 Sobonfu Somé. Reprinted with permission of HarperCollins Publishers Inc.: January 9 and 26; February 2, 3, 5, 6, 7, 8, 9, 11, 22, and 23; March 1, 6, 9, 10, 12, 20, and 24; April 2, 16, 17, 18, 21, 22, 23, 24, and 29; May 9, 13, 18, and 27; June 6 and 29; July 5, 8, 10, 11, 12, 13, 14, 15, 16, 18, 19, 28, 29, 30, and 31; August 1, 2, 3, 4, 6, 9, 10, 11, 13, 14, 15, 16, 17, 18, and 25; September 5, 6, and 9; October 10, 12, 13, and 31; November 7; December 9.

———, *Vivre l'Intimité : La sagesse de l'Afrique au service de nos relations*, Saint-Julien-en-Genevois: Jouvence Éditions, 2001: March 7, 23, and 26; April 19; July 6.

Aminata Traoré, *Le viol de l'imaginaire*, Paris: Arthème Fayard, 2002: front endpapers; January 31; March 18; May 3, 6, and 23; August 23; September 14; October 3, 7, 8, 15, and 30; November 4 and 29; December 18.

Stephen Watson, *Song of the Broken: String Poems from a Lost Oral Tradition*, Riverdale-on-Hudson, N.Y.: Sheep Meadow Press, 1991: January 30.

This book is dedicated to Sheila Jequier Nanan, who was the first to inspire us with African vibrations.

Origins: African Wisdom for Every Day has been made possible through the contributions of:

Researchers and authors who have collected the "living words" of the sages whose thoughts fill this volume:

Marcel Griaule, ethnologist, through his conversations with Ogotemmêli;

Stephen Watson, who currently teaches English at the University of Cape Town and who has collected poems from Bushman oral tradition;

Tiarko Fourche and Henri Morlighem, who have succeeded in penetrating the core of the oral tradition of the Baluba of the Kasai, revealing to mankind their code of life as well as Bantu cosmogony;

Anne-Cécile Robert, journalist for *Le Monde diplomatique* and professor at the Paris Institute of European Studies;

Marion Péruchon, psychologist and psychotherapist, with her transcultural approach to ritual practices;

Françoise Héritier-Auger, professor of Anthropology at the Collège de France;

Vladimir Jankelevitch, 1903–1985, eminent French philosopher;

Jennifer Crwys-Williams.

For literary research, we should also like to thank:

Mr. Doudou Diène, UNESCO Director of Intercultural Dialogue and UN Special Rapporteur of the Commission on Human Rights on contemporary forms of racism, racial discrimination, xenophobia, and related intolerance;

Monsieur d'Orville, UNESCO Director of the UNESCO Service for Dialogue among Civilizations;

Christian Ndombi, UNESCO researcher;

Georges Balandier, Director, Centre d'Études Africaines, Paris;

Corneille Jest, CNRS researcher, France;

Youssou Mbargane Guissé and the Institut Fondamental d'Afrique Noire, Dakar;

Ali Guindo and his research assistants;

Marie Van Leckwyck, psychotherapist;

Mame-Kouna Tondut-Sène, sociologist and ethnologist;

Christiane Diop, Director of Présence Africaine;

Madame Valérie Bouloudani, friend of Africa;

Marie-Noëlle Anderson, psychotherapist;

Madame Odette Dubois and Françoise Aurèche, archivists;

and all the griots, sages, chiefs of the villages, and initiates, who, happy to contribute to this volume, shared their knowledge with enthusiasm and generosity.

For their assistance on location:

Monsieur N'Diaye Bah, Minister for Crafts and Tourism, Mali;

Monsieur de La Batie, French Ambassador at Windhoek, Namibia;

Mahmadou Keita, Regional Director of Tourism for the district of Bamako and Omar Ballatoure, Mali;

Christian Saglio, Director of the French Cultural Center, Dakar, Senegal;

Nicole Seurat, Director of the French Cultural Center, Bamako, Mali;

Georges Paugam, Director of Terres Sauvages, Geneva, and David Rey at Windhoek, Namibia;

Melitta Bosshart, doctor to the Bushmen, with Mireille and Jean-Pierre Marty;

Philippe Ancely and the Tama Lodge team, Senegal;

Guy Catalo and Fanou Bonneaud at Bamako, Mali;

Oumar Traoré, Nouh Toumouté, and all the inhabitants of Indelou in Mali, as well as Ibrahim Oulobobo in Burkina Faso;

Luigi Cantamessa, director of Géo-découverte, Geneva;

Abraham Tsegaye, Ethiopia;

Rocco Rava, Director of Spazzi d'Aventura, Milan, and Usman, N'Djamena.

Along with generous assistance from:

Olivier Tanner and Ngawang Tashi, photography assistants; Guy de Régibus, development assistant; and Marco Schmid, photoengraving;

Viviane Bizien, Chantal Dubois, Marie-Christine De Sa, Céline Viala, Emmanuelle Courson, Anne-Marie Meneux, Laurence Duchemin, Nicolas Pasquier, Hervé Guillen at the Atelier Föllmi;

Emmanuelle Halkin, Allison Reber, Valérie Roland, Dominique Escartin at Éditions de La Martinière.

The authors also offer their particular thanks to Jean Sellier, geographer and historian, author of the *Atlas des peuples* series published by Éditions de La Découverte in Paris, for his advice throughout.

Translated into seven different languages, *Origins: African Wisdom for Every Day* is the third volume of the Offerings for Humanity series, after *Offerings: Buddhist Wisdom for Every Day* and *Wisdom: 365 Thoughts from Indian Masters*. It was generously supported by:

❖ An anonymous donor

❖ Lotus and Yves Mahé

❖ With the involvement of **FUJIFILM**

❖ And the Paris photography lab **DUPON**

All the photographs in *Origins: African Wisdom for Every Day* were taken by Olivier Föllmi in 2004 and 2005.
Olivier Föllmi is represented by the Rapho Agency in Paris: www.rapho.com
For further information, please log on to **www.olivier-follmi.com**

Project Manager, English-language edition: **Céline Moulard**
Editor, English-language edition: **Virginia Beck**
Researcher, English-language edition: **Brigitte Sion**
Jacket design, English-language edition: **Shawn Dahl**
Design Coordinator, English-language edition: **Shawn Dahl**
Production Coordinator, English-language edition: **Steve Baker**

Library of Congress Cataloging-in-Publication Data:
Origins: African wisdom for every day / [edited by] Danielle and Olivier Föllmi;
texts by Louis Armstrong ... [et al.].
p. cm.
Includes bibliographical references and index.
ISBN 0–8109–5945–3 (alk. paper)
1. Conduct of life—Quotations, maxims, etc. 2. Authors, Black—Quotations. I. Title: African wisdom for every day.
II. Föllmi, Danielle. III. Föllmi, Olivier, 1958– IV. Armstrong, Louis, 1901–1971.
PN6084.C556O75 2005
081'.089'96—dc22
2005012383

Printed and bound in Italy
10 9 8 7 6 5 4 3 2 1

Harry N. Abrams, Inc.
100 Fifth Avenue
New York, N.Y. 10011
www.abramsbooks.com

Abrams is a subsidiary of
LA MARTINIÈRE
GROUPE

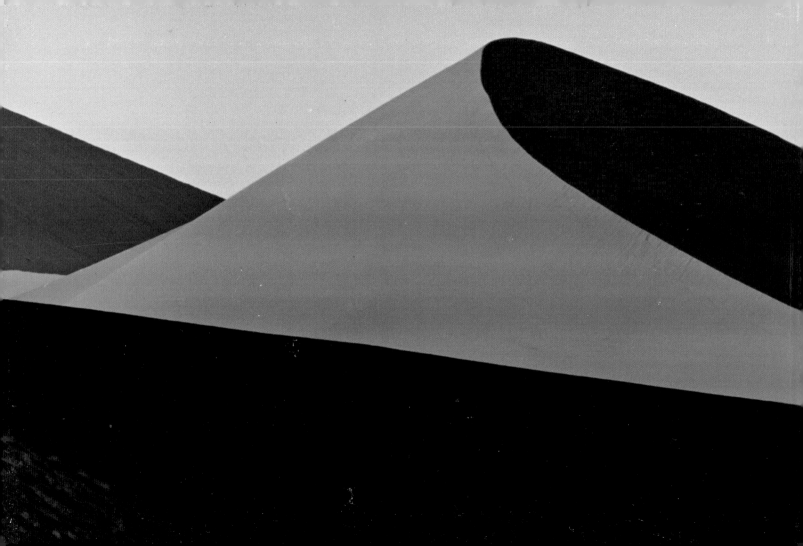